The Green Halo

The Green Halo

A Bird's-Eye View of Ecological Ethics

With a Foreword by Holmes Rolston III

Erazim Kohák

OPEN COURT

Chicago and La Salle, Illinois

To order books from Open Court, call toll free 1-800-815-2280.

Open Court Publishing Company is a division of Carus Publishing Company.

Copyright © 2000 by Carus Publishing Company

First printing 2000

Printed and bound in the United States of America.

Translated from the Czech *Zelená svatozá'* (Prague: Sociological Publishers, 1998) by the author.

Library of Congress Cataloging-in-Publication Data

Kohák, Erazim V.
 [Zelená svatozář English]
 The green halo: a bird's-eye view of ecological ethics/Erazim Kohák; with a foreword by Holmes Rolston.
 p. cm.
 Includes bibliographical references and index.
 ISBN 0-8126-9411-2 (alk. paper)
 1. Environmental ethics. I. Title.
 GE42.K64813 1999
 179'.1--dc21 99-38665
 CIP

To all who shared my life under the tumble-down dam, long ago and far away, people, beavers, porcupines, boulders, trees—and to all who today share my hopes for this beloved land.

e.k.

Contents

ANALYTIC TABLE OF CONTENTS ix
FOREWORD BY HOLMES ROLSTON, III xv
PREFACE TO THE ENGLISH EDITION xix
PREFACE TO THE CZECH EDITION xxiii

Introduction: OF HUMANS, ELEPHANTS, AND CHINA SHOPS 1

 i. Ethics and Ecological Ethics 1

 ii. The Limits of Yellow Paint 6

 iii. Ecology, Science, Philosophy 11

Part I: OF HUMANS AND (OTHER) ANIMALS 15

 i. Strangers in the Wild 17

 ii. Our Long-Lost Kin 25

 iii. Meat or Mercy? 29

 iv. The Lure of Perfection 41

 v. All Too Human 45

Part II: OF NATURE, VALUE, AND ETHICS 51

 i. The Moral Sense of Nature 53

 ii. Ethics of the Fear of the Lord 58

 iii. The Ethics of Noble Humanity 65

 iv. The Ethics of Reverence for Life 79

 v. The Land Ethic 87

 vi. Lifeboat Ethics 93

Part III: **STRATEGIES IN ECOLOGICAL ETHICS** 103

A. **STRATEGIES OF PERSONAL
 RESPONSIBILITY (SUBJECTIVIZATION IN
 ECOLOGICAL ETHICS)** 105

i. About Ecological Strategies 105

ii. Deep Ecology: Arne Naess and Friends 108

iii. Ecology of Deep Identification 118

iv. Feminism and Ecofeminism 122

B. **STRATEGIES OF RECOGNIZED NECESSITY
 (OBJECTIVIZATION IN ECOLOGICAL
 ETHICS)** 129

v. Hypothesis GAIA 129

vi. Nature and the Human Animal 135

vii. Systems Theory in Ecological Ethics 142

viii. "Ecology" as an Ideology 147

Postscript: **TURNING GREEN: THE MAKING
OF A MINIMALIST** 155

NOTES 164
NOTES FOR A BIBLIOGRAPHY 187
INDEX OF NAMES 203
INDEX OF TOPICS 207
INDEX OF BIBLICAL QUOTATIONS 211

Analytic Table of Contents

Preface: Doing ecological philosophy, xv–xviii

Technocratic and democratic model, xv–xvi; thought versus agitation, xvi–xvii; labeling needs follow experience and thought, xvii–xviii

Introduction:

i. Ethics and Ecological ethics, 1–6

Ethics = rules for guiding freedom, 1–2; might be of God or reason, 2; ecological ethics rules for dealing with the nonhuman world, 2; needed because "progress" is destroying Earth, 3–4; on level of the environment, habitability of Earth, and human relations, 5; so need rules for *treading lightly on Earth,* 6

ii. The Limits of Yellow Paint, 6–1

"Progress" destructive because humans numerous, 6–8; demanding, 8–10; powerful, 10–11

iii. Ecology, Science, Philosophy, 11–14

The meanings of science, 11–13; of philosophy, 13–14

Part I: Of Humans and (Other) Animals

i. Strangers in the Wild, 17–24

Europe: world stage for humans, 17–18; animals kin but in hierarchy, 19; the industrial revolution makes them raw material, 19; the democratic revolution equals, 20. The Renaissance stressed fallen nature, 20; Romantics innocent, 21; but serves superior humans, 22; who "have souls," 23; stressed to save humans from degrading treatment, 24

ii. Our Long-Lost Kin, 25–29

Do souls separate us? NO, 25–26; so rediscover kinship, 27; as with dogs, 28; with compassion and respect, 29

iii. Meat or Mercy? 29–41

Dilemma: so reject guilt? compassion? seek compromise, 30; parallel with slavery: justify, abolish, modify? 31–32; Singer: abolitionist, free animals, 32; assert equality: difference not morally relevant, 32–34; irreducible value, 35; (intrinsic and extrinsic value, 35–37); the abolitionist attitude: refuse structural cruelty in experimentation and meat diet, 38–41

iv. The Lure of Perfection, 41–45

Vegetarianism as a philosophic problem: how to live with imperfection? 41; can refuse to feel guilty, or achieve perfection, or seek compromise, 42. Vegetarianism and objections to it, 43–44; fanaticism: do we want to lessen suffering or claim perfection? 43–44; not "compromise" but seek compassion—and forgiveness for imperfection, 45

v. All Too Human, 45–49

Rollin: animal defender on experimental commission, change posture, 46; recognize "rights"? 47; reverse posture: impermissible unless justified, 48; the question of the place of humans in the cosmos, 49

Part II: Of Nature, Value, and Ethics

i. The Moral Sense of Nature, 53–58

Nature "has sense" in experience, 53; of hunter-gatherers, 54; of herders-ploughmen, 55; of craftsmen-traders, 56; becomes nonsensical in the experience of affluent producers-consumers, 56–57. Is greed/quest for affluence natural? 57. No, humans are exotics, 58

ii. Ethics of the Fear of the Lord (Theocentrism), 58–65

Anthropocentrism not primordial, first stance is theocentric, 59; though not as "belief in supernatural" but as living presence of Sacred, 60; Skolimowski: values of faith are conservation values, 61; while Lynn White: values of Western religious belief are values of mastery, 62. Chief contribution of Hebrew-Christian, harmony possible, 63; while to Greek humans disrupt necessarily. If possible, can seek sustainability, 64; choose responsibly in designing our way of living, 65

iii. The Ethics of Noble Humanity (Ethical Anthropocentrism,) 65–79

Beware labels! Reality rooted in experience and conception, 66; experience of (technical) domination and conception of humans distinct from nature in Descartes, 67; and in Kant, 68; leads to anthropocentrism = exploitation, 69.—But can mean also responsibility for value, 70. Sherrington: value enters in with altruism, Dillard likewise, 71; so anthropocentrism = subordinating greed to nobler values, reject consumerism, 72. So Gore: life story not about consumption, reject consumer addiction, 73–74. Systematic solution: voluntary simplicity (Elgin), 75; against consumer snobbery, 76. Arguments against consumerism, 77. Altruism against egoism, 78–79

iv. The Ethics of Reverence for Life, (Biocentrism) 79–87

Presented by Schweitzer as philosophy in an enchanted world, 79; marked by reality of value, 80; Schweitzer's sense of reference for life, 81: there is but one desire to live, dread of death, 82; so defend life. Taylor formalizes it, 83; provides formal definitions of good, norm, 84; binding on rational agents. Defines biocentrism as the awareness humans are newcomers, 85; and ought to respect life, that life is interlinked, every life valuable, so no life superior to others, 86; generating formally based ethics, 87

v. The Land Ethic (Ecocentrism), 87–93

Leopold's "thinking like a mountain," 87–88; considers biotic community of equals, 88; as a whole, its "integrity, stability and beauty," vs individual survival, 89; yet not just holistic: individual lives realize value. Holism against prevailing trends, 90; need to learn to consider whole, our place therein, 91; this *ecological literacy,* awareness, basic to human coexistence with Earth. Needs to be considered as dynamic process, 92; of which death is a part, 93

vi. Lifeboat Ethics (Neodarwinism), 93–101

Leopold accepts death but loves life. Lifeboat ethics loves struggle, the "father of all things," 94. Boulding, against the heedless cowboy ethic, proposed caring spaceship ethic, but the Earth has no captain, 95. Without one, the tragedy of the commons: humans are unable to consider long-range need unless their greed is limited by tradition or authority, 96. Invisible hands produce tragedy: our situation is that of survivors in a lifeboat, 97; need not have compassion for drowning but commitment to values, 98; help preserve those for some at least, 99. Basically tragic view, kin to Epicureans, 100. Raises the question of strategies in ecology, 101

Part III: Strategies in Ecological Ethics

III.A: Strategies of Personal Responsibility (Subjectivization in Ecological Ethics), 105–29

i. The Question of Ecological Strategies, 105–8

The level of practical reason, the world as value-laden, 105; for were it "objective," value free, why bother saving? Yet if naturally good, why save? Ecological activism builds on the idea of the world as good but flawed, 106. Flawed by what humans do? Subjectivism, seeks to change human acts. Or flaw built in? Objectivism, seeks to accommodate itself to it, 107. Practical or "flannel" ecology: conservation activism, 108

ii. Deep Ecology: Arne Naess and Friends, 108–18

Is the problem flawed technology or flawed civilizational strategy? 108. The former is shallow, the latter deep, 109. Industrial interests want to say shallow only, but traditional was deep, 110. Deep grasps life as value-laden whole, 111; builds appropriate attitudes. In later writings Naess stresses identification with all life: not narrow Ego but broad sense of Self, 112; which can be read either as dedicated activism or as preoccupation with self, 113; though Naess stresses identification is not a mystic state, 114. Deep can mean estrangement from living nature (flannel ecology), from depth of our nature ("depth" ecology), from feminine within us (ecofeminism), 115. Devall and Sessions formulate basic theses, leaving the question open, 116. Distinction between deep and depth, 117–18

iii. Ecology of Deep Identification ("Depth" ecology), 118–22

Takes the problem to be alienation from our own nature within, seeks solution in return from individual reason to emotive proto-consciousness of all being, 119. Reason alienates, feeling connects, so need ritual to open feelings, let unconscious speak, 120. Council of All Beings provides such instrument as a religious ceremony, 121; consciously overcomes alienating reason. But is the problem reason—or lazy reason? 122

iv. Feminism and Ecofeminism, 122–28

Reason alienates because it is masculine, 122. Feminism is basically democracy for all, including women, beyond that, struggle against all oppression, including of women, beyond that against oppression of women as root of all oppression, 123–24. Oppression is rooted in conceptual schemata which discriminate, 125; need be overcome before activism will bear fruit.—Ecofeminism extends this to liberation from nature (feminine), from domination of masculine principle, 126; basically a view of nature on feminine virtues, inclusive and caring rather than exclusive and dominating, 127. But might not preoccupation with our feelings alienate us from others? 128

III.B: Strategies of Recognized Necessity (Objectivization in Ecological Ethics), 129–54

v. The GAIA hypothesis, 129–35

Presented as scientific hypothesis but welcomed by deep ecologists, 129; has long tradition of Earth Mother, 130; yet Lovelock is also anti-environmental, his motives are scientific, not empathic, 131; asks can humans damage the Earth? Consideration scientific: the Earth preserves life-sustaining conditions, 132; humans are tragically bound to destroy it. Lovelock recommends quest for best technologies, not best lifestyles, 133; and quest for spiritual harmony with GAIA, 134; in an Epicurean strategy of inner peace, 135

vi. Nature and the Human Animal (Sociobiology), 135–42

GAIA is a clear case of objectivism, what is the case, but our question is what we ought to do: could that be genetically coded? 136. Since Darwin, we know we are continuous with other species. Morris describes us as he would other animals: we are primates who adopted wolf habits, 137. Sociobiology seeks to explain our behavior as aimed at species survival.—So Wilson: we are witnessing the sixth major die-out, this time human induced, 138. Our evolutionary habits change too slowly, need foresight instead, 139. Sociobiology provides it, but what is its significance? 140. Does it show us what we ought to do? explain what we do do? or warn us what inclinations, not goals, to take into account? 141

vii. Systems Theory in Ecological Ethics, 142–47

Represents the ultimate objectivism in a holistic approach: behavior of individual determined by role—*nika*—it fills in a whole. So start with statistical study of the whole, 142. Cast first doubts on the strategy of "growth," especially among its partisans, 143. In Soviet bloc, as "scientific," free of subject-related values, had some freedom, 144, to describe ecological damage. But is the conflict of culture with nature inevitable? 145. If so, effort useless, if not, must persuade subjects subjectively to build sustainability, 146

viii. Ecology as an Ideology, 147–54

Ideology here as "mere" ideology, a doctrinal system functioning as a reality substitute of a given group, 147. So ideologization in Rousseau, emphatically in Haeckel, theoretical monist rather than practical naturalist like Muir, 148. Served as radical doctrine, challenging the traditional (as aristocracy) in the name of the natural, 149. Appealed to all radicals, but rejected by all establishments (Nazi, Communist, democratic). Ecology protected from ideologization by practical commitment, 150.—Ideology as a statement of Green party policies, consistent with mainstream ecological activism. Has the advantage of purity of Green ideals, free of compromises, 151; but the disadvantage of a lack of political clout which working within mainstream party program brings, 152. Ecology is strong as a quest for solutions, weak as dogma, 153

Postscript: Turning Green—The Making of a Minimalist, 155–63

Personal postscript: Tread lightly, 155; seek ecological literacy.—Personal experiences of precious life, 156; living on a 1970s "homestead," 157. Learn from range of writers, find common lesson: it is greed of the affluent which is destroying the Earth, 156; the "American dream" is ecoterrorism.—Should we counter with more demanding technology—or less demanding humanity? 159. *Factor Four* proposes economy, encourages greed, 160; not frugality, must fail. Leads to the question of the meaning of being human, 161; locally the "meaning of history." The aristocratic conception of heroic deeds, the democratic conception of growth to human maturity, 162. The latter today means caring for the Earth, 163

Foreword

Here is perhaps the most remarkable of the several introductions to environmental ethics now available in a growing literature—remarkable both for the unusual career of its author and for the multi-dimensional nature of the work. Erazim Kohák is Czech; this book was first published in Czech. That thought alone—a Czech ecological philosopher—awakes interest.

But that is only the start. Driven from his native land, Kohák taught in the United States for a generation, eminently at Boston University, distinguished again both by his lifestyle and his work, living in a one-room rural home, without electricity, seeking firsthand experience of nature ("the beavers and porcupines"), and teaching in one of the country's most sophisticated universities. When, with the collapse of the Soviet regime, return to his native land became possible, he joined the Philosophical Faculty of Charles University in Prague. His teaching there demanded for Czech students this introduction to ecological ethics—as he prefers to call this rather remarkable turn philosophy has taken in the last quarter century.

Kohák's life in such provocative environments has challenged his native gifts, and the product is this seminal book. This is a survey of the field, as he intends; but no ordinary introduction, and that is the reason for an English edition. This overview is distinctively comprehensive, and with fresh perspectives. He is able to combine theory and practice most effectively. On every page he joins multiple tensions in the field, often finding complementary insights: the contemporary and the historical, facts and values, the *is* and the *ought,* reason and emotion, the real and the ideal, ethics and metaphysics, the subjective and the objective. He joins the natural and the cultural, the planetary and the locally particular, the individual and the corporate, the economic and the political, the scientific and the ethical, the philosophical and the religious, the secular and the sacred.

His life in multiple worlds gives him resources lacking to other environmental philosophers. He knows the naturalists as well as the philosophers. He knows American philosophy with as much facility as European philosophy. In Europe he knows not only British and Western European sources, analytic and continental philosophy; he draws readily from scholars and original sources in Central and Eastern Europe, both those challenging as well as those once within the former Soviet ideology. He knows both affluence and simplicity, illusory wealth and genuine riches; he separates wheat from chaff as he sifts his sources, and couples these insights of others with his personal experience.

Again and again, he starts with a contemporary problem, one that might

seem amenable to some technological, managerial, or political solution, to dis-
cover a dimension of depth—ethical, religious, metaphysical. "That is why
ecological activism makes sense only if we approach nature not from a purely
objective 'scientific' viewpoint but from a human, valuing one. To seek to pro-
tect, not destroy, makes sense if we consider nature, the entire system of life on
Earth, as something good, endowed with meaning and value—and we do not
consider value and meaning simply human impressions, but the very warp and
woof of reality. Or, in a word, it makes sense to save the world *if it is good*"
(p. 106).

Kohák has, fortunately, a gift both for connecting the reader with the
technical terms—"biocentrism," "ecofeminism," or "deep ecology" versus
"depth ecology"—and also putting the issues at stake in plain English. If plain
English is too unadorned, he switches to provocative metaphor and turn of
phrase—his "flannel ecology," or "making of a minimalist," or "green halo"
(as he also did earlier with his "embers and stars." Argument is clinched with
aphorism.

Kohák joins conviction and strategy. Indeed, though Kohák is more reti-
cent about this, he is a model for joining analysis and advocacy. Kohák refrains
from prescribing straight forth what we ought to do. He protests that he will
only describe ideas, challenges, problems, opportunities, and invite readers to
think for themselves. True, Kohák does not arrive immediately at the detail of
either ethics or policy. But readers who accept his invitation to think for them-
selves will find, so plausible are his arguments, that conviction and action are
inescapable. Perhaps readers need to be forewarned: many sentences that end
in question marks are quite demanding of conclusions! Kohák clearly conveys
both the invitation to tread more lightly on Earth and the urgency of doing so.

That too is model philosophy: a reluctance to advocate, restraining this at
least until there has been careful analysis. It is difficult to get the right answers
until one has first raised the right questions. Answers cannot be handed out;
conviction comes only for those who figure out their own answers. Still, as his
postscript reveals, here is life examined to make it worth living, in the tradition
of Socrates. More profoundly, here is modern life examined to discover how
misfit it can be in a world in crisis. But therein lies the opportunity. Here is a
sage, inviting and embodying personal renewal for personal responsibility.

So I am privileged to endorse this work you have taken in hand. You will
discover what Kohák and I both have discovered, in our journeys through the
last third of this century. Ecological ethics begins in what may seem (and for
decades continued to seem to most of my colleagues) a peripheral concern—
an ethics for the chipmunks and daisies, for canoe freaks and tree huggers.
Not so, however. When probed more deeply, environmental ethics is right at
the center of the challenges for the next century, the next millennium.

In the global picture, the late-coming, moral species, *Homo sapiens,* has,
still more lately, gained startling powers for the rebuilding and modification,

including the degradation, of this home planet. The four most critical issues that humans now face are peace, population, development, and environment. All are entwined, and the overview you are now beginning will make that abundantly clear. "'Ecology'—the conscious search for long-term sustainable modes of cohabitation of humankind and the Earth—is no longer the hobby of nature lovers. It is the task of humankind and the meaning of our being" (p. 106).

HOLMES ROLSTON, III

Preface to the English Edition

This book first saw the light of day as the *scripta* of my regular lectures at the Philosophy Faculty of Prague's venerable Charles University, founded by the Emperor Charles IV in 1348 and still truly a seat of learning. The lectures were open to the public. In addition to some thirty philosophy students they regularly attracted sixty or more students from all corners of that far-flung university, from Forestry to Mathematical Physics, and, as the word got around, thirty or forty more people interested in ecology from all walks of life. Lecturing to an audience that diverse I could not afford the luxury of specialization. Instead, I tried to provide my listeners with an overall orientation in contemporary ecological philosophy, from biocentrism to lifeboat ethics, from deep ecology to systems theory. My hope, which proved not vain, was that the overview I provided would both enable and induce my students to read on in pursuit of their particular interests.

As the demand for the *scripta* exceeded the reproductive capacity of our department's copying machine, nearly as venerable as the University itself, I reworked them in the form of a book brought out by Sociological Publishers, known by their Czech acronym, SLON, meaning *elephant*. This occasioned the reference to elephants at the start of the book—together with the fact that in Czech china shops have no trouble with bulls but significant problems with elephants. The standard expression is to behave like an elephant among china.

I had not intended to rewrite the book in English. Though the problems are global and much of the material comes from American authors, the telling is intimately Czech. The basic difference is that there are altogether no more than ten million Czech speakers in the world. Even with five million Slovaks thrown in—the two languages are mutually comprehensible—that community of speakers simply is not large enough to generate a critical mass of ecological philosophers, never mind ethicists, to constitute a closed community of discourse. Among ecological activists interested in philosophy in our country there are two philosophers and three or four sociologists. The rest are foresters, hydrologists, wild-life specialists, petrologists, and all manner of people who daily confront the problems of an already heavily damaged land now hopelessly vulnerable to globalization. Though we are interested in the philosophy of it—thinking through clearly the fundamental issues of human presence upon this Earth—we inevitably do it in flannel shirts, in the context of practical problems and in a language accessible to colleagues from other disciplines.

That is the spirit in which this book was written—and such was its intended audience. It could be readily translated into Magyar or Polish, Bulgarian or Lithuanian or any of the languages too intimate to have the whole range of ecological literature available in translation. But English? The primary literature is in English and, besides, English-speaking readers, I assumed, are far too specialized to find it of interest.

However, by the magic of the unintended, I found myself translating significant portions into English, my second native language. It was not for publication, but because acquaintances who wanted to translate it into several intimate languages—in this case Latvian, Lithuanian, and Ukrainian—can work readily from English but only with difficulties from Czech. I brought those partial translations with me when I visited America on the occasion of the World Congress of Philosophy—and discovered that many of my American colleagues were eager to copy them and wished the whole book were in English. Precisely because of the high specialization of English-speaking philosophers, they experienced a need for the kind of flannel-shirted overview which speakers of intimate languages write. Since I had just retired and was taking a three months' vacation in New Hampshire, surrounded by English speakers, I set about the task of writing up my lectures in English.

So here it is, such as it is and, for the most part, as it was in Czech. I have not sought to be profound after the manner of the Heideggerians or brilliant as the British, only clear and comprehensive as William James attempting stubbornly to think clearly—or perhaps Edmund Husserl, seeking to see clearly and articulate faithfully. I trust it will contribute to English readers what it provided to Czechs and Slovaks, a bird's-eye overview of the problems of being human upon this Earth, of current ecological philosophy, and of the basic strategies of the ecological movement—and a guide to further reading.

Just one more note: when I use the word *European*, it is in a cultural, not a geographic sense. Unless otherwise noted, *European* thus refers to all the lands of the European cultural heritage—which, for better or for worse, is fast becoming global. In a cultural sense, Canada and the United States are European countries and I mean to include them even when I do not specify *Euroamerican*.

Before launching the book on its English career, I should like to add some English thanks. Very practical thanks go to Alexander Jeřábek of Boston University's Mugar Library and to Kerri Mommer of Open Court, without whose long distance research assistance I should have been hard put to assemble all the data bibliographica of books I knew only in Czech translation.

A different order of thanks go to America, my home for much of my life. A great many people today are convinced, with good reason, that it is the over-

consuming *American way of life*, so eagerly imitated the world over, which poses the most terrifying ecological threat to this Earth and to all that dwell therein. In the face of that, I should like to say a word of appreciation to the land that gave me refuge when my own cast me out. I have so much for which to be grateful, starting with the campfires of IOCA—Intercollegiate Outing Club Association—in the early fifties. It was around those that I learned to love this land, my land and your land, from California to the New York Island, from the redwood forests to the Gulf Stream waters, this land was my love and my responsibility. I am grateful for New England, its sun-struck beaches, its pensive forests, and its ecological wisdom—*use it up*, *wear it out*, *make it do*, *do without*—and boxes for storing strings too short to save. (Actually, though too short to save for tying, they were saved to be made into tinder, but that is another story.) I am grateful for the America of the Carter years, for its wood-stoves and photovoltaic panels and its revival of the New England virtues of frugality and respect. I am grateful for Boston University, for my colleagues and students, and for the support and stimulation they gave me. I am grateful for a lifetime of friends. I am especially grateful for those Americans who offered the world a different vision, for John Muir and Aldo Leopold, Bill Devall and George Sessions, J. Baird Callicott and Holmes Rolston III, for Gary Snyder and Karen J. Warren, for Paul Taylor and Eugene Hargrove, and for so many others whom I have read, sometime known, always appreciated. I have returned to the land of my birth but a great part of me will ever remain in the land I have loved so long. I hope and trust that my America, having become a global threat, can also become a global hope as so often it has been.

Preface to the Czech Edition

The purpose of these lectures is to present the reader with an overview of contemporary philosophical thought concerned with human dwelling on the Earth at a time when humankind has *run out of yellow paint* and can no longer touch up the damage it is causing.[1]

Were I writing in English, I could, following Arne Naess's usage, speak simply of *ecology*. In Czech, the word has retained a more technical meaning. That is generally true of societies with an authoritarian past. Authoritarian governments tend to consider every social problem a task for technocrats. We remember it well from the long years of the Communist regime. The government would respond to every problem by establishing an *Institute for the Resolution of the Problem*. It would appoint a collective of researchers and assign them the task of preparing a solution of the problem, using the achievements of (formerly) *our Soviet comrades* or (currently) *our Western colleagues*. The research team would, in due time, present a theoretical model—and the problem would be declared solved. All that remained was for the Party and the Government to make the people conform to the solution. How to do that, that does not concern technocrats. Their task and true love is to work out theoretical models.

That, I believe, is why not only in the Czech Republic and in Slovakia, but in all postcommunist countries Ecological Institutes of all kinds enthusiastically accepted the statistical projections and theoretical models of the systems theoreticians like *The Limits to Growth* and *Beyond the Limits* and why they wax ecstatic over the latest system analysis, *Factor Four*, which in its subtitle promises "*Doubling wealth—halving resource use*."[2] In the Czech Republic and Slovakia, domestic systems literature is emerging as well, in some cases simply repeating the rhetoric of the former regime, complete with its abbreviations, hailing "progress" and praising the benefits of conquering nature, only substituting *critique of consumerist ideologies* for the old *critique of bourgeois ideologies*. It supports the development of industry and glories in technology. It all sounds familiar. Technocrats love both rhetoric and technology, they have theoretical modeling in their job description—and that applies even to questions of human dwelling on Earth. The ecological problem is considered solved once the research team turns in their theoretical model.

Democratic societies tend to see things differently, from a human standpoint. Anglo-Saxon and Nordic societies with mature democratic traditions know that even the best theoretical model is vain if a society lacks the political

and civic will for its realization. For that matter, Nordic and Anglo-Saxon experience with social democracy, based on civic will—in contrast with our experience with "real socialism," based on a technocratic model—is lesson enough. That may be why Anglo-Saxon and Nordic societies tend to consider ecology in the first place a question of human attitudes, human perceptions, and human conceptions of nature and of the place of humans therein—that is, a philosophical and a human question—and only secondarily a technical one.

Democratic societies do not in the least underestimate the importance of theoretical models. Were we to decide we *want* to save the Earth, that we *want* to seek out long-term sustainable modes of human dwelling, then we should urgently need the best technology and science available to reach our goal. In that order, though. As long as we perceive nature as a lifeless storehouse of raw materials and consider endless expansion of consumption humanity's chief task, not even the best theoretical solutions can help us. Where there is not a will there simply is not a way. The ecological problem has not been resolved when the technocrats construct a model of sustainable life style—even though the model presented by *Factor Four* is promising in many respects. The problem will be resolved only when there is civic and political will to save the Earth and to live in sustainable ways.[3]

That is why in democratic countries the word *ecology* is often used to indicate what in Czech we would describe as *ecological ethics* or *ecological philosophy* and why philosophizing thinkers like Aldo Leopold or Arne Naess tend to be better known than systems theoreticians like Donella and Dennis Meadows and the Reports of the Club of Rome, excellent though their work may be. I have lived and worked in that democratic atmosphere most of my life and so in this volume I should like to inform the reader primarily about *ecological philosophy and ethics*.

I should like to stress the word *inform*. I am writing as a teacher, not as an agitator. I want to offer information, not agitate for this or that solution. Understandably, I also have my own views and make no secret of them. They inform my whole interpretation of the problem and, should anyone care, at the end of the book I have appended a personal confession of faith, an *apologia pro vita sua*. That, though, is not the point. This is not a book about what *I think*. It is a book about ideas in the philosophic marketplace, about contemporary ecophilosophical thought. Its task is to provide the reader with sufficient background so that s/he could form her/his own opinions—or at least read on intelligently. That is why I seek to inform, not agitate, refer the reader to further readings and report on views with which I may personally disagree.

Agreement or disagreement is really the last thing about which to worry. The first point is to understand, to grasp fully just what is being said. That is

generally what distinguishes thoughtful from opinionated people. Opinionated people react to anything that is said with an immediate "I agree" or "I disagree," "You're right" or "You're wrong," as if the point were not the matter itself but *they* themselves, what *they* think of it—whether they understand it or not. Actually, they seldom do understand. For the most part, they are too busy proclaiming their agreement or disagreement to hear the speaker out. Thoughtful people bracket the question of agreement and start with different questions: What does it mean? What makes you think so? What follows from it? Only when they have thoroughly understood what they have heard do they turn to themselves and ask about reasons for agreement or disagreement. That, though, becomes relevant only on a fourth level. The first level asks for understanding, the second level for reasons, the third level asks about consequences. Only then comes agreement or disagreement.

So I beg the reader to set aside for the moment the question of agreement and disagreement. Philosophy is not about "who is right" but about what we can learn from others, be they "right" or "wrong," whether we agree or disagree with them. Much of the time I "disagree" myself. I am presenting a whole scale of conflicting views and strategies, many of which are foreign to me, though I have learned even from those. My concern is to let you form your own well informed and well considered position, based on a thorough understanding, not on superficial impressions of vague labels devoid of clear content.

In philosophy, labels generally tend to cause mischief. We cannot do without them. They provide us with a shorthand without which dialogue would be hopelessly cumbersome. Rather than repeating each time the explanation, "an attitude based on respect for all life and the pledge to protect life, care for it, and rejoice in it," we can use the shorthand expression "biocentrism," saving a great deal of tedium. With that, though, we run a great risk. We learn a label and have the impression that we know something already, that we understand something. The result is the painfully embarrassing "label philosophy" marked by pronouncements such as "biocentrism says that . . ." Humbug, quoth lovable old Scrooge. Biocentrism does not "say" anything. Theories do not speak. Only people can speak, and if they are thoughtful people, they do not say something because "biocentrism teaches . . ." That would be philosophy backwards. *Some people take certain positions*—that is the primary datum. Subsequently we use the shorthand designation "biocentrists" for them. Just by learning the label "biocentrism" we have not understood anything yet, though it may be enough to start a talk show. In philosophy, though, the point is what our label designates in human living and being in the world.

That is the approach I sought to follow in this book. In the case of all concepts I have sought to show *what in experience* they express and whereto they

point. It is not enough to give a definition in theory, in relation to other concepts. We need to explicate each concept out of lived experience. Whereon is it based? What about our experience is it saying? What follows from it? Or, in popular terms, what would change in our life world if it were or were not true? If nothing, then it is the *sounding brass and a clanging cymbal* of 1 Cor 13:1— or, spoken with Shakespeare's Macbeth, though full of sound and fury, it signifies nothing.

I have sought so to write this book that its words would actually *mean* something—and also so that it could be used as basic reading for a course in ecological philosophy and ethics. It will not save the Earth but I hope that among readers who cannot read through the vast range of existing literature it will help raise the level of *ecological literacy*.[4] I am deeply convinced that the Earth cannot be saved by even the most perfect technocratic scheme if ordinary citizens do not themselves realize the need for a basic change in the way we dwell upon this Earth, confront the apostles of consumption and find the will to live in sustainable ways.

I should like to thank my friend, ing. Igor Míchal, who carefully read and commented on an early version of the manuscript and introduced me to ecological literature in Czech and Slovak which had been inaccessible to me in America, then to Martina and Míla Průka and mgr. Marie Skýbová, who were my first sample audience, to dr. Jiří Vančura, the best and dearest of friends, who gave the book its first copyediting, to dr. Frances Macpherson who long ago gave me my forest clearing and to dr. Sheree Dukes Conrad who shared my early years in the woods. Special thanks belong to another beloved friend, Stephen Capizzano, who shares my love for that clearing by the abandoned dam in New Hampshire, to all my students and colleagues at Boston University and in the last decade at Charles University in Prague as well as all my friends among ecological activists thanks to whom ecology in the Czech lands and Slovakia is not the exclusive domain of technocrats. Most of all, very special personal thanks belong to my wife, Dorothy Mills Koháková, a native American who like Ruth the Moabitess (Rt 1:16–17) followed me to the native land denied me for forty-two years and accepted it as her second home. *Je to paráda mít kamaráda*—or, much less colorfully, it's neat to have a buddy! Thank you all.

ERAZIM KOHÁK

PRAGUE, GROUNDHOG DAY 1998

The Green Halo

Once I watched a folk carver decorating his work with left-over modeling paint. He was just painting the apostles' halos green. I was then returning from an ecological conference and so I asked about the deep significance of the green halo. He said, thoughtfully, "I ran out of yellow paint."

Introduction: Of Humans, Elephants, and China Shops

Since this book is intended for a general college audience rather than for philosophers only, the Introduction seeks to clarify basic concepts. **Section i, Ethics and Ecological Ethics,** seeks to define and explain these much misused terms, **section ii, The Limits of Yellow Paint,** explains what we shall mean by *ecological crisis*, **section iii, Ecology, Science, Philosophy** explains the relation among these three disciplines as we shall understand it in this book.

i. ETHICS AND ECOLOGICAL ETHICS

Ecological ethics—what is that all about?

It is about life, about all life on this Earth. It is about the mother elephant who tries in vain to protect her young before a danger for which nature did not prepare her, before ivory poachers with high technology weaponry bent on murder within an ever shrinking elephant habitat. It is about wolves, protectors of harmony in the forests, whom humans poison and shoot as vermin—though they themselves damage the forests more than all its other inhabitants together. It is about birds poisoned by toxic sprays and crowded from traditional habitats and about whales bewildered by the roar of ships' engines. Most of all, it is about humans who think that they are the crowning glory of creation and the lords of all creatures but behave in the world like an elephant in a china shop (see p. xix)—though anyone whom an elephant ever stroked with the velvety lip of her trunk can testify that this metaphor is all wrong. Let us try it without metaphors: *what is ecological ethics*?

I shall use the word *ethics* in the ordinary sense of a set of principles and rules which teach humans how they ought to comport themselves in their daily dealings with each other. Let me stress the *ought to*. The point is not how people actually do comport themselves. That is the subject of empirical sciences like sociology or anthropology. Those note how people in fact behave, for instance that in a given year a certain predictable percentage out of every hundred thousand inhabitants will commit murder. They do not pontificate that people ought or ought not to do that, that it is good or regrettable. They only observe that that is how it is, that it has its causes and consequences. It might, of course, be otherwise. Unlike animals with an intact instinctual system, humans in their freedom can do practically anything they wish—and the empirical sciences are not in the business of telling them what to do.

Over the centuries, however, humans have come to realize that though all things be possible, not all modes of acting and interacting lead to desirable

results. They have learned to extend their unreliable instinctual system with conceptions of what is and what is not desirable behavior. In part custom and tradition help here, yet there are situations in which humans have to decide. Ethics grows as an aid in decision making, a set of principles which indicate what kind of behavior is likely to lead to optimal results—because all things are really possible but it is not a matter of indifference which we shall choose. We can self-destruct, we can reduce life to a war of all against all, or we can create a context of peaceable coexistence. Much of the time we cannot even foresee and so evaluate the outcome of our actions. Hence ethics: proposed principles for optimal interaction among humans.

Traditionally, humans ascribed the authorship of ethics to God, and with every right. If we imagine God as good, then God would surely set such rules of comportment for God's creatures as would help create an optimal social environment. In fact, the commandments which humans usually ascribe to God for the most part coincide with tested principles of general ethics, from "Honor thy father and thy mother" to "Thou shalt not bear false witness." If we believe in God, we are justified in considering principles of ethical interaction God's will. That is how a good God would want it.

Enlightenment thinkers, who were not at all sure what to make of God, usually ascribed ethics to reason or the moral order of the cosmos, and again with every justification. They understood moral law as a set of transtemporal, absolutely valid rules of human interaction, built from eternity into the structure of human community, or perhaps as the objective counterpart of subjective reason. Justifiably so: if humankind survived all these millennia, it is evident that the rules of comportment it followed could not have been arbitrary or contingent but must have suited the structure of human coexistence. We can say with equal justification that ethics represents the moral law in practice or that ethics reflects God's will for God's creation—or, as we formulated it at the start, that ethics is a set of rules for successful interaction of humans with other humans.

The idea of *ecological ethics* is strictly analogous. It is again a set of principles and rules which indicate to humans how they ought to comport themselves in their interaction with all of the extrahuman world. In English, the thought which deals with human interaction with the nonhuman world is most commonly called *environmental ethics*, the ethics of our natural (and social) context. Many Czech authors think this term less than fortunate. To call the complex of all life, the biosphere, *our* environment may already suggest a certain interpretation, as if the nonhuman world were but a stage on which the drama of human lives and history is acted out. That, to be sure, is a possible interpretation and to a great many people it appears obvious. However, it is not simply a fact, it is an interpretation. The term *environmental ethics* suggests that the point is how humans, the center of all meaning, ought to manage a world which deserves respect only *as their environment*.

This interpretation, which lovers of labels call *anthropocentric*, really is nothing self-evident—and the present state of the world suggests that it is not even overly desirable. This is why I prefer the more neutral term, *ecological ethics*. In Czech usage, ecology most often indicates a natural science, one of the biological disciplines, devoted to the study of continuities in the complex of all life, in the spirit of the classic basic text, Odum's *Fundamentals of Ecology*.[1] It concerns the complex of all being and living—the biosphere—and the place of humans therein, without any presuppositions as to what that place is or what it requires. For that reason I think the term *ecological ethics* marginally more advantageous than *environmental ethics* for *the system of principles which indicate to humans how they ought to comport themselves in their interaction with the nonhuman world.*

The term *ecological ethics* may be of recent vintage but ecological ethics itself is far from new. We have always assumed it and acted on it, only did not consciously reflect on it. There was, it seemed, no reason. At least since the mid-seventeenth century it seemed simply too obvious to us, people of the European cultural heritage, that "nature"—the complex of all nonhuman being and living—has no meaning, no "rights" or claim to consideration which would require reflection. We really came not only to conceive of nature, but even to perceive it as the stage of human lives and a set of "natural resources" for satisfying all our wishes. In this perception the nonhuman world exists only for human use and the only rules for dealing with it—what we now call *ecological ethics*—derive from the "rights" and claims of human subjects. Then there seems to be no reason why I should not clearcut "my" forest and sell the wood for pulp or why I should not mine "my" hill and grind it into lime as long as no other human owner has a claim to it. As we habitually perceive it, the land with its creatures, all that is and lives in the forest or on the hill, all of this good earth, has no claim to consideration.[2]

When today we speak of an *ecological crisis* we are basically articulating a realization that this primitive, seemingly self-evident ethics will no longer do. We made do with it for three centuries and in a sense even longer. Ancient Romans treated nature with the same total unconcern as we. The deserts around Carthage, once Rome's granary, and deforested rocky slopes of southern Italy testify to that. The monks who brought the beaver to extinction in the Czech lands in the eighteenth century—beaver was considered fish and so allowable on fast days—were no more considerate. We have simply assumed that, whatever we do, nature is always more powerful and can make good the damage. Still during the Second World War we used to hear on the radio how many gross register tons of crude oil, destined for England, the German navy sank. We were anxious for England but never dreamed of considering the fate of the oceans and the fish. We simply assumed nature would set it right and, in general, it worked out that way.

It works out no longer. All available indicators show that humankind is drastically crippling the ability of the biosphere to make up for human interventions and to preserve an environment suitable for our kind of life.[3] Nature has not changed—it still is what it has been throughout the countless millennia of its evolution. Nor did our approach to nature change—we are still acting wholly in the spirit of "cowboy ethics," interested only in our own wishes and sublimely unconcerned about the consequences of our doing, just as drivers care little about the effect of their exhaust fumes on the city, people, or nature.[4] After all, *we have a right* and we have always done so . . . Seemingly, nothing has changed, so why worry?

Because something *has* changed. Figuratively speaking, we have run out of yellow paint for covering up the damage we are causing (see p. i). The effects of the heedless disregard which for centuries we could paint over with cosmetic measures will no longer be hid. Our mode of living upon this Earth is endangering its ability to support our kind of life. That is what the global ecological crisis for the twenty-first century is all about: we are using more than the Earth can replace. In the Czech Republic, the government for years refused to admit what scientists and citizens see ever more clearly, that our conceptions of being human on this Earth are in direct conflict with the conditions of sustainability of life. As the mythical King Canute commanded in his royal authority that the tide should stop rising, so until very recently first our Communist, then our neo-liberal leaders proclaimed that there is no ecological threat and acted accordingly, perhaps in the hope that what they will not acknowledge will not exist.

Yet the tide kept rising. Today the ecological threat is undeniable. We encounter it on three levels:

One is the evident and serious damage to our immediate environment. In spite of the decrease in factory toxic emissions as factories move elsewhere, Prague air continues to be unbreathable. The heedless explosion of automobile usage has created a new source of dangerous exhaust fumes. The number of respiratory diseases and asthmatic children rises year by year. Construction is destroying desperately needed forests and wetlands. Meanwhile quarrying is grinding down hills and countryside. Our forests are dying. The floods in Moravia indicated to us how far we have changed the land's ability to cope with our climate. Yet we continue to welcome every rise in consumption as "progress," regardless of its distribution, and care not a whit about effective use of energy or about the impact of our "progress" on the world around us. On the level of evident damage to the environment, the ecological threat is today undeniable.

The second level is global. International scientific symposia, like the attempt to strengthen the Framework Convention on Climate Change in Kyoto or the conference on global warming in Buenos Aires remind us of those. Scientists, governmental and intergovernmental commissions from the whole world repeatedly arrive at the same conclusion. The emission of greenhouse

gases, especially carbon dioxide, has exceeded the ability of oceans and forests, damaged by logging, fires, and agriculture, to maintain a balance in the atmosphere.[5] The average temperature of the Earth is rising with a series of dramatic consequences. Cold water from the melting ice cover deflects the Gulf Stream which for centuries guaranteed mild winters in England. Climatic changes threaten habitats. Investigations into availability of drinking water, into deforestation, into simply all human dealings with nature reach similar conclusions. On a global level as well, from a systems-theoretical viewpoint, the ecological threat to "nature" by human "culture"[6]—read, rising human demands—is reaching critical extent.

The third level is personal—and so ordinary that we often overlook it, though in many ways it is crucial. It is a dramatic distortion of human relations to oneself, to others, and to nature. At the conference in Kyoto it became evident that the American government is as aware of the danger as its European counterparts, but American voters are not prepared to accept any limitation which would in any way slow down the increase of their level of consumption, though it is already the highest in the world and has increased tenfold since 1960.[7] Limits on emissions might require limiting air travel or even the use of automobiles, and those have their own merciless logic of disregard. People who would never hurt an animal and would be shocked at the thought of breaking wind in their neighbors' faces think nothing of hurtling down the highway, killing animals along the roadway, and releasing emissions so deadly that the Nazis used them to exterminate those whom they considered "unfit to live." Visiting America last fall, I counted thirty-two dead animals between Keene and Québec. No dead children: the ambulances remove those. According to the local paper, though, two did die on that road at the time.

Something is happening to human relations in the affluent world which is destroying our natural restraints and making humans into a threat—and it is not only the easy accessability of firearms in the U.S. It seems that we have let ourselves be convinced that the point of living is to have ever more, that the sole task of society is to help us get it—and that ever higher levels of consumption will resolve all the problems we have failed to face. The trouble is that limitless egoism elevated to a civilizational strategy simply is not sustainable. A renaissance of human relations—Czech Friends of the Earth speak of renaissance of *natural relations*[8]—might well prove to be the precondition for successful coping with the ecological threat on all levels. In any case, their disruption is painfully evident.

On all three levels, conscious inquiry into the place of humans in nature—human ecology and ecological ethics—has become the presupposition of a sustainable future. We as humankind, as a nation, and as individuals urgently need to find ways of preserving what we consider desirable traits of our kind while at the same time living in a long-range harmony with the complex of all life on Earth. That is what long-range sustainability is all about:

treading lightly on the Earth so that, as we read in Ex 20:12, *thy days may be long upon the Earth.*

ii. THE LIMITS OF YELLOW PAINT

Though the mythical King Canute bade it stop, the tide kept rising. Though our former prime minister refused to acknowledge it, ecological danger is today an evident reality. Still, I can more easily understand those who deny the reality of the ecological crisis than King Canute. The tide has ebbed and flowed for millennia, the ecological threat is something new and unexpected. For centuries we could make do with our heedless cowboy ethic in dealing with the nonhuman world. We have based our entire strategy of social coexistence—"progress" or "development," dealing with all our problems by increasing material consumption—on that heedlessness. That strategy has not changed. If anything, today we tend to be marginally more considerate toward nature than a century ago, at least in our attitudes, if not in our practice. Why then should we change now? If we are simply doing what we have been doing all along and what has hitherto been unproblematic, why suddenly the talk of "ecological threat" and "crisis?"

Nature has not changed and neither has our traditional heedless ethic. It is we, humans, who have changed, in three basic respects. For entire millennia we were few, humble, and weak. Over the course of the last three centuries we have become unexpectedly powerful, unimaginably demanding, and incredibly numerous.

There is an extensive literature devoted to our population explosion. Overconsumers in Europe and North America, loath to examine their spendthrift ways, would rather blame ecological problems on exploding populations in the third world—and readily find reasons for it. The basic reality is that the total number of human inhabitants of the Earth, for millennia less than a billion, has risen in the course of a century to six billion and continues to rise dramatically. Does that mean that the human species has overpopulated the Earth? Or could the Earth sustain still many more humans? For how many humans is there room on Earth, anyway?

I should not like to become involved in that debate. There is no unambiguous answer. How many—but at what level? Should we all live on the level of the inhabitants of South American *favellas* or Indian megalopolises, crowding out all other species by taking over their habitats, perhaps we could fit still more humans onto this planet. If human living is to have a cultural level as well, including personal safety, the possibility of nonviolent conflict resolution, the possibility of privacy and relaxation, we would need far more space per human inhabitant. And what all are we willing to sacrifice to human population expansion? The wilderness and the beasts of the field and forest? Clear water and pure air? For that matter, how much of that can we sacrifice and not destroy the presuppositions of a life worth living?

All those are questions we should be hard put to answer. We shall do better by posing the question differently, not how many humans can the Earth support but what is the relationship of human populations to all of life (or, in the terminology of systems theoreticians, of "culture" to "nature")? Foresters and game wardens, deciding annually about permissible hunting quotas, know about that. My friends among them suggest a number of indicators. Perhaps the most important is whether a given species lives off natural yields or whether it is using up nature's substance. As long as fishers consume only the surplus of porcupines—or, in a less exotic example, as long as deer consume only as much vegetation as the forest produces annually—their numbers are balanced. When a given species starts using up so much food that it endangers future reproduction—when the fishers exterminate the porcupines or deer graze out all volunteer growth—we can speak of overpopulation. A species is overpopulating when it is living off nature's substance, not its annual yield.

According to some of my friends, another sign of overpopulation is that a species can no longer share habitat with other species, crowding them out instead. It can be a matter of competition for food, but more often it is simply a question of space. Every species needs a certain range. It does not need it necessarily for itself. Many animals get along with others. Beavers get along with otters, rattlesnakes and owls with prairie dogs. Still, such coexistence has its limits. When one species begins to crowd out another, it is a sign of overpopulation.

Some of my friends cite another indicator—a loss of the ability to care for the young and pass on to them survival skills. I have noticed that one of the signs of population explosion among the beavers in my valley was inappropriately sited and carelessly built dams, with drastic results. I was sorry for them: cavorting young beavers were among my most enchanting neighbors. Their parents, it seems, did not manage to teach them how to go about beavering. We can speak of overpopulation even when there is enough food and space if parents cannot keep up with the care of their young.

The subspecies *Homo sapiens sapiens* is manifesting all three indicators. Humans are dramatically using up not the new growth but the substance of nature. We are deforesting the Earth, exhausting supplies of clear water, in fact using so much so fast that we are enhausting even our renewable resources, not only the non-renewable ones about which the first Report of the Club of Rome worried. Humans are drastically crowding out other species from shared environments. Our ancestors shared the Czech lands with bears and wolves; today there is not even room for the once plentiful ground squirrel, *Citellus citellus*, now critically endangered. Globally, a whole range of species—tigers, grizzlies, elephants, mountain lions, and even our closest relatives, the primates—face the threat of being crowded into extinction. Human populations are rising, humans demand land. Finally, as concerns the ability to pass on survival skills from generation to generation, the feral children of third world cities—and not

of those only—speak loudly. Quite regardless of how many people could be theoretically packed onto this Earth, we can speak of population explosion and overpopulation.

That is a fundamental change. Even wholly innocent, simple activities become dangerous if we multiply them by six billion. To catch a fish seems so basically human. Multiplied by six billion, this basic human act endangers the survival of entire species once as plentiful as the Atlantic cod. Or take an example from our Czech experience. As long as there was only one weekend cottage on the entire river Sázava, it did not matter if its waste flowed untreated into the river. Today, when for miles there is a cottage every three hundred feet on both sides of the river, often in year-round use, what once seemed a private matter becomes a public danger. The same is true of exhaust fumes. Once there are ten million people in the Czech lands instead of six hundred thousand—or six billion instead of six hundred million on the Earth—everything comes to matter. We can leave nothing to the invisible hands of Mother Nature, Divine Providence, or Free Market. We need to think through the consequences of what we do. Or, in shorthand, we cannot go on the way we have been because there are too many of us. That is why we need pay conscious attention to ecological ethics even if we never have before.

Secondly, we need to pay attention to ecological ethics because we in the privileged lands and classes want too much. While the impact of the population explosion may seem most obvious in the third world, the increasing demand is most evident in those countries which we consider "developed,"[9] even though once again it is for the most part the third world which suffers the consequences. The 20 percent of humanity inhabiting the overconsuming world use up some 80 percent of all resources and generate corresponding waste. That means that if the entire population of the second and third world were to disappear tomorrow the ecological crisis would be relieved by only 20 percent. We in the overconsuming world have demands which we cannot begin to satisfy from the resources of this or that land. In all our innocence, we have become global raptors.

That is a change of the past three or four centuries. For endless millennia humans lived rather modestly. They always wished to eat their fill, though half of that would do, they wished for shelter and company of their own kind. Those were modest wishes that could be met. Perhaps they simply could not imagine life without hunger and toil—or that such life could be accessible to the many, not only the chosen few, in this world, not just the next. For millennia humans thought it natural that they should have only as much as their fathers. Today we think it natural to want and have more than the generation before us. Isn't that only natural?

History of humankind tends to suggest that no, it is not. If anything could be said to be "natural," it would more likely be stability or the quest for it. Yes, there have always been greedy individuals among us, but seldom have humans

considered greed a virtue. The anonymous wisdom of our folk tales testifies to it. The greedy person in them repeatedly becomes the victim of his/her own greed, as the fisherman's wife in the fairy tale about the golden fish. The Bible bears similar testimony. So Luke 12:20 has God saying to the rich man, "Thou fool, this night thy soul shall be required of thee: then whose shall those things be, which thou hast provided. So is he that layeth up treasures for himself and is not rich toward God."

The testimony is quite unambiguous. Traditionally, contentment appeared to humans as the desirable state. Greed, the desire to have ever more, appeared as a pathology, the state of a sick soul. Today greed seems to many natural, if not out and out an entrepreneur's virtue, and we are bade to indulge it for the good of the economy, whatever the cost to the Earth. What has changed may not be some putative "human nature" but simply the cultural orientation of Euroamerican—and derivatively today, global—civilization. Traditionally, humans expected earthly goods to satisfy their needs, not to guarantee them happiness. For that matter, humans did not think they had a "right" to happiness, at least not in this life. Happiness appeared as an unexpected gift which occasionally enters into human life and leaves a lifelong beautiful memory. As for ultimate fulfillment, humans did not think that a matter for this world.

That really has changed. The average human in the lands of the European heritage tends to consider happiness an inalienable right—and assumes that it is the right purchase that guarantees that right. Any limitation on individual consumption appears to threaten the most basic right, the pursuit of happiness. In America, I once met a retired clergyman who took up flying surplus jet fighters for pleasure. He was not a heedless or an ignorant man. He was fully aware that an hour of flight devastates the ecology of the Earth drastically, as much as a year of car travel. He had no desire to harm his fellow humans and actually thought it a pity that jet flight was so devastating. However, he explained how much pleasure it gave him. It seemed to him obvious that his right to happiness overrides all other considerations. He is convinced that he has a *right* to his innocent pastime—and of course to the incredibly overprivileged level of consumption which it presupposes. For that matter, in the Czech lands I have often been embarrassed by the incredible affluence of American ecological organizations, their catalogues of green gewgaws, stuffed whale pillows and green tourism. My American counterparts could not understand my embarrassment. To them, it seemed just a part of their way of life which includes global air travel, individual automobiles, country homes, and beer imported over half the globe. That *innocent greed of the affluent* may easily be the most threatening ecological time bomb.

The innocent greed of the affluent—and the *unheeding need of the impoverished*. Native populations in the third world which once were content with the *enough* they seldom had now desperately reach out for *more* as globalization destroys their traditional means of balanced survival. Mothers who cut

down windbreaks for fuel to feed their children are not manifesting any natural human desire for more. They are manifesting the desperate consequences of open-ended economic expansion which the affluent demand. Their despair incurs no blame—but it is ecologically no less devastating. The desert expanding where the windbreaks have been cut down, the devastation of the shallow soil of tropical forests cut down by hungry peasants, and the horrors of tribal wars fought with sophisticated "foreign aid" weaponry are all a part of the price they pay for the innocent greed of the affluent.

That, too, is a reason why we cannot simply go on as we have ever done. There are too many of us; we are too demanding, whether in the innocent greed of the affluent or the unheeding need of the impoverished. We demand more of the Earth than the Earth can give. So we can no longer simply take out of what we once considered the inexhaustible bounty of nature. We need to think through the consequences of our acts and decide what we can take and how we need divide it so that we would not destroy our planet. We need to set down rules for ourselves.

There is a third reason why we need pay conscious attention to ecological ethics. We are incomparably more powerful than those who went before us. The world has witnessed explosions of greed before, times when humans became convinced that gratifying all their desires was the path to happiness and that their "right" to happiness overrode all other considerations. In European history, the last two centuries of ancient Rome provide a graphic example of dramatically and unequally rising consumption with all the ecological and sociological consequences which today we sum up as *the fall of Rome*— though the Roman ecological crisis might be more accurate. It was literally a collapse of an entire civilization brought on equally by ecological devastation and social polarization with all its consequences. The consumer explosion already then used market globalization and organization of cheap labor to gratify the innocent greed of the privileged. The parallel between the Roman empire on the eve of its fall and the overconsuming world today is frightening.

Still, there is a basic difference. Rome extensively utilized the organization of labor, but the basis was still human labor power, at most extended by cattle. Today's consumer explosion is empowered by technology. The democratic revolution increased human demands by extending infinite demand from the privileged to the broad middle stratum. The technological revolution, from the invention of the steam engine to the utilization of nuclear energy and computer technology, has multiplied human ability not only to wish, but also to fulfill wishes in defiance of all natural limits. We have become dangerous because we cannot only imagine but also realize our wishes.

That, too, is a reason why we cannot just go on as we have been. The expectations and customs of our ancestors no longer provide either ethical principles or organizational tools which would assure an ecologically positive use of our immense power. Because we are numerous, demanding,

and powerful—and on top of that free in our unbounded imagination—we need consciously to seek rules of long-range sustainable cohabitation of humans with each other and of all of us with nature as a whole. For several centuries, we could pretend that we could plunder the Earth and cover up the scars with yellow paint—with technology which would hide the results of our numbers, our greed, our power. But yellow paint has its limits. It can cover only so much. Now the wounds are too many and too deep. Not just a specific activity like surface mining or nuclear power generation, but our whole way of going about being human, the corporate version of *the American dream*, insistently propagated the world over, is threatening life on this Earth. Now we need to devote ourselves not only to scientific ecology—the yellow paint of our metaphor—but also to ecological ethics and ecological philosophy, the stubborn attempt to think through clearly the meaning of human dwelling upon this Earth.

iii. ECOLOGY, SCIENCE, PHILOSOPHY

Had I written this book while I was still teaching at Boston University, I could have ended the introduction here. To my colleagues there it seemed obvious that the fundamental question of the meaning of being human upon the Earth—the fundamental *ecological question*—was a philosophical one and that philosophy was a legitimate human endeavor which has no need to apologize for not being a science. At Prague's venerable Charles University, after forty years of what was officially called *scientific Communism*, I have repeatedly encountered another question: *If ecological ethics deals with the* meaning *of human dwelling on Earth and with the* values *of sustainability, can it still* be a science?

In Boston, I would have answered without missing a beat—of course not, it is philosophy. However, in the Czech lands being a science remains the royal road to respectability, the most common substitute for wisdom. Only a *scientific world view* can claim validity independently of the consent of the hearer. Since in the case of the ideology of the previous regime that consent was not readily forthcoming, scientific status became all important.

In a century of scientists like Albert Einstein, Erwin Schrödinger, or Werner Heisenberg and philosophers of science like Karl Popper, Michael Polányi, or Thomas Kuhn such a conception of science was somewhat anachronistic even in our land. Our assorted *Institutes of Marxism-Leninism and Scientific Communism* clung to it as their sole guarantee of legitimacy: *we are scientific*! This conception infected public consciousness so that today, in the post-Marxist countries, both defenders and opponents of ecology in all seriousness devote themselves to the question of whether or not *it is a science* as if the legitimacy of all ecological and ethical thought depended on it. Let us then ask with them, *is ecology a science or "only" a philosophy*?

In Czech usage, the word *science* has at least three distinct meanings. When practicing scientists speak of it, more concerned with the content than with the standing of their discipline, they tend to take over a scientistic sense of the word which is closer to the English *science*. In common English usage, the word tends to suggest purely *empirico-mathematical examination of physical reality*. In this sense, science really does try to be no more than observation and statistical systematization of observed phenomena. It prides itself on its objectivity which it considers a guarantee of its truth. It seeks to be rigorously value free, avoiding speculation and simply anything related to the acting and thinking subject. It writes off anything related to a subject as *static*. In a shop-worn example, how to make a nuclear bomb is a serious scientific question, whether and on whom to drop it, that is *static* which is of no interest to the scientist.

Is ecology a science in this Anglo-Saxon sense—and ought it be such a science? Definitely elements of such rigorously positive science do belong to ecology. If we want to learn how to live sustainably on this Earth, we need the most reliable information possible about the mechanisms of the whole system of natural processes. So the inquiries of a James Lovelock, crucial for evaluating the impact of human activity on the viability of Earth, ought to be based on hard empirical science in a strict positivist sense. All ecological disciplines that deal with the chemistry or the physics of life have their positivistically *scientific* component.

The ecological question, however, is significantly broader precisely because it focuses on the continuity of life and its goal-directed activities. As long as ecology includes forestry, territorial planning, cohabitation of animal species on shared territories, in sum, the teleologically and not only mechanically intelligible web of life, then ecology needs to be a science also in the broader sense of German *Wissenschaft*. That word in German designates all systematic inquiry which requires professional competence and public verifiability of its claims. Not only sociology and psychology, but even systematic theology or art history are in German considered sciences in the sense of *Wissenschaften*.

Ecology is clearly a *Wissenschaft*, a systematic inquiry which requires both professional competence and public verifiability of its results. It deals not only with physical continuities of ecological processes but also with human inputs. Those inevitably include elements of value and meaning, related to a subject and so precluding "objectivity" in the scientistic sense of excluding the subject. Ecological calculations of sustainability inevitably include not only the impact of automobile use but also the reality that thanks to the drumfire of advertising the automobile becomes, for people brainwashed by ecstatic commercials, not only a means of transportation but also a sign of status, a badge of social standing to which they readily sacrifice both consideration for others and the health of city children. Ecology dealing with this complex phenomenon is definitely a science in the sense of a *Wissenschaft*.

Were we to restrict ourselves to ecology as a descriptive discipline seeking a theoretical understanding of certain continuities, this conception of science would suffice. When, however, we turn directly to the subject—to *human ecology* and *ecological ethics*—we are going beyond the limits of science even in the sense of *Wissenschaft*. We are dealing with the deeper and broader inquiry into the value system of life and of human dwelling in the community of all beings. It is not simply a matter of facts but of value and meaning of life—and of a normative judgment about what matters in life. Is the luxury of real ivory chopsticks a sufficient reason for exterminating elephants? Is the convenience of a personal automobile so important that we should risk global warming for it? Why is it good to protect life and bad to destroy it? What is the real meaning of human life and what is its place on the Earth as a whole?

These are no longer questions simply of the structure of life processes in the sense of a *Wissenschaft* but rather of a global comprehension of the place of humans in the cosmos. Their purpose is not simply theoretical modelling but a reliable guidance for our acting. The question is not simply what life is but what its meaning is and, most pressingly, *how we ought to live it*. The point is not only how we act and what the consequences of our actions are, but also how we *ought* to act and for what we *ought* to strive.

European cultural tradition considered such inquiry also a science, this time in the sense of the Latin *scientia*. That is a conception of science not as a theoretical skill but as a wisdom, as a comprehension of the meaning of life and the world. In Czech thought Jan Amos Komenský used the term *scientia* in this sense still in the seventeenth century. So did his younger friend, Gottfried W. Leibniz. It was only later Enlightenment which restricted science to *Wissenschaft*, and positivism which reduced it to *science* in the Anglo-Saxon sense. To be sure, as Edmund Husserl showed in his *Crisis of European Sciences*, this did not eliminate the need for seeking wisdom. Even the most thorough familiarity with the mechanism or the organism of life will not answer our most pressing question about the meaning of life—what is it all about? How ought we to live? We cannot leave the answer up to inborn instincts and contingently acquired inclinations. One of the consequences of our freedom, of our defective instinctual equipment, is that we need systematically, consciously to raise the question of wisdom, *how ought we to live that we may not only live but live well*, as the basic question of ecological ethics. *Ecology needs be not only science, but also philosophy.*

That really ought not to be a problem—except that after four decades of covert household seminars on the one hand and Institutes of Scientific Communism on the other many people in our country have a rather distorted idea of what philosophy really is.

In Czech popular imagination a philosopher is someone who speaks mysteriously and drops wisdom like horses drop food for sparrows. That is not altogether illegitimate. The tasks of philosophy include the transformation of immediate lived experiences into words, or, in Zdenek Kratochvíl's words,

from *mythos* to *logos*.[10] Philosophy here operates at the edge of poetry, conceptually preparing the immediacy of experience for reflective thought. There are legitimate ecophilosophical texts, especially in the area of "depth ecology," which undertake this task.

Then there is a wholly opposite conception of philosophy as the logic of the sciences which lays no claim to any cognition of its own, content to provide the natural sciences with conceptual clarity and to systematize their theories. That was the only conception of philosophy—except Marxism-Leninism—which our guardians of ideological purity considered admissible, under the name of philosophy of science. Understandably, it came to play an important role in the countries of the then Soviet bloc. We shall encounter its echoes—and its Western counterparts—in the systems-theoretical approaches to ecology.

Ecological ethics, though, is philosophy primarily in a third, more traditional sense which William James described as the *stubborn attempt to think clearly*. That is not a matter of mystic empathy or of theoretical constructions but rather an endeavor of basing philosophical understanding on a clear seeing and a faithful articulation of lived experience. For that reason, in this book we shall strive to avoid labels. Instead of mystifying *-isms* we shall strive to clarify all concepts from lived experience, with three critical questions: what precisely does it mean? whereon is it based? what follows from it? Only with those three questions does ecological ethical thought become philosophy and only then can it claim the status of science in the classic sense of *scientia* . . . should it be interested in such speculation. As for myself, I should rather turn to the matters themselves—to the relation of humans and nature in the microcosmic mirror of the relation of humans to other animals.

Part I

Part I: Of Humans and (Other) Animals

 The purpose of the first part of the book is to sketch the problematic relation of humankind to the rest of the natural world on the canvas of the relations of humans to other animals. **Section i, Strangers in the Wild,** examines the ways and reasons humans came to conceive of themselves as radically different. **Section ii, Our Long-Lost Kin,** focuses on the ways humans experience themselves as kin to other animals. **Section iii, Meat or Mercy?** examines the tensions arising from it. **Section iv, The Lure of Perfection,** deals with radical consequences of biotic equality while the concluding **Section v, All Too Human,** examines attempts at reconciling the conflict.

i. STRANGERS IN THE WILD

In the beginnings of the ecological awakening in the United States, some thirty years ago, for many of us a basic impetus was the startled realization that to speak of "humans and animals" is misleading.[1] We did not start from the report of the Club of Rome, *The Limits to Growth*. That seemed to us dry theory. We read Rachel Carson, *The Silent Spring*, later Peter Singer, *Animal Liberation*, and began to realize with amazement that the four-legged beings we were used to killing with our cars or shooting as vermin were not simply random objects. They have their own world and life, their social order, their understanding and feelings, they know pain and joy and a whole range of feelings which we were used to assigning only to humans, especially humans of European origin. With awe and wonder we have come to admit that those really are *little people in fur coats*—and that we humans are ourselves one animal species among many.

The original Americans, whom we were used to calling "Indians," as Columbus taught us, were always clear about it. Their mythologies recognize, in addition to the Navajo or Zuñi nations, also the nations of bears, snakes, and wolves. Those are distinctive nations, but neither lower nor alien. Between them and humans there exist mutual relations of respect and even kinship. Some tribes experience themselves heirs of bears or wolves. They know their characteristics, respect them, and learn from them. The world appears to them as a community of beings diverse yet equal, in mutual respect.

Modern European thought starts from wholly different assumptions. We, heirs of the European cultural heritage, are accustomed to considering the world a stage on which the drama of human lives, the only thing that matters, is acted out. On this stage there are also sets—mountains, forests, and inspira-

tional sunsets. Our *theatrum mundi* further includes props like the birds of the air, beasts of field, forest, and stream, perhaps also domestic animals. We label the sets and props of this theater collectively *nature* and assume its task is to serve humans as a source of raw materials, possibly for recreation and occasionally as an opportunity to demonstrate our power and glory by felling a redwood or killing a lion.

Back then in the fifties, few of us would have recognized nature and its nonhuman inhabitants as having any claim to any consideration on our part. It occurred to few of us that we ought not to build a highway to save a forest or that we ought to save the railways and restrict cars so we would reduce the damage caused by toxic emissions. In no case would it have occurred to us that we ought not to devastate land because it belongs to the owl and the lynx or that cyanide leaching for gold is problematic because it deprives animal species of habitats. That never occurred to the first European settlers, either, as they despoiled the land of the original Americans and sought to exterminate them as vermin. The modern European attitude is that of *masters*. It presupposes most of all our own superiority to all others, non-Europeans as well as nonhumans. In addition it assumes that the position of the master frees the master of all consideration toward lower beings. It excuses cruelty and disregard equally with the familiar phrase, "Those are only animals" (or, at other times, "only Indians" or "only Jews").

That calls for thought. The way humans treat other living beings is the most reliable barometer of their attitude towards nature at large. Unlike boulders or trees, other animals, especially social mammals like wolves or apes, are clearly *our kin*. We are ourselves animate beings and the difference between us and chimpanzees is minimal, incomparably less than between a chimpanzee and, say, a snail. Chimpanzees share with us a whole range of basic emotions, fear, pain, love, joy, fidelity, disappointment. Just like we, they, too, become attached to kin and to a place which is home. Just like we, they, too, are guided by their own moral code. Among many higher mammals we encounter evidence of deliberation and decision, as when a dog hesitates whether to respond to its person's call.[2] The idea of human superiority over other animals is clear evidence of racism. Still, it is so deeply rooted in the Euroamerican consciousness that we seldom realize that it is not simple reality, the way things are, but only one highly idiosyncratic approach, one of many possible interpretations of a neutral reality.

Whence the idea of human superiority to all else? In the beginnings of the ecological awakening we formed our own myth which still lingers in Peter Singer's classic study, *Animal Liberation*.[3] Though we were not aware of it at the time, our myth had its roots in a romantic dream of an innocent nature and a fallen civilization. According to it, humans lived almost idyllically at peace with other animals until the industrial revolution disrupted that peace. Only science and technology, primarily vivisection and factory farming, disrupted

the idyll. In a horror at human cruelty to other animals, many ecological activists at the time longed to return to a simpler life—and some of us attempted it on forest clearings beyond the power line and the paved road.

It was a myth, but there was some truth to it. In truth, the most horrifying cruelty occurs in animal experimentation and in factory farming. The worst part of it may be that in those endeavors we have become accustomed to considering the needs of science or of production an automatic justification for any procedure whatever, as if we owed nonhuman animals no consideration at all. Many people were shocked to read, after the war, about the medical experiments on children in Nazi concentration camps. Few of them noted that the only difference between Dr. Mengele's experiments and the experiments we accept without hesitation is that Dr. Mengele drew the line between prohibited and permitted experimental animals between "Aryans" and "non-Aryans" while we draw it between humans and chimpanzees.[4]

Yet the development of European attitudes to animals is more complex than we imagined in our enthusiasm. Very roughly, we could distinguish three stages:

Humans can—and in the Middle Ages largely did—perceive other animals as kin of lower standing. Humans lived in daily contact with animals, they shared dwellings with them, gave them names, talked with them, presupposed both understanding and responsibility on their part. At the same time, they exploited them cruelly and ruthlessly—just as human masters cruelly and ruthlessly exploited their human subjects. There was no contradiction in it. The middle ages simply assumed a hierarchic conception of the world in which lords, knights, yeomen, serfs, bondsmen, and animals all have their places—and personal familiarity and personal cruelty of humans to other animals was not significantly worse or better than the familiarity and the cruelty of the master toward the serf.

Subsequent centuries were marked by a loss of awareness of the animal as (subordinate) kin and gave rise to the conception of the animal as raw material. The worse the treatment of other animals, the more pressing the need to distinguish humans from them so that they could not be subjected to the same treatment. The development of modern slavery, for which the slave was no longer an inferior fellow human but simply property, chattel, led to distinguishing between Europeans and the natives of the newly discovered worlds. Similarly, the development of factory farming and animal experimentation demanded distinguishing between humans and other animals. This is where we encounter an insistence on the idea of total separation. Humans are angels incarnate, endowed with an immortal soul, other animals are material organisms or simply machines, without any claim to any consideration whatsoever. Figuratively speaking, humans are descended from above, in the sequence God-angels-humans, all other life rises from below, in the sequence matter-plants-animals. There is no point of contact between humans and the highest primates, orangutans and chimpanzees.

Our contemporary attitude tends to be marked both by the industrial and the democratic revolution. The industrial revolution disrupted the everyday, immediate relation of humans and other animals. We do not drive horses, we do not keep cattle. Our ordinary contact is with machines, not with animals. We continue to be dependent on animals but we need not be aware of it. We can for the most part have contact only with our pets and so can afford to recognize them as our (inferior) fellow beings. At the same time, the democratic revolution has rendered the conception of a hierarchical ordering of "higher" and "lower" problematic. For most of us it would be difficult to deal with a fellow human as with a slave or, for that matter, even as with a servant. *Fellow being* suggests to us in some sense our *equal*. Hence the modern dilemma: the consumer revolution demands expoitation of animals, the democratic revolution demands compassion. For the most part, we solve it with hypocrisy: we gush love at our pets and prefer not to ask where our meat and make-up come from.

After the initial enthusiasm when it seemed enough simply to love animals, ecological awareness provoked a serious inquiry into the origins and the contents of the Euroamerican domineering attitude toward our nonhuman kin. It really is a microcosm of human relations to nature in general and bears examination. While we spun our myths, a number of authors like Clarence J. Glacken or Keith Thomas substituted historical research for our fond imaginings.

Many researchers looked first to the roots of our attitudes in our Judeo-Christian religious tradition since until recently that was the most formative influence on our thought. For that tradition, our nonhuman kin—God's brutes—have their place in a hierarchy reaching from God and the angels down to the devils. According to Psalm 8:5, God created humans "a little lower than the angels," subordinated brutes to humans, plants and minerals to the brutes. The basic assumption here is that all the lower world was created for humans and exists only to serve them. The meaning of pig is pork, not the life of the pig, its joy and pain.

In the beginnings, the tradition has it, nature yielded to humans voluntarily. In folk tales of the Garden of Eden, animals offer themselves to humans as food—even though in the Bible Eden was vegetarian—while fruit grows of itself and falls into their hands. Only as a punishment which God imposes on humankind for original sin did nature become defiant and dangerous. Life then does not mean only earning our daily bread in the sweat of our brow but generally a battle against a rebellious, alienated—or *fallen*—nature. In popular Christian imagination, however, human sin, said to be the true reason for the fall of nature, does not change human right to rule all creation. It means only

that humans must conquer a formerly tame nature, struggle with it, and dominate it. Nature still exists only to serve humans. All exploitation, be it ever so cruel—tormenting animals for amusement, bear tamers, and circuses—is legitimate. When in the biblical story Samson tied blazing torches to foxes' tails and released them terrified into the wheatfields of his Philistine enemies (Jgs 15:4–5), it hardly occurred to any Sunday School teacher to pity the foxes.[5]

That is the conceptual heritage on which Euroamerican modernity builds. The emphasis does shift gradually. Renaissance writers tend to stress the fallenness of nature and the human task of improving it. Mountains and forests are terrifying and repulsive, animals—and, incidentally, "rude rustics"—are contemptible until (civilized urban) humans improve them with their activity. Animals tend to be associated with dark forces: the black cat, the hellhound, the ominous raven rule over the forest wilderness together with evil spirits. To clearcut a wild forest and plant a formal garden seemed to the Renaissance nobleman his noblest task. Reformed clergymen similarly saw their task as one of clearcutting the wild passions in the human spirit and replacing them with cultivated discipline. To the Renaissance just as to the Reformation, nature appeared as raw, rude, and suspect until disciplined by human reason.

This changed in the wake of the Thirty Years' War. The men of the Enlightenment contrasted fallen nature with the harmony of divine plan. Isaac Newton found proof of divine providence in the order of the planets; Leibniz considered this the best of all possible worlds. To be sure, the men of the Enlightenment sought in spite of that to improve this best possible world according to their lights. In the second part of Goethe's *Faust*, the good doctor devotes himself to building shipping canals instead of invoking dark forces. Nature no longer appears fallen, dangerous, and monstrous, only unfinished. We have here the seeds of the late eighteenth-century Romantic conception of nonhuman nature as spared original sin, exempt from the fall and so, though unimproved, in its way perfect.

One thing, though, does not change—the basic conviction that whether nature is innocent or monstrous, its sole significance is to serve human needs. Of itself, nature is devoid of value. That it is said to acquire only in serving or resisting human wishes. Humans and their wishes, whether genuine needs or frivolous fancies, are the source of all value. What is not useful for humankind is also devoid of any right to exist—unless humans come up with an ingenious way of utilizing it. Today, that takes the form of the argument that the sole reason for preserving biodiversity is that plants which seem worthless today might one day prove to be a source of medicines.

Hence also the idea that civilization goes hand in hand with the conquest of nature. Ever more distinctly do Euroamericans believe that humans fulfill their task not by serving their God and their neighbor but rather by subduing all other creation. Two centuries later people will speak of "releasing energy."

That term is new but we encounter the idea already in the sixteenth century, though at that time it meant primarily the exploitation of animals as a source of motive power and nutrition. Elizabethan England is a clear example. Englishmen clearly considered themselves superior to the much older and more advanced Chinese civilization because they had at their disposal several times the number of draft horses and domestic food animals. English authors pride themselves on the London shambles or slaughtering yards, said to be the envy of the world, and on England's meat-based diet. The guards at the Tower of London to this day proudly bear their Elizabethan name, the Beefeaters.

The same age witnessed the first steps in modern natural science—as a tool for the conquest and exploitation of nature. Zoology was not born of a thirst for knowledge but of the hunger for meat—for more effective exploitation of animals. The first zoos were founded originally as experimental stations for the utilization of exotic animals from newly won colonies. The animal behind bars represents *Victory of Man* [sic] *over Nature*, similarly antlers mounted on the walls of palaces or later the photographs of the great white hunter with a rifle and a boot on the corpse of a conquered elephant. The heir apparent to the Habsburg throne, Franz Ferdinand, was particularly fond of being photographed in that pose, much as the American writer Ernest Hemingway. Animals remain a tool and raw material, but lose even the minimal claim to consideration which the status of God's creation held out to them in the Middle Ages.

The sixteenth century witnessed simultaneously the idea of human superiority and the idea of human distinctiveness. The more drastic human treatment of other animals became, the more pressing was the need to distinguish humans from beings which can be subjected to such treatment. In that respect mediaeval thought drew on its interpretation of Aristotle. According to that, humans are equipped with an active intellect and therefore they alone belong on the side of God while all other creation stands on the side of matter. In their everday, immediate contact with animals mediaeval thinkers could not deny them the evident presence of mental activities, consciousness, emotion, understanding. For that reason, they distinguished mere "animality"—the *soul* or psyché, Aristotle's passive intellect—from the allegedly immortal spirit which, according to the biblical account, God, godself a spirit, breathed in the nostrils of humans.

That makes it important to seek out the external manifestations of that human spirituality which is to guarantee humans their alleged exceptional status. Various authors cite traits such as upright posture, clothing, the ability to smile, or a face capable of expressing feeling. More serious thinkers tend to cite three basic signs of humanity. The first is speech, the ability to capture the fleeting moment in concepts. This ability, dramatically intensified by the written word, makes possible far more rapid and effective cumulation of knowledge than the growth of customs and tradition (or genetic coding, then

unknown). The entire imposing construct of human civilization is based on this ability.

Further traits are said to be reason and freedom. Both abilities are rooted in speech. Because humans can capture immediate experience in words, they can grasp not only immediate spatiotemporal relations of continuity, contiguity, and resemblance, but also logical and ideal relations. Defining ideal relations among components of experience is precisely what we call reason. Similarly, imagination is possible only because humans are capable not only of *seeing* a given state, encountering it in physical presence, but also of imagining it in ideas and concepts. It is imagination, the ability to envision a range of non-actual possibilities among which to choose, that is the basis of human freedom.

Due to these abilities humans are capable of recognizing moral responsibility. They do not live in the innocence which modernity attributed to other animals, said to accept uncritically whatever there is. Humans can compare what is with what they imagine as what *could* or *should* be. They are aware of moral duties and are capable of worshipping God, thereby manifesting their "immortal soul" (or, more accurately, immortal spirit).

While European intellectuals debated the status of the immortal soul, European monarchs sent their sailors to distant shores in search of riches. By the first third of the sixteenth century, Spanish genocide of the peaceable tribe Taíno on the island Hispaniola was culminating. Spaniards used Indians as draft animals, hunted them for sport, exterminated them as vermin until Indian mothers preferred to kill their own children and themselves as well. Within a generation after Columbus, Spanish colonists had exerminated the Taíno virtually without remnant and replaced them with hardier and more durable African slaves. Other European colonies were no less harsh to the original inhabitants. It was, after all, profitable. Still, it needed to be justified, and a justification was at hand in the idea that all animate bodies are only machines, fully causally determined organic mechanisms. Human bodies gain the dignity of humans, created in God's image, only at holy baptism when God breathes in the already mentioned "immortal soul." Natives who wore no clothes, could not speak Spanish and, worst of all, had never been baptized by a Roman Catholic priest, had simply never become human and so had to right to any consideration.

Already in the mid-sixteenth century, Spanish physician Gomez Pereira[6] suggested that animal bodies were simply machines, not kin to humans' immortal souls. This is the idea which René Descartes popularized a century later, Lamettrie continued in the eighteenth century, and the partisans of artificial intelligence maintain today. According to it, an animal is simply a mechanism until an immortal soul makes it human—only the partisans of AI and the twentieth century generally do not believe in "an immortal soul."

Hence the unintended side-effect: the idea of animals as organic machines was originally designed to justify the degradation of animals. In the

eighteenth century, it was needed. Animal production was growing; vivisection became a fashionable pastime of the privileged. The host would nail a dog to a board by the paws and the guests amused themselves cutting it open alive. So that the desperate screams of the tortured animal would not bother them it was customary first to cut through the dog's vocal cords. Perhaps that is why a contemporary author wrote that it was necessary to believe Descartes's explanation because otherwise the way we deal with animals would be wholly unforgivable.[7] Descartes's explanation guarantees to the bearers of an immortal soul protection against shambles and vivisection much as noble origin once protected them from being put to torture. However, if ownership of an "immortal soul" is all that protects them, with the collapse of the belief in an "immortal soul" the idea of humans as machines becomes a justification for the very opposite. After all, they are just machines.

In truth, practice here seems to have become the mother of theory. Humans were taught to believe what all experience denied—that nonhuman animals know neither pain nor joy, neither fear nor love—in order to justify what they did for wholly other reasons. Perhaps this is what prepared the ground for the positive acceptance of the idea which Engels captured in *The Rise of Family, State and Private Property*, that progress is essentially a progression from animal nature to civilization. Perhaps that is also why we tend to designate unacceptable behavior as "bestiality" even though beasts commit no such acts. Arbitrary torture of our kin is not bestial behavior as much as the behavior of fallen angels, just as "behaving like animals" is distinctly a human trait. Other animals bear moral law within. Modernity, however, was not concerned with describing human and animal traits, only with assuring a firm, impenetrable barrier between those animals in whose case slaughter and vivisection were permissible and (human) animals exempt from such practices. Perhaps this was also why in England incest was not criminalized until the twentieth century while sexual contact with other animals warranted capital punishment until 1861. Just so there would be no mistake.

There were mistakes, of course, and necessarily so. Determining the signs of humanhood became justification for misuse of humans who seemed to lack this or that sign of humanity, as children, blacks but also women. Of all of those it can be said that in some sense "they are not *really* human" or at least "not altogether human." Hence the debates, whose echoes can still be heard in our time, as to who really qualifies as human—capable of feeling pain, sharing in civilization, the proud owner of an "immortal soul," as if disqualification of the victim justified cruelty and disregard. "Those are only. . . ." Generally historians tend to agree that the domestication of animals became a model for all oppression. If humans as "higher" beings do not have to act considerately towards animals, why should any "higher" being (male, white, Aryan) show any consideration toward a "lower" being (woman, black, Jew)? Humankind

will never come to terms with that question until it breaks free of the idea of human superiority on all levels.

ii. OUR LONG-LOST KIN

The development of civilization manifests an opposite trend as well, from alienation between humans and other animals to a recognition of kinship. The anthropocentrism based on an exclusive ownership of allegedly immortal souls gradually faded before the onslaught of the "scientific" view of humans, denying any special status. According to it humans are machines or organisms just like other animate beings. Even theological thought gradually abandoned the view inaccurately labeled "meta-physical"—based on the baroque conception of "immortal souls," angels, devils, and God with all the saints, all conceived as second-order objects and understood rather like an invisible animal species. Theology gradually returned to the experiential approach of the early church, based on direct experience of faith. That does not by any means represent a denial or an abandonment of the religious dimension of life. The lived experience of a presence of the sacred can be something eminently real—a real consciousness, an encounter with the holy—precisely when the holy is not conceived as an ("supernatural") *object* but as a sacred presence. That lived experience represents a powerful affirmation of the religious dimension of life—as well as a negation of an alleged second or meta-physical level of reality and so also of the exclusive status of humans as the owners of a portion of the alleged other reality. Meaning and value no longer appear as meta-physical entities in a separate or "the other" world. They are interwoven in this world, just as God in the Christian experience became human. Faith here is returning from heavens into life.

From this perspective we need to understand the all too common discussions as to whether (nonhuman) animals "have" or "do not have" souls. Usually the tone is rather passionate. Some defenders of animals stubbornly insist on their formula—animals, usually dogs or cats, "have souls." Similarly some defenders of animal experimentation and unrestricted meat production equally stubbornly insist on their formulation, that animals "do not have souls"—as if that constituted an excuse for inexcusable cruelty. Unfortunately, neither the one side nor the other bothers to explain just what "having a soul" is supposed to mean.

The very concept of a *soul* is rather problematic. In biblical Hebrew, as in many languages, including English, the word *soul* serves as a reflexive pronoun. In ordinary English we say, "I said to my self" and do not think it is an

internal dialogue with an alter ego. We hear *my* and *self* as a single word, I said to myself. In biblical English, however, we say "I said to my soul" and hear it as two words. That is all—and hardly sufficient reason for attributing to the Old Testament a strong distinction of body and soul, as if these were two entities. The Old Testament conception of humans is unitary, distinguishing at most between the physical and the mental dimension of the unitary activity of being human. Similarly Greek antiquity understood humans as unitary beings. It understood soul or *pneuma* as a set of potencies and activities like abstraction, memory, rational and voluntary acts. The netherworld of Greek imagination was a realm of ice and shades, not in the least an "other" world, as in Egyptian mythology.

An exception here is Socrates to whom Plato in the dialogue *Phaedo* attributes an Egyptian conception of the soul as a distinctive being that temporarily visits this world but finds the fulfillment of its being only after death, in the "other," more real world. Such conception prevailed in popular piety in the Middle Ages as well. In early modernity the Church itself came to defend it as a barrier against pestiferous natural science. To the sciences the Church signed over care of the body, for itself it reserved the care of the soul to which science allegedly has no access. Unfortunately, the inaccessibility of the soul to the empirical sciences gradually emptied the concept of all content until the only task left to it was to be a balloon of immortality which will leave the body upon death and whose existence science cannot disprove—or theology prove—empirically.

Contemporary theology for the most part rejects such a "meta-physical" conception of the soul. Humans in most contemporary conceptions do not "have" souls but rather *are* souls. I do not "have" a soul as a balloon of immortality. *I am soul* or more accurately *spirit* in all my being insofar as I relate to God. I am a spirit which becomes actual in incarnation much as meaning becomes actual in a word. *To be a spirit* means that my being is a value for me, that it constitutes a world as a meaningful whole. I am not only an object—Immanuel Kant would say "only a means"—I am a *subject*, I am the purpose of my activity, endowed with value and meaning.

Similarly with animals: to say that an animal "has" or "lacks" a soul does not mean a whole lot. To say, however, that an animal, too, *is a soul* means to say that animal life also has value and meaning, that it is not just an occurrence in spacetime. It means that an animal, too, experiences joy and pain, love and fear, simply that not even the animal is merely a means but is an end, a value of itself. To say that *an animal also is a soul* means to say that an animal, too, deserves to be treated with respect.

Eighteenth-century theological arguments say little to us. Few people today are likely to wax enthusiastic over the argument that if animal suffering were a punishment for sin, animal salvation, too, would have to be possible, or by a reference to the Old Testament book of Ecclesiastes (3:19–21) which

explicitly denies any difference between human and animal soul, or even by the argument of Augustus Toplady that animals must have a right to immortality because the death of a beloved animal is incompatible with the goodness of God.[8] Still, such arguments do point in an important direction. The point is not whether an animal has or lacks a putative mental organ called *soul* but whether animal life, too, has its own value and animals deserve to be treated with consideration.

The sense of kinship of humans and other animals tends in any case to follow practice that reflection notes rather than theoretical arguments that reason invents. As we have already noted, at the start of the modern age humans lived in immediate contact with animals both in the home and on the farm. They did not keep animals for sentimental reasons but for work or for food. Frequently they slaughtered them in incredibly cruel ways to make sure their flesh meat would be white and tender. They tortured animals for amusement. Until Austria's Emperor Ferdinand V the Kindly banned it in the first half of the nineteenth century, the favorite pastime of the good burghers of Prague were "chases"—a pack of dogs set on an uncommon animal in an arena. To take pleasure in watching a dog pack tear apart a deer or a bear does not suggest an overly sensitive empathy with animals.

At the same time, humans did live in intimate contact with other animals. There were many of them. Even in towns, horses, dogs, cats, goats, cows, sheep frequently lived in the same house with people. People experienced animals as personalities. Cows had their names, people spoke with them, decorated them—and even more so with horses. Humans took it for granted that horses understood what is required of them and that they can be held responsible for their actions. Animals were punished, too—the Boston Puritans in the seventeenth century are said to have hanged a cat as punishment for disturbing the peace of the Sabbath by work, namely catching mice. According to the usage of the sea, a ship is not considered abandoned as long as there is a cat on board. Animals were a part of the human community, and even though legal theory considered them chattel like slaves, in practice peasants and all the poor saw little difference between themselves, slaves, and other animals.

In addition, there have always been privileged kinds of animals just as privileged people. Horses were among those. To be sure, humans frequently treated them cruelly, did not hesitate to ride them to death, and discarded them without any consideration like used tools. Jonathan Swift writes of it in *Gulliver's Travels*. At the same time, they valued horses not only as traction but also as an expensive status symbol. The toast, "To the beauty of our wives and the speed of our horses," often inverted, testifies to an odd kind of equality. And, indeed, in the parameters of the incredibly cruel seventeenth century, the

nobility treated their horses with the consideration due treasured property, much as they did their wives or particularly skilled craftsmen among their subjects.

It was dogs who had probably the highest social status. At first for their utility: a dog was a protector, hunting companion, puller of milk carts as well as a friend. That gave rise to a close relation, without sentimentality but with understanding. Gradually dogs became pets as well. They received attention, were well fed, usually were let run free—with the expectable consequence of dog overpopulations. Even the poorest wanted to have a dog, as a friend and as a subordinate. Dogs of the cultured and wealthy tend to be friends, the dogs of the simple and the poor slaves, but in both cases there is a relation of mutual respect.

Observing animal pets leads to an awareness of animals no longer as tools but as subjects. The more humans observe animals in themselves and for themselves, the more we encounter the view of animals as feeling, thinking, and responsible. That leads to a reexamination of the conceptions of human superiority. Humans become aware that they are no better than other animals—and that other animals are as good as humans. Here we can cite the Bible once more:

> For that which befalleth the sons of men befalleth beasts, even one thing befalleth them; as the one dieth, so dieth the other; yea, they have all one breath; so that a man hath no preeminence above a beast: for all is vanity. All go unto one place, all are of the dust, and all turn to dust again. Who knoweth the spirit of man that goeth upward, and the spirit of the beast that goeth downward to the earth? (Ecc 3:19–21)

If anything, many authors in the nineteenth century attribute a nobility to animals. Animals are capable of thought and reasoning in a practical sense, something that ordinary people had known all along. Gradually comes the awareness that animals have their own modes of communication and knowing. Hence the conclusion that the orangutan is an ancestor of humans and that full humanity is simply a question of social evolution—of the labor which is said to ennoble and which, in the role of the Mother of Progress, leads humans from bestiality to socialism, at least according to the third verse of the Czech "Song of Labor."

Add to that compassion with *mute creation*. English authors in the seventeenth century frequently expressed their horror and revulsion at the way "foreigners" dealt with animals. They waxed indignant at chases, hunts, torture for amusement, attributing it to the putatively "Catholic" doctrine that animals have no souls. Yet a century earlier conditions were the same in England, with all the cruelty of indifference—not only to animals but to slaves as well. Time and again a reader will run into the indignant claim, "Surely you cannot feel

sorry for *those*"—which we heard in the Czech Republic when a group of friends of animals made a valiant attempt to rescue animals abandoned in the Sarajevo zoo during the war in Bosnia. Generally, though, the nineteenth century witnesses a shift. In 1822 England passed the first laws for the protection of animals, two years later the Royal Society for Prevention of Cruelty to Animals was founded. England changed, Europe slowly followed.

New arguments emerged as well. Theologians began to notice the other side of the coin, for instance that the Old Testament condemns cruelty—not out of compassion for animals, to be sure, but out of fear that cruelty to animals might spread to people. The idea that God created the world for human use and that humans can legitimately use animals persists, but the stress is now on stewardship, as good shepherds, following the Christ's example. Needless cruelty is wholly unacceptable. Even John Calvin, not exactly noted for compassion, claimed in 1540 that God will expect an accounting of the way we cared for the world God entrusted to us.

Doubts emerge even about the privileged position of humans. In place of the idea that the purpose of the creation is to serve humans there grows a new conception, that the purpose of *all* creation is to give praises to God. An eighteenth-century hymn—Isaac Watts's "Jesus Shall Reign Where'er the Sun"— has it "Let every creature rise and bring peculiar honors to our King." The purpose of the pig is no longer pork. The purpose of the pig is the joy of piglets in the sow, the joy by which these God's creatures bring their *peculiar honors*. To kill wantonly means to rob God of one of God's beloved creatures. Only racists continue to hold on to the idea of superiority of certain kinds. The democratic revolution lives by the slogan of *égalité!*

That equality is the battle cry of the romantics who think all kinds equal and cruelty impermissible. Not lordship over nature but consideration and good will are now said to be the signs of authentic humanity. Here we encounter the idea of humanity as a moral ideal, far nobler than the crude domineering stance of mediaeval aristocrats which the twentieth century came to admire as master morality. Besides, in the cities a "humane" attitude is far easier. People here do not need animals as tools or prey. They need not kill—the butcher does it for them and will sell them anonymous foodstuff, "meat," on a styrofoam tray. The genteel virtues of the bourgeoisie displace the rude virtues of aristocratic hunters and warriors. Compassion seems civilized, cruelty barbaric. The combination of the industrial and the democratic revolution here gives rise to a new conception of the place of humans among (other) animals.

iii. MEAT OR MERCY?

That is the source of the modern dilemma in the relation of humans and other animals. Conquer nature or protect it? Meat or mercy? We could speak of a conflict of human interests and human sensibilities. Or more exactly, it is a

conflict of noble human emotions with the impersonal modes of production which make sensitivity possible. Ruthless exploitation of animals creates the presuppositions for a higher standard of consumption and with it for sensitivity to animals.

The ambiguity of this relation presents the dilemma of all civilization—how to harmonize the demands of civilization with the sensibility which civilization makes possible? Civilization is built on exploitation: the inhuman misery of mediaeval peasants made cathedrals possible, slaughtering yards out of sight and discretely packaged meat products make possible an empathy with animals which a peasant could not afford. Civilization depends on exploitation but cannot justify it. It makes do with symbolic gestures, but the problem remains.

In principle, the dilemma allows three possible responses:

We can simply refuse all limitations and declare unabashedly that animal suffering is natural and necessary for achieving higher values—for healthy nutrition, medical progress, higher human living standards—and that animals have no rights in any case, since Man [sic] is "naturally" the lord of nature and that the market naturally subjugates the weaker to the stronger. We can simply reject the whole dilemma: we are the masters and that is that. That is usually the view held by people who are convinced that moral obligations arise only from contracts and we have made no contract with animals. It also tends to be the spontaneous view of people who have not given the matter much thought. Frequently they are not consciously hypocritical. It simply has not occurred to them that it could be otherwise.

We can, secondly, radically refuse all hypocrisy and declare that different animals may be different but that they are basically equal so that all subjugation of animals, all interference with their natural life, is in principle unjustified. We can refuse to participate in their abuse in any way. That is the position held by radical animal liberationists, in the Czech and Slovak Republics loosely linked around the Animal Liberation movement and its many organizations. These are people who refuse to compromise and refuse to participate in any way in what they perceive as a great wrong.

A third possibility is to seek compromises, seeking to satisfy humankind's real needs—and not simply its frivolous wishes—while at the same time protecting the fundamental needs of other animals. We cannot avoid a conflict of interest but we can strive for coexistence which would assure optimal life for all while accepting some conflict as unavoidable. After all, it is not human nutrition, only maximization of profits, that requires the horrors of factory farming! Cruelty free biofarming is possible. Life can never be painless, but we can eliminate vast amounts of surplus pain.

It is worth noting that we encounter these three possibilities already in the conflicts over the liberation of African slaves in the first half of the nineteenth century. Already then there were people who refused to apologize for slavery. "The Negroes," they claimed, are not human in the same sense as Europeans, lacking both rational capacity and sensitivity of feeling and, most of all, a sense for the moral order. Slavery appeared to them as quite natural, an institution we encounter from the earliest beginnings of human communities. Some people are said to be naturally masters, others slaves. Besides, slavery is the foundation of civilization. Culture is possible only where humans of higher abilities and more sensitive emotions are free to be creative, unburdened by existential concerns. Whoever attacks slavery, they claimed, attacks the very foundation of civilization

Similarly as today with respect to animals and to nature in general, the defenders of slavery appealed in the first place to alleged *property rights*. Slaves are property, slave owners are first and foremost owners. To interfere with the unrestrained enjoyment of their property by protecting or liberating slaves would allegedly be a violation of property claims they had elevated to the status of "rights." For that reason, prior to the Civil War, even those American states which did not recognize slavery still recognized the duty to return fugitive slaves from other states to their owners. The right *to be* here comes into conflict with the claim *to have*—and the property claim of *having* overrides the right of *being*, the right of slaves to be masters of their own life.

Radical democrats, labeled abolitionists, since they demanded immediate and complete abolition of slavery, rose up against the conservative position of the American South and of British aristocracy. The abolitionists held this truth to be self-evident that *all* humans are created equal and endowed by their Creator with certain inalienable rights, that African slaves experience the whole scale of human emotions, love for their children, fear or separation and death, pain, fidelity, a love for life. Yes, people are different in many ways, some are black and others white, some have curly tufts of hair, others straight, but they all love life and dread its perishing. No one has a right to deny life and freedom to another. Radicals like John Brown, immortalised by the soldiers' version of "The Battle Hymn of the Republic," were willing to lay down their lives for that. They refused to profit from the subjugation of others. To the property "rights" of slave owners they opposed the ideal of human rights. *Liberté! Égalité! Fraternité!*

Finally there were the moderates. They were shocked by the realities of slavery, by the tearing of families—some southern states did not recognize marital or parental relations among slaves any more than among cattle—by the prohibition of schooling, by the denial of personal integrity, but they considered the demand to abolish slavery too abrupt and radical. We must, they said, take into account the property "rights" of slave owners, the needs of the economy and of legal continuity—and also the limited maturity, judgment, and

knowledge of the slaves. The moderates were not defending slavery per se, but rather social stability. For that reason they did not want to abolish existing institutions. Rather, they wanted to correct grievous wrongs within the system. They strove to humanize slavery by honoring family relations, providing opportunities for schooling, showing respect for the person of the slave. They did not wish to abolish the institution of slavery as such. In contrast with the conservatives, willing to fight to preserve slavery, and with the radicals, willing to fight for its abolition, the moderate liberals sought non-violent solutions. The blacks will remain slaves but we will be considerate toward them.

Most people of color were not overly enthusiastic about that compromise but among whites it had far and away a majority support. Two hundred years ago slavery as then practiced was truly beginning to appear inhuman and contemptible, even if profitable. Similarly the demand to abolish slavery seemed wholly unrealistic and radical, threatening social stability. By far the most sensible alternative seemed to be that of humanization of slavery which would remove the most shocking aspects of the system without threatening social stability. Isn't that only reasonable? It certainly seemed so. In spite of that history bore out the claim of the radicals who rejected all compromise and insisted on one thing only: *Liberate the slaves!*

Today it is authors like Peter Singer and his followers[9] who appear as such unrealistic radicals. They insist on one thing only: *Liberate the animals!* Just as in the case of African slavery, the philosophical foundation of the entire issue lies in the democratic revolution. Inequality, superordination of one to another, runs against democratic customs and attitudes. This gives rise to questions which humans did not pose before the democratic revolution, at least not in relation to animals. Are humans really a "higher" kind, superior beings? And even if so, does that justify heedlessness toward their "lower," inferior kin?

Are humans really superior beings? Judged by what? That they are rational? That is something humans might value but dogs consider fidelity and a good sense of smell far more important. Judged by canine criteria, dogs would have to consider themselves superior. Or should we consider kinds according to their contribution to the welfare of the Earth as a whole? If so, we should have to consider humankind distinctly inferior, a deviate subspecies that clearcuts forests, poisons the atmosphere and the waters—and all that solely in its own selfish interest. That humans also created the Mona Lisa and Mozart's *Eine kleine Nachtmusik?* That serves humans only, not the Earth, the biospheric system of all life. Yes, humans are different, but it would be hard to conclude on the basis of that difference that they are also superior.

For that matter, even if we were to attribute to humans superiority in some sense, would that mean that they can treat "inferior" beings inconsiderately? A Ph.D. violin virtuoso of delicate manners is clearly different from a semi-literate beer guzzling couch potato. Some people might even say that she is a superior being because she treats even the couch potato considerately which is not true the other way around. But does that mean we may differentiate between them when it comes to Medicare eligibility or equality before the law? Or in the right to vote? Quite unthinkingly, many people might blurt out of their prejudice, Yes. Yet democracy is a discussion in which reasons, not prejudices count. Does any of the differences quoted present a morally relevant reason for discrimination? As far as Peter Singer is concerned, hardly.

The same applies to our relation to other animals. Even if we were to consider ourselves in some sense "superior," perhaps because we are more numerous, more demanding or more powerful, that would not entitle us to treat others inconsiderately. For instance in meat production: one might claim that we have a "right" to eat veal just as a wolf has a "right" to eat mutton. We, too, are a part of the food chain. Can we from that derive a "right" to subject a calf to senseless, incredibly cruel treatment so that its flesh would be more tender and its production more economical? Or, for that matter, does our "right" still hold today when we have so many other possibilities and do not need meat as food or furs as garment?

The same is true of animal experimentation. The point is not whether we might sacrifice another under extreme conditions. *In extremis* we will sacrifice even a human being. As late as the mid-nineteenth century seamen considered cannibalism acceptable if it were the sole means of saving an entire crew from death by starvation. In combat a commander must more than once sacrifice a particular soldier to save many. The problem is that some 95 percent of animal experiments are unnecessary and needlessly cruel. We often torture out of habit, indifference, or for financial advantage. Does our alleged superiority justify something like that? Or in the case of organ transplants: can we kill a person, perhaps that semi-literate beer guzzler, to save the life of the violinist? Hardly. Do we have a right to speed the death of the dying beer guzzler for the same reason? Even that is most problematic. Then what gives us the right to kill an ape who also rejoices in life and does not want to die? Just because she cannot speak Czech? A great many violin virtuosos cannot do that, either.

Usually we dismiss such questions by claiming that the answer is self-evident. We, well-educated white Aryans, are obviously superior to others. Others have no rights against us. All racists consider that self-evident. The trouble is that there really is nothing self-evident about it. The strenuous effort all animals exert to escape death shows that to them it is not at all self-evident, either. It did not seem self-evident to the original Americans, to Albert Schweitzer, Leonardo da Vinci, Pythagoras, or to the 80 percent of all Indians

who for centuries refused to devour the corpses of their nonhuman neighbors which we call "meat."

Nor is it self-evident to Peter Singer and his followers who unambiguously support a radical liberation of all animal slaves. Singer starts by insisting that he is not an "animal lover." His concern is with the morality of the ways humans relate to others. Similarly Masaryk, at the time of the Hilsner trial, insisted that he is not a "lover of Jews" but a lover of justice.[10] For that matter, to this day, the easiest way of dismissing uncomfortable ecological objections to our vulgar consumerism is to label ecological activists "nature lovers" or perhaps "tree huggers," as if it were simply a matter of personal preference. That, though, is not the point. The point is long-term sustainability of human dwelling on this Earth. Similarly Singer's point is not that warm, furry animals are cute and cuddly. He is concerned with the morality of human coexistence with other beings.

Singer's starting point is a radical conception of the equality of all life. *We are equal* does not mean that we are the same. We are not, just as women and men, Europeans and Arabs, humans and dogs are not the same. There are major differences among us. But here the question is whether the undeniable difference is also morally relevant, justifying differential treatment, or whether all have a right to the same consideration in treatment and the same possibility of satisfying the needs of their life, even though they are different. People can communicate in words, dogs cannot. Does that, though, mean that pain hurts them less, that the loss of a mother or of a child is less painful when the mother and the daughter are both dogs? Are we justified in taking a puppy from a dog just because she cannot protest verbally? Could we take a child away from a deaf-mute mother who, after all, also cannot protest in words? Or from a foreigner who speaks only Farsi and cannot communicate in any language we understand? Why should the case of the animal who has manifestly the same scale of emotions be different?

To Singer it is clear: none of the differences between humans and other animals is morally relevant. None justify domination and discrimination. Granted, there are people for whom music or literature is a basic need, others can make do with warm beer and cold pizza. There are, though, basic human and basic animal needs. Societies for the protection of animals generally recognize four basic needs common to all animals—whose satisfaction Europeans often denied even to African slaves as recently as two centuries ago. It is in the first place the possibility of free movement in sufficient space, secondly the natural cycle of day and night, of activity and rest. The third is the need for the fellowship of their own kind, including family relations. Finally, a diet natural to the animal is the fourth need. A herd of cows may not need chamber music, though that does lead to contentment and higher milk yields. They do, though, have at least those four basic needs. To lock up a cow in a stall, deprived of the

possibility of movement, segregated from others and from its calves, to expose it to continuous illumination, as is commonly done in producing veal, and to feed it artificial food and steroids, that is torturing a living being. No difference between humankind and cattle provides a moral justification for depriving a cow of the right to graze with its calf and with other cows on an open pasture. We may have different needs but we have the same right to satisfy them.

Singer vehemently rejects all attempts at deriving superiority from difference. Any idea that one group is not only different but naturally superior to another and that it can derive advantages from it for itself and disadvantage for the other is simply racism. Racism is contemptible, be it a racism of race, nationality, creed, gender—or animal kind. Granted, we are not factually equal. Factual equality does not exist even among humans. The son of a neurosurgeon and a philosophy professor in Oslo starts life with far better initial conditions than the illegitimate daughter of a Hungarian-speaking Romany charwoman in a north Bohemian city noted for discrimination. Yet though equality is not a fact, it is a moral ideal and a moral norm for treating an other. Metaphorically speaking, God does not play favorites. In the perspective of eternity one good is as valuable as any other good, the good of the porcupine as valuable in a cosmic perspective as the good of the driver who kills her/him.

According to Singer, simply the ability to suffer, to feel pain, loss, constitute a sufficient reason for consideration. Whoever and whatever lives, can suffer and die, seeks strenuously to avoid perishing and suffering. This longing deserves respect. Until people stop to think about it, they are for the most part racists. They ignore the need of other beings to avoid suffering. They start with the assumption that for other animals suffering is somehow *natural*. Perhaps they have really given it no thought, or perhaps they live with a vaguely Cartesian idea that only a conscious rational subject is the bearer of emotions and so worthy of respect. Yet there is more and more evidence that other animals, too, suffer and seek to avoid suffering, that they suffer a fear of anticipation. Children suffer from it, animals captured in the wild, animals being led to slaughter all know it. Not being able to speak does not mean that they do not feel. For Singer, the conclusion is unambiguous. The commandment, *Thou shalt not kill!* applies to all injury, to all killing. In all relations, intrahuman and interhuman, we are morally obligated to take into account the *intrinsic value of life*.

*Here a philosophical detour is in order to clarify the conception of value we are using. Mediaeval thinkers did not think it overly problematic. It seemed evident to them that whatever is, is good simply because it is God's creation, because God godself lovingly crafted it. They distinguished two senses of value. One is the **utilitarian** or **extrinsic value** which a being derives from serving some higher goal. A potato is good for a pig, a pig is good on a roasting pan, humans are good in church*

where they can praise the almighty God. A utilitarian value is what justifies the claims of various beings toward each other. It varies; in the case of a mosquito it approaches zero—the Middle Ages did not register the need of bird food for songbirds—and so the entitlement of individual beings is different. Because humans serve the highest goal, praising God, the pious person is said to have the highest justification—to the grief of the pig.

*However, quite regardless of the utilitarian or extrinsic value of a given being mediaeval thinkers were absolutely convinced that every being has also its **own** or **intrinsic value** simply because it is God's creature. God created it, God loves it, it is valuable for God even if it seems completely useless in the economy of the world. Not humans alone, but also pigs and the least of all mosquitoes are God's beloved creatures. Our utilitarian value gives us the right to use other beings, but their intrinsic value obliges us to deal with them considerately. There is nothing we could arbitrarily use up or destroy; whatever we use we need use with respect and gratitude.*

Believing Christians see it that way to this day. For recent thinkers, who no longer see the world as God's creation but only a random aggregate of particles, it is more difficult. All recognize the reality of utilitarian value quite unproblematically. Yes, the potato is for the pig, the pig is for humans. But what are humans for? Tiger food? Humans have failed catastrophically as the "shepherds of being;" they have not cultivated the world, only devastated it. Are humans good for anything at all? Or is their being absurd, literally ad surdum, reaching the surd, the ground zero for which there can be no justification?

*There are people who think so. Those who continue to believe in the value—or perhaps even traditionally in the "sacredness"—of human life have to approach the question differently. They need to insist on life's own, intrinsic value, its **value in itself**. That is difficult, because value is basically a relational reality. It emerges in the relation of something to something, of the pig to the human or, in the mediaeval conception, of humans to God. How can value, essentially a relational reality, be at the same time something intrinsic, belonging to a being in itself, apart from any relation to another?*

*The response comes from the reality that life relates to itself. Whatever lives seeks to save and preserve its life and to avoid suffering and perishing. Even the mosquito seeks to avoid the swatting hand, even a stalk of grass seeks to reach life-giving moisture. That means that **life is a value for itself**. Quite independently of whether the life of a given being has (utilitarian) value for another being, it has a value for that being itself. The **value of life for itself** is a relational reality (it is a value for a*

living being) quite indepedently of a relation to another being. It is its own value, value of itself.

Thus when people like Schweitzer or Leopold speak of the value of all beings—that is the mediaeval esse qua esse bonum est—they do not mean to say that animals are kind, friendly, or valuable. All they mean by it is that the animals' own lives are values for them and that we therefore may not destroy them needlessly, just for fun. All our relations to others have an ethical dimension.

Numerous thinkers point out that there is no reason why we should limit this intrinsic value (value for itself) to living beings. Though we must speak of it in metaphors, is it not likely that whatever is "wants" to be? That a tree does not want to perish by chainsaw or a boulder by dynamite? That all that is has its own (intrinsic) value simply because it is? In that sense we can speak of not only utilitarian but intrinsic value quite independently of religious belief. It is true of all life evidently, of all that is at least metaphorically. No one has a right to hurt or kill arbitrarily because for all that is life is an intrinsic value—and perhaps for all that is, just being is such a value.

With that we can return to Peter Singer and his analysis of the encounter of humans with (other) animals. Singer starts out with the conviction of a fundamental equality of humans and other kinds of animals. For that reason he considers all cruelty to animals utterly unacceptable and refuses to be a part of it. How, though, should we go about it?

Start, if you will, with a distinction. In the encounter of humans and animals—and for that matter of humans with humans—there is so much needless, pointless cruelty which stems simply from selfishness. People unhappy with themselves tend to be arbitrarily cruel to animals as well as children. A father humiliated at work relieves himself by kicking a dog or slapping a child. There is also cruelty of negligence. Children especially, but adults, too, can be immensely cruel simply because it does not occur to them that *kitty is hurting*. The episode with gluing paper turtles on flies' wings—whereof more anon—in František Kožík's *The Victors' Flag* makes the point. We can deal with that kind of cruelty by education to empathy and reflection. Perhaps the most important task of basic schools is to teach children compassion and understanding for the world beyond their small selves, for other children, animals, plants: to teach them to *be nice to kitty.*

Structural cruelty is something else. It does not stem from cruelty or blindness but from the order of life around us. Again metaphorically: *Be nice to kitty, give it a mousie!* Singer focuses on two regions of structural conflict, on animal experimentation and the meat industry. He is willing to set aside experiments in which animals do not suffer, even though captivity is itself suffering. He is willing to set aside experiments which are wholly necessary if we

are to prevent far greater suffering, including experiments needed for the advancement of veterinary medicine. Even so, there remain some 95 percent of all experiments which are completely unnecessary and often incredibly cruel. Read his chapter on animal experimentation—and if you think that since that time things have changed for the better, compare it with Milly Schär-Manzoli's study, *Holocaust,*[11] which cites official reports submitted by experimenters in Switzerland, the land with most advanced animal welfare legislation. The people who carry out such experiments are not necessarily sadists or psychopaths. For the most part they are wholly normal people, kind to children and perhaps even to their animal pets. How is it possible for a completely normal person to cause consciously such monstrous suffering, literally slow torture of a sensitive being?

Singer points to the "scientific attitude" which medical and many other faculties the world over seek consciously to inculcate in their students. A physician, it is said, must be able to switch off all empathy and all sensitivity in the service of a good cause because, allegedly, *the end justifies the means.* To be sure, that is not unambiguous, either. The utilitarians tend to be convinced of it, regarding the means as value neutral until the goal they serve makes them good or bad. Formalists like Immanuel Kant would tend to say that nothing can justify intrinsically bad means. A murder is a murder, even in the service of the good. It might be necessary, but it cannot ever be good: I can never murder with a clear conscience. Pragmatists like John Dewey refuse to separate the goal and the means: both constitute one whole and need be evaluated as a whole. So something good, if achieved at the cost of a great evil, ceases to be good. One way or another, though, cruelty, however justified, remains problematic.

Dr. Mengele and his colleagues, carrying out experiments on human prisoners in German concentration camps during the Second World War, provide a painful example. Today we would like to believe that their experiments were pseudoscientific and they themselves were psychologically damaged sadists with psychopathic tendencies. Available evidence, however, does not bear out either. In the vast majority of cases—for instance submersion in ice water to save lives of German seamen in northern seas—these were normal scientific experiments which would win the approval of any university ethics committee. Nor is there evidence that the doctors were sadistic psychopaths. They appear quite normal, kind to their experimental animals outside the laboratory, befriending them and bringing them treats. Only they were rigorous scientists, strictly separating their scientific activity from their private emotions. In the laboratory they would not let personal sentimentality distract them from their duties as scientists. Isn't that precisely what we seek to inculcate in our medical students?

To be sure, in the case of German doctors during the war the experimental animals were humans—or so it seems to us. In the atmosphere of the Third

Reich it could have appeared differently. These, surely, were not *people,* only *Jews*—and in the background there was the constant question, how can you feel sorry for Jews while at the front beautiful young Germans are dying in the service of the motherland and your experiments could save them? The analogy is quite accurate. Today we would say that these, surely, are not *people,* only *animals,* and we reproach students who hesitate. How can you feel sorry for animals when in the hospitals humans are dying and your experiments could save them? The creatures who suffer in experiments are, after all, *only animals.*

Why should animals be *only?* Singer rejects that absolutely, for reasons already cited. He is convinced of a total biotic equality. The suffering of one animate being is as unacceptable as the suffering of another. According to Singer, humans are not "superior" beings and we would be hard put to find a reason for thinking so. Singer disqualifies them one after another. Besides, even a superior being has no right to injure another wantonly just because s/he considers that other inferior. Singer takes democratic equality seriously in all its consequences.

Then are animal experiments ever justified? In principle Singer would have to answer in the negative, though he offers a critical test: is the projected experiment so important that you would be willing to carry it out on human subjects? Would you be willing to carry it out on your child? If not, you have no right to carry it out on an animal. If so, then human experiments have the great advantage that a human can give informed consent while other animals are always only passive victims. But even if the subject were to give consent, would a life bought at such terrible price be worth living? Would you want to go on living were you aware that your survival was bought at so horrendous a price of suffering and death? Could you live with yourself and your conscience?

So Singer reaches an unambiguous conclusion: just say NO! Let us realize to what extent we ourselves are a part of that horrifying mechanism which never hesitates to reach for profit at the price of cruelty, and reject it in every possible way. Refuse to buy cosmetics tested on animals, demand alternative research models, protest, simply consistently assume the abolitionist attitude: *Without me! Count me out!*

Singer's *Animal Liberation* takes the same approach in the case of meat production and of meat as food. We are in fact most likely to encounter animals on our plates. There might—or might not—be some justification for killing for food on a small family farm. It is just possible—though by no means certain—that the animal had a good life there, that humans cared for it, caressed it, called it by name. Perhaps at the end of that good life there was a

painless death. Still, I shall not forget the horror in the eyes of a goat at a hog killing. Normally the goat had been friendly, now she was hiding in the most remote corner of the barn, shuddering. That pig had been her friend, she had witnessed his end. Animals understand. They need most of all to build up a relation to their people, they try to win their good will. They want to trust. The animal does not know why it is beaten and there is every evidence that it experiences the death of a fellow being in the family at the hands of its person as a rude betrayal.

So it is under ideal conditions where the animal is almost a member of the family. Conditions in factory farming are incomparably more cruel. The animal here is a biomechanism worthy of no consideration. Pigs in feeding cages, chickens with burnt-off beaks whom only injections of antibiotics and steroids keep alive, calves under constant illumination in cages where they cannot even stand up—Singer and all who write of factory farming present evidence of unbelievable callousness. Transports of live animals are hardly different from the transports of prisoners during the Second World War, but any protest provokes the same answer: after all, those are only *animals!* Is pain less painful, is death less cruel, if the victim is one of the beings we dismiss as an "only"?

In some countries protests do take place. In England a group of scientists presented the Parliament in 1979 with a report criticizing the inhuman conditions in factory farming, the so-called *Bramwell Report,* but the then newly elected conservative Parliament refused to react. Most countries grant factory farms an exemption from laws for prevention of cruelty to animals in the name of cost efficiency and tradition, time honored conservative values. There have been attempts at cruelty-free farming, respecting fundamental needs of movement, the diurnal cycle, companionship of own kind and natural fodder even in our country, but public indifference and defective legislation hinder their expansion. Newly and marginally affluent customers refuse to note cruelty and do not demand ecologically considerate products. They notice only that eggs from free-nesting hens or meat from open pasture cost a few pennies more than products from mass production.

Singer's reaction is unambiguous: *Without me! Count me out!* The most important step, he thinks, is simply to refuse to devour corpses, even when they are *only animals.* Attempts at reform, at protective legislation, at humanization of production will fail again and again, and necessarily so. Factory farming is not directed by humans but by an anonymous computer programmed to maximize profits, devoid of any empathy for animals or, for that matter, for human employees. As long as demand lasts, so does the positive feedback: there will always be an entrepreneur who will produce "meat" more cruelly and more cheaply. There will always be indifferent consumers who will save a few pennies. For Singer and his supporters, the only way is to refuse the whole system, to boycott cruelty and seek out foods free of it. It is a

way of using the same economic mechanisms, though this time in behalf of the victim.

Can we change the whole global impersonal system of cruelty and exploitation which is being imposed on the whole world in the name of free trade? Hardly. Still, Singer will not be deterred thereby. He points out that every time I refuse to eat the torn bodies of my tortured fellow beings, I save suffering. When I make a hamburger out of savoy cabbage instead of ground meat, there is a tiny sliver of suffering less in the world. Perhaps fried cauliflower tastes so good also because no animal suffered and died for it. Besides, every such refusal, not loud and pompous, but calm, quiet, and determined, helps change social climate. I am not only saving suffering, I am also encouraging less horrendous approaches. Perhaps most important for Singer, it is morally right not to take part in a very great evil. That is what it is all about—to live with a clean conscience.

Singer offers some practical advice on becoming a herbivore. It is not enough, he points out, simply to leave meat out of the ordinary meat-based menu. That produces the deficient diet which opponents of vegetarianism love to invoke. We need to start gradually, say, by inventing meatless dishes which offer analogous nutrition. Visiting vegetarian restaurants can be a source of ideas. Then we can leave out meat from mass production. Then perhaps fish. Then eggs from factory farms, or perhaps eggs altogether. If you have no access to hand-milked milk from a freely pasturing cow or goat, many stores carry soy milk, which *I* at least cannot tell from cow's milk. That is ultimately Singer's conclusion: for reasons cited, he considers a meat diet a moral problem, a vegetarian diet only a practical one. Is he right?

iv. THE LURE OF PERFECTION

Vegetarianism is not just a practical problem. It is also a philosophical problem as old as human reflection. It sums up in a nutshell the whole agonizing question of living with a clear conscience in a world contaminated by evil and cruelty. So many philosophers, so many poets, so many mystics in the history of humankind have cried out, *If this is the world, let me off!* I refuse to wade in all the filth and misery. For many, that was the reason for leaving the world for monasteries and hermitages.

In principle, three attitudes are again possible. One is simply *to refuse to feel guilty* at all. The world is like that, suffering is a part of it, I can't change that. There is no reason to restrain myself. No one is perfect, so why should I try? At times, that is the attitude of people who see in the world only a meaningless whirl of particles devoid of all moral sense, though the reasons people cite for it are more often justifications after the fact—or, just as often, attempts to come to terms with agony too great to accept. There is just too much suffering. There is no hiding from it except in hypocrisy or illusion. We cannot stop

the world and get off. We have to live with all the pain. Precisely sensitive people might defend themselves by callousness. How else?

The second attitude is *to escape guilt by striving for perfection.* That is the attitude at the root of all puritanism: *Without me! Count me out!* Though I cannot change the world, I refuse to be a part of it, a participant in that very monstrous evil. Though all steal, I will not steal. I will not be part of evil, I will strive for personal innocence. No one can kill others, whether as an executioner or a butcher—or a soldier?—without deadening a part of their humanity. The only possibility is to refuse all paricipation in the fallen world. That was the posture of reformers like Petr Chelčický, John Calvin and his heirs, that is the posture of Peter Singer. Insist on perfection, good intentions will save you from condemnation.

The third attitude is one of *striving for the best we can do while accepting the inevitability of failure.* We can try to destroy nothing needlessly, to live with maximal respect while reconciling ourselves to the admission that no, we cannot achieve perfection. We can only try and pray for forgiveness. Perhaps that is what Martin Luther had in mind in his often quoted and misquoted statement, "Sin bravely but believe more bravely." It is a hope for forgiveness in face of condemnation. That takes courage. We all long for perfection. It is so much easier to be innocent! Besides, inaccessibility of perfection is such a neat excuse for giving up the effort! To strive only for what is possible does not impress anyone, yet to many it appears as the only way of functioning effectively in a fallen world without protecting oneself by insensitivity.

That is the perennial human problem which the question of eating meat compresses into a paradigm. The longing for innocence, not to have to kill even for food, is old as humankind. Ancient Greeks imagined the Golden Age as a vegetarian one. Similarly in the biblical myth the Garden of Eden is vegetarian. Adam and Eve lived on fruit. In the Old Testament narrative, a meat diet enters with the Fall—and ends with salvation. The prophet Isaiah imagines the New Jerusalem as vegetarian in one of the most quoted fragments of the scripture:

> The wolf also shall dwell with the lamb, and the leopard shall lie down with the kid; and the calf the young lion and the fatling together; and a little child shall lead them. And the cow and the bear shall feed; their young ones shall lie down together; and the lion shall eat straw like the ox. And the sucking child shall play on the hole of the asp, and the weaned child shall put his hand on the cockatrice's den. They shall not hurt or destroy in all my holy mountain. (Is 11:6–9a)

That is the age-old dream of humankind, the peaceable kingdom—and vegetarians are beginning to bring it about. They can look a cow in the eye with a clean conscience. Perhaps that is why Seneca, the philosopher most keenly aware of the evil of the world, was a vegetarian, just like many mediaeval saints.

Beginning with the Renaissance we encounter self-conscious vegetarianism, at first known as the Pythagorean regime. In addition to the old protest against "red meat and red habits," arguments from health and nutrition came to the fore. After the French Revolution the European vegetarian movement acquired a distinctly radical cast. It drew on moral revulsion at killing, conjuring up an image of a golden age of innocence. Thus far, that radicalism has not brought about a marked change in popular attitudes. While far less radical India is 80 percent vegetarian, in Europe and America vegetarianism remains marginal. Still, it does have its importance. It will not let us kill with a clean conscience. It preserves in our awareness the fundamental human longing to take no part in evil which might otherwise ill survive in a consumer society.

Perhaps that is also why vegetarianism evokes such an irate reaction. Why do we object so much to people who prefer a grain-based diet to a meat-based one? Certainly, individuals may offend by insensitivity and provocative superiority, but those we encounter in the general population as well. Do we object to their being different? The less people are confident of themselves, the harder they tolerate deviation. Could it be that we are unsure of our "red habits?"

It is not difficult to find responses to the routine objections to vegetarianism. Perhaps the most common argument takes the form of the resigned claim that *I alone* cannot change anything when *everyone* is against me. That is the argument we routinely use to justify whatever bothers our conscience, like driving a car into a hopelessly polluted city under inversion. Then the claim is that it is futile for me to crowd on the streetcar when *all others* will take their cars. Similarly the claim is that it is futile for me to give up steak when *everyone else* orders it.

Yet that *everyone* is made up entirely of individual *I alone*'s. When *I alone* refuse to take part in cruelty, it has a triple consequence. One is practical: there is one fragment of cruelty less, however tiny. There simply is one fewer *I alone* contributing to the cruelty. I also contribute to a shift of attitude. When I order lentils with onion or fried cauliflower in place of a veal cutlet, I am casting doubt on the alleged inevitability of a meat diet. People will stop and think. They might write me off as a fool but will no longer be able unthinkingly to take part in cruelty. It is precisely the unseeing indifference which makes inhuman practices possible. The third consequence is personal: I break free of the contradiction between my empathy with animals and my diet. All that is not little—and even if it were, it would still hold that *no one makes a greater mistake than those who do nothing because they could do but little.*[12]

Then there is the second common objection, that *I have to eat something.* Even if I do not contribute to the torture of animals, I contribute to the mass murder of cauliflower and the beheading of innocent cabbages. There is an answer to that, too. Yes, I must eat something, just as I have to clothe myself and keep warm. Only my freedom means that I can choose, and I need not

choose so as to cause the most pain and suffering. I do have to eat *something*, but that hardly justifies cannibalism. There is a great difference between eating human flesh, eating flesh from factory farms, eating flesh of free-living creatures, flesh from a home farm, flesh of creatures who do not have a central nervous system, between flesh and eggs, eggs from a battery farm and eggs from free-running chickens, eggs and milk products—and finally also between plants and the fruit of plants like grain, fruit, or mushrooms. Yes, I have to eat something, but I can select my food not only selfishly but also with consideration for others.

Here, though, we run into a philosophical problem. As long as the point of vegetarianism is to lessen and decrease the total fund of suffering on this earth, it is unproblematic. A considerate choice of nutrition can save suffering, and every such choice is welcome. That much is clear. As long as my concern is really to save suffering of my nonhuman kin, I can achieve it with considerate choices. The argument that I have to eat *something* does not hold. Something, yes, but I can hurt less and really considerably less, I can search for a compromise between my need and the needs of others and so lessen my impact on the Earth. Even though my presence will always have some impact, I can save suffering.

If, however, my concern is not just to save suffering but to be beyond reproach, to reach innocence before God and humans so that no one could reproach me for anything, I am in a different position. For while I can save suffering, try as I will, I shall never achieve perfection. Perfection, that is all or nothing. It is not enough to save suffering. From the perspective of guilt and innocence there is no difference between the person who eats three servings of baby whale and veal a day with ivory chopsticks and one who limits consumption to one egg a day. From the perspective of radicalism, both have sinned and fall short of the glory of God and of worldly perfection alike. Both are open to the taunt, "You are not perfect"—even from people who themselves do not even attempt to be little better.

All fanaticism arises from the longing for the safety of perfection. To be perfect, without a flaw, absolutely safe from any reproach . . . that is what leads to competitions in perfection, whether in faith, in political correctness, or in diet. Yet since perfection is unreachable, fanaticism leads to a frustrated intolerance and ultimately to its very opposite: if I cannot be perfect, there is no point in trying to be better. I shall not achieve perfection, someone will always taunt me that I fall short—then why even try? In Czech experience, Communist idealists first became fanatics, then apostles of enterprise. I have seen it many times around me—and in me. First the ever more intense effort at perfection to the point of exhaustion, then disillusion and cynicism: it is all pointless, I might as well be hanged for a sheep as for a lamb.

Martin Luther seems to have gone through something like that in his effort at perfection, in his anxiety to confess all his transgressions, even the

unconscious ones, wearying his confessors and in turn lapsing into a dark night of the soul over the futility of the effort. That was not the end of his spiritual journey. It led him to a liberating recognition which Luther understandably expressed in a religious metaphor: we all have sinned, yet we are all offered grace, wholly without merit. There is nothing we have to do to achieve salvation. God has taken care of that. We can out of sheer gratitude focus on doing good because we know that our salvation does not depend on it. Salvation is God's concern, our concern is the welfare of God's creation. Freely, out of gratitude.

Luther's religious metaphor hardly speaks to many today, but we can express the same insight with our diet metaphor. If we want to preserve our conscience, our consciousness, and the whole range of feeling and empathy, we cannot but be horrified at the suffering we are causing to our nonhuman kin, to animals who rejoice in life and suffer pain, know friendship, love, and treason. Seemingly that leaves only two options. One is a cynical indifference with which we deaden our ability to empathize. *I love animals—on my plate*. Or we can attempt innocence. We will not be the devourers of tortured corpses. We shall be pure, ever purer, striving for perfection. Yet even at the peak of perfection we know that we eat *something*, that our presence on Earth is bought at a price of death. Then comes exhaustion—and a fall into indifference.

Yet another ending is possible, one of accepting both guilt and forgiveness. We are not perfect, our life is a chain of compromises between the longing not to harm and the need to live. But *perfection is not what it is all about*. It is about treading lightly, harming as little as possible. In the grand metaphor, we shall ever be open to the objection that though we refrain from eating meat, we drink milk or eat eggs. Yet even that is not what it is all about. Innocence has to do with our relation to our own conscience—or, in older terminology, to God—not with our relation to nature. In that relation our task is to live considerately, to spare our kin. It is a task of practical help to a suffering world. Perhaps vegetarianism reaches its noblest peak not when it comes closest to perfection but when it brings about a shift from a preoccupation with our own perfection to a concern for the welfare of our kin.

v. ALL TOO HUMAN

So a compromise, after all? It is not a word we use gladly. For people like Bernard E. Rollin[13] it is not a matter of compromise but of effectiveness. Compromise is not the purpose but a consequence of the shift of emphasis from personal perfection to effective service to our nonhuman kin. Rollin is a philosopher and so does not avoid reflection. If anything, he is acutely aware of the need not to close our eyes before suffering, to learn empathy and critical thought both, to reexamine our prejudices about human superiority and realize

that the fact that we are different does not entitle us to be cruel. At the same time, he wrote *Animal Rights and Human Morality* as a professor of medical ethics at the Colorado University School of Veterinary Medicine and a member of its Ethics Committee. He could not afford absolutist postures.

Rollin's book is more of a careful analysis than an attack on emotions. The crucial point he makes is that the way humans will treat other animals will depend in great part on the way they perceive them. It is less a matter of conscious beliefs about animals than a matter of perceiving. Basic to the treatment of animals is perception, not conception—whether quite prereflectively we *perceive* them as biomechanisms or as *little people in fur coats*.

Much like Singer and most animal defenders, Rollin is anxious to avoid appearing sentimental. He does not seek to evoke compassion. What he presents are formal arguments why *every rational subject*—the hallowed incantation of formalistic philosophy—must necessarily consider animals worthy of moral concern. Like Singer, he also points out that the traditional prejudice about humans as "higher" beings whose position entitles them to sacrifice others simply will not stand. The differences between humans and other animals are real enough, but not morally relevant or binding.

The problem of Rollin's argumentation lies elsewhere. It would be hard to disagree with his claim that a critical rational analysis is a far more reliable guide for human action than sentimental irrationalism capable of killing in the name of national or species superiority. Yet while reason can provide orientation, it is compassion with the suffering of animals that motivates action. "Unsentimental" too often means also "ineffectual"—just as "emotional" often means "uncritical" and so dangerous. Rollin unwittingly exemplifies a fundamental problem of all ecological activism. If it is to be effective, it needs to link two seemingly contradictory motifs, clear critical thought and emotional generosity.

Critical analysis leads to the awareness that between humans and other animals there is only one morally relevant difference, and that is freedom. Humans are beings who can imagine that things could be otherwise, the only beings that do not live within firmly established instinctual parameters. Freedom, though, does not mean privilege. It means responsibility. Because our acting is not determined without remnant by a genetic code or "nature" we cannot blame the results on them. Those, too, depend at least in part on our freedom. We are capable of fishing species to extinction—as we have come close to doing with the Atlantic cod—but we are also capable of setting limits for ourselves, be it in fishery, diet, or animal experimentation.

For Rollin, the critical trait is not the ability to feel pain but rather interest in self-preservation. As we noted already, any life which is a value for itself is

a value in itself. It is not simply that we cannot thoughtlessly torture a sentient being. It is that we need to recognize the integrity and autonomy of any being that seeks to preserve its life as something good.

Does that mean that we ought to recognize nonhuman beings as endowed with "rights?" In the turmoil that followed the fall of the Communist regime in our country, the novelist Ludvík Vaculík proposed that the new constitution of the Czech and Slovak Federal Republic in 1991 should recognize the rights of nature which are not derivative from human needs. A forest has a *right* not to be clearcut, a mountain range has a *right* not to be sacrificed to gold mining or cement production simply because humans could profit thereby. Whatever is has a right to considerate treatment simple because *it is*.

Vaculík's proposal did not pass—and, in any case, nationalist politicians broke the Czech and Slovak Federal Republic into its component parts within the year. Still, in those velvet days before the feeding frenzy of "privatization," Vaculík's proposal met with ready approval from the public and with total incomprehension on the part of lawyers. Still, the laws left over from that fleeting period do recognize animals as subjects, though imperfectly and inconsistently, and do create the possibility of defending their right to life even against the touted "property rights" of the owner. An owner has a right to dispose of her/his property, but an animal, much like a slave, is not simply property. In a certain vague sense it is also a subject whose right to life the law recognizes and defends, in theory at least.

Would it be desirable to recognize the rights of animals fully and formally, in the form of a law? That even an animal has a right to life, that is something that wholly informally, wholly intuitively we do recognize. The fact that it is *my* horse does not entitle me to mistreat it. It depends on the good will of the owner: we can condemn mistreatment morally, but it is hard to pursue legally. Should the law recognize the rights of horses so that the prosecutor general could bring a suit in behalf of a mistreated horse?

The answer is not unambiguous. Legal recognition codifies the moral standing of a being in a community and at the same time gives force to the claims which follow from it. The moral standing of animals like dogs and horses is evident. If we recognized it legislatively, it could contribute to the moral growth of humans and would help shift our perceptions. The usual claim that "you cannot legislate morality" does not deserve to be taken seriously. Humans have murdered each other since the world began, yet that is no reason why we should not seek to influence that behavior by criminalizing murder. Laws abolishing slavery drastically affected our perception of our African fellow humans. Why not animals as well?

There is a contrary consideration, too. The more we extend the concept of *right*, the more we empty it of content. Right always designates a certain privilege with respect to others. If we start using it to cover the desire of the cat for a mouse and of the mouse for life, we will set up a paralyzing gridlock of

mutually cancelling rights. Perhaps we would help animals far more if we did not speak of "rights" but of basic needs and of respect for others, or perhaps just respect for life. Angels can take uncompromising stands. Humans do better when they analyze reasons.

This may be why the most impressive part of Rollin's book is its second part, devoted to animal experimentation. To Rollin it seems clear that in a perfect world there simply would be no animal experimentation. But this is not a perfect world. Were he to resign from the Ethics Committee to avoid soiling himself with guilt, he would leave the animals at the mercy of experimenters and animal dealers. Not from lack of compassion but out of an aching will to help Rollin considers his task to be one of seeking compromises between animal experimentation and Animal Liberation.

As a member of an ethics committee, Rollin set for himself two principles. One applies to all our dealings with the nonhuman world. The evident benefit of the experiment must unambiguously outweigh suffering or damage involved. Wherever the least doubt exists, the experiment is not legitimate.

Actually, this is an extension of the commonly accepted principle of irreversible consequences. When consequences are trivial, I can demand absolute proof before I change my behavior. If the worst that can happen is getting my shoes muddy, it would take positive proof that the meadow is flooded before I would go out of my way to avoid it. However, if there were a possibility that the meadow had been mined, I would not insist on certainty. Just the possibility would be enough for me to change my behavior. Likewise if there is a possibility that cigarette smoking causes cancer, I will not insist on proof positive before I quit smoking. Where the consequences are irreversible, even doubt is sufficient reason to stop—and agony is irreversible.

Then there is a second principle, again applicable to all our dealings with the nonhuman world. The experiment must start with a clear recognition of the animal's right to the integrity of its life, to its life and freedom from pain. In effect we need to start by assuming any intrusive experiment is illegitimate and examine reasons why in this case an exception ought to be made. We cannot start by assuming that animal experimentation is legitimate unless a reason can be found to the contrary. To torture and kill is never *prima facie* justified. We need absolutely to deny the automatic legitimacy of causing harm. There must be overwhelming reasons.

Thus Rollin's is not a cheap compromise of the kind "we can torture but not too much." What Rollin calls for is a fundamental transformation in our attitude. Ordinarily we assume that torturing and killing animals in experiments or in food production is in principle legitimate and that reasons need be shown why it is not so in a given case. Similarly we assume that devastating

nature is legitimate unless reasons can be shown why in this case my actions ought to be restricted. Rollin proposes completely opposite approach: torture and killing is *prima facie* illegitimate unless in a specific case good and sufficient reasons can be shown why it is necessary. That, too, needs to be extended to all nature. Intrusive intervention in nature is *prima facie* illegitimate unless overwhelming reasons can be given why in this case an exception should be made. Environmentalists should not have to come before the zoning board to give reasons why yet another shopping center ought not to be built on the edge of a wetland. The developer ought to be giving reasons why in this particular case the development ought to be permitted—and *private profit is not a public reason.* The reasons better be very good reasons, and the assumption ought to be that the development is not permissible unless proven otherwise.

That, finally, is what the microcosm of human relations to animals shows about the macrocosm of human relations to the natural world at large. We are neither devils nor angels, we are all too human. We cannot simply act heedlessly, assuming that any damage we cause is legitimate as long as it is *for the good of Man* [*sic*] and leaving it to Nature's invisible hand to repair it. Neither can we escape the dilemma by staking out our corner of purity and insisting that *we* have no part in the evils of human presence on Earth. Our presence will leave a footprint. All we can hope for is to make that footprint minimal. We need ecological ethics precisely because we are neither devils nor angels but all too human.

Rollin's careful analysis of various categories of cruelty in animal experiments provides an example of how much can be achieved by careful thought. I must eat something, but it makes a great deal of difference what I choose to eat. Similarly, in an imperfect world there will be animal experiments, but it makes a great deal of difference what kind of experiments it will be. Some parameters are clear and absolute. We can never be justified in causing pain and death to a feeling being just to save costs, just as we are never justified to cause damage to the Earth just to make a profit or for amusement. For that matter, even in questions of life and death the answer is not automatic. Would a life bought at the cost of monstrous pain be worth living? How high a cost should we expect nature to pay for our presence?

With that, though, we are leaving the microcosmic question of the place of humans among other animals and launching ourselves on a far broader question of the place of humans in nature.

Part II

Part II: Of Nature, Value, and Ethics

 The purpose of the second part is to outline alternative ways of conceiving of nature and its value which in ill-informed discourse parade under labels like "anthropocentrism," "biocentrism," or "ecocentrism." I have an aversion to labels and so have sought to describe viewpoints rather than define terms. In **section i, The Moral Sense of Nature**, I have sought to outline the ways in which our perceiving of nature affects our conceiving of it. In **section ii, The Ethics of the Fear of the Lord,** I have described the early, theocentric conception of nature. **Section iii, The Ethics of Noble Humanity,** presents an ethical anthropocentric position, **section iv, The Ethics of the Reverence for Life,** describes a biocentric position while **section v, The Land Ethic**, describes an ecocentric position familiarly known as Land Ethic. Finally, **section vi, Lifeboat Ethics,** examines the neo-Darwinian evolutionary ethics.

i. THE MORAL SENSE OF NATURE

When we turn from the microcosm of human relations to other animals to the macrocosm of human relation to nature at large, the question becomes more complex. We all have a reasonable experiential conception of just what we mean by "animals." What, though, do we mean by "nature?" Trees, raccoons, porcupines we can consider something given, but nature *as a whole*, as an integral reality with its own meaning, its intrinsic value, is not something we see. It is something that we constitute in the context of our experience. Certainly, we do so on the basis of a certain experiential foundation. As Paul Ricoeur put it, *something must be for something to mean.*[1] But that something we always encounter already in the framework of a certain unifying—or *constitutive*—experience. Experienced nature is always something on which experience has already bestowed meaning.

That is true even of natural scientific conceptions of nature. Not even science is a simple description. It is, rather, already a particular interpretation, starting from a certain primary conception of nature, in this case as an aggregate of material particles devoid of purpose, value, or meaning, intelligible in spatiotemporal and causal categories. Well and good: for the purposes of manipulating material reality this is a highly effective and useful abstraction. We need to remember, though, that it is not a description of "nature as it really is," only one possible way of bestowing meaning upon the diversity of lived experiences from which we assemble our conception of the meaning of nature.

To us, people of the European conceptual heritage, the natural scientific conception might really appear "natural," possibly "objective," nature as it (allegedly) *really is*. It appears quite differently for instance to the original Australians of the tribe Wurundjeji, whose perception of nature is closer to the mythico-religious conception as Cassirer presents it.[2] The point is not that the original Australians *interpret* nature differently but rather that they *perceive* it differently or, more precisely, that in the encounter with the same they perceive something different, not raw materials but a whole laden with value and meaning.[3] An account of the way humans *explain* nature is not enough. We need to ask how they *live* and *perceive* it.

Anthropologists and historians of ideas usually distinguish three basic possibilities of human relating to the whole of life or "nature":

One basic possibility is constituted by the experience of hunter-gatherers[4] who neither farm nor rule nature, only receive her gifts from her hand. That informs the entire hunter-gatherer experience of nature. The hunter-gatherer does not manipulate life, just stands before it with awe and trembling, accepting what "nature" offers. That is an experience anthropologists can reconstruct from the instances of rapidly vanishing cultures of hunters-gatherers now dying out in the margins of Euroamerican economic might, in the remote primaeval forests of Africa and South America. Our ancestors lived like that, precariously surviving in fire-lit clearings amid deep, dark forests where danger lurked but whence game and fruits of the forest came. Human life here was insecure and unpredictable, nature all around seemed endless, eternal, all-powerful, caring for humans, punishing, rewarding, destroying. It infinitely transcended humans, humans know themselves totally dependent on it. The German theologian Schleiermacher points out that the feeling of ultimate dependence is the most basic root of fear of the Lord. In the lived experience of the hunter-gatherer, nature does seem to have had all the traits which humans traditionally ascribed to God. *Deus sive natura.*

That is one of the basic possibilities of how humans can live and for millennia did live the complex of all life around them and in them. Here nature appears as epiphany, the self-revealing of the divine, the holy.[5] God here is not something above nature, God is omnipresent in it and reveals godself in it. The primordial hunter-gatherers do not seem to differentiate. Human-animal-totemic animal-sacred animal-god, all that is a continuum which does not admit of clear delineation. *Deus sive natura, natura sive deus.* The order here is the all-powerful, unfathomable will of "nature." That is why the attitudes appropriate to the basic experience of early hunter-gatherers are those of humility and fear of the Lord, worshipping nature, All-Life, and placating it with sacrifices. As long as humans live in awe and fear, as long as they sense the sacredness and the terror of nature, they live, it seems, in a harmony and mythical empathy. Once they deviate from the order of all-powerful nature, they perish.

That is the experience of nature which survives somewhere in the depth of our souls. It is the feeling of our own insignificance and of the infinite, unfathomable might of nature. Once I caught a fleeting glimpse of it in a sailboat on the grey autumn ocean beneath a leaden sky. Oh God, thy ocean is so vast and my boat is so small! It is an experience which Scouts and Woodcrafters revive around their sacred campfires and depth ecologists in their empathic harmony with the Council of All Beings.

Still, that is but a fleeting echo of an ancient memory. In our lives, layers of later experience cover over this basic experience. Among those there is the second wholly fundamental mode of experiencing nature, the mode of shepherds and ploughmen. Humans tilling the soil no longer live the experience of total dependence. They are not passive recipients of good and evil, of food and hunger, from an unfathomable will of nature. They remain dependent—they can be ruined by drought and flood, locusts and crop failure. Nature still has a head of its own. It is not, however, wholly unfathomable. It has become a partner with which the tillers of the land work. They learn to respect it, to give to it what it needs, but nature repays them in turn. Cows repay respect in milk, the soil repays manure with crops. Nature is no longer God but the visible—and intelligible—work of God's hand. Here dependence shades over into a partnership.

This is the experience we encounter in the biblical images of the vinedresser and the shepherd. God deals with Israel and in the New Testament with humans at large as a vintner with the vineyard, as the shepherd with the flock. God cares for them and expects good return from them, but also protects them, calls them by name, speaks with them, cares for them as a good shepherd. God deals with God's people with respect, not arbitrarily. Humans here are a part of an order, of an orderliness of nature.

That, too, is an experience which survives in us in fleeting glimpses when we care for a wounded tree or lovingly return to the soil something of its gifts in the form of compost. The order of nature here is sustainable interchange, the strategy is most of all a strategy of sustainability. Ecological activists return to it in striving for the renewal of the countryside and in understanding humans as creation's shepherds.[6]

The experience of the craftsman and the trader is something that most authors overlook. They tend to register only two possibilities, either the allegedly idyllic harmony with nature in the experience of hunter-gatherers and tillers-herders, or the hard and alienated consumer society we know in the present. That overlooks the entire long period of urbanization which in Europe dates from the thirteenth century. The experience of the urban craftsman is not the experience of a herder or a farmer. The rise of the cities and of trade specialization reduces the direct, daily contact with nature and with it also the direct awareness of dependence and partnership. The city dweller, to be sure, remains strongly dependent, for instance on the supply of clear water and the

removal of waste, but division of labor prevents an awareness of direct dependence. The craftsman and the tradesman no longer work with nature as tillers and herders. A carver, a stonemason, a baker respectfully refashion nature.

Here nature is no longer a partner though it remains a gift. Wood, leather, even a bent nail still is valuable material worthy of respectful treatment. Not to waste tailings, to cut with the grain, to treasure every slice of bread, all that is deeply ingrained. European settlers in New England summed up the rule of life, *Use it up, wear it out, make it do, do without*. That is the traditional New England morality: frugality as a basic life style and to this day the most basic rule of ecological ethics. To have no more than I need, not to have what I cannot care for, that is a deeply anti-consumer attitude to life which is rich in appreciating even little and not needing to waste. In New England still twenty years ago advertising had laboriously to overcome inbred resistance to consumerism and the deep wisdom of the recognition that humans are truly rich if they can appreciate even little, poor when they have so much that they cannot appreciate it. Among ecological activists, that is the wisdom of the partisans of selective demands and joy of life which from without appears as voluntary simplicity.[7]

Those, then, are the three basic possibilities of experiencing nature—as a sacred presence to be worshipped and placated, as a partner to be respected or as a precious gift to be gratefully treasured. Ecological activists today frequently lean on the echoes of one or the other experience in us. All share one trait: nature, the complex of all life, is something intrinsically valuable, wholly independently of human needs. It is sacred, worthy of respect, precious. The ethical requirement of respect for the other and good will in our dealings with the other thus extends to human dealing with nonhuman life or "nature."

This is where the experience of producers-consumers differs from all previous modes of experiencing nature. That is the consumer culture which infected America in the fifties, western Europe in the sixties, and Czechoslovakia in the seventies. Americans today speak of it as *the affluenza epidemic*, the epidemic of deadly superfluity, though it is not simply a matter of overconsumption. Far more, it is the fervently held faith that the sole meaning of life and moral duty of the citizen is to accumulate and consume ever more material goods. It is not the first time. Other societies have manifested the same symptoms on the eve of their collapse, as the Roman in the third and fourth century of our era. For the first time, however, the explosion of greed among the privileged at the cost of pauperization of the many has become a global phenomenon and a global policy which advertising seeks to make into global ideal.

The shift to consumerism—the mode of life in which the driving motor of the society ceases to be need, replaced by greed—production for profit, not for

satisfaction of need—respresents a fundamental shift in human perception of the whole of life.[8] For the first time, it is a one-sided perception which does not recognize the integrity and intrinsic value of nonhuman being. The consumerist experience is solipsistic. I, I alone, matter. The other ceases to be Thou, as Buber uses that term, and becomes simply *it*. The world is constituted as a reservoir of raw materials, humans as distracted, one-dimensional consumers. In the background there is the triple assumption: the meaning of life is to have ever more and the task of society is to make this possible, because a rise in consumption will solve all our unresolved problems. All else has to wait. First we need to produce more and consume more.

We have all seen examples—ruthless clearcutting, surface mining, polluted rivers, nuclear power plants, poisoned atmosphere. E.O. Wilson speaks of the sixth global catastrophe, von Weizsäcker of the self-destruction of a civilization oriented solely to short-term gain. Lynn White Jr.,[9] writing in 1968, saw a different driving mechanism—a society which can no longer understand the idea of *enough* and so with iron necessity must seek ever *more* until, like Plato's Atlantis, it destroys itself. White cites the example of the more efficient plough which, however, required a team of eight oxen. To maintain so large a team the owner could not be content to produce within the limits of need. Such an owner had to overproduce to pay for the team. Similarly contemporary society, bound by large investments, cannot afford contentment. It must generate discontent and artificial need. Succeeding decades bore him out. How much of all for which we strive so breathlessly did we "need" thirty years ago? We are stuck on the escalator of ever greater demands. That is the origin of the ecological crisis: an infinite demand finds itself in an inevitable conflict with a very finite world. In a world of raw materials, a world devoid of its own life, value, and order, there is nothing natural and so also nothing just sufficient. There is no more *enough*, there is only *more*.

This is where we run into the objection of the apologists of the producer/consumer mentality: is not the desire for "more" itself *natural?*[10] No, it is not, but it does correspond to the conditions of the consumer society which fashionable thinkers fondly label "post-modern"—a distracted, unstable society which continuously longs for something new only to abandon it and drive on. That is real enough, a world of the damned, though it is hardly an acceptable norm. In the vast majority of human and animal societies which live in the framework of a definite order the rule tends to be *enough* rather than *more*. Humans and other animals tend to rest and play when they have satisfied their need. To want ever *more*, mindlessly, needlessly *more*, is what is unnatural. Were it "natural," producers of consumer goods would hardly need to spend billions annually on advertising whose sole purpose is to generate discontent,

to convince people that their life's fulfillment depends on ever *more*. That may be actual, though what is natural is *enough*.

It is animals torn out of their natural habitat, like rabbits in Australia or the great snail in Polynesia, who form an exception from this rule. Neil Evernden designates them as *exotics*.[11] Those seem to lose the sense of *enough* as they strive for ever *more*, overeating and overreproducing. The traditional explanation is that in such cases the exotic kind finds itself in a context devoid of natural enemies and competitors for food. Overeating and overreproducing is supposedly the mechanical effect of this change. There are reasons to suspect, though, that the change occurs in a reverse order. Some authors seem to believe that a wolf pack in a natural context controls its reproduction in conformity with the possibilities of its habitat and, in case of a drop in food supply, lowers its reproduction in anticipation, not in sequence. When it is moved to an unaccustomed habitat, it loses this ability.

According to Evernden, humans are naturally exotics. In more familiar terms, humans are beings which have no natural habitat. They can live anywhere, from pole to pole, but do not belong in any particular place. What alienates them might be technology, creating a layer of artificiality between humans and nature. Or it might be critical reason which alienates humans from their fundamental emotions. Or it might be simply speech which interposes a layer of symbols between humans and their world. We shall trace this discussion below. This way or that, Evernden is convinced that humans *by their very nature* stand out of nature—Heidegger would say that they *ek-sist*—and so are naturally aliens, behaving accordingly.

How seriously we should take such hypothetical sociobiological explanation of human behavior is another question with which we need to deal. I cannot judge Evernden's reliability in biology though his interpretations in philosophy, in his first and last chapter, are somewhat idiosyncratic. It is surely probable that genetic elements have a tendency to incline humans in some directions. Inclination, though, is not yet necessity. The whole human world, for good as well as for ill, is based on the human ability to overcome inclination and follow a conscious decision, as saying "excuse me" where the natural response would be to strike.

At this point, though, we are not concerned with biology or sociobiology but with ecological ethics. Evernden, like Esop long before him, provides us with a striking metaphor: humans, torn by reflection out of the seamless continuity of nature, irretrievably lose the ability to act "naturally." They need to act consciously, generating images of good and evil in an act of understanding—and so also the idea of an ecological ethics: what *is* suitable human behavior on this Earth?

ii. ETHICS OF THE FEAR OF THE LORD

Is the consumerist idea that all value derives from humans and that all nature serves them something primordial, natural? Today a great many people claim to think so. They go ruthlessly after their own short-term gain, not even caring,

figuratively speaking, how many animals—if not pedestrians—they kill on their way or how much exhaust fume they release into the atmosphere, as long as nothing stands in the way of their drive to instant and effortless gratification. They try to justify it by saying that it is "natural"—that ever since the world began humans have measured good and evil solely by their individual material profit.

In reality, nothing could be farther from the truth. The kind of short-sighted egoism which we today somewhat inaccurately call "anthropocentrism" is something we normally encounter first in highly advanced civilizations, typically as a sign of decadence and approaching end, as in the final decades of Rome or in France on the eve of the Great Revolution. Early humans, hunters, herdsmen, tillers of the soil show little illusion of personal importance. Quite the contrary, they seem to be painfully aware of their own vulnerability and unimportance. Everything appears to them as a gift—in the case of gatherers quite literally, when chestnuts drop from trees. Their great reality is not humans but the infinite nature surrounding them on all sides, infinitely powerful, unfathomable, evoking a holy fear which in a later religious conception will figure as the fear of the Lord. If we were to describe the natural human attitude in contemporary terminology, we would have to call it *theocentrism*, since its basic conviction is that all value devolves from the Holy and humans are no more than one dependent part of God's creation. Such, in all probability, was the earliest "ecological" experience of humanity.

Here, though, caution is in order. "Theocentrism" is not a reality, it is not a philosophical system or a set of beliefs which humans would accept to "join the movement." It is only a label which we use today, in retrospect, to indicate a certain posture for which God—*theos*—stands at the center of all value and all meaning. Even here, though, caution is in order. Our ideas about religion are usually far removed from primordial religious experience. In the Czech Republic, where over 80 percent of the adult population are at best indifferent or more often openly hostile to religion, ideas of what religion is all about tend to echo years of indoctrination in "scientific atheism." For most people, personal experience of religion begins with contact with one of the churches, often at second hand, and remains limited to a handful of claims about "supernatural" beings. It would seem that "faith" consists of a willingness to add to the list of visible animal species a few invisible ones like leprechauns, gnomes, spirits, angels, and gods.

The experience of faith which once perhaps lay at the roots of all this here receives a verbal expression and an institutional codification. With them all too often comes a painful distortion of the original experience. Even believers more than once imagine God as a "supernatural being," usually male, which imposes arbitrary demands on humans and then rewards or punishes them

accordingly. Only slightly less naively, humans describe God as a "force for good"—as if it were up to people to decide what is good and evil and there were a certain force in the cosmos, like a djinn in a jar, which serves them in securing it.

Such a decadent conception of "god" usually emerges in an age which has lost the primordial experience of faith. In the primordial stance which we have labeled "theocentric" something else stands at the center of value and meaning. It might not even be a god-figure in a personal sense. Many Eastern believers reject such a conception of God. At the center of the theocentric experience is the transcendent dimension of the sacred which some humans encounter in the experience of faith—and for which they often do not even have a name.

The experience of faith, that primordial encounter with the sacred and the community that grows from it, is about something else than formal ecclesiastical doctrine. When we describe the primoridal or "natural" human experience of nature as "theocentric" it is not in the deeply decadent sense we often attribute to "religion." The basis of this experience is not a compilation of doctrine but the immediate experience of the presence of sacredness. Rudolf Otto coined for it the term *mysterium tremendum et fascinans*. It is the experience of absolute dependence and infinite power. As the myths of the original Americans show, primordially humans do not differentiate between God and nature. They register only one Sacred which at the same time is and is not God, nature which is and is not sacred—and themselves as a part of this whole which has its own rules and demands respect. Humans are not the center of all meaning and the source of all value. The Sacred—be it God or nature—is that. The task of humans is to live in harmony with the order and rhythm of nature. This sense of the sacred is the inmost reality behind "theocentrism."

This unambiguous subordination of human life to the rhythm of nature, characteristic of the primordial human posture, is also the reason why some contemporary authors are convinced that the condition of long-term, sustainable cohabitation of humankind with nature is a return to this fundamentally theocentric posture in its primordial sense. The Polish-American Catholic thinker Henryk Skolimowski[12] is an example. There is nothing decadently "religious" in his position, not as people brought up by "scientific atheism" imagine it. Its foundation is precisely a strong awareness of the transcendence of the sacred. Skolimowski considers contemporary fashionable attitudes, egoism, narcissism, snobbery, simply everything that leads the consumer society to destruction and self-destruction, a product of the ethical vacuum which ethical relativism generates around us. That is why he returns to the recognition of the sacredness of life which enables him to deny moral relativism by recognizing the absolute claim of the sacred. In ecological values of which the ecological crisis is making us aware we can recognize, according to Skolimowski, traditional religious values.

Respect for nature appears to Skolimowski as the ecological counterpart of the religious virtue of humility, in the ecological attitude of responsibility in relation to nature he recognizes the religious posture of worship, ecological justice—justice for all the creation—leads us to the ageless conception of divine justice. For that reason a consistent ecological stance appears to Skolimowski as fundamentally "theocentric" in the sense that in the last instance it derives value and meaning from the fundamental reality of sacred nature. And vice versa, Skolimowski is convinced that only a fundamental change of attitude which places a respect for God and for God's creation at the centre of human interest will enable us to overcome the problems stemming from human greed and self-centeredness. The point is to move humans out of the center of all attention and to put in their place God and God's sacred world in which humans are only one of many beings, even if charged with the special responsibility of the shepherd of creation.

As long as we start out as Skolimowski, from a deep experience of the sacred presence, then his argument is truly convincing. For humans whose fundamental reality is God, *mysterium tremendum et fascinans*, for humans who not only consider but truly experience themselves as unworthy servants of God, for whom the meaning of life is gratefully to care for the beloved creation that God entrusted them, the purest ecological attitude of humility, simplicity and service are an obvious expression of all of life. That is what it is all about.

Undoubtedly there are people like that living among us. I rather think Albert Schweitzer was that kind of a believer. The "depth ecologists" who strive for a full empathic identification with the community of all beings aim in this direction. The same is true of people who seek the way to a considerate stance towards nature in non-European religions. For that matter, Francis of Assisi, proclaimed patron of ecology by the Roman Catholic Church, has his followers in all the present-day Christian churches. I doubt not that Henryk Skolimowski is one of them. He is an author who richly rewards reading.

Still it would be difficult to claim that what he describes corresponds to the experience and conviction of a majority or even a large part of all who consider themselves believers. The reality is different. Even among believers faith is seldom a matter of a lived experience of God's presence which then informs a person's entire life's posture or church a communion born of that experience. More often faith is a matter of consent to certain credal statements, usually not deviating too radically from the familiar claims of philosophy and physics, to which the "believer" assents. A "believer," in common imagination, is someone who *thinks that* . . . , who assents to certain claims. Believers then are those who *think* or believe something, not those who live something, whose lives set them apart. From the standpoint of faith, that may be a decadent conception but it does describe the way most Euroamericans encounter religion in our time. For that reason, it is not enough to deal with faith in the sense of a fundamental personal experience. To understand the relation between ecology

and religion we need to consider faith also in its everyday form of a set of beliefs.

This is a theme which the English historian Lynn White Jr.[13] took up in the beginnings of European ecological awakening. White is a historian, not a theologian, and so understands faith as an outsider. That, however, is how most of our contemporaries understand it. White notes primarily that Hebrew-Christian myths of creation teach a masterful, domineering stance toward the world. In those myths God is the absolute lord of all, creating *ex nihilo*—not in a dialogue with nature, as most pagan gods, but by the strength of His own will. In these myths, man—and it *is* "man," not humans generically—presents himself as having been created "in God's image," that is, in the image of an absolute ruler of all creation. Christian myths attribute to God words in which He—for God, too, is male—charges Man with multiplying and subduing the Earth. All creation is said to be subject to him and is here only to serve him. Though there is talk of God at every turn, it is a position we could hardly call theocentric. It seems more like a primitive anthropocentrism which places Man in the center of attention and only helps itself out with a *deus ex machina*.

According to Lynn White, that is how the Christians in fact proceeded. They invoked God only to bless their doings, not to give them direction. Only in the Christian cultural region did the idea that *knowledge is power* arise, or that the point of science is to subdue nature. While in other cultural regions people are said to have asked the question of the place of humans in God's creation, Europeans posed the question about the utility of the creation for humans and about the place of God in the world of humans. In truth, only the European cultural region gave the world the idea that civilization is a matter of a "war with nature" and that draining wetlands or paving meadows represents an "improvement" of a land which without it would be "wilderness lying fallow."

The question is not whether Lynn White "is right." A number of Christian and Jewish theologians pointed out that White's explanations of biblical teachings operate on a painfully shallow level of popular superstition and that his biblical quotations are quite unrepresentative. In many places the Bible really stresses God's love for nature and the pastoral responsibility of humans for it. Other historians have pointed out that blanket destruction of nature in Europe did not begin with the coming of Christianity but with the coming of the industrial revolution in the seventeenth century. At that time, it took place equally in all industrializing countries, Christian or not. White's most radical thesis—that Christianity is the cause of the ecological crisis—simply will not stand.[14] Only that really is not the point. The point is that, be that Christianity's true meaning

or not, the idea of mastery over nature really is one of the motifs which humans can derive from the Christian contribution to our cultural heritage.

There are, however, other themes in Christianity, less familiar but much more fundamental. One of those has to do with the overall place of humans in the cosmos, though from a somewhat different perspective. The point at issue is whether humans are disruptive intruders in the order of nature *necessarily*, simply by their presence, or whether they only become that, not necessarily, but *contingently*, in virtue of certain choices they make. Were humans destructive intruders necessarily, simply by their being, then the only solution of the ecological crisis would be for humanity to self-destruct and let nature live its own natural life. That is how it tends to appear to thinkers who consider the situation in the perspective of aeons, as James Lovelock or E.O.Wilson. If, however, humans only *become* destructive intruders under certain conditions, then there is a point in striving for an ecologically considerate mode of life. Yes, we destroy, but do we do so necessarily or contingently?[15]

The answer appears less a question of fact than a question of decision: How shall we conceive of ourselves? In ancient Greek and many non-European myths, we encounter a deeply rooted conviction that humans are intruders necessarily. Jan Patočka presents it most convincingly: in Greek myths the entry of self-conscious humans into the world represents a deep wound which humans cannot undo because they inflict it by their very presence.[16] Jean-Paul Sartre expresses it in the outcry of his protagonist in *Dirty Hands*: "In the way!" Humans have no place in nature. They are simply *in the way*. Thus they have only two possibilities: either to conquer and rule over nature—or to submit to it and leave the scene. To live in harmony with nature, as one of the members of the biotic community, is supposedly simply impossible. Humans are in the way in virtue of their very humanity.[17]

To that view we can oppose the no less ancient Hebrew-Christian myths in which things appear quite differently. Here humans do not disrupt nature already and simply in virtue of having been created. God is said to create humans harmonically, for life in harmony with nature. Humans disrupt this harmony only subsequently, *by certain specific actions*—and both they and nature suffer from the consequences of this disruption. In one myth the disruption is brought about by human transgression of the prohibition of eating the fruit of the tree of knowledge of good and evil—that is, with the idea that humans need not be guided by the moral law of the creation but can themselves decide what to consider good and what bad. In another myth the occasion is the breaking of the boundary between the sacred and the profane by sexual contact between the sons of the gods and the daughters of humans. The

particular symbolism of this or that myth does not matter. What does matter is that in these myths *humans are not intruders in virtue of their nature but in virtue of certain acts.* Thus it is within the limits of their possibilities to act differently, living in harmony with nature.

That is a difference utterly fundamental not only for ancient myths and their subsequent interpretations but quite directly for contemporary ecological thought. Is there a point in striving for frugality and sustainability, in seeking to form a mode of being human in harmony with nature? Were humans intruders by their nature, that would be a vain effort. In subsequent chapters we shall encounter people who take this view. According to them all ecological effort is vain because the problem is a systemic one: culture is in principle incompatible with nature. There are even those among them who argue that there is no point trying, only in enjoying ourselves as long as we can, knowing that in the end nature will sweep us from the stage. The more evident it becomes that the astronomic profits of the multinationals in the past thirty years are possible only at the cost of catastrophic destruction of nature and traditional culture alike, the more do those who profit from them welcome such explanations. Do not constrain us: it is to no avail. After us will come the flood which will set things catastrophically right.

By contrast, if we are convinced that humans are by their nature capable of harmonic coexistence with nature and that they disrupt this harmony only by irresponsible plunder, then it makes sense to seek to restrain the predators and forge responsible, sustainable modes of being human. Certainly, it is not enough to recycle our plastic bags and use nature-friendly paints. Our irresponsibility *is* systemic. Our overconsuming way of life is deeply irresponsible, no matter how personally frugal I seek to be within it. We need, as Albert Gore argues, to restructure our whole society to seek higher quality of life, not greater quantity of consumption, and to strive toward a basic equality in consumption. Our overconsuming and our overpopulating way of life is equally irresponsible. Nature lowers consumption and populations cruelly, by famine and high death rates. It is up to us to stabilize them humanely, by redistribution and lower birth rates. We disrupt because we have successfully avoided nature's cruel constraints but have not been responsible enough to impose our own, humane ones.

Annie Dillard offers a striking metaphor.[18] Imagine that you need three railway engines. You manufacture thirty thousand of them and send them onto the rails with drunken engineers while the switchmen are on strike. The engines hurl along, derail, collide, the crews die painfully, scalded by the steam, until in the end you will have only the three engines you needed. You cannot even console yourself that the Invisible Hand selected the three best engines. Survival is mostly a matter of chance. That is how nature maintains stable populations. We humans have the capability of producing just the

needed three. Partly out of habit, partly out of greed we continue to produce thirty thousand. It is that irresponsibility that makes us destructive intruders.

The same is true of consumption. With our technology we have created the possibility of practically infinite consumption—and driven by old habits of scarcity, we blindly seek to realize it. The Earth, however, is not infinite. Especially in view of our rising numbers it is crucially important that we ourselves set limits of consumption, that we say so much and no more. The strategy we have followed in recent decades—ignoring the problems of human compatibility with nature while hoping that ever increasing consumption will solve them for us—is wholly irresponsible and does bring us into conflict with nature necessarily.

Yet from the perspective of the Hebraic myth humans are not overpopulating overconsumers *necessarily*. They can strive for enough, not ever more, for sustainability, not expansion, by reorienting their lives from irresponsible greed to respect and care for God's creation.[19] If that is so, then ecological activism is to the point, even though in the unequal battle with multinational corporations its cause may appear hopeless. It is not pointless *necessarily*, in principle.

With the emphasis on *human responsibility* to God and nature we are, however, diverging from the attitude for which the experience of the sacred, humility before the sacredness of nature and pastoral care for it are the center of all concern. That was the attitude we designated as *theocentric*. Religious myths and doctrine alike, however, present something slightly different. On the one hand, there is the image of God making humans the lords and conquerors of nature, on the other hand the idea that God called humans to the task of shepherds and offers them the possibility of harmonious coexistence with nature. Those two very different images share a common trait. At the center of attention they place not God but humans, whether as conquerors or as good shepherds. Humans here are called to act *humanly*, consciously and responsibly, not "naturally," to be the shepherds, not one of the sheep. Reverting to our shorthand designations, we could say that both readings are drifting from an emphasis on God to an emphasis on humans, from *theocentrism* to *anthropocentrism*.

iii. THE ETHICS OF NOBLE HUMANITY

Anthropocentrism again is not some sect which humans would join or a creed to whose tenets they would subscribe. If we say of someone that "s/he is an anthropocentrist and *therefore* s/he thinks . . ."—or, more awkwardly still,

"according to anthropocentrism," as if it were a creed—we are showing a basic misunderstanding of both the term and the matter itself. We can only say that "this s/he believes and therefore I label her/him anthropocentrist." Our label is secondary, naming a certain lived reality. That reality and not the label is primary. Besides, in this particular case the label is hopelessly ambiguous and can designate both a greedily exploitative and a thoughtfully caring atitude toward Nature.

For starters, it is well to note the origins of the idea that meaning and value of all that is derives from humans. It has generally a double root. One is experiential. Anthropocentric attitudes tend to emerge where humans experience themselves as the sovereign masters of *their* world. That is the experience of assorted conquerors who proclaimed themselves gods, but also the experience of Europeans since the industrial revolution. Most of us do not live in a world of living nature which has its own life and order. We live in a world of artifacts, in concrete cubicles furnished with the products of human artifice which have neither meaning nor value other than service to humans. A tree grows of itself, a squirrel lives its own life, but a table, a lamp, a typewriter, a toaster, all that would be just clutter if human interest did not endow it with meaning and value. Certainly, in an absolute sense that is wholly illusory, but simply experientially we should not be surprised that humans surrounded by artifacts produced solely to serve them gain the impression that they are the source of meaning and value. In their miniworld of artifacts, that is the way it is.

In addition to the experiential root there is also a conceptual one. The idea that humans are the source of all value emerges wherever humans lose a living awareness of God's presence and of the subjectivity of nonhuman beings. Where things come to appear lifeless, animals as biomechanisms, God as an illusion, and humans alone as subjects, there we shall naturally encounter the conception that humans are the sole source of all meaning and value. Europe started to meet both those conditions in the seventeenth century. The budding industrial revolution was creating an artificial human world. At the same time the horror of wars fought in the name of faith effectively undercut whatever faith survived the greed of the Renaissance church. The conditions became ripe for anthropocentrism.

Out of the global conceptual shift two thinkers stand out, René Descartes and Immanuel Kant, providing a conceptual form for an anthropocentric conception. Both did it basically by extracting reason from nature. For Descartes's great contemporary, Jan Amos Komenský-Comenius, reason meant the meaningful order of God's creation and at the same time the ability, given by God to humans, of grasping and understanding this meaningful ordering. Meaning— and that means in the first place value relations of good and evil—appear to

him as an inseparable part of the order of both the creation and human comprehension. Between reason and emotion, between humans and nature, there is neither conflict nor an abyss. All of it is the web of God's creation.

Descartes by contrast narrows the concept reason to a purely mathematical ordering of ideal entities—and in nature to the mechanical ordering of particles in spacetime. With that both reason and nature become accessible to a new mathematico-mechanical natural science as Galileo and Newton are forging it, giving substance to Bacon's conception of knowledge as power. Value and meaning no longer stand in the way of human mastery of the world. In Cartesian categories temporal-spatial reality or *res extensa* appears purely material, purely causally ordered. Not only the familiar cat whom Descartes is said to have kicked without hesitation, but all of nature is said to be a machine. By contrast the ideal world or reality, *res cogitans*, is characterized by purely mathematical rationality and logical necessity. In neither the one nor the other reality is there room for meaning and value. Those become purely "subjective" in a flawed sense of the word—contingent on the preference of specific individuals. Fundamental relations of respect and love, of valuing, lose whatever transindividual validity they may once have possessed. In Cartesian categories reason is only whatever can be captured mathematically or causally. Hence the idea that it is "reasonable" to clearcut a forest for maximum profit while to love and protect the forest is sentimentality and at best a wholly irrational personal fancy.

It would, to be sure, be wholly inappropriate were we to attribute to Descartes all the consequences which his followers have derived from his basic conceptions over the past three centuries. Descartes was not a Cartesian in the modern sense of the word.[20] Our concern here, though, is not with *mens auctoris*, what Descartes "really" meant, but rather what succeeding generations derived from him. That is first of all the idea that reality is wholly material and causally determined. That means that nature is of itself wholly devoid of value or meaning, that it is only an aggregate of entities (or of biomechanisms) which gain meaning or value only from a human interest. Secondly, it is the idea that reason is purely mathematical calculating ability which does not deal with meaning or value but solely with mathematical relations. That is what provides the conceptual presuppositions for a crudely exploitive approach to the world: the world is but raw material, human distinctness is the ability to calculate it and master it through that calculation.

The other thinker who significantly influenced the shift of European thought from the recognition of the intrinsic value of the world to the idea that

value is derived from reason only was Immanuel Kant. His philosophical stance is far broader and, as we shall yet note, can also represent a fundamental contribution to ecological ethics. His principle of respect for all rational beings can be broadened into a principle of respect for all beings. Still, Kant's immediate impact was distinctly anthropocentric.

For Kant's nineteenth-century English counterparts—the three utilitarian thinkers, Jeremy Bentham, James Mill, and John Stuart Mill—value is derived from the ability to feel pleasure and pain. Were the world made up wholly of chemical elements gradually constituting ever more complex compounds and wholes, the world would truly be devoid of value and meaning, solely causally ordered. However, once in the course of evolution there emerge organisms capable of feeling pain, organisms capable of pleasure and of the wish to preserve their life, a new principle of meaning and value enters into the world. Bentham himself lived before Darwin and did not use the evolutionary metaphor, but it was clear to him that we encounter meaning and value wherever there are sentient beings and so commended respect to them all.

By contrast Kant arrived at the conclusion that the only thing worthy of respect is reason in which he saw the foundation of freedom. That does not of itself lead to human egoism, which is why Kant's thought can serve ecological ethics as well. Kant, however, lacked any Comenian conception of life's world. He understood reason and the world basically in Newtonian-Cartesian terms. Nature appeared to him as a Cartesian *res extensa*, a kingdom of causal, factical necessity. To that he opposed the world of pure reason, ordered by the necessary rules of rational relations. Humans live in part in the bondage of natural necessity. Their bodies belong to the kingdom of natural necessity and through them they are subject to natural inclinations and instincts. Humans reach truly human greatness only because by their reason they are capable of understanding not only the natural, but also the moral law. Figuratively speaking, humans are beings capable of *not* repaying a blow with a blow, even though it is wholly natural, because their reason enables them to grasp the moral law which commands them not to hit back. For Kant, humans are worthy of respect only for this ability—and beings which lack this ability have no claim to any respect. Humans ought not to harm animals because it is in poor taste and unworthy of a rational being, but not because animals would have any claim to any respect whatever.[21]

Whether Descartes and Kant meant it this way or not—and there is a range of reasons for believing that they themselves would have understood their teaching differently—the Euroamerican world entered into the nineteenth century with the idea that the extrahuman world is raw material, a web of natural necessity devoid of meaning and value, and that the greatness of humans lies in their ability to break free of this meaningless necessity and to subject meaningless nature to the rule of reason. Later we shall designate this as the posture of mastery, the idea that humans are genuinely (or "authentically")

human only when they rule. Only the morality of masters, the *Herrenmoral*, then appears as "authentically" human, placing the values of strength, pride, and greatness above the "inauthentic," merely everyday slave morality of compassion, respect, kindess.

That is a theme familiar from Nietzsche and his heirs which Jan Patočka develops interestingly in his presentation of Czech and world history.[22] The principle of greatness is the will to empire, the masterful person is one who scorns death, authentic humanity can be reached only by the community of the shaken freed by the trauma of struggle—*polemos*, which Patočka translates as *war*—of all bonds to what is petty bourgeois and slavish about humanity.

Those are not surprising conclusions from the idea that humans achieve their authentic humanity by a revolt against their nature. In interpersonal relations such conclusions could serve as the ideology of a revolt against the moldy habits and cares that know neither freedom nor responsibility, only tradition. In relation to nature, however, they became an ideology of conquest. They provided the justification for the central idea of the century of industrial revolution—that the meaning of being human is to conquer the world, to populate it, to utilize it, the idea that a world that is not serving humans is lying fallow and that humans like the original Americans, who do not put it to optimal use, lose all claim to it. In the period of settlement of North America it seemed evident to the new settlers that this continent is lying fallow and that God godself calls them to improve it by human use. Though these were people with frequently strong religious motivation, it seemed evident to them that they had an unlimited right to exterminate all that stands in the way of improving neglected nature with barbed wire and steel plough, later also with concrete and blacktop. Wolves, just like Indians, seemed to them no more than vermin standing in the way of their high calling to become the *masters of the Earth.*

Today this conception of mastery as the meaning of our humanity is giving birth to the idea that anthropocentrism equals exploitation and that the sole hope of saving the Earth hinges on overcoming it. Indeed, were the stance of mastery toward nature and other humans alike the sole possible anthropocentric stance, then the clear call of all ecological ethics would have to be to replace humans at the center of meaning and value with something higher, be it God, life, or perhaps Nature as a whole. A whole range of early ecological thinkers, such as John Muir at the start of the twentieth century, did react that way. The shortsighted approach of the multinational economic empire which still today, five minutes after midnight, would prevent principles of sustainability, seems to prove Muir's point.

Yet the matter is more complex. Already in the first half of the twentieth century there were indications that the stance of mastery destroys the master

no less than the serf. So in the American West settlers systematically extermi-
nated the buffalo, in part as an obstacle to settlement, in part in order to deprive
Native Americans of their chief source of nourishment and so of their ability to
resist the encroachment on their lands. Still the 1948 film *Red River* presents
that as something positive, the masterful stance. But where the buffalo no
longer broke up the turf with their hooves and fertilized it with their urine,
there grassy prairie rapidly became semiarid, no longer capable of supporting
the settlers' herds. Today on much of it an acre will barely support one sheep.
The settlers, now farmers, resort to artificial fertilization and extensive irriga-
tion. Overutilization of aquifers, however, leads in turn to desertification of
extensive areas. Humans who could have lived with the prairie in mutual
respect conquered and destroyed it with their mastery—together with them-
selves. Ironically, the best hope today may be that the young people will refuse
to eke out a living on exhausted soil and will move into the cities. Perhaps
then, with the depopulation of entire areas, the buffalo herds will return and
with them gradually the grassy prairie—assuming, of course, that humans can
prevent a drastic climatic change by limiting their greenhouse emissions,
which is currently rather less than likely.

What is interesting here, philosophically speaking, is that even strictly
within the limits of an anthropocentric conception of meaning and value a
number of thinkers have become aware that shortsighted egoism simply is not
in the interest of either humans or humankind. They do not think that humans
ought to protect nature for nature's stake. That appears to them for the most
part as anthropomorphic sentimentality. However, they do see a number of
excellent reasons why humans ought to protect nature, concretely, to limit their
demands on nature to the level of natural renewal and so of sustainability, for
the long-range good of the human species. They remain convinced that
humans alone are a source of value and meaning. However, they contrast the
short-term robber interest of given individuals and the long-term interest of
humankind as a whole. Or, speaking figuratively once more, it is in the long-
range interest of humankind as a whole to limit settlers' herds to the levels
which the prairie can sustain in long-range symbiosis with buffalo, Native
Americans—and prairie dogs, who have a prior claim on the range in any case.

Among the noble pioneers of this mode of thought I would count the En-
glish biologist Sir Charles Sherrington in the first half of the twentieth century.
In his classic study, *Man on his Nature*,[23] he poses the question how value
enters into the world. His basic conception of the world corresponds to the
natural scientific conception from the early twentieth century. He under-
stands nature as a complex of material particles in causally determined mo-
tion, devoid of anything we could consider meaning or value. According to

Sherrington, the emergence of value requires more than the emergence of teleologically oriented life. That had been the traditional argument of eighteenth-century theologians, usually ascribed to the Reverend William Paley, who pointed to the complexity of nature's purposiveness and derived from it a purposefully thinking creator. Sherrington analyzes examples of teleology. As an example he cites a wasp who stings a caterpillar on seven nerve clusters before it lays its eggs in its body, so that it would paralyze but not kill the host. The wasp needs to have the caterpillar live long and suffer while bearing the wasp's eggs. The immensely complex life cycle of the malaria plasmodium provides another example. That plasmodium requires an entire chain of hosts and causes immense suffering to a whole series of higher organisms. Sherrington concludes that the creator of such phenomena would have to take a simply sadistic pleasure in suffering.

Annie Dillard presents similar considerations in *The Pilgrim at Tinker Creek*.[24] The basis of her considerations is a sensitive, detailed observation of nature surrounding her remote cabin in Pennsylvania. Dillard describes the full horror of the immense suffering life exacts from the living. A cat plays with a mouse: it does not kill, only cripples and goes on playing. Coyotes devour the innards of a living sheep. Millions of organisms are born and perish to assure the survival of a handful. Life is a constant escape from death. Those who survive bear the scars at the end of the summer—butterflies with torn wings, spiders missing a leg. And Mother Nature? Nature observes it all with benign indifference. Nature does not care about suffering, only about survival. Only humans observing nature suffer from empathy.

Dillard like Sherrington arrives at the conclusion that nature is neither good nor evil, only wholly devoid of feeling. That is true even of higher animals who appear to live a social life, are capable of mutual aid and of self-sacrifice, of joy and of grief over the loss of kin. According to Dillard, they simply automatically act out what nature commands. The law of the tribe, those are archaic genetic instructions which even higher vertebrates follow necessarily and automatically. Devoid of freedom, they know neither hope nor pity, neither empathy nor *ressentiment.* They are, she believes, simply programmed automatons.

Only with humans, the rational beings capable of freedom, does a new dimension enter into nature, the ability to experience empathy. Dillard is not interested in philosophy and so seems not even aware that what she is presenting is sheer Cartesianism, Descartes's conception of nonhuman beings as automatons. Nor does she seem aware that she is following Kant when she claims that only with humans does the ability to grasp ideal motivations enter into nature. According to Sherrington and Dillard alike, only with humans does altruism—freedom and the ability to act for the good of nature—enter into the world. Other, more natural subjects, never act for the good of nature. If they do act purposefully, they act only for their own good or for the good of

their kind. Only humans are said to be capable of acting on the basis of ideal motives, overcoming the natural interest in satisfying our own wishes by obedience to moral categories.

That leads to an important conclusion. In the conception of authors like Dillard or Sherrington *anthropocentrism* does not mean submitting to (natural) human interests but rather *subordinating our acts to distinctly human—meaning moral—categories*. While the wolf follows only instinct and is incapable of acting in the interest of humans, humans, following the moral law, can act for the good of the wolf.

Or more exactly, it is not the wolf's good that matters but the good of good itself, of the good of the distinctive value which humans bring into the world. Egoism, selfishness, mastery are not the apex of "authentic" humanity, only a human pathology. They represent the lowest point of dehumanization. Egoists cease to be fully human. They sink to the level of instinctive predators and so lose their distinctively human trait—the ability to act not only in one's own interest but in the interest of others, in the interest of humanity as a whole in the long range.

For that reason, the critique of consumerism need not be a critique of anthropocentrism as well. The term *consumerism*, to be sure, is of later vintage. I am using it as convenient shorthand for the idea that *consumption is the meaning of human life,* or in Fromm's familiar terms, that life is about *having,* not about *being*; secondly, that the *sole meaning of society is to remove whatever hinders a constant expansion of consumption* and, finally, that *increasing consumption will resolve all problems of personal life and of social coexistence alike*. That is what we have become accustomed to calling "progress" and to it we have subordinated all else. To many authors expansion of consumption appears as the peak of "anthropocentrism"—exploitation of all there is for human pleasure. Better informed authors see it differently. They point out that greed and selfishness, short-term raising of consumption, do not serve human interest, only short-term interest of producers and sellers—at a catastrophic cost to the Earth's ability to sustain human life and so ultimately of the very humans addicted to consumption.

Among Czech authors it was Jan Keller who pointed most emphatically to the self-destructive nature of consumerism in his study *Až na dno blahobytu*,[25] then Hana Librová writing of "the speckled and the green."[26] There is also the American ecological author who became the vice president of the United States, Albert Gore.[27] For our purposes, Gore's book is most suitable not only because it is in English, but also because Gore starts with the presupposition that humans are the source of meaning and value yet arrives at far deeper conclusions. Anthropocentrism really need not mean egoism.

The basis of Gore's argument is the recognition that every society builds on a certain story in which it narrates and so formulates its self-understanding.

Our present problem is that we have based our society on the story of consumerism according to which ever expanding consumption will overcome all personal and social problems, the sole purpose of the society is to make such expansion possible and ever higher personal consumption is the meaning of each individual life.

Gore points out that this is a destructive story. His present dilemma in the office of the American vice president confirms his analysis. Almost everything that scientists are discovering about the greenhouse effect of releasing carbon dioxide and other greenhouse gases confirms the assumption that our living on the Earth is drastically endangered by a far-reaching climatic change. To preserve human presence on the Earth we need limit drastically the generation of greenhouse gases. Europe has come to recognize it and was willing to commit itself to a 20 percent cut. Even Japan promised a 5 percent cut. The population of the United States represents altogether 4 percent of humanity, generates 25 percent of all greenhouse gases and its share of the world total is rising sharply. No one is more aware of that than Albert Gore—yet he could not push through Congress even a commitment to slowing down the rate of increase, never mind lowering the totals. The consumer story—expansion of consumption is the meaning of life, the purpose of society and the solution of all that ails us—is energetically unsatisfiable. It demands expansion of consumption down to the economic and ecological collapse of the world of humans.

We urgently need another story. Gore is critical of the idea which he attributes to "deep" ecologists, that culture is in principle in conflict with nature, and that humans are by their very nature a disease,[28] something like a global AIDS, and that the sole solution would be to free the Earth of humans. I do not know how many "deep" ecologists in fact tell this story. I do know, though, that there are opponents of ecological efforts who delight in it. They use it to draw their own conclusion from it—if the only solution is to be rid of humankind, the problem is humanly insoluble. We can reject any ecological limitations and continue to maximize the profits of the superconsuming countries until the final collapse.

Gore's primary concern, though, is not a critique of "deep" ecology but rather the telling of another story which would not be either consumerist or antihuman. He asks about the roots of our consumer disease. He does not think it belongs to human nature, as if infinite greed were a part of human genetic equipment. He sees it as an addictive substance, today's opium of humankind. According to Gore, our civilization seeks to escape the pain of far-reaching uprooting and dehumanization by a mass drug addiction. We deaden our pain no longer with religion, the opium of humankind in the nineteenth century, but with alcohol, drugs, violence but most basically with consumption. Quite concretely, Gore's diagnosis is that we cope with the meaninglessness of our lives by "going to buy something."[29] Usually we do not even know what. We follow

television advertisements to tell us what we might still "need." Or we go window shopping. A generation ago, we used to go buy something, something definite, something needed for which we had saved up. Today we *go shopping*: we wander through a department store looking for *something* to buy—and say "charge it." For that we need ever more storage space and ever more money—or credit. American economy booms in spite of an annual trade deficit thanks to the capital flowing in to take advantage of high interest rates. Like all drug addicts, we will sacrifice time, human relations, interest as well as honor and conscience to the one overwhelming need, to secure another dose of our drug, another purchase.

Naturally, as with all drugs, the dealers of our drug support our habit. They spend billions—which, to be sure, we pay back in making our purchases—to persuade us that it is urgent to go on and on consuming. The effects include a sharp increase in spiritual and social instability which is not hard to quantify: divorce rates, alcoholism, drug addiction, fascination with cruelty, fanaticism, dishonesty and unreliability, and far-reaching, all-corroding corruption. We do not want to admit our dependency and so we make up a new myth about fulfillment through consumption. People as well as economies, we assure each other, suffer mental collapses if they cannot buy something. It is all a classic descending spiral of drug addiction, leading us to the bottom. That is how American society today looks from the most insider of perspectives—and the model which we in the Czech lands so pathetically emulate, greeting every downward turn of the spiral as progress.[30]

According to Gore, the problem does not lie in individual humans but in the entire structure of the civilization which shapes them. This is what convinces him that it is not enough to change people, we need to change the rules of our socialization. We need to reward what leads to long-term sustainability—and seek to prevent whatever destroys lasting sustainability of life and its presuppositions. Provide tax advantages for using recycled rather than new materials, make mass rail transport more advantageous than individual automobile or air travel, support frugality and burden needless consumption, for instance by taxing loans and freeing income from savings from taxes, limiting the most destructive advertisements; all those are possible tools.[31] The point is to build a structure of civilization which would support all that is sound in people and counteract that by which people destroy themselves.

Gore cites Ethiopia as an example. He could have cited Haiti and numerous other countries which are paying the price of Europe's and America's consumer expansion. Ethiopia clearcut its forests for export, erosion bore soil away, then came drought and famine followed by civil war. Renewal requires first of all a renewal of the social system so that it would not encourage the first steps on the downward spiral. We need to set our society free of its consumer addiction, most of all of the illusion that all that ails us will vanish and ecstatic

happiness erupt if only we buy something more, as advertisers seek to convince us. The task of society is to generate possibility for resolving social and personal problems, not cover them over with a a coat of yellow paint—consumption escalated to the point of collapse. We tried that in the years of the feverish prosperity of the 'twenties. We paid for it with a great depression and a subsequent cycle of wars which molded nearly all of my life. I should wish better for my children.

Albert Gore is a thinker who thinks in systems. He knows that consumerism is not just a sum of individual greeds but the shared illusion that the meaning of life is to gain and have, that the meaning of society is to make it possible and that ever higher levels of consumption will resolve the unresolved problems of our lives. He seeks a systemic solution for a systemic problem. In the role of vice president he must today be aware of the power of greed embodied in multinationals which draw thousands of billions of dollars from our destructive addiction and can easily spend millions to support it, for instance by pressuring public officials to abolish rail systems and so create a new market for cars, gasoline, and concrete. We are not contending with humans who think, feel, understand. We are contending with an impersonal force and an anonymous monster programmed to maximize profits at all costs. Our Czech experience in seeking to induce the government to improve rather than phase out railways makes the point. It is difficult for an individual, even armed with the best intentions and best arguments, to contend with the forces behind the invisible hand of the market.

Yet we are still humans and individuals. Multinational corporations order advertisements and sell cars, but ordinary citizens buy them, often just because advertising convinced them that a car is status and that their personal problems will cease once they have it. If we shall *have*, we need not *be*. In spite of that there are other voices as well, voices of individuals turning to individuals and saying NO, consumerism is populism and a fraud; more consumption does not mean more happiness, only ruined lives and devastated nature. Such voices can be heard even in our Czech lands as a rejection of the snobbery of the newly rich which is a fertile ground of consumerism. A classic text is Duane Elgin's *Voluntary Simplicity*,[32] a voice from Carter's beautiful America of the seventies, when for a fleeting moment frugality meant status, the president walked on foot, opening windows instead of turning on air conditioning—while I was building my cabin in New Hampshire, with my own hands and my own ideas, a cabin which offered all the comfort needed for civilized life but without electricity and using roughly a fifth of the energy of an average home, yet sheltered six people. Back then, until the rise of Ronald Reagan, the new

apostle of consumerism, American energy consumption and pollution dropped for four years running. Evidently there was something to it.

In the Czech lands the sociologist Hana Librová writes beautifully and with deep appreciation about voluntary simplicity.[33] In spite of that, popular press managed to create a rather idiosyncratic idea of voluntary simplicity, as personified by a cave dweller who does not wash, drinks only spring water, refuses indoor plumbing, feeds on roots, and dresses in hides. It is the defensive response of Czech averageness which defends itself by ridiculing anything that might cast doubt upon it. It is the lackey's custom against which Masaryk warned us urgently—score a point with the proud and look down on the humble. There is nothing that supports consumer snobbery more effectively or hinders any attempt to break ranks.

The term "voluntary simplicity" is, admittedly, misleading. It is not a matter of deprivation but of selectively high demands. Let us be demanding, but let us be selective in what we demand. Let us be really demanding when it comes to clear water and pure air, to health care and public transport, to maximal energy efficiency and joy of living—but not when it comes to the most expensive accumulation of pointless gewgaws. That, surely, is not about living in a cave. It is about something else. It is first of all a revolt aginst the snobbery on which our consumer addiction feeds. The principle of snobbery is that whatever is more expensive and more demanding is also more desirable and worthy of greater respect so that that is for that we need strive at all costs. The principle of voluntary simplicity or selective high demand is just the opposite—*the idea that the more desirable is whatever is less expensive and less costly for nature and the human community.* The point is to cherish not the person who has more but one who knows how to be equally happy or happier while burdening society and the Earth less.

That can mean taking the train instead of driving a car, which is ecologically many times more damaging. It can mean that I shall write on both sides of my paper and that I shall make an effort to show a tourist that in Prague one can eat well modestly, not in a Czech imitation of an overpriced western restaurant. It can mean that I shall take a walk in the arboretum and enjoy the ducks on the pond instead of taking a drive to some place where there is a good train connection in any case. Voluntary simplicity is not a matter of asceticism. It is about being demanding selectively, *about joy in living instead of the transient pleasures of ownership.* It is about anti-snobbism.[34]

Duane Elgin cites three kinds of arguments for voluntary simplicity, new in the seventies, well known today. One kind are the ageless moral arguments. Humans have known for ages that they can stand much meaningful suffering and little meaningless luxury. The fates of children of the noble and the rich confirm it. Luxury—having more than I can use, care for, love—is corrosive and simply vulgar at that. The coat in the closet belongs to the beggar. Perhaps we all know the verse in the Bible which tells us that it is easier for a camel to

pass through the eye of a needle than for a rich man to enter the kingdom of God (Mt 19:24, Mk 10:25, Lk 18:25). There is little point in belaboring it. The evident argument is that the people whose happiness depends on having more can never have enough and so condemn themselves to perennial discontent. In the end, we all pay for it.

The second argument is social, thirty years ago visionary, today pressing. Consumerism leads to a vertiginous increase in the differences between surplus and starvation. Europe and America grow rich, the third world sinks ever deeper into debt and unsurmountable misery. Overconsuming countries make loans to third-world dictators to buy their weaponry, then mercilessly demand repayment from struggling democratic governments once the dictator is overthrown. The impoverishment of the third world pays for the luxury of the first. Those are the proverbial scissors which are opening no less within individual societies, including Czech society. Even our neoliberal government admitted that the sharp increase of the newly rich, wholly outside the parameters of our society, represents a problem. No one knows what it will mean globally. Perhaps, as the limits of airpower become evident, the rising discrepancy will end in a revolutionary explosion of fundamentalism or some other fanaticism of the impoverished. Perhaps the economic collapse of the third world, of which even the financier George Soros speaks,[35] will draw down the first world after it. It is hard to imagine the consequences. This much, though, is clear, that the consumerism of the superconsuming countries is creating a threatening situation. According to Elgin, we the people of the superconsuming world have not only moral but also sociological reasons to opt for the path of selective demands—or voluntary simplicity—and to decrease the level of our consumption so that the level of the most impoverished could rise.

Elgin's third kind of argument is ecological. In his day it was a prediction, today it is a reality. Any attempt to prevent an explosion or a collapse of the impoverished by raising their level of consumption—according to the principle that higher consumption resolves all problems—has catastrophic ecological consequences. The deforestation of the Earth is accelerating. The putatively "paper-free" electronically equipped offices require many times the paper once used by typists. Paper diapers save the labor of the affluent at a high ecological cost. In every way, a rise in consumption is ecologically expensive. It is not enough to attempt to compensate with more efficient technologies. We need to halt and reverse the growth of pointless consumption. If the third world is to reach a sustainable level of consumption, the first world needs to moderate its demands. This way or that, Elgin reaches the conclusion that voluntary simplicity—which we have been calling selective demand—is the only promising strategy for the superconsuming world.

I do not know whether voluntary simplicity represents a solution to the ecological problems of our world. If it restricts itself to individual choices, it helps to change attitudes but does not change the overall situation. As Albert

Gore points out, it is a problem in the system. Though I be ever so conscientious about dousing my lights, as long as I live in a society which illuminates highways all night as in the evening rush—and does not use the railway running parallel to the highway—my per capita energy consumption will remain excessive. The problem of consumer life demands systematic approaches as well, an effort so to organize society that it would be compatible in the long run with a healthy nature. Yet even here the arguments we examined with respect to vegetarianism hold. Even a small saving is a saving. Even a small saving affects the public posture. And, most of all, there is the question of conscience. To think frugally and live as a snob is a contradiction which destroys human identity. The ecological activists who drive cars along the railway track create a painful contradiction in their lives. Surely, it would be an illusion to think that I can save the Earth by personal frugality. It would, however, be hypocritical to speak of saving the Earth without making a personal contribution by being selective in my demands—in other words, by being voluntarily simple.

People who have experimented with philosophy but did not inhale love to catalogue. They will masterfully pin sensitive pioneers like Charles Sherrington and Annie Dillard and place them together with systematic thinkers like Albert Gore and Duane Elgin in a single display case labeled *Anthropocentrists*. The problem is that apostles of greed would fit in that case as well. The hallmark of the supporters of the ethics of noble humanity is not that they place humans at the center but rather what task they assign them in that position. Right or wrong, they share the conviction that only humans bring to the cosmos the dimension of altruism which is binding on humans—the ability to accept the long term interest of all humankind as our own interest. That is not a privilege. It is an obligation.

The significant difference among them is between egoism and altruism. Those are again labels which belong on jelly jars rather than on conceptual schemata. Still, the difference between them is not that "egoists" act in their own interest and "altruists" in that of others. Strictly speaking, all who act do so by definition in their own interest. They must take an interest in the effects of their action to act at all. The difference is in what they consider their own interest. If only their immediate personal gain, we can label them egoists. If they consider the good of the city their interest, it becomes more complex. They will ride the subway to work so that they would not add to the pollution and congestion of the city but will say they are doing it in their own interest. Only their interests are broader. People who, like Albert Schweitzer, take an interest in the good of all life, human and extrahuman, can still be said to act "in their own interest," only their interest is broad as life itself.

Can we still call such people *egoists*? Hardly. That would confuse the issue. Can we label such people "anthropocentrists"? Perhaps so: they conceive of the world and of their place therein in the distinctly human categories of good and evil, right and wrong. Yet it is not only their personal life that matters to them, nor human life only. It is life itself, not just my own life or only human life, that becomes the center of all value and meaning. That is what it is all about: not only humans but *the good of all life*. Lovers of labels are wont to label this attitude *biocentrism*.

iv. THE ETHICS OF REVERENCE FOR LIFE

Biocentrism—the idea that life itself, life as such, any life, is a source of meaning and value—was the only one put forward as a complete philosophical system, albeit not under this clumsy neologism. Albert Schweitzer formulated it under the title *philosophy of reverence for life* in the first half of the twentieth century. Today it sounds a bit awkward. Perhaps it was the experience with marx*ism*-lenin*ism* which cured European philosophy of the bad habit of constructing pretentious systems and making anonymous pronouncements like "biocentrism teaches . . ." instead of citing reasons. Or perhaps it was simply the maturing of our philosophical understanding. In any case, in contemporary philosophy the quest for the one true saving System seems a sign of amateurism. Philosophers are expected to think clearly and to ground their assertions thoroughly rather than to produce elaborate theoretical constructions.

Albert Schweitzer wrote in another time and another world and his *ethics of reverence for life*, though presented as a system, remained clear thinking about a clearly seen lived experience. That experience was at its root religious. Not theological, though Schweitzer was a theologian. It was religious in the primordial sense of perceiving the world as sacred, not as something that can be taken for granted. It began with wonder over the miracle that there is life at all, not just emptiness. Reverence for life in Schweitzer's conception began with the lived experience of wonder at the miracle of life. Schweitzer's world is in a sense an enchanted world.

It was an unconventional American philosopher of science, Morris Berman, who analyzed the term *enchanted world* in his work, *The Reenchantment of the World*.[36] There he points out that up to the Renaissance the lifeworld of our ancestors did not appear as mechanical and causally ordered. Today much of what seemed evident to our ancestors gets written off as superstition, but for them the warp and woof of their experiential world really consisted of relations of good and evil, of importance and unimportance, simply of relations of meaning and significance. Whether a tree is sacred or an animal significant seemed far more relevant than their cash value. For that matter, most of us still understand our personal world that way. The growth of the impersonal, "objective" consciousness and science was, according to Berman,

primarily a process of de-sacralizing the world. The Church took part in the process. The two pioneers of mathematical and mechanical natural science, Pierre Gassendi and Marin Mersenne, were priests. Isaac Newton thought himself a theologian. Yet they all strove to strip nature of its pagan sacredness, perhaps to assure the Church a monopoly on the sacred. Their effort did not produce only a new *image of the world*, but, according to Berman, literally a *new, wholly secular world* in which humans no longer encounter anything miraculous or wondrous. It is a world in which everything is ordinary and reducible to mathematico-mechanical categories. Whatever cannot be quantified, as the fragile beauty of the trillium or the miracle of new life, appears in this world as less than real, "merely subjective."

The earliest environmentalists whom we would today easily label "romantics" were primarily people who did not live in a wholly desacralized world. They were not necessarily protectors of nature. The Mrštík brothers, who did so much to save remnants of old Prague from slum-clearance, did not see only the shabbiness of the ghetto and the high monetary value of every square foot of real estate in the heart of Prague, as did the developers. They saw also the bittersweet magic of a thousand years of Jewish life in this land. They perceived an enchanted world and acted accordingly.

John Muir, perhaps the first American environmentalist, perceived it, too.[37] His writings are marked by an enthusiasm for nature whose magic he registered as intensively as its causal interconnections. He revolted against the conception according to which the world exists only to serve humans and whatever does not serve them is to be "improved" or exterminated. According to Muir, God did not create the world to serve humans but for the intrinsic goodness of the creation itself. Figuratively speaking, the meaning of a bear is not fur for a coat but the joy of a bear cub in being alive. Humans like all creation are dust and to dust they shall return. The only thing that exceeds dust is the eternal beauty, eternal truth of wilderness. That is what it is all about. Muir is convinced, like Henry David Thoreau before him, that *in wildness is the preservation of the world.*[38]

It was in great part thanks to John Muir that already at the turn of the century Americans began to establish natural parks not only for recreation but as protected wilderness areas, not for their utility for humans but wholly for their own value. In addition to the idea of national parks, Muir gave America also a series of books and writings which helped open the eyes of European conquerors for the beauty of wilderness. His descriptions of his encounter with wilderness belong to basic ecological literature. He was not, however, a systematic philosopher and so he expressed his deep experience of nature poetically more than philosophically.

It was the German physician, musician, and theologian Albert Schweitzer (1875–1965) who undertook the task of philosophical expression of the experience of nature. After a successful career as an organist and a theologian in

Europe, Schweitzer at midlife decided to go to Africa and devote himself to medical care for the natives. It was not easy. After four years, the French colonial administration interned Schweitzer in 1914 as a German national. While Schweitzer wanted to do good, Europe wanted to make war. Still he persisted. Today Schweitzer's clinic at Lambaréné has become a legend—and in the 1960s it became an inspiration for the great Czechoslovak environmentalist and one-time Minister of the Environment, Josef Vavroušek.

Schweitzer's concern was not to "save nature." Unlike John Muir, he probably was not even aware that it was threatened. His concern was to do good, not evil, and it was this deeply felt task that he formulated as the ethics of reverence for life. In one text he describes the experience which suggested the term to him, on a canoe trip to visit the sick wife of a missionary.

> At sunset of the third day, near the village of Igendja, we moved along an island in the middle of the wide river. On a sandbank to our left, four hippopotamuses and their young plodded along in our same direction. Just then, in my great tiredness and discouragement, the phrase "Reverence for Life" struck me like a flash. As far as I knew, it was a phrase I had never heard nor ever read. I realized at once that it carried within itself the solution to the problem that had been torturing me.[39]

The key to the solution was the recognition that an ethics which restricts itself to human interactions with each other is incomplete. A broader outreach is needed, a reverence for all living beings. Only such a broad outreach, as wide as life itself, could provide the framework for avoiding harm and doing good as a general posture.

Schweitzer opens his *Reverence for Life,* from which this passage is taken, with a critique of Descartes's starting point, the putatively unshakeable reflection of our own consciousness, *Cogito,* as hopelessly abstract, leading to abstract conclusions. According to Schweitzer, the real beginning, the really primordial given, is not the awareness of self-certifying thought but the awareness that "I am a life which wants to live, and I live amid a community of life that wants to live." Life gushes forth daily around us, constantly renewing itself, it is the force of all living. Ethically there is no distinction among us: we all are one life. My initial awareness is that my will to live longs for life— Schweitzer speaks more than once of "the mysterious fulfillment of joy and the horror of perishing and pain." That is the shared longing of all that lives, that is what binds all life, that is its basic meaning.

For that reason, according to Schweitzer, ethics consists primordially of showing to all life the same reverence as to our own. The basic commandment that follows from it is simple: "It is good to protect and love life, it is wrong to destroy or wound life." Humans have always recognized that as the basis of interhuman relations in general ethics. Schweitzer considers those people good who extend this posture from humans to all life. For good people all life, all being is sacred. Infinite compassion is not enough, we need active sharing,

active help. Good people destroy nothing needlessly, protect even insects from the flame of the lamp or rescue earthworms from drying asphalt into grass. They are protectors of all life—and do not fear ridicule. Schweitzer is convinced that the day will come when humanity will find it unbelievable that it could have ever been so cruel.

Love is a good term for it, though even that is a metaphor for a living feeling of tangible value: the immediate experience of the other as valuable of itself, endowed with intrinsic value. Schweitzer stresses that it does not matter whether a given object is worthy of help, whether such experiences fit a polished philosophical system or whether I can hope that my activity will change the world. There is a parable going the rounds in ecological activist circles about a lad who at low tide carries starfish trapped on sand to water lest they dry and die. An adult points to thousands of starfish on the beach and asks the lad whether he thinks that there is any point to what he is doing. The lad looks at the starfish in his hand and replies, "For this one, certainly."[40] The basic, the fundamental, and the sufficient reality is that someone is doing good.

Schweitzer expresses it systematically by starting with the immediate awareness of the general will to live of which I, too, am a part. "The force that through the green fuse drives drives my young age" sings the Welsh poet Dylan Thomas.[41] This will becomes individualized in my personal will to live. In this individualized form it is no longer concerned with life as a whole, only with its own life. This gives rise to the situation described by Annie Dillard: life comes to appear as a shocking struggle of individual wills to live—and ethics as an attempt to bridge over conflict and find once more the deep unity of all life.

There is but one will to live. Then why do we encounter struggle, conflict rather than a harmony of life? Schweitzer responds with an aching *I know not*. Evil is a mystery. I know only this much, that I myself am a will to live which longs for the unity of all life. Just like the prophet Isaiah,[42] I, too, long to live in harmony with all life. Whenever I give of myself to another, I experience this bond. It does not matter that I do not know how to solve the philosophical problem of evil. It is enough that I conquer evil by saving a fly from drowning. My task is not to solve all problems. I am called to overcome conflicts within the will to live. That, for Albert Schweitzer, is the ethics of Jesus.

The problem of traditional ethics appears to Schweitzer as the question of how to combine the egocentric will to our personal perfection (understood in the sense of a quest for personal fulfillment and gratification) with the activistic, altruistic will to do good. The ethics of reverence for life solves it by understanding the will to fulfillment as the will to devote oneself to the good of all life. It is not a matter of manipulating the other by a syrupy good will. It is a matter of generous forgiving in the knowledge of how much I need to be forgiven. Thereby I win a freedom from the world. I refuse to react to its impulses and inclinations; I focus on seeking the good of all life. Today it is common to

seek our bearings in the world by a mental radar which sensitively detects what others expect of us and acting accordingly. Schweitzer is a person guided by a moral gyroscope instead, by the reverence for life.

That is the source of Schweitzer's ethics in relation to the world. In many ways it is reminiscent of the ethics of voluntary simplicity—destroy nothing needlessly. Schweitzer cites the metaphor of the reaper who spent the whole day mowing a meadow and yet on the way home will not tread on a single flower needlessly. Similarly Schweitzer as a physician charges himself never to become inured to the horror he meets in his practice and not refuse to see it. We need to be aware how horrendous is all we do in animal experimentation, in meat production, and in all our dealings with the nonhuman world. It is necessary that we should never avoid our responsibility, that we should never kill cruelly or needlessly, that we let ourselves be guided by an active will to help and to overcome the conflict between individual instances of the will to life. Albert Schweitzer really lived in a blessed world and blessed the world around him.

At a first hearing, Schweitzer's ethics of reverence for life does not sound like a variant of Kant's rigorous formalistic ethics. Professional philosophers tended to write off Schweitzer's thought as amateurish sentimentality, and understandably so. Schweitzer presupposes in his readers a certain previous experience, a harmony with our own intense feeling for the sacredness and goodness of all life. To anyone who does not share this basic experience, Schweitzer's testimony would sound as amateurish and syrupy as a deeply felt confession of faith does to a person without the least shred of religious feeling.

That is why it is important to add to the first wave of enthusiasts, represented in the case of the ethics of reverence for life by people like Muir and Schweitzer, also the thinkers of the second, critical wave who attempt to formulate the principles of reverence for life without depending on emotional empathy, strictly on a formal, Kantian foundation. Perhaps the best rigorously philosophical version of the ethics of reverence for life is the book of an American philosopher, Paul Taylor, *Respect for Nature*. At times it can be hard to read in its rigor, as is often the case with Anglo-Saxon professional philosophy, but among scholars it has won respect precisely by that rigor. Taylor starts with the premiss that

> a set of moral norms (both standards of character and rules of conduct) governing human treatment of the natural world is a rationally grounded set if and only if, first, commitment to those norms is a practical entailment of adopting the attitude of respect for nature as an ultimate moral attitude, and second, the adopting of that attitude on the part of all rational agents can itself be justified.[43]

This breakneck formulation comes directly from Kant's principles. The point is that the binding force of a particular ethics cannot be derived from our inclinations, from possible love or sympathy for nature, or from anything that is based on some putative "human nature." The only valid reason for accepting this or that ethics can be what Kant expressed in the concept of respect for the moral law and Taylor expresses with the concept of pure and unconditional respect for nature. An ethics motivated in whatever other way is subject to the contingency of the world and so cannot be binding. And add a second condition thereto: reasons we present cannot be in any way contingent on personal sympathy or inclination. They have to be purely rational, universal, and therefore binding on all rational beings.

Therein stands out the fundamental difference between "anthropocentric" and "biocentric"—or in Paul Taylor's gentler term, "life-centered"—ethics. From an anthropocentric ethics we can derive only obligations toward humans and derived from humans. European ethics traditionally considered that self-evident. The opposite, though, follows from Paul Taylor's life-centered conception of reality—that we have prima facie obligations to other beings as well. Or, more precisely, we have such obligations to the *good* of other beings, simply because of their own intrinsic value.

Here we need to define two concepts, that of the good of any living being and that of intrinsic value. Both lead to questions. First of all, can we speak of the good of living beings when they are so different? Every defender of animals must repeatedly confront the question, *But how do you know what is good for this animal?* To define the good of living beings materially would really be impossible. When it comes, say, to good nutrition, animals are infinitely different. However, Taylor points out that we can define general good formally. For any individual animal good means the possibility to live out its life as befits its kind. For a population of a definite kind, good means the possibility of building the context for such fulfillment.

It does not matter whether a given being is aware of it. For a young male beaver, the good means the possibility of founding a family, of building a castle and a dam, of putting in a supply of young branches anchored in the muddy bottom above the dam, of living out a beaver's life. For a colony of beavers it means the possibility of creating a beaver environment. It does not matter to what extent the caged beaver is aware that it has been deprived of the good of its life. Even were it to accept it as natural that the cage is its habitat—incidentally, that is most unlikely—we would still be denying the beaver its good.

Then there is the second concept, that of intrinsic value. Every defender of animals must repeatedly confront the question, more insistent for being less than grammatical, *What is a beaver good for?* The most apt response would be another question—*And what are you good for?* It seems obvious to us that humans need not be good for anything, that humans have value in themselves,

intrinsic to them. That, though, is true of all beings, not human ones only. Formally stated, simply because a being wants to live, because it can rejoice and dreads suffering and perishing, its life is a good for it itself, and so a good independently of aught else. Quite apart from our sympathies or antipathies, every thing that lives has its own good, an intrinsic good, and deserves respect.[44]

This double recognition, that the category of the good of any being can be defined and held valid, and that every being has its own good, of itself and not as a means, necessarily leads to the conclusion that every being deserves considerate treatment. That is not a matter of inclination or emotional impulse. It is strictly rational justification of the stance of respect for nature as a basic ethical stance, not derived from any other ethical principle but itself the basis for all ethical thought. Thus it fulfills the Kantian requirement of categorical validity and universalizability. Paul Taylor reaches the conclusion that "the rules of duty governing our treatment of the natural world and its inhabitants are forms of conduct in which the attitude of respect for nature is manifested." Not great poetry, perhaps, but it is biocentrism *more geometrico demonstratus.*[45]

Though what precisely do we mean by biocentrism? In popular discussion that topic tends to be embarrassing. For the most part people understand the term as *excessive love for animals* or as the belief that *animals are more than people*, and respond with irritation. They have a "feeling" that biocentrism, the idea that meaning and value are derived from life as such and not from human wishes alone, casts doubt on their own superiority and their demands on the natural world. There is truth to that, though that truth needs be defined more precisely. Paul Taylor offers four theses to make it more precise, expressing the biocentric attitude to the world.[46]

The first is the biocentric conviction that *people, animate beings of the subspecies H. sapiens sap.,* are equal members of the community of all beings. Humans have as much right to their place on the Earth and all their being requires as any other species, though not a privileged right. We are distinctively different; we have distinctive abilities and so responsibilities as well. Still, we are one biological species among many. To claim that with the invention of computer technology or of virtual reality we have eluded our animate nature is wholly illusory. Our bodies continue to link us to nature. If anything, we are rather late comers in it. If we used a stroll down Prague's Wenceslas Square, a kilometer long, as a metaphor of evolution and began with algae at the National Museum, sharks and spiders would appear on the scene roughly at Štěpánská Street, one third of the way down, lizards at Vodičkova, more than half way down, mammals by Špalíček, almost all the way down. *Homo*, not necessarily *sapiens sapiens*, even just plain *erectus*, makes an appearance on the last two paving stones. Not the big, roadway ones. Just the sidewalk mosaic ones. In the development of life we are latecomers and modesty becomes us.[47]

So far, we have not exhibited much of it. For Nature our species represents a great and growing burden. In the last half a century—that would not be even the breadth of a hair laid across the last mosaic stone—we have speeded the extinction of many kinds of vegetation and animals, a change of atmosphere and climate, far-reaching deforestation. As against the wealth of nature still two centuries ago we have created a different, impoverished world. If we take our equality seriously, it is a reason for voluntary simplicity rather than for further demands.

The second biocentric conviction is that *the Earth is a web of mutual dependence*. It is not a cluster of unrelated objects. It is a dynamically interrelated whole. We can imagine it as a complex mechanical system of interrelated feedbacks, as is common in contemporary natural science in its intoxication with computer modelling. We can utilize a vitalistic model of organism such as Lovelock and his followers use under the designation GAIA. Finally, we could use a personalistic model of personal being like the bear, the coyote, the river, the boulder of Native American myths. How we imagine it is not crucial. The mechanistic model has the advantage of easy acceptability, the vitalistic model of greater descriptive accuracy, the personalistic model of greatest universalizability.[48] That is not ultimately important. What is important is that all we do has its global consequences and affects all else. When I start up a car, it is not just my business. The exhaust fumes disperse but do not vanish, the concrete highway alters the landscape, wheels kill. All that might be justifiable, but it requires justification. Before I fire up a car, I need to have a damnably good reason for asking the Earth to bear such a burden. That it is more convenient than the streetcar would hardly pass for a good reason—because life is a whole, and nothing is indifferent.

The third biocentric conviction demands a recognition that *every member of the biotic community is valuable simply because it is*. No being has to justify its being, not even humans, as long as they keep their demands in the limits of long-term sustainability. Every being's life has its own meaning. In terms of its philosophical ancestry, biocentrism is heir to Leibniz, not to the atomists. The basic unit of life is not a particle of matter but a teleological unit of activity. Leibniz used the misleading term monad, but he stressed that the substance of the monad is *entelecheia* which he understood as meaningful, purposive activity. Thus the basic reality is not an object which we perceive from without as we do an atom, but rather an activity of which we partake.

These three convictions lead finally to *the biocentric conclusion that the idea of human superiority is only an expression of human racism*, of a wholly unjustified attribution of privileged status to our own group which is no different from, say, the Nazi theories of *Herrenvolk* and *Herrenmoral*. Among various kinds of beings there are differences in speed, in sense of smell, in strength of muscles or in intelligence, but those are really only differences, not signs of higher or lower status. If we were to speak of superiority at all, it would have

to be judged in terms of contribution to the good of all and every life, who contributes most to the long-term sustainability of all life on this Earth. Since I am a human myself, I should not wish to enter such a competition.

The ethics of respect for life evokes a strong emotional response but, as Paul Taylor has shown, it is not mere sentimentality. It is also a coherent stance with respect to life and the world, expressing a fundamental equality of all life. Not sameness by far, but equality in difference. Equality does not mean that a turtle is entitled to a university education or that a university professor has the same right to a pile of hay as any donkey. We do differ. We are equal, though, in having all the same claim to the good, to the possibility of living our life in ways appropriate to our respective kind.

That is not a "right"—the very term "right" represents a human peculiarity and perhaps also a reflection of human arrogance. What have I said when I have said that I *have a right*? Is it any more than "I want it!" accompanied by footstamping? I do not know. In any case, I find the idea of responsibility towards all beings and the recognition of the claims of all beings to their respective good a rather more suitable way of expressing it. For, as Albert Schweitzer recognizes as much as Paul Taylor, no being has an absolute "right" to satisfy its wishes. Life is complex. No individual life can claim priority over any other individual life. The ethics of respect for life is deeply, broadly democratic. However, the prerequisites of long-term sustainability do need to have a priority. Each of us has a right to life, but not to immortality. To quote a Czech metaphor, born of decades of housing shortage, old people want to live, but the young need apartments. Only individual lives can realize value. However, at the core of all meaning and all value are not individual lives, but rather life as such, a harmony of all lives.

v. THE LAND ETHIC

That brings us to a different overall conception of ethics and of the sources of value and meaning than the ethics of respect for life. Respect for life is no longer enough. We need to take into account the presuppositions of life, the whole community of all life, the entire biotic community and the conditions of its sustainability—or in another words, we are now concerned with a *land ethic*.

The term *land ethic* comes from the work of perhaps the most influential ecological thinker of the century just past, Aldo Leopold. Leopold was a forester in the first half of the century (died in 1948) and the first American university professor to teach environmental ecology as a distinctive field. His last work, *A Sand County Almanac*,[49] contributed a whole range of themes to ecophilosophical thought, among them the expression *thinking like a mountain* which acquired a rather idiosyncratic interpretation at the hands of subsequent "depth" ecologists.

Aldo Leopold used the expression *to think like a mountain* in a very specific context.[50] He recounted killing a she-wolf sometime in the 1930s. She was still alive when he reached her and as a mother gave a last helpless look to her two cubs. Leopold "saw the green fire of life dying in her eyes." Killing the cubs was easy. They stuck to their dying mother. Wolves, protectors of the forest, were considered vermin. Their extermination so they would not compete with hunters was successful. However, without a middle predator a game population explosion followed. Beside, shepherds, formerly alert, took to grazing their flocks untended in the margins of the woods. The result was overgrazing over the whole mountain. A few downpours washed away the topsoil. Twenty years after the successful extermination of wolves only a rocky wilderness remained. From the viewpoint of the deer the wolf is vermin. From the viewpoint of the hunter the deer is that. *From the viewpoint of the mountain a pest is anything that disrupts the harmony of life.* Figuratively speaking, the mountain does not care about any individual, a deer, a wolf, a human. The mountain cares about the balance of life. In that sense Leopold wrote that an environmental ecologist must *think like a mountain*—or, less poetically, think like a forester, caring for the harmony of all life.

Value does not derive from humans or from life. It is a function of the balance of the entire ecosystem. In Leopold's words, "a thing is right when it tends to preserve the integrity, stability, and beauty of the biotic community. It is wrong when it tends otherwise."[51] If we were to coin a label for Leopold's approach, we would have to call it an *ecocentric* ethic.

Leopold presents his approach in "The Land Ethic" at first as a broadening of traditional ethics. That ethic recognized only human moral claim to respectful treatment—or at first only the claim of free male citizens. Gradually the circle of ethical consideration extended to all humans "like us," in the Enlightenment to all human beings, today we are extending it to extrahuman beings as well. Our conception of the place of humans in the biotic community is shifting from the superiority of masters to equal citizenship in the community of all life. In the opening section Aldo Leopold sounds like an echo of Albert Schweitzer.

Something, though, is wrong. Aldo Leopold liked to hunt and enjoyed eating the flesh of his victims. He was not particularly upset by the suffering of domestic, industrial, or experimental animals. Was he really too dense to realize that the Land Ethic demands respect for all animals? Or was he so hypocritical that he was aware of it but did not want to give up his passion for hunting?

According to J. Baird Callicott,[52] who studies Leopold's thought systematically, the reason is different. Leopold was convinced that there was no conflict between the Land Ethic and the ethics of reverence for life because they operate on wholly different planes. Defenders of ethics of reverence for life deal

with the sum of all individuals. Just as Bentham and both Mills—and definitely also Schweitzer—they are concerned with lessening the amount of suffering and increasing the amount of pleasure. Only individuals rejoice and suffer. Thus for the defenders of this view the evident conclusion of respect for life is first and foremost the effort at protecting concrete suffering individuals.

As Callicott reads it, Leopold's Land Ethic is not about joy and suffering but about the "integrity, stability and beauty of the biotic community," as we noted already. The suffering and death of individuals are a part of this stability. Deer hunting may be a moral duty wherever we encounter an overpopulation of deer. That a hunter in a single shot transforms a beautiful deer, the very embodiment of the joy of life, into a bundle of blood and agony, that concerns the ethics of respect for life. The Land Ethic, as Callicott reads it, is concerned with the *balance* of life. It considers it an ethical duty to protect rare predators like the bobcat and the wolf, though they kill cruelly, because they defend the balance of nature, of the Earth. It would be dangerous to protect far too numerous domestic sheep whom John Muir once described as locust on hooves, destroying the balance of life like the biblical plagues.

Callicott sees it as a conflict of a superficial individualism with a holistic approach which recognizes moral considerations and duties towards the whole as well. As against the individualism of biocentric ethics the Land Ethic is basically holistic, considering the whole as the basic reality and deriving the meaning of its parts from the whole, not vice versa. It understands nature as an integral whole, an ecosystem or a community in which individuals have their niches or "nikas," tasks which determine their status, privileges, and duties or, less poetically, they have their role in preserving that "integrity, stability and beauty" of the biotic community. Every species has a right to live but an endangered species has a right to preferential treatment in virtue of its position within the whole.

To what extent this interpretation is faithful to Leopold's intent is not self-evidently clear. Callicott polarizes, presenting all ethics of respect for life as individualistic and all Land Ethic as explicitly holistic. However, as we have already noted, Paul Taylor, a clear defender of an ethics of respect for life, considers the thesis about the Earth as an interwoven whole one of the three basic theses of any biocentric ethic, an ethics of respect for life. It would seem that respect for life need not be individualistic alone.

Conversely, Leopold's Land Ethic is not only holistic. The point is not simply that at the beginning of his work Leopold proclaims his allegiance to respect for life, speaks of widening it and of humans as equal citizens of the biotic community, though none of that is easily compatible with an exclusive holism. What is more important is that for Leopold the integrity, stability, and beauty of the biotic community become actual in the lives of individuals. The pages of Leopold's *Almanac* do not describe holistic abstractions. They are

devoted to detailed observation of individual plants and animals in the spirit of loving naturalistic sketches. Leopold is aware that the life of individuals depends on the integrity and stability of the whole and that for that reason the interests of the individual are legitimate only to the extent to which they do not disrupt the stability of the whole. He is, however, no less intensely aware that it is life and joy of individuals, who alone can rejoice and suffer, from which a whole derives its value. What would be the worth of the stability and integrity of a whole in which all individuals were unhappy, if such integrity were thinkable at all? Such a whole would be devoid of value because a whole cannot rejoice. It has to derive its value from individuals for whom it creates the presuppositions of their lives.[53]

As J. Baird Callicott would have it, the American professional public never took Leopold seriously not only because be was not working on a technically philosophical problem and did not write in the manner of analytic philosophers, but also because his reasoning led to some unwelcome results. At the time, America was carrying on a major struggle with forest fires. The symbol of the whole effort was a burnt bear cub saved by Park Service firefighters beside the body of his mother who perished in the fire. They photographed him in a ranger hat and equipped him with the slogan "Only YOU can prevent forest fires!" One look at the orphaned burnt cub was enough. Even urban Americans, used to throwing cigarette butts out of their car windows, finally realized what horror and suffering their heedlessness could cause.

Against this background Leopold came forward with the thesis that naturally-started forest fires have an indispensible place in the ecology of the great pine forests of the West. Some seeds will germinate only once a forest fire heated them to very high temperature. Fire culls the forest, opens it up to light, consumes the shell of organic detritus and so enriches the soil. Yes, animals suffer, but a healthy evergreen forest in the American West needs to burn over periodically. If Americans heard out Leopold at all, one look at the burnt cub, by now much loved as Smokey the Bear, sufficed to dismiss him as an insensitive theoretician who has no feeling for animal suffering. Respect for life still represented the basic American posture.

Leopold's views, however, did not stem from insensitivity or abstract theorizing. His thought starts from the conviction that every community, including the human, is based on an ethic in the sense that coexistence is possible only once rules of interaction impose limits on the war of all against all. A society and an ethic—which Leopold defines as *a limitation on freedom of action in the struggle for existence*, symbiosis to the ecologist and ethics to a philosopher—arise simultaneously. That then means that the validity of a

given set of rules is limited to the society with which it arose. That is why it is so difficult to build a universal human ethic. It is possible at all only to the extent to which humanity is becoming one community.

Leopold is concerned with the recognition of a broader reality, the biotic community, the community of all life and of all that sustains it. Individual lives are not unrelated in their living. They affect each other and give rise to an interlocked whole which has its social structure. That structure is more reminiscent of the hierarchical ordering of a feudal society than of the individualistic structure of modern democracy. Not individuals, but the structure of the whole defines roles into which beings are born and which then define their life's task and course. Functions, tasks, niches—or, using a word popularized in America by the British ecological classic, Charles Elton, in the 1920s, *nikas*—are what is primary, shaping individual beings, not the other way. A human community or any community can sustain itself only as long as it lives within the limits of its nika, of its role in the community of all life.Whenever it moves beyond the limits, it destroys itself and nature simultaneously. For that matter, ancient Greeks had a word for it—*hybris*.

According to Callicott, Leopold understood the Land Ethic—that is, the ethics of the biotic community which presents humans with their nika—as an evolutionary possibility and a necessity for survival. He builds it on a growing ecological awareness which Callicott calls "ecological literacy." Three concepts are basic to it, all derived from the natural sciences. One is *evolutionary biology* which gives rise to an awareness of the mutuality of all being which, in the evolutionary conception, becomes a community of pilgrims on the way of evolution. Callicott describes this as the diachronic connection. Secondly, *ecological biology* provides a synchronic connection: we are all a part of one biotic whole. Thirdly, *Copernican astronomy* leads to the recognition that our planet is a minuscule part of an immense and hostile universe. Humankind has acquired the ability to destroy this Earth which it shares diachronically and synchronically with all that is. With that it acquired also the duty to limit its infinite demand so that it would not destroy this finite Earth. All that is summed up in Leopold's observation that "A land ethic changes the role of *Homo sapiens* from conqueror of the land-community to plain member and citizen of it."[54] With that a Land Ethic becomes possible—and that is the source of its content: Right is whatever supports the integrity, stability, and beauty of the biotic community, wrong is whatever disrupts it.

Therein Leopold really goes against the current of contemporary ethics. That ethics is individualistic, dealing with individual demands or "rights" and their balancing. In Kant's version individual claims are based on reason and the ability to know the moral law. In Bentham's version they are based on feeling and the ability to experience pleasure and pain. However, both formalistic ethics derived from Kant and utilitarian ethics derived from Bentham and the Mills are individualistic and do not take into account the needs and interests of

social wholes and long-term processes. They take individual egoistic interests for a basic given.

By contrast, Leopold—like David Hume and Charles Darwin—considers altruism as basic as egoism. Humans are not only individuals contingently associated with others. Like other social animals, humans are social beings by their very nature. Social interest is their interest, too, and is binding for them. The biotic community has its own value for which all undistorted individuals have a genetically coded sense. The pathologically common egoism, devoid of a sense for the whole, is a sign of deeply disrupted psyche.

Because the biotic community is an interwoven whole, ecological thought as a thought about wholes is necessarily holistic. It is concerned with nature not as an aggregate of individual animals and trees but as an organic whole to which we can apply predicates like "healthy" and "sick." Integrity, stability, and beauty of the whole are more basic to such thought than the claims of individual beings. Process—becoming, activity, development—is something more basic than static entities and persons. Energy is something more basic than matter. Aldo Leopold here grasped the dynamic conception of reality—or "evolutionary ontology"—propagated a century ago in America by philosophers like Alfred North Whitehead, Charles Hartshorne, and other process philosophers and based on it an ecological ethical conception for which the highest good is the smooth functioning of the exchange of energy in the whole of life—or very metaphorically, the healthy life of all nature.

Thinkers who want to stress the conflict between an emphasis on the respect for life and on respect for the Earth for the most part tend to overlook the reality that process is life and that the "smooth functioning of the exchange of energy" is only a very complicated way of saying *living*. The conflict is more one between a dynamic and a static conception of reality. To preserve Life just as to preserve the Earth, as long as we understand both as processes, means to protect and preserve the multiplicity of species. It is not a matter of freezing the present state. Extinction and emergence belong to the process of living. The point is that in a healthy process species emerge in a geologic time, more rapidly than they become extinct. The distressing reality today is that humankind is destroying species far more rapidly than new species can emerge, and at the same time is destroying the ability of species to reproduce.[55] Ecological protection does not mean freezing development. It does mean a healthy development, or perhaps a healthy life of the Earth.

The great strength of Leopold's Land Ethic is the difficult recognition that the Earth is a complex of *life*—and that death is a part of life, though we are deeply loath to admit it. Albert Schweitzer was evidently aware of it though he did not seek to resolve the problem. "The world is indeed the grisly

drama of will-to-live at variance with itself," he admits, achingly concluding that "there is no answer to these questions."[56] Schweitzer continued to live with the ageless, intense longing of all humankind to drive death out of life. Leopold comes to the recognition that without death there is no life. The population explosion is demonstrating it graphically. At the root of all ecological crises is the explosion of human greed—and human numbers. As we noted before, even a very modest demand becomes an ecological threat when we multiply it by six billion. At the root of the ecological crisis there is then the one sided defense of life. It is so understandable, so human! We do not want to let anything die. Only when we drastically lower mortality but fail to lower birth rates, we cannot avoid a population explosion. To accept limits to our greed, to accept limits to our life, to accept death as a necessary part of life is the difficult challenge today.

Nor just today. The book I think the most profound expression of the tension between the ethics of respect for life and the Land Ethic—biocentrism and ecocentrism—was written in Bohemia in the first year of the fifteenth century. The author, Jan z Žatce, an official of the New City of Prague, called it *Der Ackermann aus Böhmen*, the ploughman from Bohemia, though the English translation calls it *Death and the Ploughman*.[57] The ploughman bitterly reproaches Lord Death for taking his beloved young wife. With the desperate effort of intense, infinite love he presents all the biocentric arguments. By love he would defend life from death. He is so infinitely human—or with Goethe, so *all'zu menschlich*. Lord Death—in German death is masculine—is noble, remote, responding with all shades of irony. He points out that life self-destructs. Life is not a state, it is a process, it is becoming, a constant birth of the new—and that presupposes that the old will flow away. Only death makes life possible and makes it precious.

Lord Death is devastatingly convincing. Still, Jan z Žatce does not conclude his book with a rhetoric victory of Death. Yes, all the arguments turn in his favor. Still there remains the irreducible greatness of love for life which, in spite of all, defies Death with its futile NO! That is why I think *Death and the Ploughman* captured, five centuries before its time, the contemporary ecological debate between biocentric and ecocentric ethics. They are irreconcilable, yet they complement each other and we cannot do without one or the other. Aldo Leopold shares Schweitzer's love for life—and Schweitzer's heirs reach Leopold's conclusion, that the struggle for life is not a struggle for immortality but for a life which is good—albeit mortal.

vi. LIFEBOAT ETHICS

Yet there is a difference, though to me it seems less a one between the ethics of reverence for life and the land ethic than a difference in emphasis between two of Aldo Leopold's most devoted philosophical interpreters, J. Baird Callicott

and Holmes Rolston III, arguably the two leading ecological thinkers in America today. We have noted one difference already. Leopold's Land Ethic starts out with a Schweitzer-like confession of love and reverence for life and repeats the familiar biocentric arguments. In spite of that, on Callicott's reading Leopold tends to appear indifferent to death and suffering. Then there seems to be a second difference. Leopold, like Callicott, accepts death as a part of life's story. Life is a constant process of birth and dying. Leopold does not seek to freeze death out of it. Still, in all of Leopold's texts, especially the poetic nature sketches which make up four-fifths of *A Sand County Almanac*, it is evident that Leopold loved life. Yes, he understood it dynamically as a process of birth and dying, but he *loved life*. It would not be wholly inaccurate to say that Leopold was a biocentrist at heart but had a broader and more workable conception of what *bios* is and what it means to protect it than Albert Schweitzer. In Callicott's interpretations emphasis seems to shift until it seems that not life, but the struggle for life, *polemos*, is the true meaning of all being and source of all value, just as Heraclitus would have it: "War is the father of all things."

Whether or not that is what Callicott actually meant—and I am not at all sure that he did[58]—it is a rather different playing field. All the attempts at a philosophical reflection of the ecological crisis which we have examined thus far shared an unspoken environmentalist assumption: nature is in danger, our task is to protect it. What exactly that means is a subject of discussion, but this much is clear: something precious is in danger. For all the differences we have so far been dealing with a protectionist ethic.

The idea that the fundamental *summum bonum* from which all value derives is the struggle which is humankind's tragic lot yet in which real men are born gives rise to a radically different stance which Garrett Hardin calls *lifeboat ethics*.[59] The discussion itself began earlier, with a 1966 article in which Kenneth Boulding[60] suggested two metaphors, the *cowboy ethic* and *spaceship ethic*. He pointed out that with respect to nature traditional American ethics modelled itself on the manners of the cowboys who drove their herds through open, fabulously rich and unsettled countryside. The cowboys, back then without guitars, represented the lowest rank of migrant laborers. They had no firm bond to the ranch, to the herd, and least of all to the country through which they drove. They wasted mindlessly: it was common to kill a bison, then still plentiful, cut out the tongue for food and let the rest rot. They thought nothing of trampling the fragile prairie ecosystem. They polluted their camping sites and streams, confident that they would drive on and never return to the place where they left their waste. That was cowboy ethics.

Kenneth Boulding warned his countrymen that they were treating nature the way cowboys treated the land. They, too, wasted heedlessly, polluted, and devastated, setting a model for their successors. In the 1950s some American economists praised waste which was said to accelerate the economy and encouraged conspicuous consumption to that end. When in 1959 I canoed

down the upper Minnesota River, behind each farmhouse along the bank there was a cascade of tin cans, trash, and every manner of waste, including old tires and car batteries. A dramatic factor in the awakening of ecological consciousness was the incident in which a river saturated with refinery waste caught fire—much as much later the dead branch of the Labe near Pardubice in 1985. Khrushchev's slogan about "catching up to and surpassing the West," though originally intended for steel production, applied most consistently in environmental damage.

Boulding pointed out that not only the apparently endless America from sea to shining sea, but even this planet itself is far from endless. He proposed the metaphor of a spaceship. Like the crew of a spaceship, so we on this Earth have only a limited amount of resources—and must carry all our waste with us. The idea of "dispersal" of factory and automobile exhalations is an illusion. The "dispersed" fumes continue to burden the atmosphere, generating what we now call the greenhouse effect. The forests which could help absorb them are shrinking dramatically. We are on a spaceship. We have to live with what we produce. A spaceship needs a frugal ethic. Anyone who wants to produce something needs to think whether this is a legitimate use of scarce resources— and what will be done with the product once it is discarded. Has anyone ever asked that about America's swarm of airplanes and automobiles?

We are on a ship—and we are in the same boat. In the long range, we cannot afford opulently wasteful passengers in the first class of superconsuming countries and classes, and we cannot afford desperate wretches in steerage who will light a fire for warmth and burn through our computer cables. We need consciously to prevent increasing the gap—limit the superconsumption of the privileged and ease the misery of the wretched as America sought to do in its moments of greatness, from Roosevelt to Carter. Boulding's spaceship ethics came out sounding like the idealistic ethics of generosity which inspired America from the Marshall plan up to the onslaught of the second round of snobbism and selfishness in the 1980s.

Hardin, a consummate master of metaphor, takes on Boulding's spaceship image by pointing out that a ship must have a captain—which the Earth does not. It has no common order. Selfish cliques, claiming "rights" without responsibilities, fight their petty battles and care not a whit for the ship. It is not even a Hobbesian war of all against all. It is more like a drunken barroom brawl, only there is no bartender to knock heads and bring order. Under such conditions even well intended generosity leads inevitably to the tragedy of the commons.

Tragedy of the commons is one of the most effective metaphors with which Garrett Hardin enriched ecological thought.[61] Originally it was used by W.F. Lloyd in 1833, when in England sheep still grazed on the commons, but Hardin made it a part of the American consciousness. Imagine a common pasture open to all the villagers. The pasture will support a hundred sheep. Every

villager will naturally try to pasture on the commons as many sheep as possible, but thanks to natural constraints—wars, illnesses, robberies—the overall level will remain within limits of sustainability. The commons will feed a hundred sheep, ten villagers pasture ten sheep each on it.

Those natural constraints, though, can give way. We strive for peace, make strides in veterinary medicine, we establish a municipal police force—fewer hazzards mean more sheep and every villager will be sorely tempted to add just one more sheep. That villager will be keenly aware of the advantages of having one sheep more. The disadvantage is added strain on the pasture, but that all the villagers share and so each will be aware of only a tenth of the cost. The advantage is far greater. The villager will add the eleventh sheep and so will all his neighbors. The commons will not support a hundred and ten sheep. The sheep will overgraze it and all will die of starvation.

The parable of ten sheep is rather remote to us. Imagine, though, a mediaeval city of narrow crooked streets in the Vltava valley. Even when the dispersal conditions are good, such a city can accommodate only a very limited number of cars. As long as protective tariffs were high and wages low, the number of cars per thousand people remained on a sustainable level. Then came globalization. Tariffs went down and while wages remained low, wild privatization created a whole range of unexpected possibilities of profit for the vigorous and unscrupulous. The streets of the old city were suddenly choked with some 560 cars per thousand inhabitants, up from 120. It seems unlikely that any of the new car owners consciously willed to pollute Prague's air beyond breathability or clog her streets to impenetrability. They had just the most modest wish: one little car, and maybe one for the wife so she would not have to ride the plebeian metro from Anděl to Náměstí Republiky.[62] Today Prague, which Prince Charles admired just four years ago for its freedom from automobiles, is worse off than Vienna. In the eight hours I work each day in the center of Prague, I breathe in as many pollutants as if I smoked four packs of cigarettes. I do not smoke, but every tailpipe looks to me like a pistol aimed at my lungs.

Garrett Hardin concludes that where there is a surplus of demand it is essential to limit the availability of supply—or we shall lose our common pastures, cities, oceans, national parks, and ultimately the Earth itself. We might tax cars until only the richest five thousand of the people of Prague will be able to afford them. In the fresh air the rest can walk. Or permit cars only on the basis of merit or need, to doctors, repairpeople, firepeople. Or should we draw lots? Or issue permits first come, first serve? No such solution is good but some solution is necessary. Hardin's greatest and most unpopular contribution may be his willingness to face the reality that some solution must be found even when none is acceptable. The same is true of size of families, housing, of everything. Limited resources are incompatible with unlimited demands. Our

possibilities are limited, our demands unlimited: if we are to survive, we must limit them ourselves.

How, though, limit that infinite demand? Even though Hardin generally holds the most conservative of right-wing views, he is convinced that privatization—in American parlance, "property rights"[63]—will solve nothing. He believes that experience proves that in most cases of common weal, be it countryside, a hospital or a railway, the need is to protect public good from shortsighted and greedy private owners. Our experience with tunneled out factories, railways, hospitals bears him out. In addition in case of most basic needs like pure air, clear water or urban environment division into private properties is not even possible. Such goods are necessarily common. No invisible hand will provide services like health care, transportation, police or environmental protection. Invisible hands can generate only an ethos of profit while what we need is an ethics of generosity and a life style of modesty and consideration.[64]

How, though, could you prescribe modesty and generosity? Conservatives like Hardin tend to look to tradition, though that is difficult in a rapidly changing world. Traditions, like English lawns, are the product of centuries. Today we need immediate solutions. It was one thing when the Czech lands had half a million inhabitants, another with ten million today. General rules like "thou shalt not steal" are too general—and we can hardly hope that institutions exposed to pressures and corruption can specify them. Nor can we depend on conscience. Even humans of good will are frequently unable to think in long-range terms. We need mechanisms of coercion such as we have ever used in the case of other socially harmful practices like murder and robbery. Most of all, Hardin believes, we need a wholly different kind of ethics which he proposed under the designation *lifeboat ethics*.

The Earth is neither an inexhaustible wilderness nor a spaceship. Let us imagine it rather as a dark sea which humankind navigates in a motley collection of ships, boats and jerry-built rafts. The overconsuming countries whose gross domestic product even before the astronomic polarization of the Thatcher era represented some US $7,000 annually are luxury liners providing their passengers not only survival but also the cultural values which humankind accumulated over the millennia. In a cultured comfort they can carry perhaps a quarter of all humans, if we count in the servants who may not travel in comfort but who are travelling on a safe and well supplied ship.

Two-thirds of humanity live in countries in which in the same period the GDP was less than US $300 per person per year. If we continue our metaphor, these are the unfortunates who float precariously on crowded junks or rafts, fall into water, for a moment grab on to a floating log, then fall in again and drown. All of these unfortunates long to board a safe craft. What should the crew of the luxury liners do?

That is the question of lifeboat ethics, unintentionally dramatized in the American film, *Titanic*. To start with, we need to realize that even the most luxuriously appointed ship has a limited capacity. Not even the United States has infinite resources. The Americans have already surpassed the ability of their land to renew life's needs and now are living from capital, from nonrenewable resouces—even though for the most part they draw them from other countries and worry about nothing except how to prevent any slowing down in the rate of expansion of consumption. Certainly, the United States is not overpopulated like Bangladesh. Let us say that while our metaphoric American ship could carry sixty people, there are thus far only fifty of us. America still has reserve capacity so that a crop failure in a given year need not mean a catastrophe. However, in the dark waters around our ship we can see not a handful of individuals but hundreds upon hundreds of drowning survivors, desperately struggling for life and trying to scramble on board our ship. What shall we do? *That—and not speculations about long-term sustainability—is what Hardin considers today's real question.*

One possibility is to be guided by ideals, perhaps the Christian ideal about "loving thy neighbor as thyself" or the socialist one, "to each according to their need." In that case we would drop boarding nets over our ship's side and help all the drowning on board. Naturally, our ship, with a capacity of sixty people, would sink under three hundred fifty and the rescuers and the rescued would equally drown. Perfect justice, perfect catastrophe.

The second possibility is that we will save as many as we can. The ship will carry sixty people; there are fifty of us. We shall invite another ten on board. That, to be sure, will mean using up our reserve so that in the future even a minor strain will mean danger, but so be it. Only which ten should we take? The first ten? Or the ten best who will make the biggest contribution? Or the ten neediest? And what shall we say to the eleventh?

The third possibility is that we will not take on anyone. We need our reserve, we want to preserve not only lives but the values of cultured life for future generations. With fifty on board we have a chance. We shall, of course, defend our ship against the drowning and without hesitation bring down a marlin spike to smash the knuckles of any hand that grasps the gunwale. That it is unjust? YES, IT IS. So what? No one said that life should be just. Six billion are too many for that. Besides, anyone with a tender conscience can jump into the water and yield a space to someone less sensitive. The boat will be lighter by the burden of guilt, but the objective situation will remain unchanged. We cannot save them all, let us save ourselves and our standard of living.

European community's proposed new asylum law suggests that in face of the wholesale collapse in marginal lands like Bosnia or Kosovo Europe is reverting to the lifeboat ethic which it followed when the troubles in Germany threatened to launch a flood of Jewish refugees upon the West. There are too many of us, we are competing for limited resources. Generosity can only lead

to tragedy. The lifeboat ethic provides an answer. Let us help no one, only make sure that we shall use our privileges for the preservation of common cultural values, not only escalation of personal consumption as in the past twenty years. Attempts to help others beyond that only prolong the misery.

That is how Hardin reads the population cycle. It begins on the level of sustainability. That means appropriate population with a free reserve to absorb occasional strain. Population continues to rise to the point of overpopulation, of marginal survival without a reserve so that even a minor misfortune like a crop failure causes far-reaching misery. Misery then leads to frugality: it brings about a lowering of consumption and of population alike, restoring sustainability. Hardin cites the church father Tertullian in the third century: "The scourges of pestilence, famine, wars and earthquakes have come to be regarded as a blessing to overcrowded nations, since they serve to prune away the luxuriant growth of the human race."[65]

However, when foreign aid intervenes there is no return to sustainability. Humanitarian organizations maintain high birthrates, save the sick and dying, feed the hungry and underfed—while tribal chiefs, freed of the need to feed their people and armed with the latest military technology provided by countries subsidizing their armaments industries, play soldier with real tanks. Humanitarian aid leads to ecodestruction. Undoubtedly the suffering, starving, dying desperately plead for help. However, quoth Allan Gregg, the director of the Rockefeller Foundation, "Cancerous growths demand food; but, as far as I know, they have never been cured by getting it."[66] So the green revolution, doubling agricultural yields in the third world, temporarily prevented famine but brought about a catastrophic rise of populations in which each extra mouth represents a further burden on the environment. Every life we save impoverishes the next generation—and the Earth as a whole.

The problem is that people simply are not capable of long-range, unselfish thinking. Hardin cites numerous examples of shortsightedness. There is the Aswan high dam which brought short-range advantages but in thirty years without regular flooding salination destroyed the once fertile plains along the Nile. The sacred tree gingko offers an opposite example. It survived, as the only one of its kind, only because Chinese monks, believing it sacred, would not permit its felling during the massive deforestation in China, even though children were dying of cold. Not so long ago children were dying in the besieged Leningrad because privileged bureaucrats, the elite of the Soviet society, refused to open the Soviet grain archives to the crowd. Only thanks to that could Soviet agriculture be renewed after the war. Hardin has no illusion that the elites—Chinese monks, Leningrad *aparatchiki*, mediaeval nobility, or contemporary CEOs—might be more noble or more enlightened. Hardly. They, too, are only defending their privileges. Only unwittingly are they defending humankind's long-term interest as well. Tradition is not just. However, it is necessary to protect humanity against its own shortsightedness.

Where tradition is not enough to constrain human shortsighted greed, Hardin considers as the only possibility a government of a strong hand which would stop saving lives and start saving ecosystems. Nature itself could solve the problem of overpopulation in Africa if, figuratively speaking, we would surround the continent with barbed wire, ban all humanitarian aid and provide unrestricted credit for arms and munitions. If we are not willing to do that, we will not save nature and so there is no point in depriving ourselves instead of enjoying. Nature can still save itself if we stop burdening it with our humanitarian aid. Let us create an enclave of cultivated life—perhaps including natural parks—to preserve our most precious values, from chamber music to the rule of law, for our descendants. That is a duty our privileges impose on us— as well as what justifies our privileges. Then leave the world to its own catastrophes so that nature would have a chance.

Garrett Hardin is a writer easy to hate. Yet his vision is not simply callous. It is a tragic vision. Ethics is the field of freedom. Necessity is the field of tragedy—and Hardin believes that, in its grand outline, the lot of humankind is tragic. The expansion of humankind is inevitable: it is built into our very nature. The conflict of humankind with the rest of this finite world is, for that reason, also inevitable. Culture clashes with nature necessarily. The tragic end is inevitable and will not be stayed by well-meaning environmentalists recycling their plastic bags and riding trams instead of driving. People themselves, whatever they do, are the pollutant—and the only pollutant.[67] Nature will expel them when they threaten its stability. That we cannot change, any more than we can change our mortality. Try as we will, we shall yet die. So will civilization. Yet ere we do, we can live rich, full lives, not cramped by vain striving for immortality. We can create a noble civilization, not cramped by ecological constraints—since ultimately those constraints are futile.

There is a tragic nobility to Hardin's vision which those who would save humanity from ecological self-destruction need to take into account. It is the wisdom of Ecclesiastes, of Death in *Death and the Ploughman*. Perhaps the answer must come from poetry—"Ah, when to the heart of man was it ever less than a treason/ To go with the drift of things, To yield with a grace to reason, / And bow and accept the end of a love or a season?"[68] The answer to the wisdom of Death is the courage of the Ploughman.

Ethics of the fear of the Lord, ethics of a noble humanity, ethics of reverence for life, land ethic, lifeboat ethics, all those are basic patterns with which contemporary ecological thought is groping. Each has its starting points and its consequences. All run up against a similar question—how do we go about it?

Here too, various strategies are possible. One strategy sees the root of the problem and so the key to its solution in humans, perhaps in their alienation

from nature or their irresponsibility towards it, and so seeks a solution in personal responsibility and various forms of deep ecological ethics, from deep ecology to ecofeminism. Those are approaches of personal responsibility which we could designate as *subjectivization in ecological ethics*. Their opposite, much favored in post-Communist societies and corporate boardrooms, seeks the root of the problem in a systemic conflict of nature and culture and so looks for systemic understanding of what puny human efforts cannot change. That is an approach of recognized necessity which we can designate as *objectivization in ecological ethics*. Sociobiology, the GAIA hypothesis, the projections of the Club of Rome exemplify this approach.

Can humans only accommodate to an iron necessity of civilization's development to self-destruction? Or can humans change their mode of behaving? God knows. This alone is clear: the Earth cannot in the long run sustain our present demand upon it. Sustainability demands significant lowering of demands in the overconsuming countries, elimination of misery in the third world and a global reduction in populations. That correction can happen catastrophically, as it has already five times in the history of life on earth. Or we can carry it out consciously, seeking to preserve the genuine values humanity has created, from personal safety through medical care to freedom and justice. Which way? That is the point at issue between objectivization and subjectivization in ecological ethics.

Part III

Part III: Strategies in Ecological Ethics

 The purpose of the third part of the book is to outline alternative strategies for approaching the ecological crisis. **Part III.A, Strategies of Personal Responsibility,** outlines strategies which assume subject decisions are at the root of the crisis and seek solution in changes of subject behavior (subjectivization in ecological ethics). It presents deep ecology, "depth ecology," and ecofeminism as instances.

A. Strategies of Personal Responsibility (Subjectivization in Ecological Ethics)

i. THE QUESTION OF ECOLOGICAL STRATEGIES

Hitherto we have dealt almost exclusively with ecological ethics or, a bit archaically, ecological *value theory*. We were concerned with conceptual models—how to understand the place of humans in the context of all life, the biosphere. The chief goal of our efforts was to sketch various conceptions of human dwelling upon the Earth from the perspective of meaning and value. In traditional terms, we have remained on the level of theoretical reason. In popular terms, our concern was *how it all fits together*.

However, if ecological philosophy seeks not only to understand, but also to act—that is, once it enters the level of practical reason—it needs to ask not only how it all fits together but precisely how it does not fit together, wherein and how conflict, disharmony, and threat arise and so how best to face them. So far we have dealt with the theoretical question about the basis of meaning and value. Now we are turning to the question of how evil comes into the world, what is its place therein and how, by what means, to confront it.

Please note: whether an environmental quest for living in harmony with the life of nature, seeking long-range sustainable modes of living, makes any sense at all depends on the way we understand the place of good and evil in the world. Were we to perceive the world of our life as devoid of value and meaning, as a chance aggregate of particles in meaningless mechanical motion, it would really make no sense to protect or preserve anything. Were we to assume a strictly natural scientific perspective, excluding all subject-related categories—which includes all value categories—then the world would appear to us as devoid of value and meaning. "Good," "beautiful," "valuable," all of those are value predicates anchored in the subject. If we were to consider legit-

imate only so called "objective" predicates, in relation to which the subject assumes solely the role of a disinterested observer, then we should have to restrict ourselves to recording and systematizing occurrences in spacetime, no more.

In that case we could note, for instance, that the generation of greenhouse gases, carbon dioxide in particular, is leading to dramatic climatic changes, possibly to an extinction of certain animal species, including *Homo sapiens*, but we could not judge that good or bad. That would be a value judgment and those we have excluded in the name of "objectivity." That is why ecological activism makes sense only if we approach nature not from a purely objective "scientific" viewpoint but from a human, valuing one. To seek to protect, not destroy, makes sense if we consider nature, the entire system of life on Earth, as something *good*, endowed with meaning and value—and we do not consider value and meaning simply human impressions, but the very warp and woof of reality. Or, in a word, it makes sense to save the world *if it is good*.

If, though, the world is good simply because it has its own value, good in all there is, what is there to set aright? To us the senseless death of dolphins in cruel yet financially advantageous trawl nets of commercial fishermen may appear viciously wrong, but isn't that just our shortsightedness? In the perspective of eternity, is not the extinction of dolphins and subsequently of humankind just one note in the never-ending symphony of Being? If the creation is good, do we not need to accept it as it is, built-in self-destruction included, and not seek any improvements?

That is a theme we have already encountered and shall again in the objectifying approaches. Most often we encounter it in the form of a dilemma. If nature is value neutral, then its destruction does not matter. If it is good, then whatever is natural, is good—and *everything* is natural! Manufacturing nerve gas, automobiles, and antipersonnel mines are all natural human activities. People who make fortunes devastating nature will readily convince themselves that *that is how nature wanted it* and there is no point in restricting or changing anything. They are typically willing to spend vast sums persuading others of it as well. We know it in the (post)Marxist version: whatever is real, is rational, freedom is necessity recognized—and there is no point to resisting necessity.[1]

Ecological activism makes sense only if we consider the Earth—in Leopold's sense of the system of all life, the biosphere—*something good but flawed*. The world is good but some parts of it are defective. Or perhaps nature is good, but some beings and some activities are *alienated* from it, have become *unnatural*. Then it would follow that the good Earth is endangered by something *unnatural*, something that is alienated from it, resists it—and the basis of protection must be overcoming of that alienation, restoring the harmony of human doing with the system of natural processes.

The quest can then go in one of two directions. One of those is *subjectification, seeking the reason for the disruption in human subjects and their activities*. Here the assumption is that nature is good and so are humans *in their natural state*. Their alienation is the result of certain human actions, certain human choices, certain human will. Perhaps the Fall was the result of human greed, as Navajo myths have it. Perhaps it was due to the invention of the machine which interposes itself between humans and nature. While a tool—a woodcarver's knife, a peasant's hoe—remains an extended human hand, a machine like an automated line producing souvenir ashtrays *Greetings from Connie Island* displaces and alienates the person. The task then is to seek out where in humans, where in the subjects this catastrophic failing takes place, putting humans into conflict with nature or Earth. Or quite colloquially, *what are we humans doing wrong that nature is collapsing*? That is the direction of deep ecology in all its versions which we shall yet examine.

The other possibility is objectification, seeking *not reasons* in subject acts *but causes*[2] in the system of nature and humanity quite objectively, wholly apart from what humans may wish or not wish. Humans may wish for peace but, according to some, war is coded in us by millennia of evolution. Or perhaps it is simply the nature of humankind, omnivores with infinite demands, which brings humans into conflict with freedom? Or is it only seemingly a conflict, a so-called evil, but in truth a part of the evolutionary scenario? Perhaps people who are devastating the life-sustaining ability of the Earth with their exhaust fumes are actually contributing to evolution, as cars are said to help select a breed of street-wise skunks. Spoken colloquially again, we are asking *what about the objective situation itself* leads to the ecological crisis? That was a direction taken by Marxist thinkers in the formerly Communist lands. Their heirs today proclaim it *the sole scientific world view*. There are, though, also people in the west who hold objectivist views of ecology, reject philosophy and prop up their views with the authority of "objective" science, for instance in the form of sociobiology or systems theory.

This way or that? Is the root of the problem and so also the possibility of resolving it in subject acts, subjects deciding and acting? Does it make sense to seek to affect the images of life and of human action in each subject, in every one of us? Or can we only passively look on while an objectively necessary process of culture's self-destruction unfolds with tragic necessity, at most hoping that some transindividual, transpersonal authority will intervene and force us to the sustainability of which we are not capable ourselves? Is the problem in us, individual subjects, or is it built into the very "objective" structure of nature and culture so that any solution would have to be brought about "objectively" by the structure of the system as a whole? Here subjectivizing strategies like deep ecology, "depth" ecology, or ecofeminism differ from the

objectivizing strategies of the GAIA hypothesis, of sociobiology and systems theory, though they often borrow metaphors and turns of argument from each other.

Practical environmentalists never worried about that. They simply rolled up the sleeves of their flannel shirts and set to work. They planted trees, cleaned out creek beds, built bird houses, seeking with enthusiasm and sacrifice to repair the damage humans cause to nature. Still under the Communist regime there were the local organizations of the official Czechoslovak Society of Nature Protectors, the Brontosaurus clubs and many others, organized or unorganized. In America, it was once Muir's Sierra Club, lately grown affluent, the Society for the Preservation of New Hampshire Forests, Appalachian Mountain Club—I cherish the memories. There is something utterly fundamental about such "flannel ecology," practical environmentalism. It is for real, the cutting edge. To dismiss it as futile since our species and the Earth will perish in due geological time always seemed to me like refusing to bandage a child's wound because the child will die in due time anyway. It confuses two time scales, that of geophysics and that of human lives. In human lives, it is active environmentalism that provides the emotional impetus for all other activity. Were we to give up flannel ecology and our flannel shirts, we should be hard put to sustain any other environmental effort.

Still, planting trees is not enough when smoke from power plants devastates entire forest regions. It makes no sense to clean out creek beds as long as factories would rather pay a token fine for polluting than build expensive filtration plants and multinationals ride roughshod over local environmental protection in the name of free trade. That requires action on another level where it is far more difficult. That is why we need to sketch not only ecological philosophy but also the strategies of objectification and of subjectification in ecological thought.

ii. DEEP ECOLOGY: ARNE NAESS AND FRIENDS

Strictly speaking, the kind of thought which we identify as "deep" ecology had already several centuries of tradition when the Norwegian logician Arne Naess[3] first coined this term in 1973. Still, his distinction between "shallow" and "deep" ecology helped draw clearly the crucial distinction between ecology that is interested only in the technology of environmentally friendly production and ecology which goes to the roots of the ecological crisis in human attitudes, especially in the consumer orientation of Euroamerican civilization. That is a fundamental disagreement—should we seek a solution for the ecological crisis in more demanding technology or in a less demanding humanity? Naess's great contribution to ecological ethics is most of all his clear recognition that technology is not enough. A basic shift in attitude is needed.

Regrettably, the beginnings of Naess's movement were marked by two unfortunate misunderstandings. The first was brought about by the impression, however unintended, that Naess contemptuously dismisses all ecological activism which does not share his rather idiosyncratic philosophical conceptions and terminology as superficial. Especially many practical ecological activists, heirs of John Muir (1838–1914!) and Aldo Leopold (1887–1948!),[4] did not take it kindly when the Norwegian prophet, newly arrived on the ecological scene, seemed to write off their efforts as "shallow" and proclaimed his insights not only fundamental—which they most emphatically were and are—but as original simply because he expressed them in the then fashionable philosophical terminology.

Such an impression was grossly unfair to Naess, who made a major effort to overcome this misunderstanding and stressed the legitimacy of various "ecosophic" systems, but a certain ill will toward his "deep" ecology remained. Nor did it help that Naess's original "deep" insight picked up, like a rolling snowball, a number of elements of what we shall describe as "depth ecology," theses taken over from some very idiosyncratic philosophical fashions which are far from acceptable to all who genuinely seek the roots of the ecological crisis in human attitudes. All that gave rise to the unfortunate impression that according to the "deep" ecologists anyone who does not accept a certain conception of human identity and fashionable idiom must be "shallow" and that to be "deep" one would have to accept Jungian psychology and Buddhist theology as well. Altogether, it seems most unfortunate, though understandable. Naess's deep ecology, of itself offering a rich contribution, needlessly made for itself a number of opponents out of potential sympathizers, Albert Gore among them.[5]

What did Naess have in mind when he took to identifying his thought as *deep* ecology? His early work reminds the reader more of Noam Chomsky's conception of linguistic *deep* structures than of the deep protoconscious strata of depth psychology. Basically it has to do with the matter of strategies in ecological ethics: where ought we seek the root of the ecological crisis, in human greed or in flawed technology? Where ought we seek a solution, in a less demanding humankind or in a more demanding technology? Still in the 1960s there was a distinct tendency to write off ecological problems as a marginal flaw in the beauty of "progress," understood here as the technological expansion of material consumption, brought about by inadequate technology or financing. With good reason. The directors of multinational concerns were quick to realize that the fundamental change in consumer mentality under the impact of ecological devastation, so noticeable in North America and western Europe in the mid-seventies, might interfere with their profits. Their public relations departments started to propagate the conception that the ideology of "progress"—escalation of consumption in the hope that it will resolve all

problems of humankind and humans alike—is of itself right and just and that we ought to go on escalating production (and profits), though we do need to improve the technology of production and invest more in making good the damage.[6] That is the source, inter alia, of the thesis proclaimed by the neo-liberal former prime minister of the Czech Republic, that first we must concentrate on increasing production, only then will we be able to afford ecology. It is in principle a cosmetic approach to ecology, rather like that of the tobacco manufacturers who responded to the Surgeon General's report on smoking and health by introducing filters and "light" cigarettes.

This is the approach which Arne Naess wanted to designate as "shallow" because it deals only with the *results* of human activities and not with the *basic orientation* which brought on the crisis. To it he wanted to oppose an ecological philosophy which would go to the root of things and would ask about our ideas about the meaning of life which cast us, fellow dwellers on this Earth, in the role of its conquerors and despoilers. He was concerned with an ecological philosophy which would look deeply at the civilizational posture which leads to the ecological threat—that is, with a *deep ecology*.

The notion that our identification of progress with ever higher material consumption is basically sound and that ecological damage is just an unfortunate side effect of inadequate technology—what Naess calls "shallow ecology"—is of rather recent vintage. Texts like the one just cited from John Muir show that ecological and environmental thinkers were convinced all along that ecological damage has deeper roots. The technology of ecological damage is only the tip of the iceberg. At the root there are human attitudes and assumptions such as the conception of humans as "masters" of nature or the conception of escalating production as a social panacea. That is why ecologists and environmentalists alike, from Vergil to our day, have for the most part focused on changing those human attitudes and assumptions which lead to exploitation and only secondarily on protecting nature by better technology. Arne Naess stands on solid ground: ecology was traditionally "deep" long before being called that.

It is basically this time-honored approach which Arne Naess noted in 1973 and labeled *deep* ecology while condemning previous ecology as *shallow*. According to his pivotal 1973 article, "The Shallow and the Deep, Long-Range Ecology Movements," the ecological movement is shallow because it is basically cosmetic, concerned to assure a pleasant environment for the privileged. It struggles with pollution and depletion of raw materials insofar as they threaten our affluence, it is concerned for the health and wealth of the privileged in the overconsuming countries who want nature for their garden and are willing to export polluting industries into the third world, but wholly overlooks the deep roots of ecological threat not in the failures but precisely in the successes of consumer "progress." To someone who had just finished reading

Leopold's "Land Ethic" that might seem like a surprising conclusion. However, the many people who had just finished reading the report of the Club of Rome, *Limits to Growth,* or one of the systems-theoretical ecological texts and thought them representative, might well think his characterization of ecology as shallow quite justified.

Rather than the ambiguous metaphor of depth it is useful to note what Naess considers the basic traits of his "deep" ecology. Generally it is its orientation to the roots of ecological damage in human attitudes and behaviors. Naess supplements that with a list of further marks of a deep ecological movement. It is not clear whom he is describing when he claims that "the deep ecological movement says." Perhaps a better way to approach it would be to say that Naess considers an ecological movement *deep* rather than shallow when it meets a number of conditions. Among these he includes:

rejecting the idea of external relations. The Earth is an interconnected system in which everything affects all else. It is not possible to start up an automobile and think it a private matter. The exhaust fumes are everybody's business. It is not possible to have a high standard of consumption amid a world reduced to poverty. Everything is linked with everything;

supporting biotic equality. That is Schweitzer's familiar "biocentric" thesis from the first part of the century which Paul Taylor developed systematically. For human dealings with the Earth the basic guide is not a hierarchical ordering of higher and lower but rather a fundamental equality of all lives that rejoice and suffer;

considering diversity and symbiosis rather than a "struggle for survival" *basic.* With that Naess places his deep ecology unequivocally on the side of Schweitzer and Leopold against the views of Nietzsche and Hardin. The meaning of life is life itself, not the struggle for it;

rejecting all claims to superiority, on the basis of both preceding principles. It is not possible to divide beings into those who will exploit and those who are to be exploited—humans and experimental animals, or humans of the privileged world as against cheap labor;

considering ecological practice a part of global ecological effort. The struggle against pollution and exhaustion of nonrenewable resources which the authors of *Limits to Growth* and systems theoreticians generally take for the sum of the ecological crisis deep ecology understands as a component of an effort whose essence is a struggle for a global, systemic approach to life which would be compatible with the well-being of all life in the long run;

striving for consistent global thought, not a flood of fragments of information. An ecological movement can be considered deep if—or, in Naess's own way of putting it, the deep ecological movement —takes reality not for a compilation but for a complexity—complex humans and complex organic society of many varieties, not isolation of individuals and their confrontation with a monolithic society;

standing for decentralization and local autonomy against hierarchy, supports maximal local self-sufficiency against global waste. Every long-distance transport is wasteful, advantageous only for the importer while impoverishing producer and consumer alike.[7]

Except for the last principle, Naess's deep ecology in the first round—the 1973 article—is basically a coherent summary of principles which have guided ecological thought for a century or more against newer, "shallow" approaches which seek to silence protest with cosmetic adjustments or at best would assure us a few more decades of consumer growth by globalization, rationalization and ecologization of production. Naess wants an ecological philosophy, not simply a positive science of ecology. Ecological philosophy— or deep ecology—offers a global conception of human life compatible with long range sustainability of human life on Earth. In this phase, then, deep ecology is more or less identical with traditional ecological philosophy and acceptable to all ecological activists except for the hardest core of technocrats. It is a deep ecology, but not yet "depth" ecology in the specific sense we shall examine later.

Between Naess's 1973 article and the article "Identification as a Source of Deep Ecological Attitudes" in 1985 there is a marked shift from an emphasis on *acting in the interest of life* to *identification with all life*. Naess found three talented and wholly devoted American followers, Bill Devall, George Sessions, and David Rothenberg, who provided his thought with a broader philosophical foundation while guiding the conception of ecological philosophy—or in his newer terminology, of ecological wisdom, *ecosophia*—in a distinctly subjectivizing direction. While Naess's original aim was to solve the ecological crisis by changing human attitudes, the new concern of ecosophy seems to do more with personal self-realization by identification with nonhuman being. Its supporters declare that this identification will lead to objective ecological change as humans realize not a narrow Ego but a broad Self, though it is less than clear just how that will take place.

Naess is a careful and thoughtful thinker and the development of his thought is gradual. In the article which marks the second stage of his thinking—"Identification as a Source of Deep Ecological Attitudes" which we noted earlier—he again opens with his favorite comparison of shallow and deep ecology. The first is said to appreciate diversity only as a resource for humans while the latter considers diversity a value of itself. According to the first, value always means value for humans while the latter rejects that conception as racism of our kind. The first protects a variety of species for their usefulness, the latter for their intrinsic worth. Thus far we are basically comparing anthropocentric and biocentric attitudes, though Naess does not use these awkward labels and, at the time, might not even have encountered them.

The second group of comparisons compares the attitudes of deep ecological movements with the assumptions of typical ministries of the environment,

though Naess again does not describe it in these terms. Rather, he points out that the shallow or reformist ecology opposes pollution only to the extent to which pollution interferes with economic development while for deep ecology the environment is more important than development. Shallow ecology criticizes overpopulation in the third world, deep ecology criticizes overconsumption in the world of the privileged. Shallow ecology insists that humans will not accept a lowering of their level of consumption, deep ecology points out that people ought not to accept a lowering of the quality of life. Rather, in the overprivileged countries, they ought to accept lower levels of consumption. Finally against the thesis that nature is inevitably cruel Naess presents the thesis that it is humans who are cruel, though not inevitably so.

Naess's early texts reflect a deeply felt, shared stance of all practical environmentalists—or, in insider's terminology, of "flannel ecologists." It is the stance of all for whom ecology is not just a theory but a deep personal commitment. Out of respect for nature they would *tread lightly upon the Earth*, as the Greenpeace slogan has it, not burdening it with needless demands. Out of respect for the Earth they opt for selective demands and general frugality as against mindless consumption. That, too, is a strongly shared feeling of Czech and Slovak environmental and ecological initiatives, the Czech Society of Nature Protectors, the DUHA Movement, Slovakia's forest initiative VLK (or Wolf, whose preservation they support,) the Children of the Earth, the south Bohemian Rosa, Brontosaurus and many others. These are not people who would want to return to living in caves or in trees, as their opponents often caricature them. They seek only to choose deliberately and respectfully. Respect for the Earth and love of all life preclude consumer snobbism.

All the "flannel" ecologists could share the themes of Naess's later ecosophy as well, though here Naess takes subjectivization a good bit further, shifting the emphasis from the protection of nature to self-realization through nature. His initial thesis is one of *self-realization of our common Self, not cultivation of personal ego*. Naess claims that the principle of self-realization is valid, but the question is what we shall mean by the self. That is a problem that ethical anthropocentrism faced already. Yes, we always act out of our own interest, but there is a great difference between interpreting "our own" interest as short-term personal gain, the good of all Norway, or the long-term good of all humanity. Here Naess resorts to the terminology of Indian philosophy with which I am not familiar and so can only report, not warrant the accuracy of his reading. As Naess understands it, the word *atman* or self-presence does not indicate a specific entity or organism but a nonsubstantival presence of *me* or *mine*. The task of humans is harmonization with all that is through yoga, either in meditation or in action. The great self-presence, *mah atma* Gandhi, is said to have been a *karma-yogi*, connected with being through deed. Others might find harmony through meditation.

The notion is familiar in Western philosophy as well. The difference between selfishness and generosity is not one between acting in my own interest or in the interest of another, but between having a narrow as against a wide-reaching interest. Naess had earlier pointed out as much and great many people who would readily accept the principle of acting for the common good, not for the selfish good of each individual. They tend, though, to be at a loss when we express it as "self-realization of the Greater Self." Is yoga really a necessary condition of depth in ecological thought? And is an ecologist who is not familiar with Indian philosophy necessarily "shallow" or superficial? Here there may be something of a slide from Naess's deep ecology to something we might usefully label *depth ecology*, on analogy with depth psychology.

In fairness to Naess, we ought to note that he stresses what his followers of the "depth ecology" persuasion will deny, that *identification is not a matter of a mystical state* but of grasping the basic continuity of myself with the other and with all the world. It is a matter of becoming aware of the wider dimensions of myself. Still, Naess's text is susceptible to both interpretations. In his second thesis, Naess speaks of gradual identification as the basic tool of personal growth and natural product of maturity. That, again, we could interpret along flannel lines in the sense that maturing is a process of gradual overcoming of childish selfishness and extending one's capacity for empathy. Growth is essentially opening of myself to others in empathy, sympathy, and solidarity. Naess cites an interesting example. Native American hunters intensively identified with game. They hunted it, but they lived in a true harmony with it. A great many city dwellers who would never dream of shooting a deer yet live in the utter alienation from all extrahuman life, in an alienated isolation.

Here we run into a basic trait of all subjectivizing approaches. All of them understand nature as basically good and harmoniously ordered, though in the conflicted harmony of life which Aldo Leopold describes so sensitively. Yes, there is a food chain in nature, the basic organizing principle is "eat and be eaten," yet *life is not about cruelty to the other but about rejoicing in living*. Nature is a system of conflicted *harmony* in the sense that it is free of ill will. Ill will is a human speciality which—the argument runs—grows out of alienation from the simple, guileless good will of nature to the ambiguity of reflection and at the same time confirms that alienation.

To most flannel ecologists it seems unambiguous: we are dealing with an alienation from nature in the tangible sense of the diurnal cycle, of the good Earth and fragrant wood, of the nearness of warm furry beings. How are people to understand even the link between love and labor when they have never watched a loved one bring wood and kindle a fire to give them warmth? When parents disappear each morning "to go to work" because they "have to make

money" while heat rises anonymously from central heating? How are they to understand the meaning of darkness and light when at night they see only a neon halflight and flicking a switch floods them with brightness? When they never cleaned a lamp, never trimmed a wick, never kindled the golden halfmoon of flame? How can children understand the beauty of life if they do not learn about it by caring for a living being but by following action films in television? Once I wrote a book about that myself.[8] Alienation from the world of life in the world of concrete cells—that is the fundamental lived experience from which flannel ecologists flee to nature, into the woods, to the rivers, into the hills.

Naess's theses can be read in a flannel mode, but they can be interpreted mystically as well, in the sense of a descent into the depth of a collective unconscious, into the protoconsciousness of all life. That is how those of Naess's followers for whom alienation is primarily an alienation from the depth of our identity see the problem. For them, the solution is more likely to lie in meditation than in forestry. Those we can with some justification call *"depth" ecologists.*

There is a third deep or subjectivizing approach, one which understands the alienation of humans primarily as an alienation of our dominating, masculine civilization from all that is feminine, soft, dark about us—and links us to the Earth. The oppression of the Earth then appears as one of the consequences of the oppression of women—and the liberation of women as a fundamental step toward the liberation of nature. Such an approach is usually labeled *ecofeminism.*

Naess's conception of deep ecology—or, in our terms, of subjectivization in ecological ethics—could subsume all three approaches. To me Naess's own emphasis appears fundamentally flannel, though his successors, Devall and Sessions,[9] tend to stress cultivating an ecological awareness and seeking the roots of ecosophist attitudes in the depth of the soul and in non-European thought. They point to the awareness of the unity of being in Taoism, in Zen Buddhism, in the thought and rituals of original Americans. The basis of all ecological effort is for them an awareness of the bond of all being. That is the fundamental insight of all subjectivization in ecology. *Humans are the beings whose self-realization means self-transcendence.* Here, though, self-transcendence does not have the flannel undertone of dedication to practical activity but rather one of expanding the narrow limits of personal consciousness by a wider, suprapersonal consciousness in empathy with other beings.

Like all who share a strong respect for life and for the Earth, Devall and Sessions, too, reach the principle of reverence for life, a deep version of the voluntary simplicity which we have encountered earlier. George Sessions and Arne Naess sum up that powerful conviction in the central chapter of *Deep Ecology:*

> 1. The well-being and flourishing of human and nonhuman Life on Earth have a value in themselves (synonyms: intrinsic value, inherent value). These values are independent of the usefulness of the nonhuman world for human purposes.

2. Richness and diversity of lifeforms contribute to the realization of these values and are also values in themselves.

3. Humans have no right to reduce this richness and diversity except to satisfy *vital* needs.

4. The flourishing of human life and cultures is compatible with a substantial decrease of the human population. The flourishing of nonhuman life requires such a decrease.

5. Present human interference with the nonhuman world is excessive, and the situation is rapidly worsening.

6. Policies must therefore be changed. These policies affect basic economic, technological and ideological structures. The resulting state of affairs will be deeply different from the present.

7. The ideological change is mainly that of appreciating *life quality* (dwelling in situations of inherent value) rather than adhering to an increasingly higher standard of living. There will be a profound awareness of the difference between big and great.

8. Those who subscribe to the foregoing points have an obligation directly or indirectly to try to implement the necessary changes.[10]

This is George Sessions at his very finest. The first five points surely sum up the basic, gut-level conviction of all who care about the long-term viability of human presence on Earth while the concluding call to arms represents the best of Arne Naess.[11] I still cannot read this volume without feeling a certain thrill. The presentation may not bring out anything that has not been said sometime in the history of environmental and ecological thought, yet Naess's followers present it far more evidently as a program, communicating a sense of urgency and vocation, even though it is not clear whether the last point calls for clearing out a river bed or for doing consciousness expanding exercises. Still, that call to action seems to me an absolutely crucial contribution. To appreciate *life quality* rather than an increasingly higher standard of living—that is the finest summary of the credo of all flannel ecology with which all environmental activists could surely identify without reservations.

At the same time, the sixth and seventh points do open the way to further subjectivization which might well be more problematic—to the thesis that our inability to live in harmony and long-term sustainability with nature is not a function of our alienation from living nature, from fragrant wood and warm fur, but from a putative depth of our unconscious. A certain troublesome superficiality mars this fine volume, as if the authors were more concerned with evoking an elevated mood with a compatible locution than with understanding the meaning of a text. Can including three pages of Heidegger and one on "Eastern Spiritual Tradition" serve more than evoking a mood? Those are serious questions which a reader ought to raise about this seminal volume. Perhaps behind all of them lies a deeper question, posed by Husserl to Heidegger:

Is irrationality really a solution for the problems of mathematical, technical rationality? Or do we need a broader, qualitative conception of rationality?[12]

A footnote: "deep" or "depth" ecology?

Thinking and writing in Czech, I took advantage of a distinction which that rich language offers between hluboká *and* hlubinná. *The first refers to thought deep in the general sense of profound, the latter is a technical designation of those psychologies which, like Freud's or Jung's, seek to explain overt phenomena as effects of putative latent contents. English makes a similar distinction in speaking of* **deep** *thought but* **depth** *psychology. (The distinction also appears in submarine warfare: the ocean is* **deep** *but the charge which probes it is a* **depth** *charge.)*

While Naess's native language is Norwegian, his English is superb and in it he consistently uses the term **deep ecology** *and, I believe, with every justification. He is dealing with ecological concerns in a way which is profound, deep in the sense of examining its overt human and civilizational roots, but does not seek to explain it causally by the functioning of a putative latent content, which is what would justify the designation* **depth ecology.**

In Naess's thought and even more in that of some of his followers, however, there is a gradual drift from this concern to a concern with latent content, with a putative common protoconsciousness of all life obscured from our ordinary awareness by overt consciousness which is said to lead us into conflict with Nature. To reestablish a harmony with nature, we are said to need to reach beneath such reflective overt consciousness to the depth of latent contents, the spontaneous protoconsciousness of all life. Such a conception would then merit the designation **depth ecology,** *on analogy with depth psychology.*

This shift is most clearly and movingly manifest in John Seed's handbook of ecological consciousness raising, **Thinking like a Mountain.** *The authors here explicitly seek to lead the readers beneath the everyday commonplaces to the depth of the shared protoconsciousness of all beings, as we shall examine later. I believe the designation* **depth ecology** *can be helpful in distinguishing the specific approach of John Seed's Council of All Beings from* **deep ecology** *in Naess's original generic sense which includes all ecological approaches that seek the root of the crisis in human attitudes and behaviors. Deep ecology in that generic sense includes a great deal that would seem superficial to the "depth ecologists"—while in turn their inward turn might well seem suspect to many genuinely* **deep ecologists.** *As Naess himself recognizes, there are many and diverse deep ecological systems or ecosophies and not all who*

have not studied Buddhism are necessarily superficial—though many people are convinced that such study rather than, say, active environmentalism, is the best way.

iii. ECOLOGY OF DEEP IDENTIFICATION

Arne Naess set out by distinguishing deep and shallow ecology and, for all its flaws, it was a useful distinction. There is a clear difference between thinkers who assume that the strategy of material progress, of open-ended acceleration of production and consumption, is good and right altogether and needs but be more careful in choosing its means, perhaps by aiming for not just growth but *sustainable* growth—and those thinkers who question the very orientation of our civilization to mastery and greed. Ecology, though, can be deep in the sense of looking for the deep causes of ecological distress in human acts and attitudes and yet vary significantly. It can, for one, see the root of that distress in human irresponsibility, the failure to consider the ecological consequences of our acts and to structure our modes of living accordingly. It can see that root in humankind's estrangement from living nature in an artificial human-made world and seek renewal in contact with it, in the best flannel-shirted sense. Or, finally, it can see that root in human alienation from nature within, in losing touch with the emotive and feminine aspect of our being, much as depth psychology sees the root of pathology in alienation from the depth of our psychic being. It is that third approach which, provisionally, we have labeled *depth ecology*.

Czech readers encountered depth ecology in Jiří Holuša's brilliant translation of the handbook produced by three ecological activists, John Seed, Joanna Macy, and Pat Fleming, which uses as its title the phrase of Aldo Leopold's which we have encountered before, *Thinking like a Mountain.*[13] This expression, however, acquires a rather idiosyncratic meaning in this volume. In Leopold's *A Sand County Almanac, thinking like a mountain* had a distinctly "flannel" flavor.[14] There it meant taking into account not the good of a particular kind but of the ecosystem as a whole. As such, it was a shorthand summary of the ecocentric attitude in ecological ethics.

In the writings of John Seed and his coauthors, the expression "thinking like a mountain" acquires a rather mystic tone of Naess's identification. Leopold's ecocentric interpretation was external: humans thinking of the mountain or of the Earth from the viewpoint of the whole. For the depth ecologists such a mode of thought continues to be flawed by human alienation. *Humans thinking* indicates individual consciousness, even if this consciousness is concerned with all being. For the depth ecologists, the basic reality is something else: a common consciousness or, better, the common protoconsciousness of all being in its prereflective unity. It is the being of the blade of

grass, of a gull high in the sky, of a human in a South American primaeval forest, the same today as a thousand years ago. There is but one life which lives in all things living, as Albert Schweitzer argued already. Similarly as the collective unconscious in Jung's depth psychology, so, too, the common protoconsciousness in depth ecology is allegedly the one fundamental reality.

When people begin to reflect and to think critically, the usual story goes, they stand out by their thought from this fundamental unity of all life and lose understanding for it. According to Jean-Jacques Rousseau in *Social Contract*, thinking humans are depraved animals—and here we encounter one reason for thinking it is so. Reflection, conscious thought, critical reason all carve us out of the solidarity of all being and oppose us to it. That is the answer to Schweitzer's question why, though life is one, reality is a constant struggle of lives with each other. Simply because our critical reason, our reflective thought separated us from our innermost common I, so basic to all beings.

Note how often we in fact use our reason to overcome our emotional resistance to the destruction of nature. Perhaps even a developer, looking over a quiet forest valley into which he is about to launch his fleet of bulldozers, might experience a twinge of regret over the beauty and the small inhabitants of the forest to whom that valley had for centuries been a home. Just for a moment. Then the mobile telephone rings and reminds him to *be reasonable*. Building a gated community of luxury homes represents a profit of millions— and no one thinks to ask why the world should need gated communities or why he should need those millions. For that matter, even ordinary mortals sitting down to a bloody rare steak defend their diet against any spontaneous emphathy with the victims of the meat industry and animal experimentation by an appeal to "being reasonable." If I let my feelings be my guide, I could not even drive a car—I could not come to terms with the dead animals and trees poisoned by exhaust fumes, not to mention Prague's asthmatic children. I am fortunate: Prague still has an excellent public transportion system and the Czech Republic a fine network of frequent trains. It was different in New Hampshire. Good thing there is reason!

Is it a good thing, or just the opposite, a misfortune which led us into conflict with nature and with each other, to the edge of an ecological abyss? To the depth ecologists—and I would stress that this holds really of the depth ecologists, not necessarily of all deep ecologists—it rather seems that reason is the villain. Though usually critical of Cartesianism, most of them take over uncritically a pseudo-Cartesian conception of reason as a wholly abstract, theoretical calculating ability and oppose it to feeling, as if humans had two ways of experiencing reality, (cold, abstract) rational and (warm, sensitive) emotional. Were

that the case, then it would indeed follow that the tragedy for humans and for the Earth is precisely our alienation from the emotional depth of all beings by our critical reason—and irrationality might well appear as the path of salvation. We might then well conclude that as long as humans remain in the bondage of reason, they cannot escape the vicious circle of consumerist rationality. The first prerequisite of ecological action would then indeed be to break free of this bondage—and, to the extent that rationality is reduced to narrow technical rationality, it could even be true.

Then it would indeed follow that, if reason is what alienates us, it really makes no sense to invent new rational schemata, including those which Arne Naess considers ecological. John Seed and his fellow authors do quote one fragment from Naess's later work in their handbook. However, unlike Naess, who seems to have been driven to build conceptual constructs and compile lists of good advice, John Seed and his friends do not offer another theory but rather psychohygienic practice. Their *Thinking like a Mountain* really is an eminently practical handbook in the best sense, designed to share an experience rather than communicate a body of theory. It is a guide for organizing a workshop which would help liberate the participants from their individual reflective awareness and teach not an intellectual, but a genuinely emotional return to the primordial I which really is not even an I but rather the unity of all life.

The basic meditation here is something the authors describe as *evolutionary remembering*, a profound and intense journey of self-discovery. I am—or more precisely—in me there lives all life and I bear all life within me. "Let us go back," the authors bid you,

> way back before the birth of our planet Earth, back to the mystery of the universe coming into being. We go back 3,500 million years to a time of primordial silence . . . of emptiness . . . before the beginning of time . . . the very ground of all being . . . From this time of immense potential, an unimaginably powerful explosion takes place . . . energy travelling at the speed of light hurtles in all directions, creating direction, creating the universe. It is so hot in these first moments that no matter can exist, only pure energy in the form of light . . . thus time and space are born.[15]

The authors and their Czech translator accompany the readers on a step-by-step journey through the history of evolution, their own history. "We are the descendants of the stars. We are the children of the cosmos. It was we who once glowed in the stars." That is not theory, it is an emotional method which requires a total surrender to the evolutionary recollection to live the experiences of the birth of life, of its evolution on the land and in the seas, in the forests and on the savannas. "You are now recounting your evolutionary journey," the authors conclude, "recounting how the cosmic journey has been for you so far." The Czech translator inserts a sentence true to the spirit of his translation though not to the letter of

Seed's text, "Perhaps unsuspected potential is hidden within you. Be sensitive to your feelings in this world. Do not seek to escape them."[16] If you can suspend disbelief, it is an immensely powerful, transforming experience. Those who let the mood of the ritual lead them, those who feel through all the recollection, will also feel clearly: there is but one life that lives within us. Nothing is alien to us. It is time to take part in the ritual of a Council of All Beings.

The Council of All Beings is a workshop, a ritual, and something of a religious rite which our relatively recent hunter-gatherer ancestors might have understood. Its purpose is to render the participants fit for ecological activity by an emotional fusing with all the living Earth. As for our reflective, critical reason, even the best intended ecological activity will be vain until we purge ourselves of it by the immediacy of feeling and revert to the emotive immediacy of our ancestors, hunter-gatherers.

The authors recommend starting with an hour alone in nature. It is not an hour for thought—we need to put our reason to sleep. It is an hour—no, hours remind one of mathematical rationality—it is a time of feeling, freed from thought, a time for taking in the world around us, for empathizing with it while awaiting the being who will speak out through us.

That being could be a seagull, it could be a simple weed or a perishing blossom, it can be a cow which knows joy and pain and does not understand its role in mass production. Out of construction paper, glue, and paints we make up masks which symbolize the being that spoke through us. We do not speak: speaking distracts, separates. We feel mutuality. Then comes the fire and the fragrant smoke, with it the monotonous, repetitive rhythm of drums and tambourines. Just like our ancestors, for whom drumming, drumming for hours, for days, was an important means of self-transcendence, we, too, reach a state resembling a trance. It is no longer I who live, it is Life that liveth in me and through me. Now we are ready to speak out the suffering of the Earth.

> "I am a black and white cow, fenced in a paddock, far from grass, standing in my own s—t. My calves are taken from me, and instead cold metal machines are clamped to my teats. I call and call, but my young never return. Where do they go? What happens to them? . . ."
> "The shells of my eggs are so thin and brittle now," cries the wild goose. "They break before my young are ready to hatch. I fear there is poison in my very bones." . . .
> "Hear us, oh people!"[17]

It is an experience that will leave no one indifferent who lets oneself be borne by the profound empathy with the suffering Earth. The authors are convinced that only the purification through vicarious pain enables humans to ask for counsel, no longer of their own reason, but of the beings that speak through them. Then they scatter again, to bid farewell in nature to the being that spoke through them, returning to their lives purified and renewed.

It is far, far from the world of practical ecology, of concerns with water purification and waste disposal. No theoretical description in the categories of critical reason can mediate the depth of the experience of a Council of All Beings. Theoretical descriptions belong to an alienated world. Do not form a judgment about depth ecology until you have yourself gone through the emotional exercise which breaks down the barriers among beings, in which you can live the fate of a factory farming cow, of a wild goose or a wetland drowned in spilled crude oil. Go through it at least by yourself, sensitively reading the handbook, *Thinking like a Mountain*. In the end you can agree or disagree with the depth approach, but you have to live through it first. Anyone who never felt the pain of a world being destroyed does not know what it is all about and has no right to criticize.

Then, to be sure, comes a time to ask critical questions. Perhaps the most basic is whether it is really reason that alienates. Or does reason set humans apart, setting them on a path different from those of other animals, without alienating them thereby? Is it not only reason in the service of domination which alienates, the technical reason for which knowledge is power? Do humans dominate and despoil because they are rational—or is this simply a lazy reason in the service of greed, of a corrupting emotion?[18] And is it not precisely reason in the service of love, the chastened, second-level rationality represented by writers such as Holmes Rolston III, which is capable of overcoming alienation? Does not depth ecology's rejection of reason leave humans at the mercy of emotions which include hate and envy, anger and malice? Do not humans need reason precisely in order to distinguish between love and hate, between emotions which sustain life and those that destroy it?[19] Both are equally immediate, equally "authentic." Is not the difference between them one not of "authenticity" but of good and evil which precisely reason can discern? All of those are questions which depth ecology does not answer but which do need to be raised.

iv. FEMINISM AND ECOFEMINISM

American ecofeminism, the third stream of deep or "subjectivizing" ecological thought, is far too vibrant a field for an observer to keep up with it from across a sea. Perhaps its most important contribution is that it extends the depth ecological critique of rationality with the claim that reason is destructive also *because it is masculine*. It is at the same time the instrument and the legitimation of the impoverishment of our being of all that is feminine, caring, nourishing, feeling about it. It would be folly to attempt or pretend to cover all the ongoing debate about it. We can, though, try to capture some central motifs from a basic text, much as we have throughout, and leave it up to readers to follow up with further reading.[20]

In the Czech lands as well as in Slovakia feminism tends to be a blank spot on our conceptual maps—and not because discrimination against women is unheard of among us. It is, rather, that our hermetically closed society has not yet become accustomed to life in the open and so has a tendency to reject preventively everything that might disturb familiar ways. And feminism does disturb, in part because most of us have no idea what it means.

Perhaps the most common definition is that feminism is *the struggle for the liberation of women from a subordinate position in society.* In this sense anyone who takes democracy seriously must support feminism. *Liberté! Égalité! Fraternité!* In a democracy, any inequality of right is a leftover of a hierarchic social order. There can and must be diversity in a democracy, not only "toleration" but most of all a positive attitude to diversity. There can even be division of labor, since a complex society requires specialization, but inequality of rights is an insult to our democratic conscience. If in the Czech Republic women's wages represent on the average two-thirds of men's wages, if a workshop full of women workers with a male supervisor seems natural to us and the opposite unthinkable, then there is something badly out of order with our democracy. In that sense, the feminists would claim, we all have a moral obligation to "be feminists"—to stand up against the discrimination of women.

Feminism, though, has a series of other meanings as well. A more specific meaning comes from the conviction that *the subordinate position of women is not only a product of traditional discrimination but an expression of the overall domineering posture* of this society which oppresses not only women but also the poor, the old, the foreign—and drastically also all nonhuman beings. We honor the master—and a master needs slaves, finding them on all sides, in all the groups of those who are weaker. The attempt to liberate a given group without changing the very principle of oppression is inevitably futile. Thus feminism becomes the struggle against the posture of (masculine) domination, against all exploitation. Women struggle not only for their equality but against the very principle of unequality, together with all the oppressed. The feminists see themselves as an inseparable component of the struggle for equal rights against all domination and subjugation.

Beyond that, another step is possible. Some feminists are convinced that *the oppression of women is not just one instance of oppression, but is the basis of all oppression.* According to them, human society was originally free of any oppression. Oppression enters into human affairs only with the revolt against matriarchy, or, more precisely with men's revolt against the feminine principle in us all. Psychologists, notably C.G. Jung, have convincingly argued that in our makeup we are not simply men and women. Each of us bears within both a feminine and a masculine principle, an active principle and a receptive one. The harmony of life shared is rooted in the harmony of the masculine and the feminine within each of us. The revolt of the masculine principle against the

feminine is the root not only of the oppression of women but of all oppression—and the liberation of women does not promise freedom only to women but to all the oppressed. In that case feminism becomes the effort at liberation of all the oppressed by the liberation not of women only but of the feminine in all of us. As long as all oppression is rooted in the denial of our femininity, most manifest in the oppression of women, then the liberation of our femininity and the liberation of women would mean the end of all oppression.

The feminists then ask about the mechanism of the oppression of women and of the feminine within us. A Czech can readily come up with examples. After work, a man goes for a beer, a woman goes shopping for groceries, then she prepares and serves dinner, then washes up and cleans up—and all that carefully so she would not disturb the man reading his newspaper or, more likely, watching soccer on the television. Oppression of women appears to us as something so objectively built into the structure of society that we can resist it equally objectively, say, in trade unions that insist on equal pay for equal work and generally by demanding equal rights in the work place, in the family, and in society.

However, some feminists, in great part from academic circles where evident discrimination is decently veiled by social courtesy, point to something deeper. The oppression of women may manifest itself in the work place quite concretely by wage discrimination, but its roots are deeper, in our ways of perceiving and conceiving that are so familiar that we are not even aware of them. We see the world through certain spectacles, a certain conceptual schema, and it seems to us that that is what the world is really like, of itself. I saw it at a meeting in Prague, shortly after the collapse of the Communist regime. Suddenly nothing was routine, everything had to be solved anew. As the meeting dragged on, the chair looked around at those present and turned to the only woman with the question, "Anička, would you make us coffee?" The chair never even noted that the woman addressed as "Anička" was a full professor while all the others were instructors. They were men. Making coffee, that is women's work. Incidentally, in the case just described the chair was herself a woman. Those glasses are so firmly fixed that the world seems to us to be like that.

Some such conceptual frameworks are simply a matter of local habit, for instance how hard it has to rain before I will take an umbrella. Many conceptual frameworks, however, are intrinsically oppressive. Take for instance the suffix of belonging which the grammar of Czech requires for women's surnames. I am Kohák, my wife is not. Being a woman, she is Koháková, the one who belongs to Kohák. Incidentally, not being Czech is no protection. Even Margaret Thatcher is barred from the Czech language unless she tags a feminine ending on her name, Thatcherová.[21] We never stop to think that we are not

just saying that this is Mrs. Kohák but unwittingly also proclaiming that while a man is free-standing, a woman is a dependent and has to belong to someone. Perhaps to the Koháks.

That is the rub. Some conceptual frameworks are oppressive not because they make overt oppressive assertions but because they code oppression into our ways of perceiving, as the Czech -ová or the rule according to which including even a single male—even a two-year-old boy—in a whole company of women is enough for the verbs describing them to lose their feminine endings.

Specifically, in the focal text cited earlier, "The Strength and Promise of Ecological Feminism," Karen J. Warren points out that oppressive conceptual frameworks are marked by three traits. One of those is *hierarchical thought*, which automatically orders any two realities as "better" and "worse," as higher and lower, and is incapable of grasping the idea of just being different. Surely, two can be simply different; one need not be worse or better. Yet especially in our Czech homeland something seems to resist the very idea that two could be different and not hierarchically ordered, that, in a trivial example, British and Canadian pronunciation can be different without one being "the right one"—or that women and men can be different and equal. The habit of oppression is simply too deeply rooted.

A second trait of an oppressive conceptual framework is a dualism of values which interprets difference in terms of conflict, not in terms of complementarity, as exclusive, not inclusive, and as necessarily unequal in value and dignity. A classic instance is the inability to recognize that emotions and reason complement each other, that one does not exclude the other and that neither need be "higher." The habits of hierarchy which mark already our nonhuman ancestors are too deeply encoded. Equality is a very recent human invention, a moral ideal of democracy which we have been trying to learn only since the Great French Revolution. One of the two, after all, *must* be higher, better—and in our conceptual framework the better in any pair whatever is always the masculine.

Thirdly, an oppressive conceptual framework has the logic of oppression built into it and the entire framework justifies it. It starts already among the hunters among whom men have the first claim on food because they have captured it and need the strength to hunt again. It seems so logical that it never occurs to us that men could hunt because women built a shelter, lit a fire—and just incidentally bore sons so that there would be hunters in the first place. The primacy of the patriarch is simply unjustifiable; it is only a habit defended as "natural" by those who profit from it—the males of the dominant races and classes. Even the history of philosophy as we teach it is a history of dead white males—and a pillar of the logic of oppression.

All argumentation, all effort is in vain. As long as we see the world through the prism of an oppressive conceptual framework, oppression will seem natural to us and will continue. That is why, according to the feminists who hold this view, the most important task of feminism is the struggle against the oppressive patriarchal conceptual system. Wage equality or equality before the law will come once we have fundamentally transformed the conceptual framework through which we perceive the world and will at last cease to see women as second order beings. To work for wage equality is simply an example of what Marx used to call "trade union mentality"—preoccupation with details, overlooking what is fundamental. According to the feminist thinkers who accept this analysis, we need struggle for what is fundamental, for a transformation of our conceptual framework.

That is a glimpse of what feminism is about. *Ecofeminism* then represents a natural extension of the struggle for the liberation of women from oppressive conceptual framework to the liberation of nature. Notice: in most languages nature is feminine, progress masculine. Most feminists would say that that is no accident. Nature belongs to all that is feminine in our being. Nature is the womb which bears us and the embrace which cares for us. Nature is soft, dark, feminine. By contrast, reason is distinctly masculine, aggressive, dominating. The oppression of women came about, in the European development, by the subordination of the feminine principle to the masculine principle, the oppression of nature came about by subordinating the emotive feminine perspective to the domineering masculine perspective. It is not even a conviction, only a habit: we see a woman as "only a woman," a nonhuman kin as "only an animal," and we dread the equality of women just as we dread the equality of all beings.

Yet ecological inequality is directly related to the oppression of women. Karen J. Warren cites the example of the ruthless clearcutting of natural forests and their replacement with commercial tree farming. Men profited by it, women paid the price. The primaeval forest provided fuel, food, fodder, dyes, medicines. The monoculture of fast growing hybrid poplars is good only for pulp for a hundred pages of advertisements somewhere in the overconsuming world. Feminists are inevitably ecofeminists both because it is primarily women who pay the price for ecological devastation and because the key to ecological renewal is in overcoming the oppressive patriarchal conceptual framework and returning to the emotional values of femininity in all of us.

Karen J. Warren sums up ecofeminism in eight basic theses—and they are theses familiar from deep ecology. According to those, *ecofeminism*

- *is fundamentally anti-naturalistic* just as it is anti-racist, anti-class, opposed to very hierarchical ordering, every superordination. In other words, ecofeminism supports *biotic egalitarianism*;

- *is contextualistic*: it does not understand ethics as a question of formal rights and rules but as a matter of organic shared life which grows out of the life of the community;

- *is pluralistic*: refuses to choose nature or culture, understanding culture in the context of nature, treasuring diversity and refusing a return to one or the other;

- *is developmental*, understanding theory as something that develops, grows, and lives in the narrations of women who refuse the oppression of women just as the oppression of nature;

- *is inclusive*, growing out of the voices of all oppressed women who speak in different voices, listens to the voices of Black ecology and ethics, renewing traditional Native American values of diversity and mutuality;

- *is partisan*, refusing, with all feminism, any attempt at "objectivity," unabashedly taking the side of the oppressed against the oppressors, of nature aganst those who plunder it, of women against men: there can be no "balanced," "objective" position between oppression and suffering;

- *stresses the values of caring*, of love, friendship, trust, and mutuality against the domineering values of conquest and plunder;

- *rejects abstract individualism*, understanding humanity in its relatedness, not only among humans but especially in the relation to nature.

In sum, *ecofeminism calls attention to the connection between the oppression of women and nature*, so showing that feminists need to participate in the protection of nature just as ecologists have moral obligation to include the protection of women in the protection of nature. Paraphrasing Karen J. Warren, the point of feminism is to create a world in which diversity does not lead to oppression and so includes protection of women and of all feminity against all masculinity which oppresses and destroys nature just as it destroys women.

Is it so? We have travelled a long way from the "flannel" beginnings in environmental ecology which seeks the root of the ecological crisis in the alienation of humans from nature and the solution in long-term sustainability which we learn from the active care for nature. The first steps in the subjectivizing approach semed so obvious! Of course, the destruction of nature is a

result of human decisions and human attitudes. Humans are free, they choose how to live—and nature suffers the consequences of their decision for a consumer existence. We need to decide otherwise, put on a flannel shirt and go plant trees, learn from living nature how to live in harmony with each other and with the Earth.

Only human decisions do not happen in a vacuum. Is there a deep alienation from our nature behind the obvious alienation from nature? Or even deeper, is it alienation from the feminine side of our being? How deep into our subjectivity need we submerge to reach our own foundations. And if we do reach them, is human consciousness an affective mass—or a decisive direction? When we immerse ourselves in our putative unconscious, can we still call it ecological ethics—or have we crossed the boundary between care for nature and self-centered narcissism? At the end of the article we have cited, Karen J. Warren recounts with deep sympathy how a young Sioux learns to hunt:

> Shoot your four-legged brother in the hind area, slowing it down but not killing it. Then, take the four-legged's head in your hands, and look into his eyes. The eyes are where all the suffering is. Look into your brother's eyes and feel his pain.[22]

Is that experiencing empathy—or tormenting an animal whom a shot in the head could have saved much of the suffering? Are we here still interested in nature—or has our interest shifted in the first place to our feelings? Unquestionably, an ecological ethics without emotion and empathy would be an ethic devoid of all ability to reach out to the other and devoid of motivation to act, as the systems ecologists demonstrate. Depth ecology and ecofeminism speak of something crucial to our personal growth. Do we not, though, need also to recognize the *otherness* of the other, the other's integrity and "objectivity," lest we sink into a narcissism? The other is not just a projection of our feelings and should not be perceived as such. The other deserves a respect for her/his own integrity. Our relation to others is always a matter of balancing openness with respect for the otherness of the other. It is the difficult balancing of a love which knows kinship with respect which honors the integrity of otherness.

In this instance, did the scale tip to one side? You be the judge.

Part III: Strategies in Ecological Ethics

Part III.B, **Strategies of Recognized Necessity**, outlines strategies which assume that the problem is a function of the system and that a solution, if any, must be an "objective," systemic one. Here the GAIA hypothesis, sociobiology, and systems theory provide examples.

B. Strategies of Recognized Necessity (Objectivization in Ecological Ethics)

v. THE GAIA HYPOTHESIS

When James Lovelock first presented his GAIA hypothesis to the scientific community in 1979,[23] he presented it as a scientific hypothesis about the functioning of the Earth, not as a speculative essay in ecological ethics. It was an imaginative hypothesis, to be sure, but it was a scientific hypothesis, presented to the community of scientists to be examined, discussed, and tested. Scientists proved cautious rather than enthusiastic. Lovelock was proposing a fundamental change of metaphor, a model of the biosphere as a (super)organism, capable of complex organic response in maintaining an internal environment required for its own life, much as a beehive, also a (super)organism, is able to control its internal temperature. Though Lovelock repeatedly disclaimed any trace of purpose or teleology, to many of his colleagues his conception appeared suspect of reviving worn-out vitalist theories of the late nineteenth century, associated with names like Hans Driesch or our Emanuel Rádl.[24] Vitalism was deemed dead. The scientific community had grown accustomed to using the model of a complex feedback mechanism. Given the exclusively objectifying and reductionist tendencies of contemporary science, they considered the mechanical model far more compatible with their work. Besides, computer modeling can be used far more easily with a mechanistic than with an organic model. Lovelock's scientific colleagues watched—and hesitated.

Ecologists and environmentalists of what we have labeled the *depth* persuasion were rather less reticent. In spite of Lovelock's demurrals, they gave his hypothesis their own interpretation, not as a scientific hypothesis but as Mother Earth in a romantic sense—an embodiment and distinctly a personification of the intrinsic value of the Earth. While Lovelock described the totality of life simply as an organism,[25] depth ecologists interpreted his hypothesis as a

person, a Mother Earth who cares for her children, animals, and all the members of the biotic community. Understandably, they reacted as orphans who had found a new mother.[26]

The conception of the Earth as a personality has its tradition. The word GAIA is the ancient Greek name for the Earth Goddess, though the Greeks tended to imagine it more as a sacred nature than as a personality. Plato in the *Timaeus* speaks of the Spirit of the Earth. Whatever there is, is animated by one life which the Romans translated as *anima* and we tend to translate somewhat misleadingly as *soul*, even though life principle might be more accurate. Even Lucretius, a materialist, shared the conception of the world as animated by one soul and, unlike Plato, was convinced that the soul of the Earth is as mortal as a human soul. He concluded that even the Earth is aging and will die one day. It is Philo Judaeus of Alexandria who writes about the Earth as Mother explicitly in his *On Creation*. "Fitly therefore on earth also, most ancient and most fertile of mothers, did Nature bestow, by way of breasts, streams of rivers and springs, to the end that both plants might be watered and all animals might have abundance to drink."[27] Christians rejected this conception. For them, the Earth is God's creation, not a semidivine being between God and humans. However, even the Christian conception does not exclude the possibility that all creation is one being. Environmentalists and depth ecologists could thus easily take Lovelock's hypothesis about the life of the Earth GAIA as a return not just to a vitalistic, but to an explicitly personalistic conception of nature.

While presenting his hypothesis as a scientific explanation of certain data, Lovelock did not reject a "depth" interpretation outright, in part, perhaps, because he tends to understand religion as science done by other means but seeking the same goal.[28] It appeared to him that his scientific hypothesis is reviving an ancient faith, though this time on a rigorously scientific level. In his second book, he wrote of it, "That Gaia can be both spiritual and scientific is, for me, deeply satisfying." He added, to be sure, that "in no way do I see Gaia as a subject being, a surrogate God."[29] Depth ecologists did not readily quote the latter part. Like it or not, in the eighties Lovelock became something of a guru for the depth ecologists who made identification with GAIA their slogan. Though Lovelock opens his *Ages of Gaia* by insisting that his is not a guidebook for a New Age cult, his claim that "in our guts and those of other animals, the ancient world of the Archeon lives on" does read as if taken directly from John Seed's *Thinking like a Mountain*.[30] In the former Czechoslovakia, Lovelock's first book appeared in the same depth ecological publishing house ABIES as Seed's handbook.

At the same time, Lovelock's second book, *The Ages of Gaia*, first published in 1988, appeared in the Czech Republic with a subsidy from the Ministry of the Environment during the tenure of a viciously anti-environmental minister who made James Watt seem like John Muir by comparison. Lovelock

became not only the darling of depth ecologists but also the ecologist of choice for all Ministries of the Environment and foundations striving for industrial growth with a nod to ecology. It is not surprising. Lovelock has always spoken with vitriolic contempt about ecological activists whom he describes as "providing ripe material for exploitation by unscrupulous manipulators" while "environmental politics is a lush new pasture for demagogues."[31] He accuses them of causing the 1970s oil shortage with their attempts to protect the fragile Alaskan environment and so blocking progress of whose desirability he has no doubt. He rails against scientists who would ban the manufacture of CFCs, deriding them as tribal elders on the warpath[32] while he condemns opponents of nuclear energy as leftists duped by Soviet propaganda.[33] An ecologist with a deep feeling for the unity of all life and empathy for the suffering planet who is at the same time a partisan of development and enemy of ecological activists—how does that fit together?

Quite well, actually. Lovelock represents a classic example of objectivization in ecology. His fundamental concern is not with people, but with the well-being of Gaia or, less colorfully, with the stability, integrity, and beauty, to use Leopold's phrase, of the entire system of life on Earth. His attitude to nuclear energy, anathema to most ecological activists, shows this most clearly. Radiation, he emphasizes, endangers some humans, locally, while the consequences of burning fossil fuels place the very complex of life or Gaia at risk. But at the outset Lovelock pointed out that "There is little point in helping people if by so doing [they] damage the Earth." From a Gaian viewpoint, nuclear energy is far preferable to fossil fuels.[34]

It is useful to read carefully Lovelocks reasons for presenting the GAIA hypothesis. It was definitely no empathy with suffering nature. Lovelock, who in the sixties, while Carson was writing *The Silent Spring*, worked for Shell Research Ltd., is a technician or, as he puts it, a scientist. He was interested in ways of detecting life on Mars and Venus and pointed out that instability of the atmosphere is a sign of life since life is inevitably entropic. The atmosphere of Mars and Venus is dead stable. The Earth, by contrast, has a tendency to instability and so should have long ago had an atmosphere like that of Mars or Venus, consisting almost entirely of carbon dioxide. Life is possible on Earth only thanks to the 2 percent of oxygen and to the presence of gases like hydrogen and methane. The Earth, it seems, somehow compensates its own tendency to disequilibrium. This feedback loop would be inexplicable if we did not consider the possibility that, very figuratively, the Earth designed life for the purpose of consuming carbon dioxide and manufacturing oxygen. Or, less figuratively, we need to assume that the Earth behaves like an organism caring for its self-preservation.

Less figuratively, more factually, life does in fact function to protect the Earth against the catastrophes thanks to which Mars and Venus are lifeless corpses. Humankind, however, broke out of the natural order. It pollutes,

destroys ecosystems, destroys the natural variety of life needed for a dynamic equilibrium or homeostasis. This gives rise to the question whether it is possible that human activity could limit the possibilities of systemic functioning so that the Earth would lose its homeostatic abilities and would be unable to assure its own equilibrium. In his first book in 1979, written for general audiences, Lovelock responds unquivocally: yes, from a scientific viewpoint humanity is capable of crippling the Earth so much that it will no longer be capable of assuring the presuppositions of life. The threat is not technological development, which Lovelock supports, but the shortsighted greed of consumers.[35] For that reason, in this volume Lovelock comes to the conclusion that humankind needs a new harmony with the organism of all life, Gaia. It needs actively to protect variety of species, give up technocratic domination of "resources," and follow a new biospheric ethics.

The argumentation is detailed and inevitably distorted in any summary.[36] Still, even in broad outline, it is impressive. Lovelock points out that it would have been enough if in the course of the past 3500 million years the warmth or humidity, salinity or acidity of the Earth had risen or dropped just a shade beyond the very narrow limits within which life is possible—and life would have perished. That is what leads him to the hypothesis that living matter is not passive but actively searches out ways of preserving the conditions of life, much as a human body maintains an internal temperature in spite of external variations.

There had in fact been such external variations. Over the course of the Earth's existence, roughly 4000 million years, the temperature of the Sun rose so much that the Earth today receives 3.3 times as much energy as in its beginning. This demanded changes. In its beginnings, the Earth was wrapped in an atmosphere of ammonia which functioned as a greenhouse. It limited radiation and so cooling, helping to preserve the warmth needed for the rise of life. Life drew on this ammonia layer—and so needed either to replace the used-up ammonia or to change the Earth's surface so that it could retain heat and prevent global icing as on Mars. Covering the planet with a green breathing biomass served this purpose and contributed to further dramatic change. Overproduction of ammonia could bring on a drastic rise in temperature and destruction of the preconditions of life as on Venus. It did not happen because life managed to lead the Earth over to an oxygen atmosphere. In spite of the rising temperature of the sun, the Earth's surface has thus managed to maintain surface temperature within 20° C for 4000 million years. Certainly, individual changes—such as methane controlling the amount of hydrogen by carrying it from the Earth's surface to the stratosphere—could be described mechanically. Lovelock repeatedly denies attributing consciousness or purpose to the complex of life, but the overall effect of his observation suggests not mechanical but organic functioning. The Earth is not a person or an animal, but Lovelock has presented enough evidence to warrant considering the hypothesis that it is

indeed a superorganism analogous to a beehive. So no Earth Mother, even though Lovelock goes on using the metaphor GAIA. Another metaphor, though, might do greater justice to his cause, not that of an organism, but that of an invisible hand, not of the market but of evolution, or, more precisely, the *invisible hand of life.*[37]

Lovelock is a geochemist and an inventor, not a philosopher. Unlike philosophical ecologies which stress the relation of humans to the Earth Lovelock's ecology barely touches on humankind. His is the grand overview of three billion years in which humans are a blip on the screen. His concern is not with the fate of humans but with understanding the overall order of life or Gaia. His focus is inevitably on necessity, not freedom. Freedom is a human term, a reflection of human provincialism. Even when Lovelock does turn to humans, it is to humans as a part of the whole of life, as a part of Gaia, acting out a role defined by her much as all of life does. Hence Lovelock's poetic inclination tends not to activism but to the image of tragedy so dear to Hardin as well. The grand global picture, the life of Gaia, is marked by tragic necessity.

A number of consequences follow. One of them is that Lovelock is ever less concerned with the human threat to the Earth. It is real enough. Humans can destroy the presuppositions of *human* life and are well on the way to doing so. The great ecological threat is not nuclear energy, which is entirely natural, lethal only in excessive doses and even then only to humans. Far more devastating to the balance of life—to Gaia—are primitive farming techniques which replace vast tracts of life-giving forest with deadly barren farmland. The ominous danger comes, as we already noted, from the three Cs, *cars, cattle, chainsaws* (see note 35). Lovelock does write with poetic sensitivity of the meaning of nature for humans, as the importance of trees for the soul, and, for the sake of humans, regrets its destruction. The grand trend of humankind's development, however, does not appear to him as a question of individual human will and individual decisions. It is encoded in our being—and that suggests that it is a part of the life of Gaia. It means changes, certainly, but these changes are ultimately changes only, not destruction. It could be a change as far-reaching as a transition from a world of mammals to a world of insects. Ants, claims E.O. Wilson, are in the total collectivization of their life far better suited to survive than humans in their individuation. Lovelock repeatedly raises the possibility that in our collective folly we are in fact preparing the world for a new dominant species. That is in the invisible hand of evolution. We humans can only recognize the neccessity of the development whose part we are. Ecology thus is not a matter for activism. It is not in the power of humans to determine the evolution of Gaia. In the interview with *Newsweek* which we cited earlier Lovelock compares our present position with the situation on the eve of the Second World War. Then, too, we were aware that we are approaching a catastrophe. Neither then nor now was that a reason why we should stop living and enjoying life. Ecology is a question of recognized necessity.

Such is Lovelock's overview of a scientist who deals with the development of life from the perspective of millions of years. It is immensely enriching for ecological thought, all too often much exercised over environmental damage which is immediately painful, as the bulldozing of old growth forests for parting lots, but from the perspective of Gaia not significant. Still, though we might think in geological time, we do live in human time and must make choices therein. Though through the prism of the objectivistic model it may seem that the overall development of humankind—actually just a moment, geologically speaking—is predetermined, though, in grand outlines, it even may be, we do live in this moment and must choose therein. The question pressing us is one with which geophysical sciences do not deal—how to harmonize our life in this brief lifetime with the changeless order of all life. This is why Lovelock, who has absolutely no use for "flannel" ecologists who would change the world, is so much in tune with *depth ecology* which would change human spirit instead.

At the end of his *The Ages of Gaia: Living Planet* Lovelock raises the question of how to live with Gaia. He does not seek to answer the question of how humankind at large can fit into the grand scheme of Gaia. That is up to the invisible hand of evolution, up to the logic of life or Gaia. The fact that humans live as they do, overreproducing, overusing resources and polluting the planet, simply shows that that is how it is, however much we may wish it were otherwise. What is real is rational, what is, is what ought to be. We might grieve the fact that the expansion of humankind is impoverishing us of all that Nature meant for our forebears, but we cannot change it. We may grieve the passing of the pre-industrial English countryside, and Lovelock genuinely does. We can, however, change only our personal acting and feeling, and that is not little. Though holding out a glimmer of hope in human rationality, Lovelock fundamentally concludes, like Hardin, with something rather like Stoic equanimity, *atharaxia*. Gaia gives and Gaia takes away, its life will live on in its own way.

Or, perhaps, it is not so much a Stoic as an Epicurean perspective. Epicurus, much like the Stoics, reached the conclusion that the forces of fate are moving with an inexorable inevitability to destroy the world as he knew it and that it is vain to resist them. He saw all Greco-Roman civilization disintegrate around him, a whole cultivated way of life vanishing, grieved it but was wise enough to recognize that he cannot prevent the catastrophe. However, he need not be a part of it. That was the origin of the legendary Garden of Epicurus, enclosed with a tall wall to keep out the sounds of a civilization in disintegration. It will not change the outcome but neither will it speed it needlessly. We can lead civilized lives in the eddy of a tragic historical necessity until the final collapse—which will probably not come in our time, anyway.

Lovelock responds to the question of how to live in harmony with Gaia in that spirit. He offers himself as an example to emulate. He had bought an abandoned farm in a relatively undisturbed corner of England. He modified the

dwelling to suit his needs, furnishing the barn as a laboratory. Gradually he cultivated the forest and the fields and so built up, on his thirty-five acres, a bit of protected nature where he can go for walks, talk to the birds and the trees and live in a spiritual harmony with Gaia. Meanwhile elsewhere the country-side vanishes, due not to ill will but to the demands of human expansion—and that expansion is an intrinsic part of the life of Gaia. As an individual who can protect thirty-five acres in a remote corner of the world, Lovelock can create a refuge for plants and animals threatened by development. He may eat fewer hamburgers so that he is at least contributing less to the vicious spiral of more cattle, fewer forests, more exhaust fumes, and so on to the point of destruction. He may not, though, block the path of progress—and it would be vain were he to attempt it.

As long as we see human activity in the cosmic measure of four billion years, that may seem like a wise conclusion. The doings of humans really do not represent a cosmically significant difference. In the long run it cannot influ-ence the development of the cosmos. What it can affect is how we ourselves will live our little lives within the immense cosmic framework. Essentially that is the wisdom of the biblical book Ecclesiastes, the wisdom of recognized necessity. The wind bloweth where it listeth: we cannot change the cosmic development. That has a necessity of its own which we can only recognize. We do, though, have a choice. We can either live in conflict with the order of things, needlessly destroying the world and ourselves, or we can live in har-mony with the order of things and with the peace of mind provided by a depth experience of nature. Understandably, this conception seems close to those depth ecologists who, whether that is how Arne Naess intended it or not, are concerned in the first place with self-realization of their greater self by identifi-cation with the community of all being. It is equally understandably close to the system theorists who proclaim systematic necessity in the name of a scientific world view and ask of humans only that they submit to recognized necessity.

Unquestionably, for anyone seeking to come to an understanding of the place of humans in the cosmos it is crucial both to grasp in depth their affinity with all creation and to glimpse the grand overview of four aeons. There is something profound both in the depth ecological sense of the oneness of all creation and something grand in Lovelock's vision of cosmic necessity. It would be hard, though, to blame those "flannel" activists who strive for long-term sustainability of human presence on earth if Lovelock's version of the harmony with Gaia were to appear to them increasingly like a lifeboat ethic.

vi. NATURE AND THE HUMAN ANIMAL

Lovelock's GAIA hypothesis clearly exemplifies the virtues and weaknesses of objectification in ecological ethics. Excluding the subject appears to offer a possibility of scientific certainty. We shall describe reality as it is, within the

limits of strict scientific objectivity. Seeking to modify human behavior would be unscrupulous manipulation, ideas of stewardship a sign of hubris, a global version of benevolent colonialism.[38] We shall describe and recognize the objective necessity of evolution. That will be the end of debates; at last we shall know with certainty.

Or will it? From the perspective of philosophy of science, such a positivist conception of science as a strictly objective, indubitable description of a given reality is rather problematic. To most contemporary thinkers natural science, too, appears as an ongoing quest for understanding dependent on human modes of perceiving the world. Even were we willing to accept the positivist conception of science, we would not resolve the question of the transition from a cosmic and descriptive attitude to an involved human one. The claim of positive science to a certainty independent of consent (so called "objective truth") is based on excluding judgments of value and meaning, inevitably subject-related (so called "subjective prejudices"). A science which proclaims its objectivity thereby itself denies its ability to pass judgments of value and meaning which necessarily relate to a subject.

Yet precisely such judgments are what it is about. In a schema of four billion years, evolution may appear to us as necessary and the age of the mammals—or the even narrower age of humans—as a very transitional stage determined by the overall development. Our pressing questions, though, are precisely the geologically short-range ones. They have to do not with so-called "facts," but with *what we humans ought to do*. Human overpopulation may be a part of our destiny—though that is far from unambiguous—but our question is normative: what ought we do? Perhaps having a dozen children is "natural" or perhaps not, but is it desirable? The desire to reproduce may be natural, but ought we to support high birth rates? Or ought we to limit our numbers and save some habitats for bears and pumas? Objectivizing approaches restrict themselves to providing us with the most reliable information about what there is. The normative question, what ought to be, is a question not of fact but of ecological ethics. For better or worse, it deals with human subjects in their freedom.

What, though, if that freedom is illusory not only in some grand cosmic sense but even in the concrete determination of our acts? Isn't it possible that even the actions of human subjects are determined by our psychophysical endowment and not by free decision? This possibility emerged the moment Darwin convinced Europe of the continuity between humans and other animals. As long as we could convince ourselves that while all of the nonhuman world rose up from matter while our souls came down, so to speak, from God godself, we could believe that the genetic determination we witness in other

animals does not apply to us. Once we acknowledged ourselves as just the next step in the development of primates, it appeared otherwise. The nineteenth-century "monists"—those who believed that creation is one and continuous, not divided between a realm of nature and a realm of spirit—raised that possibility together with the possibility of a science of ecology, extending the laws of nature to humans. A hundred years later the battles of creation and evolution have grown irrelevant and the battle cry of monism with them. While devotees like Gregory Bateson continue to expound on the continuity of primate behavior between apes and humans, the public at large has come to take it for granted but found behaviorism far more compatible with the democratic optimism of the early twentieth century.

Beneath the behaviorist surface, though, the monist theme continued to work. It surfaced into public view when in 1967 an American zoologist, Desmond Morris, published a book entitled *The Naked Ape*[39] in which he sought to study human behavior purely as a zoologist. The book proved a best-seller—the Czech translation alone sold some seventy thousand copies. Though the sociobiological approach, seeking to understand human behavior in the mirror of our nonhuman kin, was hardly something new, Desmond Morris called it to public attention with skill and grace rare in scientific writing.

Morris's basic thesis is that humans, belonging to the order of primates, bear in their genes an archaic primate genetic memory. Primates tend to live in loosely associated bands in constant movement. They need neither division of labor nor care for a home. When they soil a particular place, they move on. They do not gather around a meal, only continuously pluck fruit and nibble along the way. They do not need firm family relations. Though during care of the young parents do associate, partner or "marital" loyalty does not appear to be overly highly prized. Primates live freely—and allegedly we bear that freedom in our genetic memory.

However, as Morris reads it, when our ancestors descended from trees and switched to a meat diet, they in effect moved to a wolf mode of life which requires wolf social organization as well. A wolf pack urgently needs both firm discipline and long-term partner loyalty. That comes from the division of labor. The males hunt, frequently at long distances; the females remain home and care for the young. The habitat needs to be kept clean to prevent explosions of parasites. The pack, figuratively speaking, sits down to eat: when it downs a larger animal, the whole pack gorges itself, then sleeps, then goes on to hunt. Wolves do not nibble.[40]

In a style more popular than rigorous, Morris describes American society of his time as a society torn between the primate and the wolf components of our genetic memory. We have lived for a long time after the manner of wolves—pack meals, hunt, care for the home, marital bonds. We continued, though, to carry within us our long ago primate habits and today, under the pressure of rising affluence, are returning to them. Once again we live on the

move, in loose associations, feeding continuously on snack food and seldom sitting down to dinner. Having lived in America at the time, I can testify both to the book's impressionistic accuracy and to its impact. Suddenly it seemed as if all that seemed random from a behavioristic perspective were making socio-biological sense.[41]

Morris called attention to the scientific discipline of *sociobiology*, seeking to understand human comportment in terms of our genetic memory. Whether we read a latter-day monist, Gregory Bateson,[42] or a biologist like Konrad Lorenz,[43] we shall encounter the theme that what appears to us as evil has its place in the ecology of nature so that the real, intrinsic evil is human intereference in nature and against nature.[44] Humans, Lorenz points out, are beings capable of killing a brother—in the conviction that they are doing good. Toward the end of his life Lorenz reached the conclusion from which the Czech sociobiological thinker Pecina sets out—that it is possible to change human behavior by self-understanding but that such understanding needs to stem not from ideological constructs but from the sociobiological continuity of life. Other holistic thinkers—thinkers who believe that the logic of the whole explains the behavior of its parts: a quiet bureaucrat can act like a rowdy when he is caught up in the passion of a racist mob—think similarly. The thesis they all share with Lorenz is that human behavior, too, needs to be understood as a way of satisfying basic needs.

Of the sociobiological studies accessible in Czech, Edmund O. Wilson's *Diversity of Life*[45] is perhaps the most impressive. The author offers the reader a readable yet thoroughly grounded introduction to evolutionary biology. He traces the rise of the diversity of life from the first monocellular organisms 3500 million years ago. With conviction flowing from encyclopaedic knowledge he points out that diversity literally *is* life. The possibilities of life open up in its diversity and the immensely complex interconnection of individual species. The more complex an organism, the more possibilities it creates, and the same is true of the community of species. The flowering of life on Earth means a flowering of interconnected diversity.

In the history of life on Earth,Wilson points out five periods of major transformation and mass dying out when the number of species dropped drastically. In each of the catastrophes key species became extinct while new species became dominant. Wilson considers the age of humans, continuing the age of mammals, as the most recent historical epoch. From Wilson's narrative a merciless reality stands out—that at the present time the age of humans is becoming the sixth period of catastrophic dying-out. It is not just that species die out but that they are dying out far more rapidly than before human presence—Wilson claims that many thousand times more rapidly—and also more rapidly than evolution can replace them. Species are disappearing primarily due to loss of habitats, pollution of the environment and introduction of exotic species into remaining natural ecosystems.

Wilson points out that the idea that humans could prosper separately from the rest of living nature is wholly illusory.[46] In spite of that, humankind is massively devastating the nature on which it depends. Human behavior, Wilson claims, does manifest remnants of natural biofilia, the longing for a touch of living nature. However, he points out that human genetic memory does not prepare humans for the conditions of a purely culturally determined life. Humans experience a deeply encoded fear of what had been dangerous in nature, of open spaces or of serpents. The incredible speed of modern development means, however, that humans do not even begin to develop a similar instinctive fear of far more dangerous things like automobiles and firearms.

Thus Wilson's conclusion: for the preservation of life, human and nonhuman alike, "the chief ethical principle ought to be foresight . . . We should never permit any species or kind to become extinct with our knowledge. — The goal of a lasting natural ethics will not be simply to preserve the health and freedom of our kind but also to preserve for all the world in which human spirit was born."[47]

Wilson's *Diversity of Life*, just as his *Of Human Nature*, undoubtedly belongs to the most important contributions of sociobiology to ecological thought. Unlike many sociobiological works, it is not philosophically naive. Wilson is aware that it is understandable to derive superficial moralizing from indignation over human behavior, but that it is not legitimate. Precisely because he refrains from all moralizing his work effectively proclaims a clear ecological imperative: the present mode of human dwelling on Earth is destructive and untenable. By far the most pressing task of humankind is to think through the consequences of what we are doing. Thus far we have acted quite irresponsibly, leaving the consequences of our acting up to the invisible hand of nature. Wilson is showing that the changes which humans have introduced into the system of all life are so far-reaching and especially so rapid that evolutionary mechanisms cannot compensate for them. If humans and life are to survive on this Earth, humans will have to accept responsibility for their acting and consciously shape modes of dwelling which would not lead to far-reaching genocide of nonhuman life. That is not a matter of a depth-ecological mystic harmony with Mother Earth. It is the attitude of rolled up flannel sleeves: an ecological ethics that would change the human mode of dwelling on Earth.

Of the many texts in objectivistic ecology I would most recommend Wilson's *Diversity of Life* and, for the philosophical aspect, his *On Human Nature* in which he stresses, *inter alia*, that "innateness refers to the *measurable probability* that a trait will develop in a specified set of environments, not to the certainty that the trait will develop in all environments."[48] Wilson makes it clear what an objectivistic approach to ecology can offer—a clear awareness of the threat, the pressing need to change human behavior. In a way, Wilson represents a response to the ideas and attitudes of James Lovelock, no less rigorously grounded, yet responding differently. Still, the question remains: what

importance should we attribute to all we are learning in sociobiology about the nature of life and of humans? It is highly significant, to be sure, for without a thorough knowledge of our nature we would be hard put to select effective ways of acting. What, though, is the significance of our putative nature or "genetic memory" for moral decisions? Is what is unnatural—as equality— necessarily wrong? Is what is natural—as unlimited reproduction—also morally acceptable or binding?

That is the basic question for all sociobiology: is the natural *eo ipso* also good? One possible interpretation really understands sociobiology and our alleged nature generally *as a source of reliable moral laws*. Rousseau and the romantics, convinced that whatever is natural, is good, and only what is artificial can be wrong, provide a clear example. The traditional root of that conviction was the faith that God created a good world, humans brought evil into it but their fall did not distort the nature of God's creation. Its modern root is in evolutionary theories. Evolution is based on the transmission of the genetic code from generation to generation. It knows only one good, the survival and growth of diversity. Simply the fact that a given species survives and multiplies proves that it is capable of survival and so good. All that interferes with survival is *eo ipso* unnatural and wrong, but also *eo ipso* doomed to perish.

That is the interpretation tempting to depth ecologists on the one hand and to objectivistic ecologists like Konrad Lorenz or James Lovelock on the other—together with all who, for personal reasons, would like to believe that among primates partner infidelity is natural and so, even if not good, then at least acceptable among humans. The problem here is that the very concept of *right* derives from cultural, not genetic, memory. On a purely natural level we could say at most that something is so, not that it is "right" or that it "ought to be." Those are not descriptive predicates. Moral justification arises only with a conscious direction of human activity. It is essentially unnatural, a product of human reflection. For that reason we cannot derive it from what is "natural." That our genetic memory equips us with certain inclinations like a fear of snakes may be a fact, but it does not yet mean that we should consider such inclinations normative. Sociobiology cannot take the place of ethics—or of ecological ethics.

A second approach treats sociobiology as presenting not a justification but an explanation of the alleged causes of our behavior. According to this interpretation, sociobiology does not justify our behavior, but it does explain it. In the case of Morris's half serious example, marital infidelity occurs *because* while we live after the manner of wolves we carry within us the genetic memory of primates. This is a far less pompous interpretation of sociobiology, yet even it is problematic. We cannot explain human behavior from a single causal factor. Each new state of the world—and so each human act— flows from the entire preceding state. For millennia of evolution there is a complex set of components at work, most recently also cultural components

such as conceptions of the world and their complex evaluation. The diversity of cultures is—or at least until recently has been—as rich as the diversity of natural species. Certainly, even that is rapidly disappearing. Relentless globalization is in our time replacing that cultural diversity with a commercially produced civilizational monoculture which is as vulnerable and unsustainable as monocultures of forests and fields. The point, though, is that diversity of cultures testifies to the presence of not only genetic but also cultural elements. The idea that sociobiologists could identify the cause why humans act thus and not so is exaggerated at best.

A third approach seems to me in order—sociobiology as an attempt to understand our natural inclinations which neither cause nor justify our behavior but help us to take it into account in our decisions. In Morris's metaphor, marital infidelity is neither natural nor necessary, but we do have an inclination to it—and so it is wise to avoid situations which lead to temptation. Racism provides a more serious example. Defenders of racism like to claim that "racism is natural." That is somewhat exaggerated though it is the case that, though there are exceptions, most species prefer the company of their kind, fear unknown kinds and express their fear naturally as aggression. We can therefore expect that when a Romany lad enters a class of Czech first-graders, especially if his Czech is halting, the others will cluster defensively on the other side of the classroom and might even attack him, verbally or physically. It is natural, but that does not in any sense or way mean or suggest that it is right. This society is based on other principles of coexistence than those of the great apes, noble though those may be. We cannot even conclude that racism is inevitable. It is not. Human young can learn other modes of dealing with each other. The only thing that we can derive from it is that the teacher must be prepared and make a conscious effort to find ways in which children of diverse origins can come to know each other, overcome their fear and understand the vulnerability of the other.

That I think the great, wholly fundamental contribution of biology and sociobiology to ecological ethics. It helps us recognize what we bear within us, unaware of it though we may be, and for what we need be prepared. Learning what is natural does not provide us with a guide to acting. A whole range of our wholly natural, deeply encoded reactions can be as destructive as the porcupine's natural impulse to curl up defensively against an oncoming truck. When authors like James Lovelock make far-reaching pronouncements about what is and what is not good—as when they condemn ecological activists or dismiss any criticism of nuclear energy as political naivité—they are clearly exceeding the limits of their competence. When, however, they offer us insight into the natural impulses encoded in our genetic memory and so into what we can expect of ourselves, they are offering us immensely valuable information. They do not free us of the need to examine critically the consequences of our

actions. They do not free us of the need to decide how to act. They do, however, enable us to decide knowledgeably, not blindly. If you have not read Wilson's *Diversity of Life*, you will do well to start.

vii. SYSTEMS THEORY IN ECOLOGICAL ETHICS

Systems theory represents another attempt at *objectivization in ecology*, that is, at explaining the ecological crisis *without reference to human decisions*. *General systems theory*, as its originator, Ludwig von Bertalanffy[49] called it, grew from philosophy of science as a reaction to the individualistic empiricism of the turn of the twentieth century. The basic dogma of naive empiricsm was that cognition is necessarily a cognition of particulars and that conceptions of the behavior of wholes are something we construct out of particular cognitions. The supporters of systems theory pointed out that the behavior of a particular is intelligible only in the context of a whole. It is familiar enough, for instance, in psychology that a child will behave quite differently in the context of the family and outside of it. The child's behavior is a complex coming to terms with an entire network of relations which the family represents. There are similar instances in all other fields of study. That is why the partisans of systems theory recommended starting out from the behavior of the entire system (hence *systems theory*) or of the whole (hence *holism*, the term more common in the sciences.)

For scientific ecology that was from the beginning the obvious approach. Ecology in the technical rather than moral sense is a science of contexts, dealing with ecosystems, explaining individual organisms in terms of the *nika* into which they enter. In the Anglo-Saxon world Sir Charles Elton,[50] one of the founders of scientific ecology, explicitly supported a systems-theoretical approach. Similarly, Aldo Leopold, who understood life as an exchange of energy in life's pyramid, clearly thought in systems-theoretical terms. Systems-theoretical thought is hard to separate from ecology—though most ecologists have not given it a thought.

Systems theory enters into ecological ethics with the statistical projections of Donella Meadows *et al., The Limits to Growth* and *Beyond the Limits.*[51] *The Limits to Growth*, presented as the first report of the Club of Rome, represents one of the roots of ecological activism. One root was traditional, in care for the environment. It stemmed from love and respect for nature and from horror at its devastation, manifesting itself in flannel activism. The second root was statistical: *The Limits to Growth* seeks to show that our current modes of production are leading to exhaustion of nonrenewable resources and to the damaging of natural mechanisms by pollution. Not a word of any love for nature. American ecophilosophical bibliographies—as Davis's *Ecophilosophy*—do not even cite *The Limits to Growth*. The editor apparently did not think it ecological philosophy, only a statistical projection.

In spite of that, the Meadowses' systems-theoretical approach had a significant impact. Both in America and in Europe it brought the ecological threat to the attention of circles and strata innocent of any love for nature and quite immune to the least hint of regret at its destruction. Technocrats and corporate executives who refused to think in terms other than those of expanding production had to admit that their approach is self-destructive. Especially in what was then Soviet Europe, where a scientific image lent respectability, *The Limits to Growth* cast doubt on the dogma of "progress" at any cost. The Meadowses' team did not appeal to respect or sympathy for nature, as even Rachel Carson did in *The Silent Spring*. They restricted themselves to a dry, highly factual observation that, given the existing directions of development, industrial growth will run into unsurmountable limits. Waste and overconsumption will deprive it of resources in the broadest sense. *The Limits to Growth* did not warn that nature is at risk, but rather that what is at risk is growth, development, progress, that great fetish, unlimited expansion of material consumption from which modernity expected the solution of all problems it had failed to solve.

Among environmentalists *The Limits to Growth* had, understandably, only limited impact. Their concern was the protection of nature and a change of human attitudes. The failure of "growth," as we experienced it in the seventies with a decline in the use of energy and raw materials, lower polluting and less strain on the land and, most of all, with the change of attitude from waste to frugality, would be a definite plus for the protection of nature. The seventies were, for America, genuinely a unique period when frugality, not ostentatious waste, meant status. To the environmentalists it was clear all along that "growth" is not a solution but precisely the problem. That is why they typically choose a strategy of less demanding humanity rather than more demanding technology.

That much greater was the impact of *The Limits to Growth* among the partisans of "growth." For them it represented a threat to their inmost interest. They reacted expectably, incidentally just like tobacco companies responded to the Surgeon General's report. First they tried to cast doubt on the book—and that is never difficult in detail when dealing with a global projection. They consoled themselves that *it really can't be that bad*, whether with smoking or with growth. In the second phase, they had to admit that it really was that bad, but consoled themselves that the ideology of "growth" could be preserved by better technology—or in the case of smoking and cancer, with better filters. Most Ministries of the Environment have not progressed beyond this phase to this day. Only in the third phase came the admission of what the second report, *Beyond the Limits*, makes even clearer: that *the problem is the ideology of "growth" itself* and that the need is to find modes of sustainable development. That *sustainable* and *growth* of material consumption is a fundamental contradiction,[52] that was something recognized only by the environmentalists who

have long since lost all illusions about "growth" and now use the expression *sustainable life.*

The systems-theoretical approach was especially important in the lands of the former Soviet bloc where it still occupies an exceptional place in ecological thought. There was a double reason for that. As a putatively purely scientific, "objective" approach which does not make value judgments and does not criticize attitudes and ideas, the systems-theoretical approach seemed harmless to the ideological monopoly of Marxism-Leninism, the foundation of the rulers' legitimacy. Even a critique of consumerism, understood purely quantitatively, seemed to apply solely to the overconsuming west, not to the scarcity economies of the Soviet bloc. Besides, the systems-theoretical approach is compatible with the habits of technocrats. No need to think, no need to change life styles, all that is needed is to project the statistics into the plan. It is not surprising that the (post)Marxist philosophers so readily claim systems theory as their own. In the Czech and the Slovak Republics, a large part of ecological thought is a continuation of these approaches with the sole difference that the critique of consumerism is coming uncomfortably close to our own *nouveau-riche* society.

Under the old regime there was a second reason as well. Because technocratic approaches to the problems of the environment enjoyed a certain acceptability, they represented a way in which ordinary citizens, limited to a censored press, could learn something about the whole ecological problem. Ecological activists, who would have run into deep trouble if they used the terminology of humanistic or deep environmentalism, could work both theoretically and practically as long as they used systems-theoretical terminology. It would be hard to overestimate what their activity, sheltered by systems-theoretical terminology, meant to people living within the Communist ideological strait jacket—the magazine *Nika*, the activities of the local organizations of the Czechoslovak Union of Nature Protectors, the Brontosaurus clubs and other local environmentalist groups.[53] Years later we still have reason to be grateful to them—and so to all who worked on *The Limits to Growth.*

Their contribution is significant even today. There is, first of all, the clear recognition that we are dealing with a systemic conflict. Nature is not a garden in the human world, as the cosmetic ecologists would have it. Nature is not the stage for the drama of human progress. Nature is, first of all, what authors like Schweitzer, Lovelock, or Wilson point out in their several ways: a system of all life from its beginning, in all its intervowen diversity. Nature is a living system within which there arises an only partly autonomous dependent system of human doings. Josef Šmajs presents it clearly in his *Culture at Risk.*[54] As Lovelock pointed out in 1979, the system of all human doings—"culture"—is dependent on the system of all life—"nature"—but is capable of threatening its host. If "culture" is to survive, it is essential that it form modes of living

with nature which would not strain it unbearably. Individual good will, recycling plastic bags, and using nature friendly paints are fun but not for real. To the ideology of consumption we need to oppose a conception of the meaning of human life which would not seek meaning and hope in escalating consumption.

When we were dealing with theocentric ecological ethics we ran up against the question of *why* culture burdens nature. One possible answer is that culture, the complex of human doing, is in conflict with nature essentially, by its very being. Some depth ecologists[55] share this conception with systems theoreticians like Josef Šmajs or, for that matter, James Lovelock. In that case all attempts at sustainability would be in vain, short of an apocalyptic transformation of the very nature of human "culture." Depth ecologists and systems ecologists imagine that change somewhat differently, but they will agree that without it all ecological activity is vain—and often speak of it with the same condescending contempt as Karl Marx about "trade union mentality."[56] A second possibility is that the systemic conflict is not the result of human nature but of definite human choices. In terms of their nature—or symbolically speaking, in their original state—humans are finite,[57] but live in an undisrupted relation with their natural (and likewise undisrupted) environment. The conflict of culture and nature is something that comes about only as a result of certain human acts, for instance irresponsible escalation of populations and consumption. Because in this conception the conflict between nature and culture is not primordial, there is a point in seeking its causes—and a hope of undoing them.

This tends to be the conception of "flannel" ecological activists—if they worry about theory at all. The point is that *sustainability is in principle possible*. The contradiction of culture and nature here does not appear as built into the structure of the world. It can be explained variously, perhaps by alienation from nature, by the invention of private property or of patriarchy or by the explosion of human populations, demands, and technological power which exceed the self-renewing abilities of nature. To be sure, humans never did worry about the results of their actions, devastating their environment by their very being. However, as long as they were few, modest and weak, nature could compensate for the damage they did. With a sharp increase of human capacities humankind needed to take on responsibility for what it was doing. Figuratively speaking, forests and oceans can compensate for five cars, when there are five million of them, we need to think through how to deal with exhaust fumes. Long-range sustainable life would mean a community which does not see the meaning of life in consumption and which consistently cares about the compensation for all the results of its actions. Metaphorically again, the cost of an automobile and its use would need to include up front not only its disposal, but also damage to health and nature. Since in that case gasoline would have to

cost some eighteen dollars a gallon, a long-range sustainable society could not afford to abolish its railways. It could, though, afford pure air and clear water.

The basic problem for all systems-theoretical approaches is how to create such a society. Systems thinkers typically contemptuously dismiss any approaches based on education and ecological activism aimed at the ideals and laws of a given society as subjectivistic. They point out the limitations of all things subjective, of "the level of moral suasion."[58] Most of them link their hopes to political forces which would create and impose objectively a sustainable social structure, offering a technocratic solution to a systemic problem. Perhaps that, too, is why systemic approaches seem so attractive to the heirs of Marxism-Leninism. An American philosopher and animal defender, Tom Regan, describes this as "ecofascism," not without reason.[59] A Czech or a Slovak reader would be likely to think of another parallel.

The trouble is that experience suggests that enlightened despotism is not viable. Those who wield power cannot but be a sample of the general population, sharing its weaknesses. Despotic rulers will repeat the errors people make—with the difference that there will be none to correct them. A solution requires an active support of a majority. Otherwise it will fall victim to civic sabotage, much like the theoretically most desirable "achievements of socialism" under the previous regime. The success of any systemic solution of the systemic problem depends, in the end, on that scorned "moral suasion." Even ecological romanticism, however limited as a solution, can play a significant role as a motivator. Objectivistic systemic analysis remains rhetoric without a civic will to resolve the problem.

It is a difficult task. The ideology of consumerism is no longer simply a personal conviction. It has become part of a social system which supports it both with laws and with advertising indoctrination. Communications media become dependent on multinational monopolies with immense capital reserves, willing to sacrifice the future of nature and humankind alike for short-term profit. The inability of the American government—whose vice president is a distinguished ecological thinker, Albert Gore—to push through the Congress laws for limiting greenhouse gas emissions, attests to their power.[60] No one denies that we are living well after midnight and that it is urgently necessary to limit emissions. Even the resources of the American government, however, cannot overcome the immense power of the system of materially advantageous devastation. That, too, we need to recognize as a systemic element. The problem is not insoluable though the hope of a successful solution may not be great and the task is definitely not easy.

Systems theories play a wholly irreplaceable role in the problems of long-term coexistence of nature and humankind. Only with a systemic view can we break free of noble but ineffectual intoxication with love and pity for suffering nature. Deep and flannel-shirted ecologists alike need to read Lovelock, Wilson, and the reports of the Club of Rome. However, the opposite is true as well.

Only by sympathy and effective love for nature can we break free of the practical helplessness of systems-theoretical solutions which tempt us to "enlightened" despotism. Objectivistic approaches are understandably tempting to technocrats—and ironically also to those who would rather identify deeply with nature than seek practical approaches to a sustainable human coexistence with it. Perhaps precisely for that reason objectivistic approaches will necessarily remain an ancillary tool, not the motor of ecological solutions.

viii. "ECOLOGY" AS AN IDEOLOGY

Strictly speaking, our concluding topic does not belong in a separate section as much as in footnotes throughout the work. Reflection on the place of humans in the cosmos is always in danger of sliding from philosophy to ideology. We have encountered that tendency both in the case of "depth" ecology and ecofeminism and markedly in the case of systems ecology and sociobiology. For that matter, even vegetarianism can become an ideology. Opponents of the limitations required by sustainability love to take advantage of that and eagerly label ecological philosophy "mere ideology," writing off its adherents as confused children, unscrupulous manipulators or at best idiosyncratic enthusiasts. The assumption here is that ideology is the confession of faith of a certain small group of *aficionados*, perhaps *nature lovers* or *animal protectors*, irrelevant to those who do not share their interest in nature or animals. I have heard it many times: "Global warming does not concern me; I am not interested in ecology." Ecology then is presented not as a generically human problem but as only *an ideology of the Greens*.

What actually does ideology mean, and when does philosophy become an ideology? In the rhetoric of the Communist regime in Czechoslovakia ideology meant a system of views and ideas in which a given group clarifies and defines its identity.[61] That, though, would be true even of the philosophy which we defined as the stubborn attempt to form the most viable conception of the place of humans in cosmos. That was actually the original meaning of the word *l'ideologie* as the philosopher Destutt de Tracy used it in the early nineteenth century. Only later did the word acquire the pejorative meaning of false consciousness in the Hegelian and Marxist sense.

Rather than seeking to untangle dictionary definitions, let us look to lived experience. What is the difference we seek to capture when we differentiate philosophy and ideology?

It is first of all a difference we have encountered before between the primacy of experience and the primacy of concepts. Are our conceptions—that system of views and ideas—a premiss or a conclusion of our doing? Do we assume a stance of respect for life *because* "we are biocentrists?" Or do we consider ourselves biocentrists *because* respect for life guides what we do? Philosophy begins with a question, with an active intercourse with the world of

living and being. Its answers are always provisional, subject to constant verification, ever incomplete. From what we have defined up to now we cannot derive a priori how to deal with a new situation and a new problem. Philosophy is a stubborn, unending effort to think clearly and systematically.

Yet *litera scripta manet*—a word once spoken and written tends to petrify. We have noted that repeatedly in the case of philosophical labels. Reverting to our earlier example, we label the attitude of respect for life as *biocentrism* and suddenly it seems to us that biocentrism is a reality of itself. We no longer ask to what question, what problem it seeks to respond, what it says about it, what it derives from it. We tend to announce simply that *biocentrism teaches*... as if there were no reality, only a conceptual system. This is where philosophy slides into ideology and further. *"If you are a biocentrist, you have to..."* Here ideologization reaches into dogmatism.

Ideologization comes about most easily where thought does not stand in a constant confrontation with a problem. The question of the consequences of biocentrism is clear enough face to face with the problem, for instance, whether to poison pigeons to prevent statue pollution or whether to shoot raven, the sacred birds of the original Americans of the Koyukon people,[62] lest they disturb the afternoon nap of good burghers of Nymburk. It becomes obscure when we no longer set out from a lived situation and do not stand face to face with a problem that needs to be solved, only toy with a certain concept.

In part the problem may be that ecological philosophy and ethics antedate evident ecological threat—and some thinkers arrived at it independently of a lived experience of nature. Jean-Jacques Rousseau knew precious little about nature. His starting point was the a priori idea of early romanticism that nature did not share in the original sin and so has preserved its innocence. Hence a return to nature would constitute a return to primordial innocence, overcoming the evil which is the product of human reason—and so of the original sin of plucking the apple of knowledge. Without lived experience against which he could test his conception, Rousseau unwittingly made up an ideology, a dogmatic complex of convictions wholly detached from the world of lived experience.[63]

Unlike their American counterparts, living in immediate confrontation with a nature untamed by Europeans, early ecological thinkers in Europe were city people. The German biologist Ernst Haeckel, the European counterpart of John Muir, who first used the term ecology in his *Generelle Morphologie* in 1866, knew and encountered nature as a biologist—and as a person with a sense for beauty.[64] Both he and his companions built on biology and evolutionary theory, not on wilderness wanderings, and within their framework sought to understand humans within the order of nature. Unlike the solitary backwoods wanderer John Muir, they did not set out from a practical problem and from an immediate awareness of an ecological threat. They coped with the question of the place of humans in the cosmos in a sociological rather than an

environmental context. As against the older conception of humans as God's special creation, wholly separate from a merely material world, the conceptual trends of holism and monism—Haeckel was an active member of the Monist League—proposed a conception of the *unity of all creation and of humans as one kind of being among others* which, like all life, is subject to the laws of nature.

"Ecology," as the nineteenth-century monists understood it, was a revolutionary doctrine. It rejected as something artificial, unnatural all the privileges of traditional aristocracy, all the surviving city states and their princes, the entire massive weight of tradition which was the basis of the conservative governments of the nineteenth century in their reaction to the Great French Revolution. Turning away from the laws of humans to the laws of nature meant for the monists first and foremost a revolution of equality, nationalism, and socialism as the term was then understood.

Such a turn, to be sure, assumed a knowledge of the laws of nature not only in the mechanistic sense of physics but also in the ecological sense of the continuity of animate behavior. In this context Sir Charles Elton published his *Animal Ecology* in which he introduced the Anglo-Saxon world to the concept of a *nika*. In Germany, Konrad Lorenz began to develop his theories of aggression and flight. Interestingly, Lorenz attributed a normative element to his works from the very beginning. Some authors, Anna Bramwell among them, see the slide of ecology from philosophy to ideology precisely in that. The behavior of other animate species becomes a norm for the human animals as well. Deviation from such putatively "natural" behavior then represents a lapse. As Konrad Lorenz claimed, as long as aggression has its role in the order of the life world, we cannot consider it "evil."[65]

At the root of ideologization is the fact that the conception of humans as a part of the biosphere, of the world of all that is and lives, can represent either a factual recognition of the continuity and interdependence of humans and nature, or a normative conception of what is "natural" and therefore acceptable and desirable. Ecology so understood really does become an ideology from which we derive norms of desirable comportment. In such ecological ideology both the right-wing ideology of a "return to nature" and the leftist ideology of the critique of consumerism, based on an a priori resentment of technology and of ever less manageable technological civilization, can find an ideological justification quite independently of any recognized need to achieve sustainability.[66]

German right-wing ideology, including its Nazi component in its early phase, really did contain a strong "ecological" impetus in the sense of an ideology of a return to the soil and to nature. This emerged in the slogan *Blut und Boden*, in the glorification of the German farmer—and, for that matter, in Heidegger's mystically oriented texts about belonging to the Earth and in his fondness for peasant garb and peasant mores.[67] In its right-wing version, *ecologism*[68] represents a flight from responsibility—turning over responsibility for our relation to the extrahuman world to the invisible hand of Mother Nature.

Similarly, the revolutionary left revolted against the "bourgeoisie" and its old rotten world in the name of what is natural, in this case understood less as regularity of natural processes than as the spontaneity of the forces of nature. It attracted especially young people, impatient with the burden of customs and longing for freedom as Gary Snyder expresses it when he speaks of "The Practice of the Wild." The chapters "Reds, Greens and Pagans" and "Is Ecology a German Disease?" in Anna Bramwell merit reading, in spite of a certain superficiality which reduces ideas to slogans and sequences of names.[69] Ecological ethics needs to be wary of the temptation to ideologization which makes it the shared false consciousness of a certain sect, not a pressing question for all humanity.

The implicit critique of ecology in Anna Bramwell's work does not seem to me particularly convincing. Ecological philosophy can undoubtedly become an ideology, as happened in the case of various ecologisms. Basically, though ecological philosophy and ecological ethics is not about constructing conceptual systems. But for individual exceptions, it is not about an antiquarian longing to return to the roots nor about the revolt of untamed youth against stale old customs. Nor, for the most part, is it about a saving faith to hold and defend. It is about something else altogether—*about a stubborn coping with a pressing problem.* That problem is quite immediate. On a wholly personal level it is a matter of a suffering nature, exploited by human mindlessness and greed; on a global level it is about the balance of the biosphere; and overall it is about intense search for long-range sustainable values and modes of living on this Earth. To refuse the call to ecological responsibility—for instance Jonathon Porritt's call, *"Save the Earth! No ecological challenge is as pressing as to slow population increases in the developing countries while concurrently lowering the levels of consumption of the wealthy North!"*[70]—because right-wing romantics once celebrated the peasant as a folk hero appears to me as either treacherous sophistry or a deep misunderstanding. This time it is not a matter of constructing ideologies. It is a matter of resolving a pressing problem. Ecological philosophy falls in danger of ideologization whenever it presents and defends a creed. It can defuse the temptation to ideologization as long as it is constantly aware that its task is to solve a problem, the threatening conflict of human demands with the biosphere.

Ecological ethics can become an "ideology" in a second, less problematic sense, as a program of an ecological party, usually labeled the Greens. Green parties in Germany, Austria, Sweden, and marginally in other countries as well do play a greater or lesser role in parliaments. Antje Vollmer, former vice chair of the lower house of the German parliament, and Joschka Fischer, current Foreign Minister, belong to the Green party. Other Green politicians, as Petra

Kelly and Rudolf Bahro in Germany or Jonathon Porritt in England have also entered public awareness.

Porritt presents the philosophy of Green parties in his classic programmatic work, *Seeing Green.*[71] A reader at all familiar with contemporary ecological philosophy will probably note most of all that the political program of the Green party does not significantly deviate from the overall consensus of ecological thought. It sets out from the same diagnosis of an Earth at risk, perhaps only with a lesser component of system ecology. It contains a critique of industrialism which subordinates the interests of citizens to maximization of profit. It points to its consequences in the form of destructive wars and social disintegration in the third world. Finally, it points to a deep alienation which marks the superconsuming societies. Were someone like the Czech sociologist Jan Keller to write such a program today, it might be more up to date, supported by far more precise statistics, but in its overall outline it would present the same diagnosis.

The same is true of proposed solutions. Porrit's starting point is pointing out that the present industrial society is marked by an absence of opposition. Mass communications media generate an automatic consensus of listeners who know the price of everything and the value of nothing.[72] The first task, then, is an educational one—to present the public with the possibility of alternative thought and life.

The proposals that follow are also reasonably familiar. It is not possible to leave economic development simply to the interests of maximization of profits. We need to support trades and crafts actively, provide tax relief for ecologically considerate and humanly meaningful production in industry and agriculture alike. Long-term sustainability is the central concept here. Porritt wrote before sustainability became a household word, yet he stresses that not only is small beautiful, as Schumacher would have it, but *human* is beautiful. Against the dehumanization of the human world and the plunder of the extrahuman one the Greens present an ideal of humanization in harmony with nature. The Green program basically does not differ from the common stances of ecological ethics, propagating neither radicalism nor terrorism.[73] What, then, is the difference?

Primarily it is a question of tactics. People who deal with the problems of ecological threat—perhaps with the exception of systems technocrats—want to affect social development. They consider raising ecological literacy and ecological involvement a common first step. It is possible that the most important effect of recycling is not saving resources but involving the personal interest of citizens in the protection of the environment.

That, though, is not enough. It is vain to propagate recycling in a society which provides neither the possibility nor the motivation for it, for instance, by green taxation. It is vain to propagate ecologically considerate transportation if the society lets rail transport disintegrate. Civic activity needs to express itself

not only individually but also as a political will. The question is how to go about it. In most countries ecological activists opted for a strategy of infiltration. They do not seek gain control of one of the existing parties or to found one of their own but rather to induce all parties to make saving the Earth a part of their programs. The ecological threat affects everyone, and so all parties are potentially interested. It is also important that ecological questions should not come to appear as the interest of a particular interest group or a special party. That is why in the United States just as in the Czech Republic most activists opt for global propagation, familiarizing the public with the ecological threat and with proposed solutions in this or that case.

Partisans of political involvement in the form of a Green party point out, on the other hand, that striving for global acceptability inevitably dulls any ecological program. If such a program is to be acceptable to an average political party it must not be too sharply pointed. We cannot call for what we think desirable, for instance, an absolute rejection of nuclear energy in any form or prohibitive pricing of gasoline for private use. That would cost us votes. We have to hold back, call for publication of background documents concerning the building of a nuclear power plant or for a regional referendum. The same is true of everything. No broadly based party can afford to go into an election with a program of a basic change of life style—and that is what is needed. Cosmetic changes are not enough, we need a fundamental change of attitude. Only a party which is unabashedly green from the start can afford such a program.

Understandably, a party which presents an unambiguously ecological program has little hope of wide electoral success. Still, in countries which use proportionate representation it can hope that in the country as a whole there will be enough votes here and there to add up at least to one or two seats. A couple of Green deputies naturally has no hope of passing fundamental ecological legislation. Their presence, though, does mean that the public has before it a clear supporter of a clear ideal, not only masked compromises. There is also the possibility that in the case of a deadlock among the main-line parties the Green delegation will become the swing factor and will be able to affect all legislation.

Only, is that worth it? There is a whole range of objections. One is that the uncompromising clarity of our own party is not an advantage. None of us is omniscient. The great advantage of democracy is that single-minded ideals have their sharp edges worn off to the point of practical utility. Whenever a ruling party could put through its will without the need of such smoothing in compromises, the results were always unfortunate. Only all-knowing and all-good beings could be omnipotent enlightened despots—and the proportion of the all-knowing and all-good among the Greens is no higher than in other parties. The second disadvantage is that with the rise of a Green party there arises also the impression that the ecological threat and its solution is only a partial

interest which does not concern all citizens but only the voters of this party, a special interest group of "nature lovers." That is damning for any ecological activism. Then a third objection: parties need programs. Civic initiatives can address a specific problem and offer specific solutions—stop the nuclear power plant, save the railways, clean up toxic dumps. They do not have to have a position on everything. A political party cannot afford that. It has to present an overall program with answers to everything. Such programs, though, all too easily become ideologies, too rigid to be politically fruitful, as the ongoing debate between the fundamentalists and the realists in the German Green Party attests. Should we then opt for civic initiative rather than party participation, after all?

I know no unambiguous answer that could be applied in all situations. There is a clear need to find effective ways of effective political involvement. There is a problem common to all single issue groups. Only . . . are the Greens a single issue party? Or is a green program a global one, an overall stance of being human upon this earth? We know what we seek: we are looking for a long-range sustainable mode of life, consisting of social rules and support as well as of personal stance and initiative. What solution we derive from it goes beyong the limits of this first overview of the field. The same is true for instance of the question whether the value of zoological gardens compensates for the imprisonment of animals and for the capture of other, hitherto free animals. We no longer permit capturing human slaves. What makes enslaving nonhuman animals acceptable?[74] For that matter, even the question of nuclear energy cannot be solved a priori, deducing conclusions from the general principles of ecological ethics. I may be personally convinced that, for a whole range of good reasons, nuclear energy is ecologically destructive and wholly unacceptable in any form. Josef Vavroušek, the late Czechoslovak Minister of the Environment, whose name I pronounce with the same respect as that of Aldo Leopold, never took an unambiguously antinuclear stand. He was willing to risk it to save northern Bohemia, devastated by soft-coal power plants. Or would energy saving be a better solution?[75]

A number of readers of the Czech version of this book wrote me of their disappointment that I did not give them unambiguous answers to such questions, whether to be vegetarian, oppose nuclear power, protest agains zoos or, for that matter, organize a separate political party to support such positions. Indeed I have not, though I have often presented my positions and reasons for them in periodical literature. Nor do I think I ought to do so in this book. I am convinced and have sought to show that what has brought us to the brink of an ecological disaster is *heedlessness*—that as individuals and as humankind we have not thought through the consequences of our choices. In my usual

metaphor, we have turned the key in the ignition before we thought through the problem of exhaust fumes. Or in a sharper metaphor, we have built nuclear power plants before we thought through the problem of nuclear waste.

That is what we can no longer afford. We cannot afford to act thoughtlessly. Ecological literacy cannot mean simply memorizing the right answers. It needs to mean *thinking* about the right problems. No book in ecological ethics—and in the end no program—can be a *Junior Woodchuck Handbook* in which you need but find the right page to find the absolute answer to absolutely everything. That would be ideology in the worst sense. An author should not and cannot think for the reader. She or he can only offer the reader information, background, reasons for or against as best able. The work of thinking is one all readers have to undertake for themselves.

Should there be a Green party or a Green platform in all parties? Should we reduce our dependence on fossil fuels by using nuclear energy or just the other way around? Or should we strive for equitable distribution and modest use of the goods of this world to reduce both dependencies? Should we . . . the questions are endless. I do not see my task here as giving *my answer*, much less *the right answer*. I should be content if I have succeeded in raising the right questions and in presenting the raw materials of possible answers. Only one thing seems to me unambiguously clear: there should be people who think about being human upon this earth and seek to tread lightly upon it.

Postscript: Turning Green: The Making of a Minimalist

 This concluding confession really is a postscript, not an integral part of the book, and I would encourage the reader to omit it. It is rather personal, an *apologia pro vita sua*. It made a sense of sorts in the original Czech edition. Ours is an intimately small country, we tend to know each other personally and so to be curious about each other rather like neighbors in a village. It makes little sense in a world language. Here it is ideas, not persons, that matter. Treat it, if you will, as one person's confession, no more.

When I lectured on these matters at the Philosophical Faculty of Charles University in Prague and at Boston University before that, I always refused to answer the inevitable question, "What do *you* think about it?" I saw my task as a teacher as one of presenting my students with problems and ideas, not with an autobiography. It is ideas, not personal views, that ought to matter in the classroom. My concern in surveying the range of ecological alternatives was not and is not that obsession of all ideologues, East and West, with *which is right*. My interest is in what we can derive from each of them, independently of personal agreement or disagreement. That, I think, ought to be the concern of the classroom. With this book, though, my lectures entered the public domain—and the question about my own views is being answered for me, often in strange and wonderous ways. So perhaps a few personal words are in order, in self-defense, lest I be charged with ideas I have sought to present rather than advocate.

By hint and indirection, I have borne my witness. I love this Earth with an active love in the spirit of apostle James;[1] I rejoice in all that is and lives with a Schweitzer-like joy; I dread wanton destruction and vain perishing. For me, ecological philosophy is not an ideology but an effective response to the threat and destruction of life on this Earth. That is why for me practical "flannel" ecology is the very heart of the matter and Leopold and Rolston my favorite writers, though I have learned from the entire spectrum of ecological thought. Flannel ecology is the reality testing that keeps subjectivizing approaches from narcissism, objectivizing ones from turning into abstractions and all of it from sliding into ideology. The purpose of ecological thought is not theory but practice, forging ways of human dwelling on this Earth that would respect both its integrity and the integrity of humankind. In the words of the Greenpeace slogan, I want to *tread lightly upon the Earth*.

In the long range, to be sure, I am rather persuaded by the Old Testament prophets that injustice is at the root of the problem. It is the ability of the super-

consuming countries and social strata to exploit without thought or hindrance the vast majority of humankind that makes profligate overconsumption, the major source of ecological danger, possible in the first place. It is the desperate impoverishment, spiritual and material alike, of the rest of the world that is the driving force behind the second ecological danger, overpopulation. Global equitable distribution may well be the long-range key to lowering overconsumption and overpopulation alike.

That, though, is in the theoretical long range. The pressing, shortrange need seems to me the raising of *ecological literacy*—enabling humankind, especially its profligate overconsuming segment, to become aware of the implications of its choices and its acts. Metaphorically—and literally—the fact that in spite of global warming most humans still consider automobiles something desirable pinpoints the problem: we literally *do not know what we are doing*. A revolt of the impoverished might contribute to more equitable distribution, but only if it is matched by far greater social and ecological awareness on the part of the overprivileged. Technologization of overprivileged lives contributes heavily to the ecological insensitivity which makes heedless exploitation possible. The triple need may well be for ecological equity, ecological literacy, and ecological sensitivity.

My own earliest ecological experience was actually a secondhand one. It was a scene at the start of a book of a great Czech narrator and sensitive human being, František Kožík, named *The Victors' Flag*. The boy protagonist Toník is learning to do magic: paper turtles that move. He is trying to glue a paper turtle onto a fly's wings. Malina, a gymnastics coach, interrupts him. Toník feels ashamed and I, the small reader, felt ashamed as well. I realized I was perfectly capable of doing it, too, without even thinking. Thanks to František Kožík I became aware of the horror of indifference to the humble lives that surround us.

Then one more secondhand experience. My father, who took part in the anti-Nazi resistance from the first day of the German occupation of Czechoslovakia, was a prisoner of the Gestapo from 1941 on. Once he recounted to me the days he spent on the wooden benches in the basement of the Petschek Palace where the Gestapo brought its prisoners each day for interrogation, waiting in deadly anxiety to be called. He would sit thus with his fellow prisoners perhaps the entire day. He was permitted to look neither left nor right, only straight ahead at the whitewashed wall.[2] Once he recounted to me the gratitude he felt when a fly landed on the wall and began to clean its wings with its hind legs. It was a touch of life. Till his death in 1996 my father never killed flies. He would catch them under a glass and take them outside. Perhaps with a word of thanks. I do it after him to this day.

There are many more fragments that make up a life, like a short story I read a lifetime later which made me intensely aware of the plight of laboratory animals about which I had read so much theoretically.[3] Perhaps one more recollection is in order, in self-defense—the years I spent living in a New Hampshire clearing, beyond the paved road and the powerline. Among my Czech countrymen, legend has painted it as a log cabin straight out of Sergeant Preston and *The Challenge of the Yukon*. Actually, it was nothing of the sort. It was one of those homesteads that sprouted all over America as the survivors of the urban shipwreck of the Viet Nam years took to the woods, armed with a tape of Woody Guthrie and a copy of *Little House on the Prairie* in place of the family Bible. It was one room with a half loft, eighteen by twenty-four feet, built largely by self-help and with maximal economy.[4] There was neither a paved road nor electricity, but it was hardly wilderness. The house was clean, perhaps not as in *Better Homes and Gardens*, but clean as a farmhouse a century ago. I was not out to prove that it was possible to live primitively. The rural poor the world over prove that far better than I possibly could. My concern was the opposite—to show that cultivated life need not be economically or ecologically costly to this Earth.[5]

The house was built so that it could be heated by one woodstove and insulated thoroughly so that it would not take that much wood. The very first installation in the house, then not yet finished, was a toilet free of dirt and odor. It was a recirculating toilet hooked to an automobile battery, inexpensive and economical. Cold water flowed into the tub by gravity, warm was heated in a coil of copper tubing in the chimney. For light there were oil lamps with an inch wick. Later, as my eyes grew weaker, I supplemented them with LP gas lights. That replaced the two-burner white gas stove on which I cooked in the summer. A cool cellar worked well as a refrigerator—scalded milk lasted four days. Most of all, I remained within my very tight budget, yet I lacked nothing to live well. The greatest gift was the virgin darkness of the valley, the pensive silence of the woods and the proximity of little people I had never known so intimately—of porcupines, raccoons, woodchucks, chipmunks, beavers, and occasional deer. It was immensely restorative and I shall ever be grateful for it.

On that remote clearing where the dusk spreads from beneath the hemlocks and the night is full of stars I started to think about nature. The book that was born of that experience, *The Embers and the Stars*, is in some ways kin to the writings of the depth ecologists. It is an intensely personal book whose main contribution is transforming the reader's sense of nature. The alienation from living nature is something all too real. It dulls in humans both their ability to feel and their will to protect. An intimate encounter with nature opens a person to it, teaches empathy, and so provides motivation for ecological activism. I do not think, however, that we would solve the ecological crisis if we reverted to oil lamps and wood stoves. For that, far more clear and rigorous thought is needed. Perhaps that is why I never agreed to a Czech translation. It

was a book about personal renewal. A different kind of a book is needed now, about personal responsibility.

Cataloging my ecological views would quickly become boring. I do not feel comfortable in any of the pigeonholes I have been describing, having richly drawn on all of them. When a philosophy proclaims itself the One True Faith that will save humankind, it becomes irrelevant. On the other hand, when philosophical thought seeks to define a problem clearly and casts about for solutions, it can learn from a whole range of perspectives. I cherish Schweitzer and Leopold, Rolston and Callicott, but, for all my distrust of irrationalism, I also appreciate John Seed's empathy with living nature and even Garrett Hardin's sense of hard choices and the Stoic-like starkness of his views. I have little interest in taking sides, only in taking ideas that can be put to use in coping with the problem at hand. Seeing that clearly seems to me the crucial task.

Thanks to thinkers like E.O. Wilson, Donella Meadows, and yes, even James Lovelock that problem is emerging rather clearly. This Earth—or perhaps Nature, in the sense of the complex of all life and all that sustains it—cannot long survive the demands we are making upon it. There are too many of us, we demand too much—and we are powerful enough to wrest it from the Earth, heedless of cost. As E.O. Wilson and others point out, a correction must come, a radical lowering of both our numbers and of our level of consumption in the overconsuming world so that the impoverished world can rise out of misery. The only question is whether we shall continue to increase our numbers and our demands until we trigger a catastrophe—drastic impoverishment and massive die-out—or whether we shall be wise enough and mature enough to accept responsibility for forging a sustainable mode of living before a catastrophe cancels all demands.

In the affluent world, it is much in the vogue to assume that the root of the ecological crisis lies in the population explosion, presumably largely in the third world. That shifts the responsibility for resolving the crisis onto the third world. Let them introduce family planning. Just the sheer weight of numbers is staggering and numbers, however impoverished, require space. Throughout the third world, forest expanses are shrinking and species are dying out, crowded by the desperately poor struggling for space.

That, though, is only a small part of the truth, and by itself deceptive. The United Nations *Human Development Report 1998* points out that while the impoverished world accounts for some three quarters of the world's people, it accounts for only twenty percent of the world's consumption and waste production. The exact figures cited in various reports differ marginally, but the lesson is clear: while it is urgent to deal with the population explosion on humanitarian as well as ecological grounds, even if the entire third world were to disappear, it would affect the ecological crisis only marginally. Eighty percent of the problem is the insatiable gargantuan demand of the overconsuming world. What we are wont to call affluence is in fact a paroxysm of greed. The

real ecoterrorists today are the innocently greedy denizens of that world, living their consumer caricature of the American Dream, who think it is their right to consume many times their share of what the Earth produces and deposit on it many times their share of waste.

The assurance offered by some objectivistic approaches, that Nature will bring about a correction, is to me rather less than reassuring. Catastrophic corrections tend to be rather unselective. There are human achievements which I believe worth preserving. Among those I would count a healthy environment, personal safety, availability of medical care, access to basic education but also such minima, denied to most humans, as clean water and safe waste disposal. Are we, the overconsuming ecoterrorists, willing to change our ways so that we could preserve what is truly significant and extend it to all humans? It need not mean choosing poverty. Just curtailing air travel in favor of trains, opting for more economic concentrated housing instead of suburban sprawl, substituting public transport for a second or third car, and using free time in less costly ways than globetrotting would represent a hefty saving. That is not a return to the cave. It is simply a matter of willing modesty and justice in place of greed.

How can we go about it? Two distinct strategies present themselves. One would resolve the crisis of demands and possibilities with *more effective technology*, the other with *less demanding humanity*. As long as we demand more than we can satisfy sustainably by present means—and that is the real nature of the ecological crisis—we need either desire less or produce more. Which will it be, more frugal humanity or more profligate technology?

The earliest reaction to the awakening ecological consciousness, represented in America by Rachel Carson's *The Silent Spring* and the Meadowses' *The Limits to Growth*, was ambivalent. Then the oil crisis of the seventies seemed to awaken old New England virtues of modesty and hard work, the morality of Puritan settlers. Wholly in the spirit of President Carter, America turned toward frugality. In four years it took a series of decisive steps both in ecological legislation and in ecological attitudes. Perhaps most symptomatically, Americans, though too entrapped in their suburban sprawl to turn to public transport, at least started demanding smaller, more economic cars.

Car manufacturers and oil companies mounted a powerful counterattack. Commercials ridiculed economic cars as "econoboxes." Presidential candidate Reagan proclaimed that frugality was un-American, that the American way is to produce more and consume more. The election in 1980, opposing ecologically oriented Carter to Ronald Reagan, the ultimate apostle of growth, was in a way a plebiscite about frugality. To many of us it seemed that in it America rejected its New England heritage. Ronald Reagan won by a wide margin—

and America turned to the policy it has followed ever since, escalating afflu-
ence at home by expanding its sway over the globe. The idea of more efficient
technology, labeled sustainable development, provided a salve for sore con-
science.

In Europe, the strategy of more demanding technology has its proponents
no longer so much among the Thatcherites as in the authors of the new report
of the Club of Rome, *Factor Four*.[6] The subtitle captures the basic promise—
Doubling the Wealth. It is not surprising that the book affected many European
readers the same way as Reagan's slogan that frugality is un-American, that
the American way is to produce more and consume more. Increasing con-
sumption is a slogan which, in the twentieth century, has become almost a syn-
onym for increasing happiness. Though nothing bears it out, Europeans
believe it as fervently as the Americans and are willing to sacrifice the
deprived countries no less than nature to the pursuit of affluence. The irony
may well be that social injustice might prove the ultimate cause of the ecolog-
ical disaster. It is the reduction of much of the world to poverty that sustains
the arrogant affluence of Europe and North America. Yet it is that affluence
that is destroying the ecology of the Earth and so its own presuppositions.
Neoliberalism provided a salve for any twinge of conscience with respect to
exploitation of the third world. *Factor Four* seems to offer a corresponding
ecological salve: a guarantee that the pursuit of affluence can continue with a
clear conscience, at least as far as ecology is concerned, under the label of sus-
tainable development.

For all that, the book has much to offer that is clearly positive. In contrast
with the post-Marxist rhapsodies about (sustainable) development and benefi-
cial conquest of nature, *Factor Four* offers a wealth of concrete information
both about the wastefulness of the present procedures and about the possibility
of more economic ones. *Factor Four* propagates railways, restoration rather
than replacement of old buildings, local rather than global production and con-
sumption together with economic stimuli to encourage it. It will supposedly be
possible to reach sustainability *without consumers having to reflect about their
lifestyle*—or, in the terminology of system ecologists, without resorting to sub-
jective approaches. We are promised twice the consumption and a clear con-
science to boot.

Perhaps the most positive aspect of *Factor Four* is something that the
authors mask by the bombastic title about doubling the wealth and by the
equally bombastic style which avoids even a hint of social criticism. Still, the
authors cannot escape the human dimension of their analyses. They get to it at
the very end of the book, on the last twelve of 320 pages in the Czech edition.
Here they speak of nonmaterial affluence, complain that selfishness is in the
ascendancy and conclude that until our civilization overcomes the mechanism
which suppresses nonmaterial gratification with material development, it can-

not prevail in the contest between the growth of effectiveness and the uninter-rupted growth spiral.[7]

The conclusion of *Factor Four* proves to me that the strategy of more effi-cient technology is not viable. The first problem is the very idea of unlimited growth on a demonstrably limited Earth. I do not in the least doubt that we need the most efficient and most economical technology but as long as we use it solely to satisfy rising demands we solve nothing, only increase the problem. The race between new motorways and new automobiles in Los Angeles is a classic example. Every new freeway brings more cars into the city. Building freeways solved nothing, only increased saturation by automobiles. Only at the end of the nineties is Los Angeles beginning to consider public transport which it let disintegrate half a century earlier. To me reading *Factor Four* emphasizes the need to admit out loud what the authors admit covertly at the end of the book, *that the ultimate solution of the ecological crisis lies not in more effec-tive technology but in more frugal and more generous humankind in what is today the overconsuming world.*

That is why I think ecological philosophy and ethics the key to the whole ecological problem. It seems to me utterly fundamental to think through and live through the whole philosophical question about the place of humans in the cosmos and in nature. It may be that a dramatic revolt of the deprived will drastically reduce the affluence of the privileged and restore the balance between human demands and nature's needs. Hoping for a catastrophe, though, is ever a height of folly. Catastrophes bring about adjustments un-selectively. If we want the change to be healing rather than destructive, it is important to be clear just what we are trying to accomplish with environmen-tal protection and long-range sustainability so that we would not become entangled in a whirl of vague generalities and conflicts over labels and slo-gans. We need no less to take an active part in acting quite locally, in protect-ing this or that, both for the results we achieve and the different, unestranged relation to nature we build. We need to learn to empathize and share not only with the human, but also with the nonhuman world.

That, though, is no longer simply a question of ethics but a far more basic question of philosophy, of the meaning of being human upon this earth. What is it that really matters, and what can we do without? Is life really about ever expanding consumption? Or does life, not just individual lives, but the life of humankind, have a different purpose? What is the *nika* of humankind in the history of the Earth?

In the Czech lands a century ago, that is something we discussed with great fervor under the label of the "meaning of our history." Those discussions

generated more heat than light, yet they concealed something fundamental. Our positivists pointed out that *meaning* is inevitably a subject-related category. "Objectively" speaking—that is, without reference to a subject—history can only be, though even that is problematic. It cannot "mean." For that reason Josef Pekař, the greatest of the Czech positivist historians, refused to look for some underlying *meaning of Czech history* and insisted on a positive description of our past in all its conflicted multiplicity.[8]

Among those who seek the meaning of history in relation to subject there are those who imagine the subject as a great personality that projects its temporality into historicity and with its authentic deed challenges all the inauthentic everydayness of the lives of our kin.[9] It is basically an aristocratic conception. While the faceless crowd is said to fall into the petty accumulation that marks the meaningless everyday life, the authentic deed of the decisive individual tears aside grey everydayness and illuminates temporality with historical meaning. So the great Czech philosopher at mid-twentieth century, Jan Patočka, in his study *What Are the Czechs?*, cited earlier, stresses the role of heroic individuals like Přemysl Otakar II who attempted to establish Czech hegemony in central Europe in the thirteenth century—Patočka speaks of *the will to empire*. For that reason, too, he considers the thirty years of political and philosophic effort of T.G. Masaryk, the philosopher and later founder of the modern Czechoslovak state, at building up the Czech nation insignificant petty work and sees Masaryk's significance in the heroic or authentic act of revolt against Austria and founding a state.[10] History—and so being human at large—here becomes meaningful in relation to a heroic individual.

Against this aristocratic conception of history, thinkers in the democratic tradition object that meaning derived from a putative heroic individual is individually subjective and contingent on preference. If the meaning of our humanhood is not to be purely contingent, it has to relate to humanity as such, or, in Husserl's terms, to *transcendental subjectivity*, structural subjectivity as such, not this or that set of subjects. So Husserl sees the meaning of humanity in the uniquely human possibility of guiding life by conscious, well grounded decision—he would say, *out of reason*—rather than being led by instinct, habit, or "tradition."[11] Masaryk understood that life in responsibility as the growth of humans to full humanity. For that reason, he thought the ongoing effort at the humanization of this land rather than heroic deeds the most significant moments of Czech history.[12]

I am convinced, with Husserl and Masaryk, that if we can speak of the meaning of our humanity at all, it is not in reference to heroic deeds and dramatic gestures but in the distinctive possibilities of our humanhood. Today that is no longer just the growth of individual humans to full stature of their humanity but the possibility of "saving the Earth"—finding a way of being human that would not end in natural self-destruction. Numerous commentators stress that humanity was led into conflict with sustainability *naturally*, by its instinc-

tive expansion of all exotics. Humanity, however, has also no less naturally the possibility of living not out of instinct and custom but *morally* out of conscious, reflected decision. It has the possibility of overcoming consciously the "natural" tendency to self-desctruction by a willed quest for sustainability. "Ecology"—the conscious search for long-term sustainable modes of cohabitation of humankind and the Earth—is no longer the hobby of nature lovers. It is the task of humankind and the meaning of our being.

That, though, would be the topic for another book, one dedicated to that "Think globally" in the Greenpeace slogan. Our task here is more modest—to "act locally." Let us set about learning all that the system theories overlook: let us learn to love this Earth and to treat it with gratitude and respect. The point is not whether humankind can "save Nature." That always sounded to me as sheer megalomania. Perhaps we should say that the question is whether we can save humanity from the consequences of its own shortsighted greed. Most fundamentally, though, it is not a matter of any saving. It is a matter of learning to live in harmony, so that our cohabitation with the whole of life would not burden the Earth beyond the limits of sustainability. Or more poetically, to tread lightly so that, in the words of Exodus 20:12, *thy days may be long upon the land.*

N o t e s

PREFACE

1. The DUHA (Rainbow) Movement, the Czech member organization of Friends of the Earth, offers the following assessment: "The Earth is confronting a global ecological crisis. There is global warming, the fragile ozone layer is seriously threatened, several biological species become extinct daily, the primaeval forests are rapidly vanishing, the extent of arable land is shrinking while deserts are expanding, the chemical pollution of soil, water, and air is growing, unique supplies of irreplaceable resources are being wasted. . . . The ecological crisis did not just happen: it has its clear causes. It is, on the one hand, the overall orientation of the industrial civilization toward what is called 'development,' reduced to economic expansion. Given the organization of industrial economy, it can not grow otherwise than at the expense of nature. To that correspond present-day irresponsible life styles whose characteristic trait is the effort to increase personal material affluence accompanied by pointless overconsumption and shocking waste." Jan V. Beránek, *Proč je třeba zastavit JE Temelín* (Why the Temelín Nuclear Plant Must Be Blocked; Brno, DUHA, 1997):23.—Unless otherwise noted, all translations of cited material are mine.

2. Donella Meadows *et al.*, *The Limits to Growth* (New York: Universe Books, 1972), Donella Meadows, Dennis L. Meadows and Jorgen Randers, *Beyond the Limits* (Post Mills, VT: Chelsea Green Publishers, 1992), Ernst Ulrich von Weizsäcker, Amory Lovins, L. Hunter Lovins, *Factor Four: Doubling Wealth—Halving Resource Use: A New Report of the Club of Rome* (London: Earthscan, 1998). The last delighted Czech technocrats who take its lesson to be that greed can be ecological and we can overconsume with a clear conscience.

3. The concept of long-term sustainability came to the fore at the intergovernmental ecological conference at Bergen in Norway and, in that connection, "sustainable development" has become an excuse for business as usual with a courtesy nod to ecology—automobiles, yes, but running on lead-free gas. I wish to use it in its profound sense, as a mode of life and set of values which would not burden the Earth more than it can renew, for instance using no more wood than forests can replace and releasing no more pollutants than the oceans and forests can absorb. More efficient technology can help, but only if there is a will to sustainability—and to modesty. The key, as we shall argue, is values which do not place an excessive burden on the Earth's resources—such as a walk in the woods rather than an afternoon drive. See Thijs de la Court, *Beyond Brundtland: Green Development in the 1990s* (trans. Ed Bayers and Nigel Harle, New York: News Horizons Press, 1990) and *Different Worlds: Development Cooperation Beyond the Nineties* (trans. Lin Pugh, Utrecht, NL: International Books, 1992).

4. I have several times seen the term "ecological literacy," which David Orr used as the title of his 1992 book, attributed to Aldo Leopold's *A Sand County Almanac* (New York: Ballantine Books, 1947; 1990), but have never found it in his writings. As far as I can determine, it comes from J. Baird Callicott's essay, "The Conceptual Foundations of the Land Ethic" in J. Baird Callicott, ed., *Companion to A Sand County Almanac: Interpretive and Critical Essays* (Madison, WI: University of Wisconsin

Press, 1987):194. Closest to it in Leopold is *ecological comprehension of the land* in *op. cit.*, 262, though that is really about something else. All of Leopold, to be sure, belongs to the most basic ecological literacy.

INTRODUCTION: OF HUMANS, ELEPHANTS, AND CHINA SHOPS

1. Eugene P. Odum, *Fundamentals of Ecology* (Philadelphia: Saunders, 1953 and many reprints) Lovelock's favorite ecologist, much beloved by generations of students and considered the bible of ecology in Czech schools. Interestingly enough, the basic bibliographies of ecologico-philosophical literature such as D.E. Davis, *Ecophilosophy: A Field Guide to the Literature* (San Pedro, CA: R. & E. Miles, 1989) or David Orr, *Ecological Literacy* (Albany, NY: SUNY, 1992) do not even list this text even though it had first appeared already in 1959. Their interest focuses not on the functioning of natural mechanisms "of themselves" but rather on the mutual effect of humans and nature, what Odum would call *human ecology*. In philosophy they focus on conceptions of the meaning of nature and the place of humans therein on which humans ought to base their decisions and actions. It is, in our terms, ecological ethics with its own academic *niche* or *nika*, though by no means a replacement for Odum's classic work.

2. Kenneth Boulding, in his "The Economics of the Coming Spaceship Earth" in Henry Jarrett, ed., *Environmental Quality in a Growing Economy* (Baltimore, MD: Johns Hopkins Press, 1966), 3–14, called such an approach "the cowboy ethics" which the Americans had hitherto taken for granted. The debate about ecological ethics began in America with casting doubt on this ethics of plunder. More of that below.

3. There is virtually a flood of scientific reports published both by individual governments and the United Nations, all reaching similar conclusion: we are using too much too fast. So Thijs de la Court, cited earlier, and subsequent works down to the third report of the Club of Rome, *Factor Four* and most recently the United Nations *Human Development Report 1998* (New York: Oxford University Press, 1998). In the Czech Republic, the Worldwatch Institute report, *State of the World 1998* (New York: W.W.Norton, 1998) which appeared for the first time in Czech, had some impact. For the most part, however, such reports do not ask the questions of ecological ethics, what to do and how to motivate humans to do it, they only systematically analyze the ecological situation of the Earth and suggest what might be desirable . . . if someone were to care to do it.

4. In Czech Miroslav Šuta published an interesting study, *The Impact of Automobile Exhaust Fumes on Human Health* (Brno: C & S Traffic Club, 1996). Yet less than a third of the pollution caused by automobiles is due to exhaust fumes. The manufacture, ancillary needs, and liquidation of motor vehicles is even more polluting and would be even were electric cars to become universal.

5. Though experts consider a 50 percent lowering in carbon dioxide emissions essential, the American delegation in Kyoto finally agreed only to 8 percent—and not now, only in a decade. In spite of that, when Vice President Gore presented the agreement to the American senate, the Republican majority attacked it. See also von Weizsäcker, *op. cit.*, 20ff.

6 (Post-)Marxist systems theoreticians like Jiří Cetl *et al.*, *Příroda a kultura* (Prague: Svoboda, 1990) or Josef Šmajs, *Ohrožená kultura* (Brno: Zvláštní vydání, 1995) use the terms *nature* and *culture* as technical terms, designating the independent

system of all being and living (nature) and the dependent subsystem of human being and doing (culture). They see the essence of the ecological crisis in "culture" threatening the viability of the "nature" on which it depends. Other systems theoreticians such as Donella and Dennis Meadows, James Lovelock and E.U. von Weizsäcker use similar concepts. See Part III.B.vii below.

7. See United Nations' *Human Development Report 1989*, also von Weizsäcker, *op. cit.*, 20 and 232–48, also 318–20.

8. The Rainbow Movement—Hnutí DUHA—is one of the most active and articulate environmental initiatives in the Czech Republic. Their monthly, *Sedmá generace* (*Seventh Generation*), deals most consistently with the renaissance of natural relations. The dangerous temptation here is that we shall interpret the renewal of natural relations as a return to a (mythical) non-problematic past. Dr. Burda in Svěrák's ecotragedy, *Co je vám, doktore?* (1984, one of the finest and wholly overlooked Czech films) acts this out. Another example is Helen Norberg-Hodge in her Ladakh rhapsody, *Ancient Futures: Learning from Ladakh* (San Francisco: Sierra Club Books, 1991). It is worth noting that the Dalai Lama in his preface gently yet unambiguously distances himself from the author's romantic idyllization of grinding poverty in Ladakh.

9. The term *developed* is problematic when used as a synonym for wealthy. Wealth was never a sign of maturity among humans—if it were, we could consider the children of the wealthy mature at birth. We need a different way of evaluating maturity when it comes to societies. Numerous authors address that question, as Jan Keller, *Nedomyšlená společnost* (The Unthought-Out Society, in Czech; Brno: Doplněk Publishers, 1992) or Ezra J. Mishan, *The Economic Growth Debate: An Assessment* (London: George Allen and Unwin, 1977), though even the incurable technocrat von Weizsäcker is aware of it, see *op. cit.*, ch. 12, section asking for a new measure of affluence (288–91 in Czech edition). I shall use the term *overconsuming* rather than *developed* as more accurate.

10. Zdenek Kratochvíl and Jan Bouza, *Od mýtu k logu* (Prague: Herrmann and Sons, 1994). Martin Heidegger speaks of "naming the gods;" Karl Jaspers uses a nice term, *Existenzerhellung*, casting light on the human mode of being, though the meaning he gives it is somewhat different.

PART I: OF HUMANS AND (OTHER) ANIMALS

1. This chapter is not "about animals." It is about the way humans relate to other animals because that relation is a microcosm of the way humans relate to nature and to the nonhuman world generally. For that reason, I have not based it on zoological studies, much though I appreciate authors like Pavel Pecina and Zdenek Veselovský or their fellow biologists abroad like Konrad Lorenz. Rather, I have drawn on the monumental historical study, Clarence J. Glacken, *Traces on the Rhodian Shore: Nature and Culture in Western Thought from Ancient Times to the End of the Eighteenth Century* (Berkeley, CA: University of California Press, 1967). Though few will read eight hundred dense pages of tiny print, at least the fourth part, from Francis Bacon to the end of the eighteenth century (461–705), seems to me essential for understanding the development of European ecological assumptions. Keith Thomas loosely takes up the narrative in his *Man and the Natural World* (New York: Random House, 1983, most regrettably out of print), taking the theme to the twentieth century. Occasionally Paul Veyne, ed, *Histoire*

de la vie privée (in the English of various translators *History of Private Life* in four volumes, Cambridge, MA: Harvard University Press, 1987–92) proved helpful, though it deals with attitudes to nature only marginally, preferring to focus on the mating rituals of the subspecies *H. sap. sap.*

2. Since the mid-century a number of studies by authors like Jane Goodall, Thomas Bledsoe, Diane Fossey, Cynthia Foss, and many others have amply demonstrated thought and feeling of animals on the basis of observation both in the wild and in imprisonment. Donald Griffin, the director of Harvard University's Zoological Musem, summed up the results beyond scientific doubt in his book, *Animal Minds* (Chicago: University of Chicago Press, 1992). Less rigorously but rather more readably Jeffrey M. Masson and Susan McCarthy, *When Elephants Weep* (New York: Delacorte Press, 1995) demonstrate the same, as does Elizabeth Marshall Thomas in her *Hidden Life of Dogs* (Boston: Houghton Mifflin Co., 1993). In Czech translation, these two books brought about a visible shift in popular perception of nonhuman animals.

3. See the chapter dealing with the history of philosophy which I would hesitate to recommend for the study of history, though the book itself is absolutely basic. Peter Singer, *Animal Liberation* (New York: Avon Books, 1975), 192–202. Many times reprinted and translated, unfortunately so far not into Slovak or Czech. Regrettably, the updated edition (New York: Avon Books, rev. ed., 1991) was unavailable to me at the time of writing.

4. Robert N. Proctor, "Nazi Doctors, Racial Medicine and Human Experimentation" in George J. Annas and Michael A. Grodin, *The Nazi Doctors and the Nürnberg Code* (New York: Oxford University Press, 1992), 17–31 points out that the Nazi doctors were generally well educated and cultivated scientists, convinced that they were serving science and that the use of Jewish or Romany subjects did not differ from experimenting on other animals.

5. While this is how critics read the Bible, it is a rather selective reading. For a far more reliable report, see Pavel Nováček, *Chválí Tě sestra Země* (Sister Earth Praises Thee, Olomouc: Matice cyrilometodějská, 1998). This thoughful and thorough compilation of ecological thought and Scripture very badly needs translation into English.

6. Keith Thomas, *op. cit.*, 36ff brings up Gomez Pereira. Morris Berman, *The Reenchantment of the World* (Ithaca, NY: Cornell University Press, 1980) describes Spanish attitude toward Caribbean natives. However, already in 1537, under the pressure of the advocate of the *Indíos*, Bartholomeo de las Casas, Pope Paul III issued a bull, *Sublimis Deus*, in which he clearly proclaims that "Indians" are humans capable of faith and salvation. So Clarence J. Glacken, *op. cit.*, 360.

7. Keith Thomas, *op. cit.*, 39.

8. Elizabeth Marshall Thomas, whom we have noted already as the author of *The Hidden Life of Dogs*, responded to a question on New Hampshire Public Radio whether dogs will "go to heaven" quite directly: "What kind of a heaven would it be if there were no dogs?" even though she herself does not share such a "metaphysical" conception of heaven.

9. As basic reading I would recommend, in addition to Peter Singer's *Animal Liberation*, Bernard E. Rollin, *Animal Rights and Human Morality* (Buffalo: Prometheus, 1981), Tom Regan and Peter Singer, eds., *Animal Rights and Human Obligations* (Engelwood Cliffs, NJ: Prentice-Hall, 1976), Tom Regan, *The Case for Animal Rights* (Berkeley, CA: University of California Press, 1983), J. Baird Callicott,

"Animal Liberation: A Triangular Affair," *Environmental Ethics* 2, no. 4 (Winter 1980), though the field is constantly growing and I have not been able to follow it systematically since leaving the United States.

10. Leopold Hilsner was a young drifter convicted of the murder of a Christian girl in the Czech town of Polná, then a part of Austro-Hungary. The conviction was based on the claim that Jews need Christian blood for religious ceremonies. Tomáš G. Masaryk, professor of philosophy at Charles University, mounted a strenuous campaign to have the case retried and the verdict reversed. He succeeded in the first, not the second. Hilsner remained in prison until he was amnestied by the same Masaryk who had become the first president of newly liberated Czechoslovakia in 1918. Jiří Kovtun, *Tajuplná vražda* (Prague: Sefer, 1994).

11. Milly Schär-Manzoli, *Holocaust* (trans. Edith Barritt-Playell, Switzerland, ATRA:AG STG, 1994). The author draws on reports which experimenters themselves filed with the office for the protection of animals in Switzerland, the land with the best legislation in this area. Czech legislation is far less worked out. Ironically, the Czech reading public largely ignored the book.

12. In environmentalist circles it is customary to attribute this particular truism to Edmund Burke. It is in his spirit but I cannot document the authorship—and in any case, it vastly does not matter: the claim stands on its own.

13. Bernard E. Rollin, *Animal Rights and Human Morality* (Buffalo, NY: Prometheus Books; 1981). Though rigorous philosophy done in the British manner makes for less than lively reading, Rollin's excruciatingly conscientious stand as a member of an ethics committe charged with approving animal experiments gives his work exceptional weight. He knows whereof he speaks and cannot dodge the difficult questions.

PART II: OF NATURE, VALUE, AND ETHICS

1. The famous quote from Paul Ricoeur comes from *The Rule of Metaphor* (trans. Robert Czerny, Toronto: University of Toronto Press, 1977), 303.—The conception of science as one possible symbolic form comes from the work of the German philosopher, Ernst Cassirer. His classic *An Essay on Man* (New Haven, CT: Yale University Press, 1944), written in English during the war, contains both a succinct summary of Cassirer's philosophy of symbolic forms and an interpretation of myth and of science as symbolic forms.

2. Marlo Morgan, *Mutant Message Down Under* (New York: Harper Collins Publishers, 1994).

3. Morris Berman describes the transition from mythico-religious perception of nature to a natural scientific one as a *disenchantment* of nature. Berman, *op. cit.*, esp. pp. 67–115.

4. For the best account by far of hunter-gatherers, Paul Shepard, *The Tender Carnivore and the Sacred Game* (New York: Scribners, 1973) and other works. E.M.Thomas evokes the experience of a hunter-gatherer culture in *Reindeer Moon* (Boston: Houghton Mifflin, 1987). See also all studies of the life of original Americans as long as they are not a romanticized distortion like Karl May, much beloved in central Europe. See also Marlo Morgan, cited earlier (note 2, Part II).

5. Sociobiologists point to the possibility of genetic coding of such experience, pointing for instance to goose bumps reminding us of bristling the fur we have long

since lost. We shall deal with that below, Part III.B.vii. In the present context we are concerned with the *lived meaning*, not the mechanisms of living—that is, with philosophy, not with sociobiology.

6. See the collection of texts on this topic listed in Loren Wilkinson, ed., *Earthkeeping in the '90s* (Grand Rapids, MI: Eerdmans Publishing, 1991 or, in Czech, the collection edited by Karel Šprunk, *Člověk-pastýř stvoření* (Brno: Cesta, 1995).

7. Since the Czech nation was reborn in the nineteenth century as a nation of peasants and laborers while the wealthy and the nobility tended to be German and so alien, the mentality of frugality, reinforced by romanticism, is deeply rooted in it, as in the classic literature, Božena Němcová's *Babička*, Karel Rais's *Zapadlí vlastenci* or Alois Jirásek's *F.L.Věk*. Whether that sense for the goodness of life can survive the vicious onslaught of supranational consumerism is problematic.

8. In the rhetoric of post-Marxist system ecologists "consumerism" has replaced the "bourgeois ideology" of yore in the role of the class enemy and has acquired a rather idiosyncratic and very general meaning of envied affluence. In this book, I am using the term "consumerism" differently, in the clearly defined sense of an attitude to life which assumes that (i) the point of any human activity is expansion of material consumption, that (ii) the only role of the state is to make such unrestricted expansion possible ("neo-liberalism") and (iii) that the expansion of consumption will automatically resolve all problems, social as well as personal, and will guarantee a nebulous "happiness" ("progress"). A society can be oriented as a consumerist one even when it is communist (or "real socialist") and has a low level of actual consumption, as the Soviet Union in the Brezhnev era. Conversely, it can have a high level of consumption and yet be oriented in a wholly non-consumerist spirit, as religious and alternative communities in North America. If ecological ethics is not to dissolve in rhetoric, I think it necessary to use the term "consumerism" as a clearly defined description of a certain mode of life, not as an expression of class hatred.—See analyses of consumerism in the work of Ezra J. Mishan in English or Jan Keller in Czech.

9. Lynn White, Jr., "The Historical Roots of our Ecological Crisis," *Science* 155 (10 March 67):1203–7.

10. We shall deal with the very problematic concept of "natural" below, p.106 and note 1. Here we should note, with Holmes Rolston III (*Philosophy Gone Wild*, 30 *ff.*) that we can equally well call everything humans do "natural" as proceeding from their nature or deny anything humans do is "natural" since it is the work of freedom rather than instinctual necessity, so the "natural" ends up meaning simply the habitual or the effortless. As for the conception of "natural" as inborn, note E. O. Wilson's caution, that natural in that sense means measurable probability, not necessity, *On Human Nature*, 99–100.

11. Neil Evernden, *The Natural Alien* (Toronto: University of Toronto Press, 1985):108–9 and below, Part III.B.vi.

12. Henryk Skolimowski, exiled from Poland, studied in England, lectured in the United States, now lectures alternately at the University of Michigan and at the Technical University in Lodz. His writings include *Eco-Philosophy: Designing New Tactics for Living* (London, NH: Marion Boyars, 1981) and *Eco-Theology: Toward a Religion for our Times* (Ann Arbor, MI: EcoPhilosophy Publications, 1985.)—On similar grounds we could consider Pierre Teilhard de Chardin, the author of *Le phénomène humaine*, a theocentrist, but no less so the depth ecologists who wholly reject tradi-

tional religion and worship Mother GAIA instead. Theocentrism does not mean centrality of God in the traditional European conception but rather the centrality of a sacred transcendence and the posture of sacred awe.

13. *Op. cit.*, readily available in many reprints. Here I am quoting from the reprint available to me in the Czech Republic, in Louis P. Pojman, ed., *Environmental Ethics* (Boston: Jones and Bartlett, 1994), 9–14.

14. To follow this up further, see Pojman, *op. cit.*, 15–24, which reprints several critics and cites extensive bibliography, though most scholars tend to regard the discussion as closed. For a more up-to-date report on this topic, see Loren Wilkinson, ed., *Earthkeeping in the '90s*.

15. I have dealt with this in the article "Greeks, Jews and the Relation of *Nature* and *Culture*," *Filosofický časopis* 45, no. 4 (Sept. 1997):669–72 (in Czech).

16. Jan Patočka, "The Truth of Myth in Sophocles' Labdakian Dramas," *Art and Philosophy II* (Archival transcript, Prague):185–93 (in Czech).

17. Most post-Marxist systems ecologists tend to this view as well, as Josef Šmajs in *Ohrožená kultura*, whereof more below, Part IIIB.vii.

18. Annie Dillard, *Pilgrim at Tinker Creek* (New York: Harper and Row, 1974), cf. chapter X, "Fecundity," 159–81. To the great discomfort of my more romantically inclined fellow ecologists, I included this striking passage in our basic reader, Kohák *et al., Závod s časem* (Prague: Torst, 1996):58–67.

19. This is the lesson many Christians draw from the Bible. The convention of the *Ústí nad Labem seniorát* (roughly diocese) of the Czech Brethren Protestant Church addresses its sisters and brethren: "Both the Biblical testimony and the tradition of the Reformation and its heirs offer us an ethical model of a fitting moderation which knows how to accept gifts gratefully and not fall prey to egoistic greed and waste.—One of the main reasons for the growing material consumption and the consequent damage to the environment is spiritual emptiness. Yet humans lack not so much material goods as their own identity, community, motivation, recognition, love, and joy.—We bid all clergy to remind all the faithful that care for the environment belongs inseparably to Christian responsibility and to guide all by word and example to the ideal of modesty against the overconsumption of a consumer society." Reprinted in *Křest'anská revue* 65, no. 1 (Jan. 98):20–22. I know of no clearer response to Lynn White Jr. or a better statement of my personal conviction.

20. Perhaps the best analysis of this theme is Jan Patočka's in his lecture "Cartesianism and Phenomenology," first published in Czech in a *samizdat* collection in honor of Karel Kosík in 1977. English translation in Erazim Kohák, *Jan Patočka: His Thought and Writing* (Chicago: University of Chicago Press, 1989):285–326.

21. To give Kant his due, his claim is that from the rationality of human subjects (in his usage, *Geister*, spirits) there follow for each rational subject direct duties to all other rational subjects. There are no such direct duties to nonrational beings (i.e., non-human animals), but from human duties to other humans there follows indirectly a duty not to mistreat animals lest humans grow so accustomed to cruelty that they begin to use other humans cruelly as well. The concern is for humans, only indirectly for animals. See the much cited passage in Kant's "Duties to Animals and Spirits," English in *Lectures on Ethics* (trans. Louis Infield, New York: Harper and Row, 1963), 239–41, though extrapolation from *Critique of Practical Reason* might lead to less unlovely conclusions.

22. Jan Patočka, "What Are the Czechs," a series of letters to the widow of the German philosopher Ballauf, published in book form in original German and Czech translation by Ivan Chvatík and Pavel Kouba, eds., *Co jsou češi* (Prague: Panorama, 1992); see also Jan Patočka, *Heretical Essays in the Philosophy of History* (translated by Erazim Kohák, Chicago: Open Court, 1997), especially the concluding essay.

23. Nature here refers to typical human modes of functioning rather than the biosphere. Sherrington wrote his inquiry into European self-understanding on the eve of the Second World War so that the book did not become widely known in Europe though it did see an American edition, Charles Sherrington, *Man on his Nature* (New York: Doubleday, 1953).

24. Annie Dillard, *Pilgrim at Tinker Creek,* note 18 above.

25. Jan Keller, *Až na dno blahobytu* (To the Dregs of Affluence, Brno: Hnutí DUHA, 1993) and a number of subsequent studies, including *Sociologie a ekologie* (Prague: Sociological Publishers, 1997).

26. Hana Librová, *Pestří a zelení: kapitoly o dobrovolné skromnosti* (The Speckled and the Green: Studies of Voluntary Simplicity, Brno: Hnutí DUHA, 1994).

27. Albert Gore, *Earth in the Balance* (New York: Plume-Penguin, 1993). Gore's book, which appeared in a Czech translation within a year of its original publication, represents an appealing combination of nobility and realism in stark contrast with the short-sighted exploitative mentality of the American congressional majority of his time.

28. Gore appears to have had but vaguely impressionistic ideas about deep ecology. The idea of a fundamental conflict between "nature" and "culture" is far more typical for post-Marxist (but also Western non-Marxist) system theoretical thought represented in Czech by Jiří Cetl et al, *Příroda a kultura.* Gore's introduction seems to me more of an attempt to distance himself from mythical "ecoterrorists" who live for the most part in the arrogant ignorance of Gore's political opponents and of their Czech counterparts.

29. The Ústí Czech Brethern convention, cited earlier (note 19 above,) reaches the same conclusion: "One of the main causes of the increasing material consumption and of the increasing environmental damage deriving from it is spiritual emptiness, with people needing not so much material goods as their own identity, community, motivation, recognition, love and joy," *op. cit.*, pp. 21–22.

30. See Keller, *op. cit.*, esp. pp. 14–29; of English language authors Ezra J. Mishan, *op. cit.*, esp. part IV, "The Waning Hope of Economic Growth," pp. 82–106 of the Czech translation.

31. Von Weizsäcker's *Factor Four* suggests an outstanding compilation of such tools, unfortunately as a substitute for changing attitudes rather than as a means of bringing about change, and so comes to the conclusion that we have only fifty years left to change but unfortunately there is no interest in changing and so nothing can be done—the typical dilemma of systems-theoretical approaches.

32. Elgin's book, *Voluntary Simplicity: An Ecological Lifestyle That Promotes Personal and Social Renewal* (New York: Bantam Gooks, 1982) contains *inter al.* an excellent bibliography, but is hard to come by even in English. Kristin Shrader-Frechette offers a fair summary of the argument in her *Environmental Ethics* (Pacific Grove, CA: The Boxwood Press, 1981):169–91.

33. In addition to her *Pestří a zelení*, cited earlier, see also her *Láska ke krajině?* (Brno: Blok, 1988). Unfortunately neither of the works of this foremost Czech

ecophilosophic writer is available in an English translation.

34. In English schools intended for the nobility the abbreviation *s.nob.—sine nobilitatis*—indicated the sons of the newly rich, lacking titles though amply supplied with money, who helped keep the school afloat financially but usually strove to make up for a lack of breeding by a surfeit of spending. They were only both vulgarly rich and richly vulgar—and gave us the words *snob* and *snobbery.* — Since Elgin's time, the expression *to tread lightly upon the Earth* has largely displaced the term voluntary simplicity. See Bill McKibben, *Hope, Human and Wild: True Stories of Living Lightly on the Earth* (Boston: Little Brown and Co., 1995).

35. George Soros, *The Crisis of Global Capitalism [Open Society Endangered]* (London: Little, Brown and Co. UK, 1998). While Mr. Soros is interested in defending what, following Karl Popper, he calls an "open society," his analysis of the conflict of global capitalism with democracy since the 1970s (esp. pp. 108–12) deserves careful attention.—In his 1999 New Year message, reported in the Czech press, John Paul II, the Bishop of Rome, issued a similar warning. The critique of greed, it seems, is no longer a socialist monopoly.

36. Morris Berman, *op. cit.*, pp. 47–66.

37. John Muir (1838–1914), a Scot by origin, lived in the United States in the period following the Civil War, at the time of the worst plunder. His writings were the chief motivating factor for the founding of the first national parks and protected forests. Today they are most readily accessible in a collection of essays, *The Wilderness Essays* (Salt Lake City, UT: Peregrine Smith, 1980). Muir defended the preservation of wilderness in a pristine state against Gifford Pinchot who favored multiple use of protected areas.

38. We all have read this statement many times, including on the T-shirts of the Forest Protection Society WOLF in Prešov in Slovakia and in Aldo Leopold's essay, "Thinking like a Mountain" in *A Sand County Almanac* (New York: Ballantine Books, [1949] 1990):141. Originally it comes from Thoreau's essay "Walking" and can be found in *Henry David Thoreau: The Natural History Essays*, ed. by C.F. Hovde, W.L.Howard, and E. Hall (Princeton: Princeton University Press, 1980):112. The entire essay, pp. 93–136.

39. *Civilization and Ethics*, translated by A. Nash (London: Black, 1923), cited in Louis P. Pojman, *Environmental Ethics*, pp. 65–66.

40. This parable is somewhat problematic. Healthy starfish normally float away with the tide, only here and there a dead one will be left behind. I have never seen "thousands of living starfish" caught on the beach. Nor is the author clear. In this case I am citing one J.D. Baum from a leaflet published in Czech by Nadace Klíček to accompany the exhibit VITA HUMANA in 1996, hardly a scholarly reference. None of that, though, is to the point. The point is that it is meaningful to save perhaps just a single child even though thousands of them disappear in orgies of destruction. I think of it each Christmas when instead of frying our traditional carp we release it in a natural shallow pond on a nearby river: for this carp, it does matter.

41. Daniel Jones, ed., *The Poems of Dylan Thomas* (New York: New Directions, 1971):77.

42. Isaiah 11:6–9a, cited earlier. These verses, taken quite literally, became in the nineteenth century the favorite theme of New England folk artists seeking a peaceable kingdom in the new world.

43. Paul Taylor, *Respect for Nature* (Princeton, NJ: Princeton University Press, 1986):3, 99–100, 169.

44. For detailed analysis, see Part I.iii above.

45. *Op. cit.*, 169. Taylor also offers a succinct summary of his position in a paper which appeared in *Environmental Ethics* 3 (Fall 1981) and is reprinted in Pojman, *op. cit.*, 71–83, passage cited, p. 75.

46. Taylor, *Respect for Nature*, 99–100.

47. In translating Taylor's feet and inches into metric measures, more readily understood in these parts, I may have introduced some distortion. If you prefer English measure, see Pojman, *op. cit.*, 77.

48. Adepts of technical philosophy will find a detailed justification of the advantages of a personalistic conception in Edmund Husserl, *Ideen II, Phänomenologische Studien zur Konstitution* (ms. completed 1917, published thirty-five years later, Marly Biemel, ed., The Hague: Martinus Nijhoff, 1952), §§ 63–64. English translation by R. Rojcewicz and A. Schuwer, *Ideas Pertaining to a Pure Phenomenology and to a Phenomenological Philosophy*, Second Book, *Studies in the Phenomenology of Constitution* (Dordrecht: Kluwer, 1989):294–318.

49. *A Sand County Almanac* (New York: Ballantine Books, [1949], 1990) is a collection of philosophizing observation of nature and of an explicitly philosophical essay in which the famous—and according to Davies (*Ecophilosophy*, p. 61) infamous—essay, "The Land Ethic," is a part (237–64).

50. *Op. cit.* "Thinking Like a Mountain" is the title of one chapter in the part "Arizona and New Mexico." The episode with the killing of the she-wolf and her cubs is on pp. 138–39.

51. *Op. cit.*, 262.

52. J. Baird Callicott, "The Conceptual Foundations of the Land Ethic" in J. Baird Callicott, ed., *A Companion to A Sand County Almanac* (Madison, WI: University of Wisconsin Press, 1987), 108–19. This collection also contains studies by Leopold's biographer, Curt Meine, and by his most faithful historian interpreter, Susan L. Flader.

53. Here I have found Holmes Rolston III most helpful. Though he is not commenting on Leopold, his observations in "Lake Solitude: The Individual in Wilderness" in his collection of essays, *Philosophy Gone Wild* (Buffalo, NY: Prometheus Books, 1989) are much to the point. Note esp. p. 227 ff.

54. Leopold, *op.cit.*, 240.

55. This is a point made by many authors, as by E. O. Wilson, *The Diversity of Life* (New York: Penguin, 1992):243–47, but most dramatically documented by Lester R. Brown *et al.*, *State of the World 1998* (New York: W.W.Norton, 1998), esp. chapters 1 and 10. However, compare the 1999 edition of this report, notable for its orientation to building sustainability.

56. Pojman, op. cit., 67.

57. The author was evidently bilingual, but wrote in German, using the name Johannes von Saaz. In English the book appeared as Johannes von Tepl, *Death and the Plowman, or, The Bohemian Plowman* (translated by Alois Bernt, New York: AMS Press, 1969, © 1958)—perhaps the best statement of the debate between biocentrism and ecocentrism *ante verbum*.

58. Yet once more I would urge readers to read Callicott's *In Defense of the Land Ethic* (Albany, NY: SUNY Press, 1988) which is a careful and many-layered reading

and form their own judgment. Here I am concerned with the Heraclitean thesis itself rather than with whether Callicott in fact subscribes to it.

59. Garrett Hardin, "Living on a Lifeboat," *Bioscience* 24 (Oct. 1974):561–68, many times reprinted.

60. Kenneth Boulding, "The Economics of the Coming Spaceship Earth," in Henry Jarrett, ed., *Environmental Quality in a Growing Economy* (Baltimore, MD: Johns Hopkins Press, 1966), 3–14.

61. Garrett Hardin, "The Tragedy of the Commons," *Science* 162 (13 Dec. 1968):1243–48 and many times reprinted. Here I am following the reprinting in Shrader-Frechette, *Environmental Ethics*, 242–52.

62. For readers not familiar with Prague, that is four stops on the metro, about six minutes. Since it crosses the Old City, it can take up to an hour by automobile in the rush hour, with parking, I am told, virtually impossible at either end.

63. This is an approach not much represented in ecological thought: the contradiction between individual greed and common need is too blatant. One attempt to resolve it by applying laissez-faire economics to environmentalism is Karl Hess, Jr., *Visions upon the Land* (Washington, DC: Island Press, 1992). Let the reader judge.

64. Garrett Hardin, "Living on a Lifeboat." Here I am citing from the reprint in Louis P. Pojman, *op. cit.*, 283–90.

65. Pojman, *op. cit.*, 286.

66. *Ibid.*, 288.

67. Cited by Lovelock, *Gaia*, 114.

68. Robert Frost, "Reluctance," in Edward Connery Latham, *The Poetry of Robert Frost* (New York: Henry Holt and Company, 1979), 29–30.

PART III: STRATEGIES IN ECOLOGICAL ETHICS

1. Holmes Rolston III, analyzes this problem with surgical precision when he points out that either everything, human doings included, is a part of nature and so "natural" (the objectivist perspective) or nothing human can be "natural," since as human it is the product of artifice—and in neither case are the categories of natural and unnatural helpful. Cf. his *Philosophy Gone Wild* (Buffalo: Prometheus Books, 1989):30–52.

2. For the purposes of clarity I wish to distinguish what ordinary usage frequently confuses, *reason* and *cause*. I shall use the word *cause* to indicate an event which brings about some subsequent event with mechanical necessity. The most common example is the movement of billiard balls: the impact of ball A is said to be the *cause* of that of the second ball. I shall reserve the word *reason* for an event which leads the human noticing it to certain free deciding and acting. My noting that the National Theatre is producing *The Firebrand's Daughter* can be a *reason* why after work I choose to walk by the box office. Here we are distinguishing relations of natural necessity (causal relations) and meaningful freedom (relations of motivation). Husserl already analyzed the relation and peculiarity of motivational linkage of human acting in *Ideen II.iii*: While natural events are intelligible in relations of cause and effect, human action is intelligible in relations of meaning and decision. As to why we cannot consider reasons "mental causes," see A.I. Melden, *Free Action* (London: Routledge and Kegan Paul, 1961). That is not a question I wish to resolve here. My concern is solely with *distinguishing a cause, which brings about its effect*

necessarily, and a reason (of motivation) which inclines me to certain course of action without coercing me.

3. Arne Naess, "The Shallow and Deep, Long Range Ecological Movement," *Inquiry* 16 (Spring 1973):95–100; compare to his later essay, "Identification as a Source of Deep Ecological Attitudes" in Michael Tobias, ed., *Deep Ecology* (Santa Monica, CA: IMT Productions, 1985), reprinted Pojman, *op. cit.*, 105–12; David Rothenberg edited a collection of Naess's texts, *Ecology, Community and Lifestyle* (Cambridge: Cambridge University Press, 1989) which provides an overview of Naess's views.

4. So John Muir writes at the turn of the century of "This planet, our own good Earth . . ." in *A Thousand Mile Walk to the Gulf* (Boston: Houghton Mifflin, 1916), reprinted *inter al.* in Gruen and Jamieson, *Reflecting on Nature* (New York: Oxford University Press, 1994):23–25).

5. Albert Gore (*op. cit.*, 217–18) names Arne Naess, though what he writes about deep ecology as understanding humans as a deadly virus leading to a sole possible cure, removing humans from the face of the Earth, is more reminiscent of John Muir who died sixty years before the term *deep ecology* was ever used—or of James Lovelock, who quotes Garrett Hardin as saying that people are the only pollutant (*Gaia*, 114).

6. This is the conception represented in the Czech Republic and Slovakia by post-Marxist system ecologists, such as Jiří Stehlík who in his *Manifest budoucnosti* (Manifesto of the Future; Prague: Koniklec, 1998) claims that the idea of "progress" is justified and the notion of the battle for conquest of nature undoubtedly meritorious (p. 21), even though it has certain negative side effects.

7. This table comes from the 1973 article, "The Shallow and the Deep, Long Range Ecological Movement" (note 3 above). Naess offers a different table in the 1985 article "Identification as a Source of Deep Ecological Attitudes" (note 3 above). Naess likes to compile tables and comparisons, as in *Ecology, Community and Life-style*, pp. 16, 81, 108, 136. On p. 81 he offers a formula, $[W = G2 (P_b+P_m)]$, in which W= sense of well-being, G=glow (passion, fervor), P_b=bodily pains, P_m = mental pains. This approach, which Jeremy Bentham called hedonistic calculus, made a brief appearance in English utilitarian thought in the forties of the century just past. Naess proffers his equation with a touch of irony. However, he takes over utilitarianism itself without irony (so *op. cit.*, 81ff.)—and while readers of a literary bent find his tables jejune, many more practically oriented readers think them the book's great virtue as clear, unambiguous programmatic statements.

8. Erazim Kohák, *The Embers and the Stars* (Chicago: University of Chicago Press, 1982), 25, 32–33 *et passim.*

9. Bill Devall and George Sessions, *Deep Ecology: Living as if Nature Mattered* (Salt Lake City, UT: Peregrine Smith Books, 1985)—This sampler of brief fragments exhibits the drift from deep to "depth" ecology and, given the brevity of the selections—Heidegger gets three pages, 98–100, Christianity two, 90–91—perhaps also to an impressionistic superficiality. However, a fine annotated bibliography makes further reading possible.

10. *Op. cit.*, 65–77, note esp. p. 77.

11. For an excellent summary of Naess in his grandeur and ambiguity, I would recommend section "Ecosophy T" in Rothenberg, ed., *Ecology, Community and Life Style*, pp. 163–209.

12. Edmund Husserl, *Crisis of European Science*, §6, p.16 in the English, also note 18 below.

13. John Seed, Joanna Macy, Pat Fleming, *Thinking like a Mountain: Towards a Council of All Beings* (Philadelphia: New Society Publishers, 1988). The Czech translation was *Myslet jako hora* (translated by Jiří Holuša, Prešov: ABIES, 1993). Jiří Holuša's translation of one of the chapters, "Evolutionary Remembering," varies significantly from John Seed and Pat Fleming's original text. By his own admission in a personal communication, Holuša in effect rewrote the text, believing himself faithful to the spirit of the book while pushing this chapter significantly in the direction of depth ecology.

14. See also an excellent study by Susan B. Flader, also entitled *Thinking like a Mountain*, though with a different subtitle, *Aldo Leopold and the Evolution of an Ecological Attitude toward Deer, Wolves and Forests* (Columbia, MO: University of Missouri Press, 1974). The authors of the handbook apparently were not aware that Flader had used the title ten years before them—and perhaps were not even aware of the meaning of the phrase when Leopold first used it in his *A Sand County Almanac*.

15. Seed *et al.*, *Thinking...*, 45ff. Compare the same passage in the Holuša translation, p. 49: "Let us go back, way back, to a time when there was yet no Earth, far, far back when there was no cosmos; when there was no time, when there was only present, only now, no "had been" or "is to be," when there was no space, when everything was here, when there was no there. A state of absolute silence, harmony, a state of immense potential. *Perhaps you do not realize it but in the depth of your heart you well know that state*." (My italics highlight an added sentence, others are rephrased in the same spirit).

16. Seed, 51, Holuša translation, 57. This addition together with the sentence added to the previously cited passage may be a good illustration of the shift from deep to depth ecology. In the translator's defense, the shift he introduces may well be justified by other parts of the book, for instance by Joanna Macy's sensitive essay, "Our Life as Gaia," Seed, 57–65.

17. *Ibid.*, 84.

18. I owe the term *lazy reason* to Edmund Husserl (*Crisis of European Science*, § 6, p. 16 in the English) whose analysis of the problems of technical rationality and irrationalism seems appropriate here.

19. Perhaps it may be useful to note that while for Aldo Leopold *thinking like a mountain* means thinking like an enlightened forester, taking into account the long range balance of life, for John Seed "when one thinks like a mountain, one thinks also like a black bear, so that honey dribbles down your fur as you catch the bus to work" (*op. cit.*, 39). Perhaps that sums up the difference between deep and depth ecology in a nutshell.

20. For Czech and Slovak readers, the best starting point is a balanced and comprehensive presentation by a Slovak sociologist, doc. PhDr. Zuzana Kiczková, CSc, *Príroda: vzor žena!?* (Nature: Declined as Woman!?, Bratislava: Aspekt, 1998) which combines philosophical maturity with thorough scholarship. Unfortunately it appeared after the Czech original of this book had gone to print.— For readers of English, a useful starting point which I shall also use might be a classic study by one of the foremost ecofeminist philosophers, Karen J. Warren, "The Power and the Promise of Ecological Feminism" (*Environmental Ethics* 12, no. 2 (Summer 1990):125–46. Susan J. Armstrong and Richard G. Bothler, *Environmental Ethics: Divergence and Convergence*

(New York: McGraw Hill, 1993):430–74 provide a good selection of ecofeminist texts. See also the important article by Val Plumwood, "Nature, Self and Gender: Feminism, Environmental Philosophy and the Critique of Rationalism," *Hypatia* 6, no. 1 (Spring 1991):3–22. Going beyond articles to books, an influential study is Susan Griffin, *Women and Nature: The Roaring Inside Her* (New York: Harper and Row, 1978) which stresses an instinctual feminity in the spirit of depth ecology. From the same period, see also Elisabeth Dodson Gray, *Green Paradise Lost* (Wellesley, MA: Roundtable Press, 1979), with a religious and poetic slant. Similarly Rosemary Radford Reuther, *New Woman, New Earth: Sexist Ideologies and Human Liberation* (New York: Seabury Press, 1975) who stresses the role of the ideology of oppression in a Christian context—and whose book was published by an Episcopal publishing house. From the viewpoint of professional philosophy a basic text is Carolyn Merchant, *The Death of Nature: Women, Ecology and the Scientific Revolution* (New York: Harper and Row, 1983). An excellent more recent source is a collection edited by Irene Diamond and Gloria Feman Orenstein, *Reweaving the World: The Emergence of Ecofeminism* (San Francisco: Sierra Club Books, 1990). This, however, really is a dynamic field. Undoubtedly sources have appeared since my departure from America which will be well worth tracking down.—In this presentation, I shall use Karen J. Warren's classic, "The Power and the Promise of Ecological Feminism," cited above, as primary reference.

21. Lest grammarians rush in in righteous indignation, let me note that there is a grammatical as well as a gender difference. According to the rules followed by Czech records offices or *matrika*, if a foreign feminine name ends in a consonant, it takes on the ending *-ová*. If it ends in a vowel, it does not. So Karen J. Warrenová, but Vandana Shiva, without an added ending.

22. *Ibid.*, p. 146.

23. James Lovelock, *Gaia: A New Look at Life on Earth* (Oxford: Oxford University Press, 1979, hereafter *Gaia*). Lovelock traces the history of the concept in the preface to his second book, *The Ages of Gaia* (New York: W.W. Norton, 1988, revised edition 1995, hereafter *Ages*), viii–xx.

24. Concerning the role of Hans Driesch in the German ecological movement, see Anna Bramwell, *Ecology in the 20th Century: A History* (New Haven, CT: Yale University Press, 1989: 54–55 *et passim*.—Emanuel Rádl (1873–1942) was a Czech vitalist biologist turned philosopher, familiar to English historians of biology, though none of his philosophical works have been translated into English.

25. Lovelock insists on this even while considering the religious significance of Gaia. He stresses his conception of nature as "objective" (*Gaia*, 201) and emphasises that in no way is Gaia as subject being, a surrogate God (*ibid.*, 204).

26. Lovelock quotes the English Green activist Jonathon Porritt as saying that Gaia is too important a symbol for the Green movement to be left solely to the scientists (*Gaia*, xiv, *Ages*, xii). Joanna Macy's sensitive essay, "Our Life as Gaia," Seed, *op. cit.*, 57–65 *et passim*, supports his claim.

27. Philo Judaeus (10 BC–50 AD), a hellenistic Jewish philosopher in Alexandria, originator of the allegoric interpretation of the Scriptures, liked to find alleged allegories of Greek thought in Jewish texts. The quotation above comes from his "On the Account of the World's Creation given by Moses" in *Philo* 1 (trans. G.H. Whitaker, NewYork: G.P. Putnam's Sons, 1929), 313, cited in Glacken, *op. cit.*, 14.

28. This is most evident in the chapter on God and Gaia in *Ages*, 206–7 where Lovelock stresses the parallel: both seek explanatory hypotheses in their respective ways. While he recognizes the religious approach as far more sensistive and emotive (so *ibid.*, 192–99), I know of no place where he would recognize religion as asking a radically different question, what ought I value? how ought I live? rather than, what is the cause?

29. *Ages*, 204.

30. *Ibid.*, xvi and 202, compare Seed, *op. cit.*, 47. The reason, to be sure, is the opposite: the depth ecologists were inspired by Lovelock's hypothesis and freely admit their kinship to him.

31. James Lovelock, *The Ages of Gaia* (New York: Norton, 1988):136–37.

32. These green pearls can be found in *Gaia* 136–37, *Gaia* 120–21, and *Ages*, 160.

33. Interview in *Newsweek* 127, no. 16 (15 April 1996):56.

34. Analysis of nuclear energy, *Ages*, 162–64, the point about helping people at cost to Earth, ibid., xx. Lovelock cites a different objection to nuclear energy: humans endowed with so much power would devastate the earth, *ibid.*,164.

35. In a special issue of *Time*, sponsored by Toyota, we learn that the problem is not the manufacturer of automobiles, who presses them on the consumer in advertising, but the consumer who shortsightedly opts for a cheaper, polluting automobile instead of a more expensive but ecologically superior Toyota. Given the sponsor, the issue does not consider the possibility that the problem might be the automobile as such, though the United Nations' *Human Development Report 1998*, noting the dramatic rise of consumption in the overconsuming world makes it clear that that is precisely the case. Lovelock, who supports technological expansion and spiritual depth reorientation which is not in conflict with expansion, is understandably far more acceptable than Gore or Leopold. Cf. *Our Precious Planet*, special issue of *Time* (150, no.17A, Nov. 1997). In fairness to Lovelock, he does condemn automobiles as one of the three chief villains of ecological destruction, *cattle, chainsaws,* and *cars* (*Ages*, 239) and speaks of cars farting [*sic*] smog (*ibid.*, 145).

36. For a development of the argument and supporting evidence, see *Ages*, chapters 2–6, which Lovelock describes as a presentation of his case to the scientific community.

37. Lovelock does in fact use this expression, in *Ages*, 28. It is rather more consistent with his philosophical preferences: in *Gaia*, 114–17, he recognizes only René Dubos and Garrett Hardin as legitimate ecological thinkers—and expresses a decided preference for the latter, as *ibid.*, 114.

38. *Gaia*, 138.

39. Desmond Morris, *The Naked Ape* (New York: McGraw Hill, 1967) was more of a highly successful popularization than a serious scholarly effort. However, it called attention to the work of scholars like Konrad Lorenz who studied sociobiological determinism already in prewar Germany where some propagandists tried to use such ideas to justify German claims to *Lebensraum*. In America, Gregory Bateson speculated along similar lines. In all of them the problematic question is how to derive moral normative force from putative natural necessity. Say that we could show that group aggression is "inborn" among primates, would that mean that in the case of the subspecies *H. sapiens sap.* it is morally justified? See Edward O. Wilson, *On Human Nature*, 99–100.

40. I am not an expert on the *canidae*, nor does Morris claim to be one. He presents highly readably the basic sociobiological thesis that human behavior is determined by genetic coding. However, readers interested in wolf behavior will do better with more informed studies, such as Stanley P. Young's old but still useful classic, *The Wolves of North America* (Washington, DC: American Wild Life Institute, 1944), still concerned with "control" rather than conservation, or far more enlightened and more recent studies like Barry H. Lopez, *Of Wolves and Men* (New York: Scribners, 1987) or Robert Hunter and Paul Watson, *Cry Wolf!* (Vancouver, BC: Shepherds of the Earth, 1985).

41. As a skilled narrator, Desmond Morris has his Czech counterpart in Pavel Pecina who, still under Communist rule, published a series of studies in the one then permitted ecological magazine, *Nika*. The book version, *Kořeny zla* (Prague: Nika, 1994) deserves translation. Until then, Elizabeth Marshall Thomas's *The Hidden Life of Dogs* is equally delightful.

42. Gregory Bateson, *Mind and Nature, a Necessary Unity* (New York: E.P. Dutton, 1979)—the unity of mind and nature is the classic monist theme.

43. Konrad Lorenz, *On Aggression* (New York: Harcourt Brace and World, 1966), though ecologically perhaps most interesting are the works of his older years, *The Waning of Humaneness* (Boston: Little, Brown, 1987) and his conversations with Kurt Mündl, *On Life and Living* (trans. Richard Bosley, New York: St. Martin's Press, 1991). The widely read brochure, *Civilized Man's Eight Deadly Sins* (New York: Harcourt Brace Jovanovich, 1974) seems by contrast a clear example of the ease with which one can find a sociobiological justification for strongly held views, whatever they are. The problem is always the transition from the *is* to the *ought*.

44. Essential reading here is Holmes Rolston III's excellent analysis of the meanings of the term "nature" and of alleged returns thereto, "Can and Ought We to Follow Nature?" in Holmes Rolston III, *Philosophy Gone Wild* (Buffalo: Prometheus Books, 1989), 30–52. Rolston is definitely on my *Most Wanted* list for translation into Czech.

45. Edward O. Wilson, *Diversity of Life,* cited earlier, appeared in Czech as *Rozmanitost života* (trans. by Antonín Hradílek, Prague: Nakladatelství Lidové noviny, 1995). While the literary quality of the translation may be faulted ("Environmental ethics" becomes *přírodní etika,* "natural ethics"), the inherent value of the book, especially of the first and the last chapter as an introduction to the ecological significance of sociobiology, richly makes up for it.

46. Wilson, *Diversity of Life,* 333. Similarly Quinn's guru gorilla in *Ishmael* responds to the question of what gorillas would do without humans by asking what humans would do without gorillas; Quinn, *Ishmael* (New York: Bantam, 1995), 262–63.

47. Wilson, *op. cit.*, 335.

48. Wilson, *On Human Nature,* 99–100, *cf.* also Rolston, *op. cit.*, note 44 above

49. Ludwig von Bertalanffy, *General Systems Theory* (New York: George Braziller, 1968), popular introduction in Donald J. Polkinghorne, *Methodology for the Human Sciences* (Albany, NY: SUNY, 1983):135–68.

50. Sir Charles Elton, *Animal Ecology,* cited by Anna Bramwell, *op. cit.*, 214.

51. Donella Meadows et al., *The Limits to Growth* (New York: Universe Books, 1972), Donella Meadows., *Beyond the Limits* (Post Mills, VT: Chelsea Green Publishing Co., 1992) or perhaps the clearest and to some of us most discouraging example of

the systems-theoretical approach, Alexander King and Bertrand Schneider, *The First Global Revolution*. Most recently, Ulrich von Weizsäcker *et al.*, *Factor Four,* of which more below.

52. Precisely this contradiction earned von Weizsäcker's *Factor Four* a nomination for the ironic prize, Green Pearl of the Year, which the Czech ecological activist organization, Children of the Earth, bestows on the most prepostrous eco-pronouncement of the year. The subtitle promising *double the wealth* powerfully encourages the mentality of greed to which it claims to oppose technology guaranteeing *half the use of natural resources.* Not surprisingly, the authors find that "selfishness is booming."— The term sustainable life or *udržitelný život* was the contribution of Josef Vavroušek, Czechoslovakia's last Minister of the Environment.

53. An important source of information is the history of ecology under the Communist regime by Miroslav Vaněk, *Nedalo se tady dýchat* ("We could not breathe here," Prague: Maxdorf for ÚSAD AV ČR, 1996), note esp. 31–43 and 87ff.

54. Josef Šmajs, *Ohrožená kultura*, criticizes "flannel" attempts at protecting nature, considers a change of ideological foundations basic. The author calls for an "evolutionary ontology" which he understands as a philosophy which, in accord with recent thought from Hegel through Bergson and Heidegger to Hartshorne, considers becoming (evolution) rather than being, a static state, the basic reality. Is, though, having the correct ideology really the key to brighter tomorrows?

55. Dave Foreman, as he appears to Albert Gore, *op. cit.* 217—though for myself I think it more reliable to let Foreman speak for himself, as he does for instance in "Earth First!" in Peter C. List, ed., *Radical Environmentalism* (Belmont, CA: Wadsworth, 1993), 185–94 and 253–54.

56. There is an interesting parallel between the internal strains in the socialist and in the ecological movement. Just as the Communist wing of the workers' movement (Lenin) insisted that all activity to improve the lot of the working class is vain before a revolutionary transformation of society, so "depth" and systems-theoretical ecologists tend to think that environmentalism is vain before a revolutionary transformation of humankind itself. On the other hand, the trade union or social democratic wing of the workers' movement (Bernstein) built on the assumption that fundamental change grows out of a cumulation of small improvements within the framework of democracy. Similarly the "flannel" or environmentalist wing of the ecological movement tends to believe that fundamental change in human relating to nature comes about by concrete changes in attitudes and actions. We could find a parallel in every movement striving for change, whether the Hussite reformation or the grasping for democracy in the U.S. and France at the end of the eighteenth century. Marginally see Anna Bramwell, *op. cit.*, 85–103, though I do not know a detailed study of this theme on the ecological side. On the Marxist side, see the first volume of Leszek Kolakowski's *Main Currents of Marxism* (trans. P.S. Falla, Oxford: Clarendon Press, 1978).

57. For readers interested in biblical myths, yes, Adam and Eve *were mortal.* God's reason for expelling them from the Garden is given as preventing them from achieving immortality (Gn 3:22) after they had achieved knowledge of good and evil. However, they are presented as living at peace with nature and their own nature and so, presumably with their own mortality.

58. Josef Šmajs, *op. cit.*, 10.

59. Anna Bramwell, op. cit., 161–73.

60. John Elkington reports some signs that the multinationals may be awakening to the need for sustainability, albeit for wholly commercial reasons, in his *Cannibals with Forks,* reviewed in *The Guardian Weekly* 160, no. 13 (28 March 1999):27. While their concern may be no more than cosmetic, "cannibals eating their victims with cutlery instead of using their hands," it is interesting that they should be concerned at all.

61. Verbatim, including the abbreviations: "A system of views and conceptions in which a class becomes aware of its position and interests (which are obj. econ. determined and which the work. class defends in ideological struggle with the bourg., to which the coexistence of two coexist. world syst. does not apply.) Soc. ideol. has sci. foundations and propagates truthful revol. ideas, while bourg. ideol. distracts the attention of work. class from soc. problems." Any reader who finds this formulation hard to believe can confirm it, abbrev. and all, under the entries *ideological struggle* and *ideology* in the great encyclopaedia, *Velký encyklopedický slovník* (Prague: Czechoslovak Academy of Science, Academia Publishers, 1980), vol. I, on page 914 on which, with all the charm of the unintended, the last entry reads *idiocy, the most serious level of mental deficiency.*

62. To anyone interested in my friends the ravens who have compensated me for the absence of prairie dogs in Prague I would recommend Richard K. Nelson, *Make Prayers to the Raven: A Koyukon View of the Northwestern Forest* (Chicago: University of Chicago Press, 1983). A delightful albeit not overly informative article appeared recently in that much beloved source of natural lore, Douglas H. Chadwick and Michael S. Quinton, "Ravens: Legendary Bird Brains," *National Geographic* 195, no. 1(Jan. 1999):100–15.

63. Anna Bramwell, *op. cit.* deals with ecology entirely as ideology, as if ecology were essentially and exclusively an ideology and not a serious mode of thinking about a pressing issue, only a hobby of its *aficionados.* The fact that the book went through three printings in as many years suggests that there are a great many readers who would like to write off ecological ethics as an ideology.

64. So Ernst Haeckel, *Die Natur als Kunstlerin* (Nature as an Artist, written in 1914, first published in Berlin, Vita Deutsches Verlagshaus, 1924). Haeckel is far better known for his *History of Creation* which was wildly popular in the latter half of the nineteenth century, the English translation alone going through some thirty editions.and printings. Most recent was Ernest Haeckel, *The History of Creation: A popular exposition of the doctrine of evolution in general, and that of Darwin, Goethe and Lamarck in particular* (trans. from *Natürliche Schöpfungsgeschichte* (1868) by E. Ray Lankester (London: Henry S. King and Co., 1990).

65. Konrad Lorenz, *On Aggression,* cited earlier, note 43 above. Bruce Chatwin charged that in a 1942 article Lorenz echoed Nazi propaganda. Lorenz was a member of the Nazi party and used the then current terminology. That falls far short of making him a Nazi propagandist. See his biography by Alec Nisbett, *Konrad Lorenz* (London: Dent, 1976):81–97.

66. That is how Anna Bramwell understands ecological ethics or "ecology." Not even in the chapters devoted to contemporary trends does she note the possibility that ecology could represent a program of action for the preservation of nature and not a self-serving ideology. The conception of ecology as a theoretical ideology emerges also in the "post-modern" ecological ethics preoccupied more with conceptions of nature

than with the experience of nature and the threat to it. A Czech might comment, "*Podle sebe soudím tebe*"—we assume others to be what we are.

67. Cf. three essays, "Bauen Wohnen Denken," "Das Ding," and ". . . dichterisch wohnet der Mensch" in the collection, Martin Heidegger, *Vorträge und Aufsätze* (Pfullingen: Günther Neske, 1954), 139-98. Concerning Heidegger's involvement with Nazism, see Hugo Ott, *Heidegger: A Political Life* (English translation by Allen Blunden, New York: Harper Collins, 1993).

68. Anna Bramwell, *op. cit.*, 6ff., introduced this term as a designation for ecology (or ecological ethics) in the role of an ideology of revolt against the dominant conceptions.

69. *Ibid.*, 211-36 and 177-209.

70. Jonathon Porritt, *Save the Earth* (London: Dorling Kindersley, 1991) is one of the very few books which is eminently readable and interesting to young people, factually sound, and aiming at modes of coping, not poetic resignation. Placing it in the hands of every high school student may be the most important single step in ecological education.The call cited heads section 4.2, Population, in that volume.

71. Jonathan Porritt, *Seeing Green: The Politics of Ecology Explained* (New York: Basil Blackwell, 1985).

72. Porritt, *op. cit.*, 141—The reference is to Oscar Wilde's familiar statement that "A cynic is one who knows the price of everything and the value of nothing." Porritt unfortunately thinks it so familiar that he does not give a reference.

73. Radicalism in ecological philosophy is a highly relative term. Some American industrialists consider "radical" anything that casts doubts on the idea of unlimited growth while at the other end of the spectrum the activists of *Earth First!* do not conceal their contempt for *Greenpeace* as too timid. Once again I would recommend the work cited already, Peter C. List, *Radical Environmentalism*, as a good introduction to the entire problem of coping within the limits of the law with a power which mocks and flaunts the law, like Shell Oil in Nigeria.

74. Prof. Zdeněk Veselovský, an erudite and thoughtful person, dedicated his book *Chováme se jako zvířata?* to "My greatest teacher, the Prague Zoological Garden," directed at one time by Pavel Pecina, author of an enchanting book, *The Roots of Evil* (only in Czech—sorry!) Both are animal defenders and at the same time supporters of zoos. On the other side of the argument stands Dale Jamieson, "Against Zoos," in Lori Gruen et al., *Reflecting Nature* (New York: Oxford University Press, 1994):291-98. Pavel Pecina's articles "Keeping Nondomesticated Animals" and "More about the Task of Zoos" provide an informed and balanced view, unfortunately so far only in Czech.— When the Czech organization Writers for Animal Rights succeeded, after immense effort, in buying two sick bears whose private owner kept them for years in a transport cage in which they could not even stand up and in placing them in a habitat at the castle Točník for recuperation under a vet's care, a large inscription in English appeared on the palisade, "Free the Bears!"

75. It may not be a *Junior Woodchuck Handbook*, but Jan V. Beránek provided basic information about the pros and cons of nuclear energy in pamphlets published by DUHA, the Czech branch of Friends of the Earth. I presume the same organization together with Greenpeace can provide such materials in English.—James Lovelock's case for nuclear energy, note 34 above.

POSTSCRIPT: TURNING GREEN

1. "What doth it profit, my brethern, though a man say he hath faith, and have not works? can faith save him? if a brother or sister be naked, and destitute of daily food, and one of you say unto them, Depart in peace, be ye warmed and filled; notwithstanding ye give them not those things which are needful to the body; what doth it profit? Even so faith, if it hath not works, is dead, being alone" (Jas 2:14–17)—I do not think this passage "against Protestants" or at odds with Paul's and Martin Luther's stress on God's grace received through faith, but a crystal clear grasp of the intertwining of love and labor.

2. The Gestapo used the Judicial Palace in Pankrác as its prison, taking the prisoners scheduled for interrogation in a police wagon in the morning to its headquarters at the Petschek Palace at the corner of what today is Washington Street and Political Prisoners Street in Prague 1, across from the main railway station. The basement room, known as "the cinema," where prisoners awaited interrogation, is open to the public as a memorial. When next in Prague, visit it, sit on the bench, stare at the wall.

3. "The Last Rat" by Sheree Dukes Conrad recounts, with consummate art, the defiance and defeat of a laboratory rat who knew his fate. I read it in manuscript in 1986 but have never been able to track it down in print. I hope this book will be a testimony that that rat's fate did not disappear in the flow of time but, as Whitehead would have it, is forever inscribed in the consequent nature of God.

4. I wrote about it in Czech in the article "The Meaning of Home" in *Domov* 38, no. 3 (Mar. 1998):74–77. The pictures I have are of a later date, by which time I had added three rooms and there were six of us sharing the home—Amanda and Frank with little Alexander, my adoptive brother, Stephen Capizzano, my wife Dorothy and I and our dog Andy. A single woodstove kept us warm all winter. Life really need not be ecologically destructive to be good.

5. Perhaps that is why I was not enthusiastic about Helen Norberg-Hodge's book *Ancient Futures: Learning from Ladakh*. Already the title presents desperate poverty as a model and shows how beautiful it is. *It is not beautiful.* I know poverty from the third world: the poor can often be beautiful, poverty itself is ugly and evil. I think it absolutely crucial that ecological activists seek a long-range sustainable mode of life free of poverty, not returns to it, in the present, not in long ago memories, like the protagonist of Svěrák's excellent 1984 film, *What's with you, Doctor?* In place of Norberg-Hodge I would recommend Bill McKibben's *Hope, Human and Wild: True Stories of Living Lightly on the Earth*, and Hana Librová, *Pestří a zelení*.

6. Ernst Ulrich von Weizsäcker *et al.*, *Factor Four*, cited earlier for its technical usefulness and its ethical futility.

7. In the Czech edition, it is page 313. In other editions, look for chapter 14, "Non-material Affluence" where you will find the passages dealing with will to sustainability appended as a wistful afterthought. You will look in vain for any mention of the pioneer of appropriate technology, E.F. Schumacher.

8. So Josef Pekař, "The Meaning of Czech History" in anonymously edited collection, *Josef Pekař, On the Meaning of Czech History* (Rotterdam: Stojanov-Accord Edition, 1977):383–405.

9. The terminology of "authenticity" and of inauthentic everyday accumulation comes from Martin Heidegger's influential work, *Being and Time* §§74–76, where

Heidegger presents his conception of historicity as born of "authentic" assumption of a person's heritage.

10. Patočka interprets Masaryk similarly in his Masaryk studies, for instance, "An Attempt at a Czech National Philosophy and its Failure" (in Czech) in Ivan Chvatík and Pavel Kouba, eds., *Jan Patočka: Tři studie o Masarykovi* (Prague: Edice Váhy, 1991), 21–52.

11. "Philosophy and the Crisis of European Humanity," so called "Vienna Lecture" in Edmund Husserl, *Crisis of European Sciences and Transcendental Phenomenology* (trans. David Carr, Evanston: Northwest University Press, 1970), 269–300.

12. This theme comes up again and again in Masaryk's work. Masaryk deals with it systematically in *The Ideals of Humanity* (trans. M.J. Kohn-Holoček, George Allen and Unwin: London, 1938) or again in *The Meaning of Czech History* (trans. Petr Kussi, Chapel Hill, NC: University of North Carolina Press, 1974) in 1895. That is why Masaryk's followers, who shared his conviction—Rádl, Čapek, Peroutka—did not see Masaryk's greatness in the heroic deed of founding a state but in his life-long effort to support the cultural growth of our nation in democratic work, not in the aristocratic deed.

NOTES FOR A
BIBLIOGRAPHY

When I first began to lecture on ecological ethics in Prague after the fall of the Communist regime, my problem was a virtually total unavailability of ecophilosophical literature in Czech. Together with two colleagues, one a forester, the other a researcher, we bridged the gap between languages by editing and translating a collection of readings, *Závod s časem*, in which we included a broad range of selections. It may not have been ideal, but it helped orient my audiences, many of whom were struggling to learn English, among possible readings as they gradually became available.

Today, in Czech and English alike, the problem is not scarcity but surfeit of ecological literature—as of practically everything in the overconsuming world which the media seek to persuade us the Czech Republic must join even at the cost of ruthless McDonaldization of our heritage. My strategy for dealing with the flood of literature has been to direct students to texts that have stood the test of time. So I steer them to Albert Schweitzer and Paul Taylor, Aldo Leopold with J. Baird Callicott and Holmes Rolston III, Arne Naess with George Sessions and Bill Deval, James Lovelock, E.O. Wilson and Donella Meadows *et al.*—and just for the joy of it, Daniel Quinn's *Ishmael*.

For people who prefer to read more broadly, here are some of the texts that reached me in the Czech Republic. And, lest I give you the impression that translation is a one way street, please note that I have included also books in Czech which would make a major contribution in an English translation. The titles of the texts I think particularly important are set in boldface.

Abbey, Edward. *The Best of Edward Abbey.* Edited and illustrated by Edward Abbey. San Francisco: Sierra Club Books, 1984.—*A sampler of a prolific guru from the prairies and deserts of American southwest, one time prophet of forceful action, note the selection from* The Monkey Wrench Gang, 101–6.

———. *A Voice Crying in the Wilderness: Notes from a Secret Journal.* New York: St. Martin's Press, 1989.—*A slender volume of aphorisms and meditations compiled shortly before the author's death, immensely enriching for times when you are not feeling systematic.*

Andreska, Jiří. *Čas hájení, čas lovu* (Time to Protect, Time to Hunt.) Vimperk: Nakladatelství VIK, 1995.—*Nature observations in the spirit of Aldo*

Leopold, unfortunately only in Czech. This author's books are always a walk through nature.

Beránek, Jan V. *Proč je třeba zastavit JE Temelín* (Why the Nuclear Power Plant at Temelín Must Be Stopped.) Brno: Hnutí DUHA, 1997.—*Sober collection of documents, richly supported by convincing evidence, concerning the most problematic project of its kind since Seabrook;*

Berman, Morris. *The Reenchantment of the World.* Ithaca, NY: Cornell University Press, 1981.—*A focal text in alternative philosophy of science which describes the rise of scientism and offers a nonpositivist conception of science and knowing.*

Berry, Thomas. *The Dream of the Earth.* San Francisco, CA: Sierra Club Books, 1988.—*One of the many works of religiously oriented American thinkers whose works show that ecology can be genuinely deep without becoming a "depth ecology."*

Bertalanffy, Ludwig von. *General Systems Theory: Foundations, Development, Applications.* Revised edition. New York: B. Braziller, 1973.—*Theory of knowledge which scientific ecology assumes, usually without mentioning.*

————. *Robots, Men and Minds: Psychology in the Modern World.* New York: G. Braziller, 1969.—*Another missive from the originator of* General Systems Theory, *marginally relevant to the present topic but available and influential in Czech translation since 1972.*

Bookchin, Murray. *The Modern Crisis.* Philadelphia, PA: New Society Publishers, 1986.—*One of the many works of a social critic who calls his thought "social ecology;" here a critique of market economy from the viewpoint of "moral economics" with strong emphasis on sustainability.*

Boulding, Kenneth. "The Economics of the Coming Spaceship Earth." In Henry Jarrett, ed. *Environmental Quality in a Growing Economy.* Baltimore, MD: Johns Hopkins Press, 1966, 3–14.—*One of the classic articles which helped start the debate about ecological ethics; a must, fortunately readily available in many reprintings.*

Bramwell, Anna. *Ecology in the 20th Century: A History.* New Haven, CT: Yale University Press, 1989, 1992.—*Deals with ecology as an ideology, informs about Green parties, about the ties between German nature romanticism and Nazism, about the love-hate relationship between the European left and ecology, though more as a list of names than a philosophical analysis in depth.*

Brown, Lester R. *et al. State of the World 1998.* New York: W.W. Norton, 1999.—*An annual inventory of basic aspects of ecology from the state of the forests to the flow of capital, for the most part eschewing prediction in favor of inventory. However, the 1999 edition shows a definite orientation to seeking solutions, with such topics as Rethinking Progress and Building Political Will.*

Callicott, J. Baird. *In Defense of the Land Ethic: Essays in Environmental Philosophy.* Ed. David Edward Shaner. Albany, NY: SUNY Press, 1988.—*Really an interpretation more than a defense: the author stresses that Leopold is a philosophically significant thinker and makes the point in a careful and systematic presentation of materials which Leopold did not himself systematize.*

Callicott, J. Baird, ed. **A** *Companion to* **A Sand County Almanac:** *Interpretive and Critical Essays.* Madison, WI: University of Wisconsin Press, 1987.—*Commentaries on Leopold's text by leading American writers, edited by one of the most qualified Leopold scholars who tends to read Leopold holistically.*

Carson, Rachel. *Silent Spring.* Boston: Houghton Mifflin, 1962, 1987.—*This book for the first time cast serious doubt on the dogma of "progress" by pointing out that toxic sprays threaten to destroy songbirds. Together with the Meadowses'* The Limits to Growth *it signaled the rise of an ecological consciousness in the U.S.*

Carter, Forrest. *The Education of Little Tree.* Albuquerque, NM: University of New Mexico Press, [1976] 1990.—*A dream of childhood as it should have been, Native American folklore strongly reminiscent of the folk wisdom of Czech romantic literature.*

Cassirer, Ernst. *An Essay on Man.* New Haven: Yale University Press, 1944.—*A convenient summary of the views of a neo-Kantian philosopher about humanity, stressing the role of symbolic forms and pointing out that natural science is one possible symbolic system, not the "positive" truth about the world.*

Cetl, Jiří, Stanislav Hubík, Josef Šmajs. *Příroda a kultura* (Nature and Culture). Prague: Svoboda, 1990.—*Ecological essays of three (post)Marxist authors; an interesting example of systems-theoretical approach in Soviet bloc version.*

Cronin, John, and Robert. F. Kennedy, Jr. *The Riverkeepers.* New York: Scribner, 1997.—*A classic example of flannel ecology and civic initiative in action, seeking to restore Hudson River.*

Cronon, William. *Changes in the Land: Indians, Colonists, and the Ecology of New England.* New York: Hill and Wang, 1983.—*The role of conceptions and needs in the transformation of virgin land into a thickly settled megalopolis in less than three centuries.*

Davies, Donald Edward. *Ecophilosophy: A Field Guide to the Literature.* San Pedro, CA: R. E. Miles, 1989.—*Exactly what the title promises: a clear annotated list of ecophilosophical literature in English to 1989, with interesting evaluation of Leopold's* Land Ethic *as "notorious."*

de la Court, Thijs. *Beyond Brundtland: Green Development in the 1990s.* Trans. Ed Bayers and Nigel Harle. New York: New Horizons Press,

1990.—*While Europe waxed euphoric about "sustainable development," this author noted the inherent problems of the concept;*
———. *Different Worlds: Development Cooperation Beyond the Nineties.* Trans. Lin Pugh. Utrecht, NL: International Books, 1992.—*The author provides the best report available in Czech of the Bergen conference which enshrined the concept of sustainable development and of the need for and possibility of extending its scope.*

Devall, Bill, ed. *Clearcut: The Tragedy of Industrial Forest.* San Francisco, CA: Earth Island Press and Sierra Club, 1993.—*A magnificent and expensive, incredibly luxurious book, trim size 35x30cm, gorgeous two-page color photographs, collection of excellent essays, ranging from depth to flannel, documents extensive devastation of forests in USA and Canada by the lumber industry and government indifference. At the same time documents the paradox of American environmentalism: an opulently wasteful presentation of the case for the conservation of forests.*

Devall, Bill, and George Sessions. *Deep Ecology: Living as if Nature Mattered.* Salt Lake City, UT: Peregrine Smith Books, 1985.—*A collection of fragments demonstrating the breadth of deep ecology and its drift to "depth" ecology. The length of individual fragments—Heidegger gets two pages—casts some doubt on the author's seriousness, yet as popular presentation excellent.*

Diamond, Jared. *Guns, Germs and Steel.* New York: Random House Vintage, 1998.—*Highly informed and informative overview of the spread of civilizations over the globe from a neo-Darwinian perspective; the author's presuppositions and conclusions seem linked to evidence presented largely by his political preferences. Still, a wealth of information.*

Dillard, Annie. *Pilgrim at Tinker Creek.* New York: Harper and Row, 1974.—*Naturalistic essays from a different perspective, stressing the cruelty and meaninglessness of nature; necessary reading for anyone dreaming of loving Mother Nature.*

Elgin, Duane. *Voluntary Simplicity: An Ecological Lifestyle that Promotes Personal and Social Renewal.* New York: Bantam Books, 1982.—*A forgotten classic of the American seventies and a manifesto of sustainable future, unfortunately marked by the author's literary antitalent. Cf. also McKibben, Bill.*

Evernden, Neil. *The Natural Alien: Humankind and Environment.* Toronto: University of Toronto Press, 1985.—*Though the first and last chapters suffer from a problematic familiarity with Husserl and Heidegger, the second and third chapters, presenting the thesis of humans as natural exotics, are crucially important in the context of philosophies based on the idea of "alienation."*

Flader, Susan L. *Thinking like a Mountain: Aldo Leopold and the Evolution of an Ecological Attitude toward Deer, Wolves and Forests.* Columbia, MO: University of Missouri Press, 1974.—*Arguably the finest interpretation of Leopold's thought by a historian most familiar not only with his writings but his thought, speech, and mood.*

Gehlen, Arnold. *Man in the Age of Technology.* Translated by Patricia Liscomb from the German *Die Seele im technischen Zeitalter.* New York: Columbia University Press, 1980.—*Anna Bramwell considers Gehlen a representative of German right-wing eco-ideology, the American edition does indeed have a foreword by Peter Berger. Let the reader judge.*

Glacken, Clarence J. *Traces on the Rhodian Shore: Nature and Culture in Western Thought from Ancient Times to the End of the Eighteenth Century.* Berkeley: University of California Press, 1967.—*Nothing short of an encyclopaedic report on Western thought about nature from ancient Egypt to the end of the eighteenth century, on highest scholarly level. Indispensible. Loosely and rather more modestly, Keith Thomas,* Man and the Natural World, *carries the theme to the end of the nineteenth century.*

Gore, Albert. *Earth in the Balance.* New York: Plume/Penguin, 1993.—*An analysis from the perspective of ethical anthropocentrism, with systems-theoretical elements; the author is a convinced environmentalist in spite of his involvement in politics.*

Griffin, Donald R. *Animal Minds.* Chicago: University of Chicago Press, 1992.—*A superb collection of hard-nosed scientific evidence for all who still claim that ascribing thought in the broadest sense is anthropomorphism. Combines sensitive insight with impeccable scholarship.*

Haeckel, Ernst. *The History of Creation or the Development of the Earth and its Inhabitants by the Action of Natural Causes.* Translated from the German, *Natürliche Schöpfungsgeschichte,* by E. Ray Lankester. London: Henry S. King and Co., 1990.—*First published in English in 1876 (by which time it had gone through eight German editions already) with the subtitle "A popular exposition of the doctrine of evolution in general and of that of Darwin, Goethe and Lamarck in particular," it went through some thirty editions and did more than any other single volume to forge a naturalistic—or "monistic"—world view we take for granted today.*

————. *Die Natur als Künstlerin.* Written 1914, published Vita Deutsches Verlagshaus, Berlin, 1924.—*A beautiful example of a monist search for the aesthetic order in nature.*

Hardin, Garrett. *Filter against Folly: How to Survive Despite Economics, Ecologists and the Merely Eloquent.* New York: Viking, 1985.—*Idiosyncratic views of ecology from the pen of the ultraconservative author of* Lifeboat Ethics. *Not enjoyable but important to read.*

————. *The Limits of Altruism.* Bloomington, IN: Indiana University Press, 1977.—*An unabashed attack on the ethics of good will from a hard-core neo-liberal standpoint.*

Hargrove, Eugene C. *Foundations of Environmental Ethics.* Denton: Environmental Ethics Books, 1989.—*The author, longtime editor of Environmental Ethics, has an exceptionally broad overview of the field, here presents informed insight into its historical basis, with special sensitivity for what Haeckel called "Natur als Künstlerin."*

Harrison, Robert Pogue. **Forests: The Shadow of Civilization.** Chicago, IL: University of Chicago Press, 1992.—*Relation of humans to forests as a microcosm of human relation to nature at large: the book offers with respect to forests what the first part of this book seeks to do with respect to animals.*

Hess, Karl, Jr. *Visions Upon the Land.* Washington, DC: Island Press, 1992.—*Care for the environment from a radical laissez-faire perspective, a graphic demonstration of the compatibility of laissez-faire with maximization of profit and its incompatibility with ecological ethics.*

Husserl, Edmund. *The Crisis of European Sciences and Transcendental Phenomenology.* Trans. David Carr. Evanston, IL: Northwestern University Press, 1970. —*Not really an item for an eco-bibliography at all, here listed only because I have drawn much from Husserl's analysis of the meaning of human history and of the technicization of reason in modern science and its results for the development of Euroamerican self-understanding—which I think more of a root of ecological crisis than alienation from nature.*

Keller, Jan. *Až na dno blahobytu* (Down to the Dregs of Affluence). Brno: Hnutí DUHA, 1993, 1995.—*Passionately written dissection of the myth of "progress," with a number of sharp perceptions from the pen of a leading Czech ecological thinker; in Czech, for English parallel see Ezra Mishan.*

———. *Nedomyšlená společnost* (The Un-Thought-out Society). Brno: Doplněk, 1992.—*Earlier work of same sociologist, pointing out the time bombs built into what we take for granted.*

———. *Přemýšlení s Josefem Vavrouškem* (Meditating with Josef Vavroušek). Prague: G + G, 1995.—*Josef Vavroušek, who died tragically in an avalanche, was the short-lived Czech and Slovak Federal Republic's last minister of the environment, is to Czech ecological thought what Schweitzer and Leopold together are to American.*

———. *Sociologie a ekologie* (Sociology and Ecology). Prague: Sociologické nakladatelství SLON, 1997.—*A book of reading from world and Czech eco-thought. An interesting example of ecological thought seen through Czech eyes.*

Keller, Jan, Fedor Gál, and Pavol Frič. *Hodnoty pro budoucnost* (Values for the Future). Prague: G + G, 1996.—*A project launched by Josef Vavroušek and completed after his death by the coauthors, very much in JV's intentions. The basis of frugality and so of sustainability is to know what matters and wherein to rejoice. Fairly begs for translation. Unfortunately so far it is in Czech only—and more's the pity.*

Kiczková, Zuzana. *Príroda: vzor žena!?* (Nature: Declined as Woman?). Bratislava: Aspekt, 1998.—*An exceptionally fine, well informed overview of American ecofeminism.*

Kohák, Erazim. *Člověk, dobro a zlo* (Of Humans, Good and Evil). Prague: Ježek, 1994.—*Scripta of lectures offering a very rough sketch of European moral conceptions from ancient Greece to the ecological crisis.*

————. *Dopisy přes oceán aneb čertování s Míšou.* Prague: Státní pedagogické nakladatelství, 1993.—*A collection of meditations with nature themes, written in New Hampshire, broadcast by Radio Free Europe 1980–84.*

————. *The Embers and the Stars.* Chicago: University of Chicago Press, 1982, 1985.—*A philosophical quest for personal renewal of the moral sense of nature. In spite of the author's protestations, reminiscent of H.D. Thoreau. See criticism in the present volume.*

————. "Of Dwelling and Wayfaring." In: Leroy Rouner, ed., *The Longing for Home.* Notre Dame, IN: Notre Dame University Press, 1977, 30–46. *Autobiographical reflection on the relation of humans to a place.*

————. *P.S. Psové.* Prague: Panglos, 1994, 1996.—*Another collection of meditations with nature themes, this time written in Prague and broadcast by Czech Radio in 1993.*

Krutch, Joseph Wood. *The Best Nature Writing of JWK.* Edited by the author. New York: Pocket Books, 1957.—*Often described as the Thoreau of the twentieth century, Krutch reminds me more of John Muir. A great read, especially for lovers of noble English.*

Leopold, Aldo. *A Sand County Almanac.* New York: Oxford University Press, 1949; paperback, New York: Ballantine Books, 1990. —*A series of informed and sensitive nature essays leading up to Leopold's Land Ethic. Arguably the focal work of ecological thought in English. Though translated into Czech three years ago by Anna Pilátová, still not published. Since that is not an obstacle for English readers, a must.*

————. *The River of the Mother of God and Other Essays.* Ed. Susan L. Flader and J. Baird Callicott. Madison: University of Wisconsin, 1991.—*The essential Leopold, selected from his inedita and inaccessible journals, superbly selected and edited by a historian and a philosopher devoted to Leopold's work. Another reason to be grateful for SLF.*

Librová, Hana. *Láska ke krajině?* (Love for the Land?) Brno: Blok, 1988.—*A profound yet intelligible philosophical reflection which already in the Communist years cast doubt on the idea that Nature is but a stage of human lives, played a role in Czechoslovakia similar to that of Rachel Carson in America.*

————. *Pestří a zelení: kapitoly o dobrovolné skromnosti* (The Speckled and the Green). Brno: Veronica - Hnutí DUHA, 1994.—*A leading Czech eco-*

logical sociologist reflecting on modes of life which do not lead to self-destruction. See also McKibben, Bill.

Lorenz, Konrad. *Civilized Man's Eight Deadly Sins.* Translated from the German *Die acht Todsünden der zivilisierten Menschheit* by Marjorie Kerr Wilson. New York: Harcourt Brace Jovanovich, 1974.—*Lorenz calls this a book of sermons "more appropriate to a preacher than a natural scientist." It would be hard to disagree with him. The unanswered question is whether natural scientific standing constitutes a credible qualification for moralizing.*

———. *On Aggression.* Translated from the German, *Sogenannte Böse,* by Marjorie Kerr Wilson. New York: Harcourt, Brace & World, 1966.— *Lorenz at his most sociobiological. A provocative rather than wise book, with moralizing conclusions linked to the text more poetically than philosophically.*

———. **The Waning of Humaneness.** Translated from the German, *Der Abbau des Menschlichen,* by Robert Warren Kickert. Boston: Little, Brown, 1987.—*From the perspective of ecological ethics easily Lorenz's most important work. Author believes that humankind is rushing to self-destruction—but that, biologically speaking, this development is not causally determined and can be influenced by human freedom.*

———. *Das Wirkungsgefüge der Natur und das Schicksal des Menschen.* Munich: Piper, 1983, 1990.—*An inexpensive pocket edition of selected works for German readers.*

Lovelock, James E. *The Ages of Gaia.* New York: Norton, 1988.—*The favorite author of both technocrats and depth ecologists unfolds his hypothesis that the behavior of life can best be explained if we assume that the Earth is an organism, this time for scientists while Gaia was written for lay people.*

———. **Gaia: A New Look at Life on Earth.** Oxford: Oxford University Press, 1979.—*Vitalism in modern dress: life on Earth is best modeled on the behavior of an organism. Suffers from the limitation of all systems-theoretical analysis: how to derive a mode of acting from the theoretical model? Equally beloved by technocrats and depth ecologists.*

———. *Healing Gaia: Practical Medicine for the Planet.* New York: Harmony Books, 1991.—*Lovelock's first admission that, in addition to technology and mysticism, we may also need some practical changes of life style; Lovelock's familiar three C's—cars, cattle, chainsaws—as the source of ecological threat.*

Masson, Jeffrey Moussaieff and Susan McCarthy. *When Elephants Weep.* New York: Delacorte Press, 1995.—*"The most comprehensive and compelling argument for animal sensibility that I've yet seen," says Elizabeth Marshall Thomas. I can only add that it is utterly delightful reading. Another must.*

McKibben, Bill. *Hope, Human and Wild: True Stories of Living Lightly on the Earth.* Boston: Little Brown and Co, 1995.—*Examples of sustainable lives, written with literary flair.* See also Elgin, Voluntary Simplicity *and* Librová, Pestří a zelení.

Meadows, Donella, Dennis L. Meadows, and Jorgen Randers. *Beyond the Limits: Confronting Global Collapse, Envisioning a Sustainable Future.* Post Mills VT : Chelsea Green Publishers, 1992.—*The Limits to Growth twenty years later. A systems-theoretical approach again, but this time at least marginally recognizes the importance of modes of life for ecology.*

Meadows, Donella *et al. The Limits to Growth.* New York: Universe Books, 1972.—*The first Report of the Club of Rome which pointed out the self-destructive consequences of "progress" and "development" and provided the nascent ecological movement with unambiguous statistical arguments.*

Meine, Curt. *Aldo Leopold: His Life and Work.* Madison, WI: University of Wisconsin Press, 1988.—*A biography and at the same time an introduction to ecological thought; together with Callicott's* Companion, *Flader's* Thinking like a Mountain *and Leopold's own* A Sand County Almanac *and* The River of the Mother of God *the best possible start for thinking about ecology.*

Merchant, Carolyn. *The Death of Nature: Women, Ecology and the Scientific Revolution.* New York: Harper and Row, 1980.—*An ecofeminist classic. According to the author the replacement of the prescientific organic conception of the world by a mechanistic natural scientific one provided an impetus for the oppression of nature and women alike*;

Míchal, Igor. *Ekologická stabilita* (Ecological Stability). Brno: Veronica, 1994.—*One of the finest natural scientific introductions to ecology I know, clearly written by a forester with a philosophical undertone.*

————. *O odpovědném vztahu k přírodě: Předpoklady ekologické etiky* (Relating Responsibly to Nature). Prague: Edice Nika, 1988.—*Well informed overview of problems of ecological ethics and a living proof that even under the Communists it was possible to think and write, in spite of narrowly limited access to literature.*

Mishan, Ezra J. *The Economic Growth Debate: An Assessment.* London: George Allen and Unwin, 1977.—*Thoroughly documented overview of the debate whether "development" is something desirable.*

Morgan, Marlo. *Mutant Message Down Under.* New York: Harper Collins Publishers, 1994.—*I have read this book only in a Czech translation which may color my impression of its literary quality. Still, as an insider view of the life of Australian hunter-gatherers it is impressive.*

Morris, Desmond. *The Naked Ape: A Zoologist's Study of the Human Animal.* New York: McGraw-Hill, 1967.—*A popular sociobiological essay stressing the parallels of human and other animal behavior. Readable rather than scholarly.*

Mowat, Farley. *Vlci* (The Wolves). Prague: Svoboda, 1997.—*I have not been able to secure the English original and after my experience with the Holuša translation of Seed, hesitate to judge by translation, but if the original is anything like the translation, it is superb, perhaps the best report on the wolves in the wild thus far.*

Muir, John. *A Thousand Mile Walk to the Gulf.* Boston: Houghton Mifflin, 1916.—*Notes from Muir's long hike along the Appalachians, from Maine to Florida, which helped provide support for the Appalachian Trail.*

———. *Wilderness Essays.* Salt Lake City, UT: Peregrine Smith Books, 1980.—*Observations of perhaps the first conscious environmentalist in America from the turn of the twentieth century—and proof that ecology was deep long before it was called that. Chief virtue of this volume is that it is still in print.*

———. *The Wilderness World of John Muir.* Ed. Edwin Way Teale. Boston: Houghton Mifflin, 1976.—*More vintage Muir. A fine representative volume, testifying to the skill of its editor. Alas, out of print.*

Naess, Arne. *Ecology, Community and Lifestyle.* Ed. David Rothenberg. New York: Cambridge University Press, [1989] 1998.—*A collection of texts by the Norwegian "ecosophist" who coined the term "deep ecology" for ecological philosophy, systematized by one of his philosophically most competent followers. The bibliography provides useful reference to Naess's key articles cited in the present volume.*

Nash, Roderick. *The Rights of Nature: A History of Environmental Ethics.* Madison, WI: University of Wisconsin Press, 1989.—*An outstanding overview of American writings in ecological philosophy, combining readable style with thorough scholarship.*

Nelson, Richard K. *Make Prayers to the Raven.* Chicago, IL: University of Chicago Press, 1983.—*The life of the forest and of its inhabitants through the eyes of the Koyukon people in Alaska. An outstanding introduction to a non-European ecological perspective.*

Nisbett, Alec. *Konrad Lorenz.* London: Dent, 1976.—*A solidly researched biography of Konrad Lorenz notable for its outstanding bibliography.*

Norberg-Hodge, Helen. *Ancient Futures: Learning from Ladakh.* San Francisco: Sierra Club Books, 1991.—*An idyllic vision of extreme poverty untroubled by reflection. Both beautiful and troublesome: is contentment possible only on a prereflective stage? Or is it simpler to admire poverty than to relieve it?*

Nováček, Pavel. **Chválí Tě sestra Země** (Sister Earth Praises Thee). Olomouc: Matice cyrilometodějská, 1998.—*Ecology in the light of the Scripture. A collection prepared by an ecological activist who is also a scientist and a Christian. Wise and sober, wholly free of the unfortunate kitsch too common to the genre. Had I but world enough and time, I would eagerly translate it into English.*

Odum, Eugene P. *Fundamentals of Ecology.* Philadelphia: Saunders, 1953, many reprints.— *Classic text from which generations of students learned; translated into Czech it shaped Czech conceptions of biological ecology much as it had the American. James Lovelock's favorite ecology text.*

Oelschlaeger, Max, ed. *Postmodern Environmental Ethics.* Albany, NY: State University of New York Press, 1995.—*A somewhat diversified collection of articles from* Environmental Ethics; *the common denominator appears to be a greater interest in speaking about nature than in nature itself.*

Orr, David W. *Ecological Literacy: Education and the Transition to a Postmodern World.* Albany, NY: State University of New York Press, 1992.— *A superb broadly based survey of the field addressing specifically my own concern, that of raising ecological literacy. It is to Orr I owe the recognition that the environmental crisis is fundamentally a crisis of sustainability and much, much more.*

Patočka, Jan. "The Danger of Technicization in Science according to E. Husserl and the Essential Core of Technology as Danger in M. Heidegger." In Erazim Kohák, *Jan Patočka: His Thought and Writings.* Chicago: University of Chicago Press, 1989.—*A profound analysis of the difference between Enlightenment and Romantic conception which manifests itself in ecological ethics in the difference between deep and "depth" ecology.*

Pecina, Pavel. *Kořeny zla.* (The Root of Evil). Prague: Nika, 1994.—*Moral lessons from the lives of animals: enchanting sociobiological reflections in the tradition of Aesop's fables—only rigorously grounded in scientific knowledge. In Czech, and nobly worth translation.*

Pollan, Michael. *Second Nature: A Gardener's Education.* New York: Bantam Doubleday Dell, 1991.—*According to the author, nature has been too disrupted to attempt to save wilderness. Instead, he recommends caring for nature as for a park.*

Porritt, Jonathon. *Seeing Green: The Politics of Ecology Explained.* New York: Blackwell, 1985.—*Ecological ethics as a political program for a Green party, old but still relevant.*

Porritt, Jonathon, ed. *Save the Earth.* London: Dorling Kindersley, 1991.—*An exceptionally well done, richly illustrated introduction to ecology, written to be intelligible even on a junior high level yet still interesting to high school seniors—a must for every high school library. Alas, since its publication, there has been serious deterioration in a range of respects.*

Quinn, Daniel. *Ishmael.* New York: Bantam-Turner, 1992.—The *human mode of life as seen through the eyes of a guru gorilla; witty and informative reading; not scholarly yet profound—and utterly delightful.*

Rollin, Bernard E. *Animal Rights and Human Morality.* Buffalo, NY: Prometheus Books, 1981.—*A member of a medical school ethics committee wrestles with his conscience. Written in the dust dry idiom of analytic philosophy, yet worth the effort.*

Rolston, Holmes, III. *Philosophy Gone Wild.* Buffalo, NY: University of Buffalo, 1986.—*A collection of essays by arguably the most important living ecophilosopher, defender of biocentrism. Cf. Paul Taylor, Respect for Nature—only Rolston is a pure joy to read. This, together with Leopold's* A Sand County Almanac *and an inflatable raft is what I would recommend if marooned on a desert island.*

Rothenberg, David, ed. *Ecology, Community and Life Style.* New York: Cambridge University Press, 1989.—*A fine collection of Arne Naess's somewhat fragmentary writings, with an excellent systematizing essay by the editor. Perhaps the best introduction to deep ecology.*

Scheler, Max. *Man's Place in Nature.* Translated and introduced by Hans Meyerhoff. New York: Noonday, 1961.—*Philosophically significant work of Scheler's Catholic period, yet, in spite of its title, only marginally relevant to ecological ethics. To place in context of Scheler's thought, see following item.*

————. *On Feeling, Knowing and Valuing.* Ed. and Intro. by Harold J. Bershady. Chicago: University of Chicago Press, 1992.—*A representative selection of his writing; note selection I.3, "Emotional Identification," as relevant to deep ecology.*

Schumacher, E.F. *A Guide for the Perplexed.* New York: Harper and Row, 1977.—*Though the idiom may seem dated, this defense of Christian humanism helped shape the first generation of activists.*

————. *Small is Beautiful: Economics as if People Mattered.* New York: Harper and Row, 1973.—*Proposal of an economics with a human face as against technology which serves producers at consumers' expense. Nostalgic reading: in the "neoliberal" age of globalization the latter technology won massively.*

Schweitzer, Albert. "Die Ethik der Erfuhrt vor dem Leben." In *Kultur und Ethik* (Munich: Beck'sche Verlagsbuchhandlung, 1923); in English, *"The Ethics of Reverence for Life"* in Albert Schweitzer, *The Philosophy of Civilization*):240–64 — *Schweitzer's "biocentrism" in a nutshell.*

Schweitzer, Glenn E. *Borrowed Earth, Borrowed Time.* New York: Plenum, 1991.—*Similarity of names purely accidental yet it led me to purchase the book. I do not regret it. The author, a professional chemist, worked for the American federal government's toxic waste program, offers an insider's report.*

Seed, John, Joanna Macy, and Pat Fleming. *Thinking like a Mountain: Towards a Council of All Beings.* Philadelphia, PA:New Society Publishers, 1988.—*Vintage "depth ecology" (as distinct from deep ecology), a practical handbook for workshops designed to teach identification with the protoconsciousness of all life.*

————. *Myslet jako hora: Shromáždění věch bytostí.* Translated by Jiří Holuša. Prešov: SR, ABIES, 1993.—*A translation of previous item,*

though rewritten by the translator so extensively as to merit separate listing; comparison with the original is a good example of the slide from deep to depth ecology.

Shepard, Paul. *The Tender Carnivore and the Sacred Game.* New York: Scribners, 1973.—*Hunting-gathering as paradise lost, agriculture as the original sin; though the reader may not share the author's valuation, the book is a must for grasping the hunter-gatherer experience of nature.*

Singer, Peter. Animal Liberation. New York: Avon Books, 1975.—*The classic, most influential first study of the relation of humans and other animals, from the perspective of biotic equality. To this day the great manifesto of animal defenders. Definitely a must.*

Šmajs, Josef. *Ohrožená kultura* (Culture at Risk). Brno: Zvláštní vydání, 1995.—*Relation of "culture" and "nature" from the viewpoint of systems theory, with supplemental moralizing; exemplifies the problem of systems theories: how to make the step from theoretical understanding to effective action.*

Snyder, Gary. The Practice of the Wild. San Francisco, CA: North Point Press, 1990.—*Translating just the many-layered title is a challenge no Czech has met, and more's the pity. The author's deep probing of nature informed by many years of study of Zen Buddhism and here presented with poetic grace proves that even depth ecology need not be affectation.*

————. *The Old Ways: Six Essays.* San Francisco: City Lights Books, 1977.—*Collection of six essays by the poet of depth ecology. Snyder is always deeply rewarding reading, and this collection is no exception.*

————. *Tahle báseň je pro medvěda* (This Poem is for the Bear.) Trans. and ed. Lubor Snížek. Prague: Argo, 1997.—*A collection of poems from various sources in Czech translation which I am citing in part because I love the book and in part as evidence that you can pick up any Snyder at random and not regret it, regardless of language.*

Šprunk, Karel, ed. *Člověk—-pastýř stvoření* (Humans—Shepherds of the Creation). Monothematic issue of *Universum Review* 16 (Winter 1994/95). Brno: Cesta, 1995.—*A collection of ecological essays from a Christian perspective which surely has an English equivalent.*

Stehlík, Jiří. *Manifest budoucnosti* (Future Manifesto.) Prague: Koniklec, 1998.—*Interesting example of post-Marxist systems theory according to which the only viable philosophies are Marxist or Berdayevian-Teilhardian The conquest of nature is desirable, so is growth, only with ecological safeguards, and all this presented as ecological ethics.*

Šuta, Miroslav. *Účinky výfukových plynů automobilů na lidské zdraví* (Effects of Automobile Exhaust Gases on Human Health). Brno: CS Traffic Club, 1996.—*Precisely what the title promises—and a shocking recognition of the unintended effects of our thoughtlessness. Had I an automobile, I should be ashamed of myself.*

Taylor, Paul. *Respect for Nature: A Theory of Environmental Ethics.* Princeton, NJ: Princeton University Press, 1986.—*Philosophical systematization of Albert Schweitzer's ecological thought from the perspective of a Kantian formalism. Not exactly a breezy read but absolutely superb technical philosophy: biocentrism on the highest professional philosophical level.*

Teilhard de Chardin, Pierre. *The Phenomenon of Man.* Intro. by Julian Huxley. Trans. Bernard Wall. New York: Harper, 1959. —*A theory of the evolution of matter, life, and thought: material evolution phases over into mental evolution. Bold speculation leaving a question: is nature here anything more than an evolutionary stage on the way to the noosphere?*

Thomas, Elizabeth Marshall. *The Hidden Life of Dogs.* Boston: Houghton Mifflin Co., 1993—*Ethnological observation of the dynamics of a dog pack, global bestseller; the excellent Czech translation a victim of the "privatization" of the book distribution system. A delightful read in any language and a bestseller in most.*

Thomas, Keith. *Man and the Natural World.* New York: Random House, 1983.—*Loosely takes up the story of European conceptions of nature where Glacken leaves off. Follows the development of European attitudes to the natural world on the example of England. Unfortunately out of print and seldom in secondhand bookstores—this is not a book one would willingly sell.*

Thoreau, Henry David. *Walden and Other Writings.* New York: Bantam, 1962.—*Thoreau needs no comment. I recommend this long out of print edition to secondhand bookstore browsers because the introduction is by one of the noblest American nature essayists, Joseph Wood Krutch.*

Time Magazine. *Our Precious Planet.* A special ecological issue of *Time* Magazine, 150.17A (Nov. 1997).—*Collection of texts of foremost authors, including Albert Gore, only financed by an automobile manufacturer- an interesting attempt at squaring the circle.*

Tokar, Brian. *Earth for Sale: Reclaiming Ecology in the Age of Corporate Greenwash.* Boston: South End Press, 1997.—*Analysis of the possibilities of ecological action in light of the dramatically rising power of multinational corporations on a global scale, seen from America—an important and rather frightening book.*

United Nations. *Human Development Report 1998: Special Issue: Consumption for Human Development.* New York: Oxford University Press, 1998.—*Annual report available in major libraries, together with the WorldWatch* State of the World *annual report provides a comprehensive factual survey of human impact on the Earth.*

Vaněk, Miroslav. *Nedalo se tady dýchat* (We Could Not Even Breathe). Prague: Ústav pro soudobé dějiny AV ČR, 1996.—*History of ecological activism in the Czech lands from the Soviet occupation of 1968 to the fall of the Communist regime in 1989, fascinating reading . . . if and only if you read Czech.*

Veselovský, Zdenek. *Chováme se jako zvířata?* (Do We Behave Like Animals?) Prague: Panorama, 1992.—*Highly readable yet rigorously scholarly introduction to etology by an author immensely erudite in the field and with genuine love for nature.*

Vološčuk, Ivan a Míchal, Igor. *Rozhovory o ekológii a ochrane prírody* (Conversations about Ecology and Environmentalism.) Bratislava: Knižnica zborníka prác o Tatranskom národnom parku, 1991.—*An environmental classic, from the perspective of philosophically competent foresters.*

von Weizsäcker, Ernst Ulrich, Amory B. Lovins, and L. Hunter Lovins.. *Factor Four: Doubling Wealth—Halving Resource Use: the New Report of the Club of Rome.* Translated from the German *Faktor vier: Doppelter Wohlstand—halbierter Naturverbrauch,* translator not given. London: Earthscan Publications Ltd., 1997.—*A flagrant example of technocratic systems-theoretical ecology. The German title promises not just double wealth, but double well-being, then devotes over three hundred pages to superb, highly suggestive analyses of possible savings of energy while increasing consumption—and twelve pages to how to bring it about. Considering that it lures readers with the promise of double the affluence it is not surprising that, as the authors note ruefully, there is not interest in frugality.*

White, Lynn Jr. "Historical Roots of Our Ecological Crisis." *Science,* sv. 155 (10 March 1967): 1203–7. Commentaries thereto in Pojman, *Environmental Ethics,* 6–24.—*Classic article with which the English historian opened the debate concerning the reponsibility of Christian conceptions of the place of humans in the creation for the ecological devastation of the Earth, often rebutted, still provocative.*

Wilkinson, Loren, ed. *Earthkeeping in the Nineties.* Grand Rapids, MI: Eerdmans Publishing, 1991.—*An excellent overview of contemporary ecological philosophy from an ecumenically Christian perspective.*

Wilson, Edward O. *The Diversity of Life.* New York: Penguin, 1992.—*Easily the best example of sociobiology with no dogmatic freight, with sobering results: the age of humans may prove the six global die-out.*

———. *On Human Nature.* Cambridge: Harvard University Press, 1978.—*A philosophizing view of human biological nature from a biologist who is aware of philosophical problems.*

Wright, Robert. *The Moral Animal: The New Science of Evolutionary Psychology.* New York: Pantheon Books, 1994.—*Author loosely follows Darwin's life story as he presents contemporary neo-Darwinism not only as a biological theory but as a philosophical and ethical conception of humans and society. Suggestive, whether or not author's biological premisses justify ethical conclusions.*

Because of the unavailability of literature in English in the Czech Republic at the time of my return, hard upon the fall of the Communist regime, I referred those of my students who could read English to collections of readings I brought with me from America and placed on reserve in the library. I shall be ever grateful for having had them in those early years. They are:

Armstrong, Susan J., and Richard G. Bothler. *Environmental Ethics: Divergence and Convergence.* New York: McGraw-Hill, 1993.—*A somewhat idiosyncratically organized collection which contains a number of crucial texts inaccessible otherwise.*
Gruen, Lori, and Dale Jamieson. *Reflecting on Nature: Readings in Environmental Philosophy.* New York: Oxford University Press, 1993.—*A philosophically conceived selection which includes Aristotle, Locke, and Darwin, long since translated, but also some important texts including Jamieson's study of the ethics of zoos (291–98).*
List, Peter C., ed. *Radical Environmentalism: Philosophy and Tactics.* Belmont, CA: Wordsworth Publishing, 1993.—*A collection of texts about "ecology of the deed," otherwise wholly inaccessible in Prague, including the confession of a group which by a major sabotage of Icelandic fishery significantly contributed to the protection of theoretically protected whales whom no one protected, together with a discussion about the ethics of such "ecoterrorism."*
Pojman, Louis P. *Environmental Ethics.* Boston: Jones and Bartlett, 1994.—*A valuable collection of extended texts, not just snippets, in ecological ethics together with texts from the debate about individual problems, from population through nuclear energy and global warming to long-range sustainability.*
Shrader-Frechette, Kristin. *Environmental Ethics.* Pacific Grove, CA: Boxwood Press, 1981.—*A pioneer work which served well in many reprintings. Excellent full-length selections of pre-1980 material.*

Having become acquainted with American textbook publishing over thirty-five years of teaching in that country, I am sure many others have appeared since. However, in the name of all the students who wore my copies to shreds in our reserve book room I should like to express gratitude to those cited.

INDEX OF NAMES

Annas, George J., 168

Bacon, Roger, 67
Bacon, Francis, 167
Bahro, Rudolf, 151
Baum, J. D., 173
Bateson, Gregory, 137, 179, 180
Bentham, Jeremy, 68, 88, 91, 176
Beránek, Jan V., 165, 183
Bergson, Henri, 181
Berman, Morris, 79, 80, 169, 173
Bertalanffy, Ludwig von, 142, 180
Bledsoe, Thomas, 168
Boulding, Kenneth, 94–95, 166, 175
Bramwell, Anna, 149, 150, 178, 180, 181, 182, 183
Buber, Martin, 57
Burke, Edmund, 169

Callicott, J. Baird, xiii, 87–88, 90–91, 93–94, 158, 165, 168, 174, 175
Calvin, John, 29, 42
Capizzano, Stephen, xviii, 184
Čapek, Karel, 185
Carson, Rachel, 17, 131, 143, 159
Carter, Jimmy, xiii, 75, 95, 159
Cassirer, Ernst, 54, 169
Cetl, Jiří, 166, 172
Chadwick, Douglas H., 182
Chatwin, Bruce, 182
Charles, Prince of Wales, 96
Chelčický, Petr, 42
Chomsky, Noam, 109
Comenius, see Komenský
Conrad, Sheree D., xviii, 184

Da Vinci, Leonardo, 33,
Darwin, Charles, 68, 92, 136
Davies, Donald Edward, 142, 166, 174
de la Court, Thijs, 165, 166
de las Casas, Bartholemeo, 168
Descartes, René, 23, 24, 66–68,71, 81
Devall, Bill, xiii, 112, 115, 176
Dewey, John, 38
Diamond, Irene, 178

Dillard, Annie, 64, 71–72, 82, 171, 172
Driesch, Hans, 129, 178
Dubos, René, 179

Einstein, Albert, 11
Elgin, Duane, 75, 76, 77, 78, 172, 173
Elkington, John, 182
Elton, Sir Charles, 91, 142, 149, 180
Engels, Friedrich, 24
Esop, 58
Evernden, Neil, 58, 170

Ferdinand V (Habsburg), 27
Fischer, Joschka, 150
Flader, Susan L., 174, 176
Fleming, Pat, 118, 177
Foreman, Dave, 181
Foss, Cynthia, 168
Fossey, Diane, 168
Francis of Assissi, 61
Freud, Sigmund, 117
Fromm, Erich, 72
Frost, Robert (quoted), 100, 175

Galileo Galilei, 67
Gassendi, Pierre, 80
Glacken, Clarence J., 20, 167, 168
Goethe, Johann Wolfgang von, 21
Goodall, Jane, 168
Gore, Albert, 64,72–75,77–78, 109, 146, 166, 172, 176, 179, 181
Gray, Elizabeth Dodson, 178
Gregg, Allan, 99
Griffin, Susan, 178
Grodin, Michael A., 168
Guthrie, Woody, 157

Haeckel, Ernst, 148–49, 182
Hardin, Garrett, 94–100, 133–34, 158, 175, 176, 179
Hargrove, Eugene, xiii
Hartshorne, Charles, 92, 181
Hegel, Georg Wilhelm Friedrich, 181
Heidegger, Martin, 58, 116, 149, 181, 183, 184
Heisenberg, Werner, 11

Heraclitus, 94, 175
Hess, Karl, Jr., 175
Hilsner, Leopold, 169
Holuša, Jiří, 118, 177
Hume, David, 92
Hunter, Robert, 180
Husserl, Edmund, xii, 13, 116, 162, 174, 177, 185

Isaiah (OT prophet), 42, 82

Jan z Žatce (Johannes von Saatz, also von Tepl), 93, 174
James, William, xii, 14
Jamieson, Dale, 183
Jarrett, Henry, 166
Jaspers, Karl, 167
Jeřábek, Alexamder, xii
Jesus of Nazareth, 82
Jirásek, Alois, 170
John Paul II, Bishop of Rome, 173
Jung, C.G., 117, 119, 123

Kant, Immanuel, 26, 38, 66, 68, 71, 83–85, 91, 171
Keller, Jan, 72, 151, 167, 170–72
Kelly, Petra, 150–51
Kicková, Zuzana, 177
King, Alexander, 181
Kohák, dr. Miloslav (author's father), 156
Koháková, Dorothy Mills, xviii, 124–25, 184
Kolakowski, Leszek, 181
Komenský (Comenius), Jan Amos, 13,66
Kosík, Karel, 171
Kovtun, Jiří, 169
Kožík, František, 37, 156
Kratochvíl, Zdenek, 14, 167
Krushchev, Nikita Sergeevich, 95
Kuhn, Thomas, 11

La Mettrie, Julien, 23
Leibniz, Gottfried W., 13, 21
Leopold, Aldo, xii, xvi, 37, 87, 88, 90–94, 106, 109, 111, 114, 118, 130, 142, 153, 158, 165, 166, 173, 174, 177, 178
Librová, Hana, 72, 76, 172, 184
Lopez, Barry H., 180
Lorenz, Konrad, 138, 140, 149, 167, 179, 180, 182
Lovelock, James, 63, 86, 129–35, 139, 140, 141, 144, 146, 158, 167, 175, 178, 179, 183

Lovins, Amory and L. Hunter, 165
Lloyd, W.F., 95
Lucretius, Titus L. Carus, 130
Luther, Martin, 42, 44, 45, 184

Macpherson, Frances B., xviii
McCarthy, Susan, 168
McKibben, Bill, 173, 184
Macy, Joanna, 118, 177, 178
Marx, Karl, 126
Masaryk, Tomáš G., 34, 76, 162, 168, 185
Masson, Jeffrey M., 168
May, Karl, 169
Meadows, Dennis, xvi, 143, 143, 159, 165, 167
Meadows, Donella, xvi, 142, 158, 159, 165, 167, 180
Mengele, Dr. Joseph, 19, 38
Meine, Curt, 174
Melden, A. I., 175
Merchant, Carolyn, 178
Mersenne, Marin, 80
Mill, James, 68, 88, 91
Mill, John Stuart, 68, 88, 91
Míchal, ing. Igor, xviii
Mishan, Ezra J., 167, 170, 172
Mommer, Kerri, xii
Morgan, Marlo, 169
Morris, Desmond, 137, 141, 179, 180
Mozart, Wolfgang Amadeus, 32
Mrštík, Alois and Vilém, 80
Muir, John, xiii, 69, 80–83, 88, 108–10, 130, 148, 173, 176

Naess, Arne, xvi, 108–20, 135, 176
Nelson, Richard K., 182
Němcová, Božena, 170
Newton, Isaac, 21, 67, 80
Nietzsche, Friedrich, 69
Nisbett, Alec, 182
Norberg-Hodge, Helen, 167, 184
Nováček, Pavel, 168

Odum, Eugene P., 166
Orenstein, Gloria Feman, 178
Orr, David, 165
Otto, Rudolf, 60

Paley, Rev. William, 71
Patočka, Jan, 63, 69, 162, 170, 171, 185
Paul of Tarsus, 184
Pecina, Pavel, 138, 167, 180, 183
Pekař, Josef, 162, 184

Pereira, Gomez, 23, 168
Peroutka, Ferdinand, 185
Philo Judaeus, 130, 178
Pinchot, Gifford, 173
Plato, 26, 57, 130
Plumwood, Val, 178
Polányi, Michael, 11
Polkinghorne, Donald J., 180
Popper, Karl, 11, 173
Porritt, Jonathon, 150–51, 178, 183
Přemysl Otakar II, 162
Proctor, Robert N., 168
Průka, Martina and Míla, xviii
Pythagoras, 33

Quinn, Daniel, 180
Quinton, Michael S., 182

Rádl, Emanuel, 129, 178, 185
Rais, Karel, 170
Randers, Jorgen, 165
Reagan, Ronald, 75, 159–60
Regan, Tom, 146, 168
Reuther, Rosemary R., 178
Ricoeur, Paul, 53, 169
Rollin, Bernard E., 45, 46, 49, 168, 169
Rolston, Holmes, III, xiii, 94, 158, 170, 174,
 175, 180
Roosevelt, Franklin Delano, 95
Rothenberg, David, 112, 176
Rousseau, Jean-Jacques, 119, 148

Sartre, Jean-Paul, 63
Schär-Manzolli, Milly, 38, 169
Schleiermacher, Friedrich, 54
Schneider, Bertrand, 181
Schrödinger, Erwin, 11
Schweitzer, Albert, 33, 37, 61, 78–84, 87–88,
 92–94, 111, 119, 144, 158
Schumacher, Ernst Fritz, 151, 184
Scrooge, Ebenezer, Esq., xvii
Seed, John, 117–21, 130, 158, 177, 179
Seneca, Lucius Annanaeus, 42
Sessions, George, xiii, 112, 115, 116, 176
Shepard, Paul, 169
Sherrington, Sir Charles, 70–72, 78, 172
Shiva, Vandana, 178
Shrader-Frechette, Kristin, 172, 175
Singer, Peter, 17, 18, 32–41, 46, 168

Skolimowski, Henryk, 60, 61, 170
Skýbová, Marie, xviii
Šmajs, Josef, 144, 166, 171, 181
Snyder, Gary, xiii, 150
Socrates, 26
Soros, George, 77, 173
Šprunk, Karel, 170
Stehlík, Jiří, 176
Šuta, Miroslav, 166
Svěrák, Zdeněk, 167, 184
Swift, Jonathan, 27

Taylor, Paul, xiii, 83–88, 111, 174
Teilhard de Chardin, Pierre, 170
Tertullian, Quintus Septimus, 99
Thatcher, Margaret, 97, 124
Thatcherová, Margaret, 124
Thomas, Dylan, 82, 173
Thomas, Elizabeth Marshall, 168, 169, 180
Thomas, Keith, 20, 167, 168
Thoreau, Henry David, 38, 80
Toplady, Augustus, 27
Tracy, Destutt de, 147

Vaculík, Ludvík, 47
Vančura, dr. Jiří, xviii
Vaněk, Miroslav, 181
Vavroušek, Josef, 81, 153, 181
Vergil, Publius V. Maro, 110
Veselovský, Zdenek, 167, 183
Vollmer, Antje, 150
Veyne, Paul, 167

Warren, Karen J., xiii, 126–28, 177, 178
Warrenová, Karen J., 178
Watson, Paul, 180
Watt, James, 130
Watts, Isaac, 29
Weizsäcker, Ernst Ulrich von, 57, 167, 172,
 181, 184
Wilde, Oscar, 183
Wilkinson, Loren, 170
Wilson, E.O., 57, 63, 133, 138–39, 144, 146,
 158, 170, 174, 179, 180
White, Lynn, Jr., 57, 62, 170, 171
Whitehead, Alfred North, 92, 184

Young, Stanley P., 180

INDEX OF TOPICS

affluenza epidemic, 56, 73, 158
agreement vs. understanding, xvi–xvii, 155
alienation from nature, 114–18, 157
altruism, def. 78; vs. egoism, 111–14; as iden-
tification, 112; as source of value, 70–72
animals, 27–40; animal experimentation, 33,
38–39, 46–49, 83, 157; animal liberation,
17, 30–34, 39; animal needs ("rights") 34,
47; cruelty to, 29; kinship with humans,
27–29, 33; "little people in fur coats," 17,
46; salvation of animals, 26, 27; as tools,
22;
anthropocentrism, 3, 59, 65–79, 84; and bio-
centrism in deep ecology, 112; egoistic vs.
moral, 69–72; ethical, defined, 72
America: New England, xii–xiii, 56, 157–58;
American dream as ecoterrorism, 159;
American way of life, xiii, 11
automobile, 5, 12–13, 75, 76, 96, 145, 161,
166, 179

Being, symphony of, 106
biocentrism, def. 85–87, 79–87; life-centered
ethics, 84 (*see also* ethics)
biofarming, 30
biotic community, 88, 91, 130; its "integrity,
stability, beauty," 89
Bramwell Report, 40
buffalo in prairie ecology, 70

cannibalism, 44
cars, cattle, chainsaws, 133
central heat, metaphor of, 115–16
Christianity and ecology, 62–64
civilization and exploitation, 30; dilemma of,
30
consumerism, 57, 72–77, 144, 149; def. 170
consumption, as addictive, 73–74; conspicu-
ous, 94; need of the impoverished, greed
of the affluent, 9, 10; and sensitivity, 30
culture, 6, 141, 144; based on exploitation, yet
fosters sensitivity, 31; European, 3, 9, 13,
17, 54, 108; vs. nature, 7, 144–49, 172
Czech Brethren on sustainability, 171, 172

death, as price of life, 45, 71, 92–93, 94–95
democracy: social democracy, xvi; democratic
revolution, 20, 29; and ecology, 146, 152
"depth" ecology, 61, 87; and common proto-
conscious, 118–119; Council of All
Beings, 55, 121–122; emotion over rea-
son, 118, 120; evolutionary remembering,
120; Gore's critique of, 73; identification
as self-transcendence, 118
Deus sive natura, 54
die-outs (biology), 138, 158
diversity of species, 138–39, 141
DUHA Movement, 113, 167, 183

Earth Mother, 71, 129–30, 139, 149–50
ecocentrism, 87–93
ecofeminism, 115, 122–28; basic ecofeminist
theses, 126; calls attention to link between
oppression of women and of nature, 127;
reason as masculine, 122
ecological situation, 3–6; population, greed,
power, 133–35, 144–46
ecological literacy, xviii, 91, 156
ecology: def. 111, 118; deep (vs. depth), 117;
deep (vs. shallow), 108–13; "depth," 14,
73, 109, 115, 118, 130, 134–35; "flannel",
xi, xii, 108, 113–16, 134–35, 139, 145,
155; as ideology, 147; as science and as
philosophy, 11–14
ecosophy, 109, 112, 117
egoism, 72,79; and altruism, 111–14
empiricism and system theory, 142
Ego vs. Self, 112
enlightened despot, 146–47
environmental ethics, *see* ethics, ecological
Epicureans, 134
equality, biotic, 29, 34, 39, 87; in deep ecology,
111; in ecofeminism, 127; humans as
equal, 91; as moral ideal, 35, 39, 88, 125
ethics, def. 1–2, 91; biocentric, 79–87, 93;
coercion in, 97; cowboy ethics, 4, 94–95;
ecocentric, 88–93; ecological, 1–3, 8–14,
91; formalist, 83, 84, 91; Leopold's def.,
90; lifeboat, 94–100; options in, 98;

spaceship ethics, 94–95; theocentric, 58–65, 145; utilitarian, 91

exotics, humans as, 58

Factor Four, xvi, 160–61

factory farming, 18–19, 40

faith, contrasted with belief, 59–62

fanaticism, 44–45

feminism, 122–26; conceptual schema, 124; and democracy, 123; struggle against oppression of women, against all oppression, and key to all oppression, 123–24; when oppressive, 125–26

fly on the wall, 156

foreign aid as ecologically problematic, 99–100

foresight as ethical principle, 139

forest fire in ecology, 90

freedom, as definitive of humanity, 1, 23, 43, 46, 71; ethics as field of, 100; as recognized necessity, 106–7, 134–37; 139, 141; and wildness, 150

frugality as life style, 56, 74–78, 99, 113, 143, 159, 160–61

Gaia hypothesis, 86, 101, 108, 129–35; wellbeing of Gaia, 131; as worshipped, 171, but note 178n25, 179

Garden of Eden, 20, 42

God, 21–25, 35, 66, 77, 130; and created world, 136; as shepherd, 55; as Spirit, 22; and value, 2, 45, 80, 140

greed as motivator, 72, 93, 158; capable of crippling Earth, 132; as "natural" 57, 58

Greeks, ancient, 26, 63, 91, 130

greenhouse effect, 4–5, 73

green revolution, 99

Greens, the, 147, 150–54

guilt, burden of, 98; as motivator, 41, 42; perspective of, 44

history, aristocratic vs. democratic, 162; meaning of, 161

holism, and Land Ethic, 89, and deep ecology, 111; and sociobiology, 138; in systems theory, 142, 149

Holy, also Sacred, 59–62

Homo sapiens sapiens, 7

human relations strained, 5, 74

human rights, 31, and animal needs, 46

humanity, signs of, 22

humans as intruders, 63–65

incest, 24

identification in deep ecology, 132–34; not mystical, 114

ideology, def., 182; ecology as an, 147–54

Indian philosophy, 113

individualism in ethics, 89, 90

industrial revolution, 20, 66

Invisible Hand, 49, 64, 97, 133–34, 149

irrationalism and rationality, 117

irreversible consequences, principle of, 48

Judeo(Hebrew)-Christian tradition, 20, 62–65

knowledge as power, 62, 67

labels in philosophy, xvii, 65–66, 74, 147–48

land ethic, 87, 88

life as value, 13, 36, 37; life as life-force (will to live), 81, 93; life about joy, not cruelty, 114; preserving conditions for, 132–35; religious dimension of, 25

life-world (world as constituted by life), 68, 105

limiting availability, 96

logic of oppression, 125

Marxism-Leninism, 11, 14, 144, 146

mastery, posture of (also *Herrenmoral*) 18, 68, 69, 86, 88

moral law, 2, 68, 84

moral relevance, principle of, 34, 46

monism, 137, 149

multinationals, 108, 109

mysterium tremendum et fascinans, 61

mythology, Egyptian, 26

narcissism as danger, 128

nature, experience of: craftsmen-traders, 55–56; herders-tillers, 55, 59; hunter-gatherers, 54–55, 59, 121

Native Americans, Navajo, 17, 107, Sioux, 128, Zuñi, 17

nature, 4, 49, 144; Cartesian conception of, 68; vs. culture, 3, 5, 14, 57, 63–64; experience of, 53–58; as fallen, 20, 21, 106; human nature, 9, 135–42; natural as good, 106, 140; revolt against, 69; tragic clash, 100

nika, niche (role within system), 91

nuclear energy, 10, 131, 133, 141, 150, 179

objectivity, 106; honoring integrity (objectivity) of other, 128

objectivization, 101, 107, 129–47, 155, 159
organ transplants, ethics of, 33
organism, Earth as super-organism, 129–33, 135

perfection, as moral ideal, 41, 42, 44, 45
philosophy, def. 13–14; and depth ecology, 110–14; meaning of history, 161–63; objectivity and subjectivity in, 105–8; and poetry, 14; reason and irrationality, 121–22; to seek understanding, not conformity, xvi–xvii; tragic view, 99–101
population, 6, 99, 136; population explosion, 8, 158
presumption of integrity, 48
private profit not public reason, 49
privatization as feeding frenzy, 48
privilege as tool of conservation, 99
progress, 4, 6, 109–10
property rights, 48, 97; and slavery, 31
Puritanism, 42, 159; re. animal accountability, 27
Pythagorean regime, 43

racism, 35, 141
rail transport, 74–76, 78, 146
railway engine metaphor, 64–65
rational subject, 46, 84
reason, 23, 148; alienating, 122, 148; as lazy reason, 122; theoretical and practical, 105
reasons vs. causes, 107
recycling, 74
"red habits" (meat diet), 43
Reformation, 21
Renaissance, 21, 43, 66
religious values, 60, 61
reverence for life, 79–88
right, idea of, 48,49, 87
romanticism, 21, 80, 148
Rome, ancient, 3,10, 56, 130
Rome, Club of, xvi, 7, 17, 101, 111, 142, 146, 160, 166

science def., 12–13, 53; meanings of, 12; positivist, 136; "scientific" world view (reductionism) 25, 107

self-preservation as sign of subjectivity, 46
self-realization vs. egoism, 113, 114, as self-transcendence, 115
shepherd metaphor, 65
sin, 26, 42
slavery, slaves, 20; animal liberation as abolitionism, 31, 39; human and animal, 29–32, 158
Smokey the Bear, 90
smoking, metaphor of, 143–44
snobbery, 76, 95, 173
sociobiology, 58, 135–42; def., 138; questions for, 140–41; as ideology, 147
soul, as sign of humanity, 23–26
starfish metaphor, 82, 173
Stoics, 134, 158
subjectivization, 101, 105–7, 108–28, 146, 155
superiority, alleged human, 18, 22, 25, 32–33, 86
sustainability, 5, 11; its possibility, 145
symbiosis in deep ecology, 111
systems theory, xv, 142–47

teleology, 71, 129
theocentrism, 58–65, 171
thinking like a mountain, 87–88, 118–22, 130
tragedy of the commons, 95–97
tragic vision, 100, 133
treading lightly upon Earth, 5–6, 45, 113, 155, 173

value, intrinsic and extrinsic, 35–37, 57, 85–85, 86; source of, 70; as structuring world, 106; utilitarian, 36, 38
vegetarianism, 41–44; objections to, 43–44
vivisection, 18, 24
voluntary simplicity, 75–76, 83

Wenceslas Square (Prague), metaphor, 85
wildness as salvation of world, 80, 173
world as a stage, 17, 18; enchanted, 79–80; secular, 80; as value-laden, 106

zoo, in Sarajevo, 29; as problem, 153, 183

INDEX OF BIBLICAL QUOTATIONS

Genesis 3:22	181	Matthew 19:24	77
Exodus 20:12	6, 163	Mark 10:25	77
Judges 15:4–5	21	Luke 12:20	9
Ruth 1:16–17	xviii	Luke 18:25	77
Psalm 8:5	20	I Corinthians 13:1	xviii
Ecclesiastes 3:19–21	26, 28	James 2:14–17	184
Isaiah 11:6–9	42, 173		